CONTEMPORARY PAINTING IN GERMANY

CONTEMPORARY PAINTING IN GERMANY

BEATE STÄRK

CRAFTSMAN HOUSE

G+B ARTS INTERNATIONAL

Distributed in Australia by Craftsman House,
20 Barcoo Street, Roseville East, NSW 2069
in association with G+B Arts International:
Australia, Austria, Belgium, China, France, Germany,
Hong Kong, India, Japan, Malaysia, Netherlands,
Russia, Singapore, Switzerland, United Kingdom,
United States of America

ISBN 976 8097 28 0

Design *Craftsman House, Sydney*
Printer *Kyodo, Singapore*

CONTENTS

ACKNOWLEDGMENTS

I am especially grateful to Nevill Drury, Publishing Manager of Craftsman House, who gave me the chance to write this book. Also, I am indebted to all the artists represented in this book and to their dealer galleries, who supplied the photographs reprinted and who have generously helped with biographical data, exhibition lists and catalogues.

For their patience and support, I thank all my friends, especially Bianca Tarabella, for her advice and encouragement throughout.

INTRODUCTION

At the end of the 1970s and the beginning of the 1980s, German art, more specifically West German painting, achieved a spectacular and surprising presence on the national and international art market. 'Neo-Expressionists' or 'New Wilds' were only two of the terms used to describe most of the disparate artists.

Many of those painters, who became internationally acknowledged during this time, are represented in this book. The works of artists who did not follow this particular path are also discussed. Since the Berlin Wall came down on 9 November, 1989, the art scene in Germany has been stimulated also by a large number of artists who have been living and working in the former German Democratic Republic. Here, we introduce to an international audience the works of several of these painters.

Together, these 48 artists have contributed to a vivid art scene in Germany. Their works reflect a large variety of most diverse styles and themes and present us with approaches, sometimes diametrically opposed.

The following short history of German art after 1945 introduces the discussion of how, when and where figuration again began to become a major motif of the paintings of many artists. In the subsequent text, not every artist can be mentioned, nor each movement or group. Instead, the essay concentrates on the description of the interconnections particularly between some of the 48 represented artists. Also for this reason, Berlin and Cologne, which are generally seen as the main centres of the art scene of the early 1980s, have been chosen as examples to delineate the development of two artist groups, the Berlin group of artists who co-founded the 'Galerie am Moritzplatz' and the Cologne group *Mühlheimer Freiheit*. This discussion is followed by a brief survey of the situation of artists in the former German Democratic Republic before the German reunification.

At the end of the Second World War, isolated from their own tradition and the international art movement by twelve years of a National Socialist regime of terror, a whole generation of young artists began their work in between bombed cities without art academies and galleries. The collapse of the art scene began in 1937 with

the humiliating campaign against 'Entartete Kunst' ('Degenerate Art') in the course of which thousands of works were confiscated. Many well-known artists such as Oskar Schlemmer, Christian Rohlfs or Ernst Ludwig Kirchner did not survive the war, while others like Josef Albers, Wols or Kurt Schwitters had to leave Germany and never returned.

After 1945 German painting was, for many years, characterised by a close dependence on the international art movement. On one hand, as Wolfgang Max Faust once pointed out, the artists surely felt an 'enormous need to catch up'[1] with international modern art. On the other hand, looking at and learning from the artists in Paris or New York also allowed for a rejection of their own history.

Until about the mid 1950s, Paris was the undisputed capital of the arts. Here, the French *Tachisme* or, as it was later called, *Informel*, was developed as the European version of the American *Abstract Expressionism*. Acting as mediators between France and Germany were two German emigrés, Hans Hartung, an important member of the École de Paris and Alfred Otto Wolfgang Schulze, known as Wols. The paintings of these two artists are very different in appearance. While Wols' works are characterised by a filigreed nervousness, Hartung's show the tracks and traces of the painting procedure, reflecting the momentary human existence. Both artists, however, share a spontaneous approach. 'The spontaneity of this kind of painting', Karl Ruhrberg asserted, 'its explosion of all forms, coupled with the expressive force of the pronouncedly individual "handwriting" of these "New Primitives" of the fifties, meant both romantic and expressionist tendencies within a specifically German cultural heritage could be elaborated in abstract form. The essential mood of this kind of art was dark, its colour and tonality broken. Its intellectual background was provided by the philosophy of existentialism, which at the time dominated European thought.'[2]

Yet, it was not only the French *Informel* which influenced the young German artists. Almost parallel to the French and American art tendencies, Willi Baumeister had developed a non-figurative autonomous abstract art by reducing representational

figuration to, as he described it, the essential content of art, that is form. More than any other post-war painter, Baumeister became a remarkably influential teacher and theorist and his book *Das Unbekannte in der Kunst* (*The Unknown in Art*), written in the winter of 1943 and published two years after the war, was regarded for many years as the major treatise on abstract painting. Other painters, who followed a similar path and who also contributed to this development, were, for example, Max Ackermann, Theodor Werner, Fritz Winter, Ernst Wilhelm Nay, Georg Meistermann and Julius Bissier. Through Baumeister's influence and authority, however, abstract painting became to be acknowledged publicly. Artists like Emil Schumacher, Hann Trier, Fred Thieler, Bernhard Schultze, Karl Otto Götz and the Danish-born K.H.R. Sonderborg followed the path he had smoothed and the latter two, in particular, began to create abstract paintings based on spontaneous gesture only.

This lyrical, often emotionally depressive and existential abstraction was in 1955 consciously opposed by Konrad Klapheck. He was twenty years old and a student at the Staatliche Kunstakademie, Düsseldorf, when he created *Die Schreibmaschine* (*The Typewriter*), a depiction of a Continental typewriter, painted as exact, austere and unpoetic as possible. From then on, the ironic depiction of objects became the theme of Klapheck's art.

Then, in 1957, ZERO was founded in Düsseldorf. It was the first independent German art group after the Second World War. Its protagonists were Günther Uecker, Heinz Mack and Otto Piene. In contrast to the painters of the *Informel*, the ZERO artists based their art on an optimistic feeling for life, confidently proclaiming 'ZERO: we are living. ZERO: we are for anything.'[3] The group, specifically interested in colour, light and movement, drew its major stimulation from the monochrome paintings of Yves Klein and the white *Achromes* of Piero Manzoni as well as from Lucio Fontana's perforated and slit open canvases and the early experiments of the Bauhaus artists, in particular the kinetic art works of Laszlo Moholy-Nagy. As well, their thinking was influenced by far-Eastern thought, more specifically Zen Buddhism.

The early works of the three artists were especially dominated by the non-colour

white. Günther Uecker, for example, decided on a white zone 'as the utmost colourfulness, as the culmination of light, as triumph over darkness.'[4] For him, a white world was a human world, which allowed people to feel alive and experience their own colourfulness. Also, white was seen as expressive of silence, as a kind of spiritual language, a kind of prayer, which could initiate meditation and which could be a spiritual experience.

At the same time, the ZERO group's early experiments with light led to Günther Uecker's well-known 'nail-works' — he covered the surfaces of most diverse objects with hundreds of nails — and to the utilisation by Mack and Piene of grid-like structures since they were seen as non-emotional, as non-expressive.

Later on, these works were developed into kinetic art objects by using light and introducing movement. Already two years after the formation of the group, Heinz Mack created the first light-dynamos and Otto Piene started working on the idea of a light-ballet. By 1960, Günther Uecker had created the first light-boxes.

Although ZERO was the most dominant art movement opposed to the *Informel* tendencies, other artists, too, counter-balanced the spontaneous approach. The most prominent representatives of this so-called *Geometric Abstraction* or *Neo-Constructivism* were Rupprecht Geiger, Winfried Gaul, Raimund Girke, Reimer Jochims, Günter Fruhtrunk, Karl Georg Pfahler and Gotthard Graubner. Compared to the colourfulness of the tachist paintings, their frequently monochrome works are self-reflexive, are distinctly contemplative, subtle and ascetic. During the following decade, Graubner, for example, developed his work towards 'beautiful colour-spaces and colour-space bodies, which, following Caspar David Friedrich and J.M.W. Turner, soak up light and reflect it. The colour which opens up space is Graubner's only theme, realised with an exceptional quality of *peinture*, which extends the legacy of the great European colourists in a very personal fashion into the present.'[5]

Yet, comparable to the ZERO movement, the *Geometric Abstraction* brought itself to a standstill through its own decorative aspects which often led to 'uninspired, trivial patterns.'[6]

Then, during the late 1950s and the 1960s, the art scene was overtaken by the most diverse artistic innovations, like the American and English Pop Art, the French Nouveau Réalisme, Op Art and Hard Edge Painting as well as Minimal and Conceptual Art.

In Germany, one figure in particular, became prominent during this time both as artist and as teacher — Joseph Beuys. 'His unshakeable faith in the creative forces in every human being, his understanding of sculpture as the summation of all social and intellectual activities — even "thinking" is sculpture — has extended the whole notion of art beyond all previous limits and broken through the narrow boundaries of different genres. The sculptor, maker of objects, painter, drawer, environmental-happening-process-and-performance artist and founder of the "Free International University" has done more than any other person this century to bring contemporary German art to international attention'[7], as Karl Ruhrberg appropriately summed up Beuys' profound and multidimensional approach, his mythical and political concerns and his outstanding achievements.

Also during the late 1950s and early 1960s, the first figurative paintings were created by those artists who only received international acknowledgement towards the end of the 1970s. These were, for example, Gerhard Richter (born 1932), Horst Antes (1936) — Kiefer's teacher at the art academy in Karlsruhe, Eugen Schönebeck (1936), Georg Baselitz, Bernd Koberling and Karl Horst Hödicke (1938), A.R. Penck (Ralf Winkler) (1939), Markus Lüpertz and Sigmar Polke (1941) as well as Jörg Immendorff and Anselm Kiefer (1945).

Gerhard Richter, for example, had left Dresden, where he had studied for six years at the art academy and where he had received an intensive training in the technique and themes of 'Socialist Realism', and come to Düsseldorf at the beginning of the 1960s, where he studied a further two years at the art academy. In 1963, he first exhibited together with Konrad Lueg (Fischer), who later became known as a successful gallery-owner for Minimal and Conceptual Art. Their exhibition 'Life with Pop', shown at the Düsseldorf furniture store Berger, is generally seen as the birth

place of their concept of 'Capitalistic Realism' which ironically alludes to 'Socialist Realism', the artistic dogma developed in the Soviet-dominated German Democratic Republic since 1945. It opposed all abstract and expressive art tendencies and was characterised by a sarcastic distortion and critique of the German day to day reality, an aspect which also became apparent in the early paintings by Sigmar Polke, K.H. Hödicke and Wolf Vostell and which was taken further by the Neo-Dadaist actions of the Happening and Fluxus artists.

Sigmar Polke, had come from Silesia to West Germany in 1953. Between 1961 and 1967, he studied under Hoehme and Goetz at the art academy in Düsseldorf and was later particularly influenced by Joseph Beuys. In his earliest works, he painted gesturally on wallpaper or cheap tablecloths, or, contradictorarily, transformed trivial motifs like vases and buttons, socks and shirts, biscuits and chocolate, palm trees as well as pin-up girls, press and family photographs into paintings with a screen structure, recalling Seurat's Pointillism, as well as the four-colour printing technique. Like Richter's 'Photo Paintings', created since 1962, Polke's screen paintings are anonymous in their appearance, negate any possible meaningful content and clearly confront the emotionally charged action painting, too.

ZERO, Klapheck, Graubner, Beuys, Richter and Polke all contributed to Düsseldorf's status of being one of the two capitals of the German art scene in the 1960s and particularly 1970s. The second city was Berlin. Yet, while Düsseldorf was open to the art tendencies and developments coming from Paris and later from New York which were evaluate rather self-confidentialy by the artists, Berlin was considerably isolated, an island amidst the Eastern block. Several artists, however, moved from the East to West Berlin and brought new and different impulses for the art scene, 'different from the orientation towards French and American art in West Germany after the Second World War. Because the artists, coming from the East, are more influenced by the memories and experiences connected to Caspar David Friedrich or Ernst Ludwig Kirchner than by the influences from Yves Klein or Jean Dubuffet.'[8]

One of these artists was Georg Baselitz (Hans-Georg Kern), who was born in

Deutschbaselitz, Saxony. He had studied at the Hochschule für Bildende und Ange-wandte Kunst in East Berlin, from which he was expelled after two terms for 'social and political immaturity'. He finally shifted to West Berlin in 1958, where he studied under Hann Trier at the Hochschule der bildenden Künste. In 1961, he adopted the name Georg Baselitz. Together with the painter Eugen Schönebeck who had also left the GDR, he formulated in the same year the manifesto '1. Pandämonium', a 'pathetic-expressive' program which also demanded an indigenous outlook for German arts. It was followed by the '2. Pandämonium' in 1962. Baselitz' opposition to the Abstract — by then already more design-like — Expressionism which was taught at the academy is clearly displayed in the paintings with inverted motifs, which he developed since 1968/69. Yet, already in the early 1960s, the artist had created works like *Der nackte Mann* (*The Naked Man*) (1962) and *Die große Nacht im Eimer* (*Big Night Down the Drain*) from 1962/63. At his first solo-exhibition at the Galerie Werner & Katz in 1963, both paintings were confiscated for obscenity and pornography by the public prosecutor. 'In the opposite sense that exhibition was just as successful as the manifesto', Baselitz said in interview with Johannes Gachnang in 1981, 'All of a sudden, as a result of misleading articles in the press, people started coming into the gallery who had never seen a painting before, who otherwise never went to galleries and looked at pictures. It was all a complete misunderstanding. These people were outraged and horrified by what they saw … But I had never intended to be provocative. My aim was to distance myself from tachisme and from abstract painting.'[9]

Nevertheless, the act of prosecution also highlighted 'the ambiguous bourgeois narrow-mindedness and bigotry of those years. While the first sex-shops were opened, an erotic painting like *Big Night Down the Drain* was banished through a pornography verdict, although the masturbation which it depicted was a metaphor for obsessions of isolation, of alienation and the grown tiredness of the consumer society.'[10]

This grown tiredness of the consumer society, the desire for change and the

dream of individual freedom and self-realisation, also became apparent in the subjective and expressive works and the activities of two other Berlin artists, K.H. Hödicke and Bernd Koberling. In 1961, both became members of the artist group 'Vision' (1960–64) — a name which speaks for itself. While Hödicke's early paintings of the big city, of the glamour and glitter found particularly in Berlin where pubs and clubs were allowed to be open for twenty-four hours, reflect both the attraction and irritation of this world. Koberling's works, which depict romantic landscapes, mirror his withdrawal from this atmosphere.

Analogously, the very idiosyncratic dithyrambic paintings, developed by Markus Lüpertz, who had moved to Berlin in 1962, are expressive of an ecstatic and pathetic feeling. Like Hödicke, Lüpertz also was a founding member of the self-help gallery 'Großgörschen 35' (1964–68), where he proclaimed his 'Dithyrambic Manifesto', published in 1966: 'The charm of the 20th century becomes visible through the dithyrambe which I invented.'

In 1965 Koberling had his first solo exhibition, entitled 'Sonderromantik' ('Special Romantic') in the independent exhibition space 'Großgörschen 35' — named after the street in which it was situated in. It was established in an old factory in Berlin-Schöneberg in Mai 1964 by fifteen artists. Wolfgang Petrick — the teacher of Heike Ruschmeyer — as well as Hans-Jürgen Diehl, Ulrich Baehr and Peter Sorge belonged to this group of 'Berlin Critical Realists', four artists, who, in the 1970s, consistently continued their ironical, sometimes aggressive and macabre satires on the bourgeois daily routine and the political reality.

The political reality is also of concern to the Düsseldorf artist Jörg Immendorff, who had studied under Joseph Beuys. In 1966, he explicitly expressed his concern about a self-satisfying and uncritical art as well as his opposition to academic conformism with the self-contradicting picture *Hört auf zu malen* (*Stop painting*). A year later, he initiated LIDL which manifested itself through protest marches and the rebellion against institutions. Immendorff's approach here clearly reflects the historical situation.

Already at the beginning of the 1960s, students in America protested against the archaic structures of the university system and the Vietnam war, a movement which soon reached Europe and was at its height in Germany around 1967/68. Here, the rebellion was also directed against the authority of family, school and church and the affluent society was accused of having never been truly concerned with its fascist past.

Due to the Vietnam war and the Watergate affair, America was no longer the model for the German art scene. Independent European and German energies came to the fore, resulting in an art scene which became more and more pluralistic.

Yet, the belief in change and the optimistic confidence which carried the revolts in the late 1960s and early 1970s soon evaporated. The result was in Germany and Europe as well as in America 'a retreat to past cultural values or a concentration on the individual privacy … Instead of a socio-political commitment, the own inwardness was cultivated.'[11] This privacy was made use of rather unreservedly and expressed itself in exhibitionist gestures as well as in quiet, subjective and very individual activities. Artists like Michael Buthe, Nikolaus Lang, Anna Oppermann, Rune Mields, Fritz Schwengler and Jochen Gerz come to mind when talking about the creation of different kinds of 'Individual Mythologies'.

The works, created in the 1970s by Jörg Immendorff, A.R. Penck and in particular by Anselm Kiefer, too, are concerned with myth and history. Yet, for them, it was specifically the German history which was of importance. Immendorff and Penck — who, in a sense, has an outsider position since he did not move to West Germany until 1980 — concentrated on the more recent historical event, the German separation by the Berlin Wall. Kiefer, on the other hand, was to examine his identity as an artist and as a German, concerning himself with the Third Reich, the fascist past of Germany as his earliest works already prove. His book *You're a Painter* and a series of photographs showing the artist in the Nazi *Sieg heil* pose in various places, were both created in 1969. Kiefer's complex and later often monumental paintings confront the viewers — as it was demanded during the student revolt — with

historical events, often suppressed and forgotten.

Yet, the art scene of the 1970s was still dominated by Critical Realism, Minimal, Land and Conceptual Art, by performances and installations, video and film creations. Towards the end of the decade, however, the socio-political situation in many industrialised countries led to feelings of isolation and alienation and the 'no-future' attitude arose. In this atmosphere, the art scene responded with subjectively and spontaneously created art works, with paintings in particular. 'What everybody wanted became clear: a strong, emotionally effective picture, which would reach the viewer directly, without reflection-filter. It was not to be abstract, since it had to have a definite message yet a message with a subjective slant. This creative spontaneity was particularly achieved by painting.'[12] As a result we perceive in the late 1970s and, in particular, the early 1980s, a true flood of paintings coming from the studios of artists in Germany, but also from Switzerland and Austria.

Already a few years before, Italian painters, like Sandro Chia, Enzo Cucchi, Mimmo Paladino and Francesco Clemente, known as the 'Trasavangardia' or 'Transavangarde', had developed a similar approach. In the United States, the artists had also responded to the unemotional and intellectual conceptual art with, for example, 'Bad Painting' and 'Pattern Painting'.

As it was shown, several artists in Germany had already begun in the early 1960s to counter the prevailing art forms. In the late 1960s and the 1970s, Jörg Immendorff's LIDL-Academy (1968–70) followed a similar aim as did the artist group 'Normal' (Milan Kunc, Peter Angermann and Jan Knapp) and the 'YIUP-Gruppe' with as members such artists as Imi Knoebel, Blinky Palermo, Jörg Immendorff, Sigmar Polke, Gerhard Richter, Ina Barfuss and Johannes Brus.

Then, towards the end of the 1970s, more young artists than ever before began to oppose with paintings the theories and methods taught at the schools of fine arts. These frequently expressively painted works became popular almost overnight. The media reacted instantly and entitled the artists as 'New Wilds' or 'Neo-expressionists'.

The term 'The New Wilds', chosen by Wolfgang Becker, was originally not

thought to be descriptive of these young artists. Instead it was the title of an exhibition at the Neue Galerie/Sammlung Ludwig shown between January and March 1980. Becker explained in his text for the catalogue, that he discovered the title 'Les Nouveaux Fauves — Die Neuen Wilden' in the exhibition 'Paris-Berlin' shown at the Centre Pompidou, Paris, 1981. For him, the question about similarities and motivation of the paintings of the 'Fauves' and that of the German Expressionists of around 1910 was not answered sufficiently in this exhibition. Also, he wanted to find out whether the recent French and German painting showed a motivation akin to that of the early 20th century and whether today there are still comparable similarities and dissimilarities between French and German painting.

Also the term 'Neo-Expressionists' misrepresented many approaches. Its employment clearly misjudged both the historic Expressionism and the German art of the 1960s and '70s. It was evident that the complexity of the German painting, whether that of the 1960s and 1970s or that of the 1980s, could not be reduced in favour of an oversimplified scheme of avant-garde standards.

Nevertheless, the terms 'New Wilds' and 'Neo-Expressionists' became catch-words. Thus described, many of those artists, who are represented in the following portraits, exhibited nationally and internationally in copious solo and group shows. In 1981, for example, the exhibition 'Bildwechsel — Neue Malerei aus Deutschland' at the Akademie der Künste, Berlin, showed works by H.P. Adamski, Elvira Bach, Peter Bömmels and Werner Büttner, Walter Dahn, Rainer Fetting, Thomas Lange, Helmut Middendorf, Albert Oehlen, Jürgen Partenheimer, Eva-Maria Schön and Bernd Zimmer. At the 'Rundschau Deutschland' exhibition in Munich during the same year, paintings were also included by Ina Barfuss, Martin Kippenberger, Markus Oehlen, Stefan Szczesny, Volker Tannert and Thomas Wachweger. On the other hand, the early large international exhibitions, such as 'A New Spirit in Painting' at the Royal Academy of Arts in London and 'Art Allemagne Aujourd'hui' at the ARC/Musée d'Art Moderne de la Ville de Paris, mainly showed the works of the older generation of artists, like those by Georg Baselitz, K.H. Hödicke, Jörg Immendorff, Anselm Kiefer,

Imi Knoebel, Bernd Koberling, Markus Lüpertz, A.R. Penck, Sigmar Polke and Gerhard Richter.

One exhibition in particular, 'Zeitgeist', shown at the Martin-Gropius-Bau in Berlin in 1982, brought together the three generations of German artists with those from other European countries and the United States, who had developed a similar style.

Already the title of the exhibition points to a specific understanding of this kind of painting. It was understood as a phenomenon of the 'Zeitgeist', of the spirit of the time. Like the expression 'Hunger for Paintings' which was coined by Wolfgang Max Faust, 'Zeitgeist' was to be, as Christos M. Joachimides explained in his text for the exhibition catalogue, 'a metaphor for all contemporary artistic suggestions which signal a distinctive change in the fine arts. A direct sensual relation to the artworks is sought. The subjective, the visionary, the myth, the suffering, the charm are brought out from their exile. A Dionysian fundamental feeling is often characteristic for the artistic self-understanding.'[13]

Specifically in Berlin, this 'wild and visionary' kind of painting could be recognised. Here, already in 1977, the self-help 'Galerie am Moritzplatz' was founded and was to be one of the centres for contemporary German art until 1981 when it closed with the exhibition 'Topeng' by Thomas Hornemann and Bernd Zimmer. The gallery, which was managed by the artists themselves, was established by Rolf von Bergmann, Rainer Fetting, Peter Hebeisen, Anne Jud, Franz Lehr, Helmut Middendorf, Dagmar Niefind, Salomé, Bertold Schepers, Peter Schliep, Yoshio Yabara and Bernd Zimmer. These artists came from diverse artistic positions, directions which clearly reflected the prevailing pluralistic art forms of the late 1970s. They painted, made sculptures and acted in performances, worked with photography and created costumes and stage-sets.

Yet, due to the 'hunger for paintings' towards the end of the 1970s and the beginning of the 1980s, only the painters of this group, Fetting, Middendorf, Salomé, and Zimmer received international acknowledgement. These four artist figure as the nucleus of the Berlin 'Wild Painting', 'a type of painting which is clearly indebted to

the tradition of expressionist art (in particular Van Gogh and the German Expressionists) which aimed at capturing the feeling and attitudes to life of a young generation.'[14] Yet, it is also indebted, we might add, to the art of those Berlin artists who had begun to paint figuratively in the 1960s, to Karl Horst Hödicke, who was the teacher of Middendorf and Salomé, as well as to Baselitz, Lüpertz and Koberling.

The motifs of the art of the young Berlin wild painters — including Elvira Bach and Luciano Castelli — are usually drawn from their day-to-day experiences while the human being, often the self-portrait, is at the centre of their interest. Thus, the paintings, which are of a dynamic and shrill colourfulness, often portray the Berlin night life and atmosphere, the interaction of the individual and its social environment, trendy discos and the gay subculture, dance clubs, rock concerts and street scenes, singers and dancers. These works, executed with fast and fierce brush strokes, clearly reflect the constant movement of the city, the experiences and perceptions which do not endure. Often cheap materials were employed like dispersion paint and untreated cotton cloth to keep the cost of production low and the spontaneity flowing.

In 1980, the works of Fetting, Middendorf, Salomé and Zimmer were shown for the first time programmatically in the exhibition 'Heftige Malerei' ('Wild Painting'), curated by Thomas Kempas at the Haus am Waldsee in Berlin-Zehlendorf.

During the same year, the very different works of another important group of German artists were exhibited at the Galerie Maenz in Cologne under the title 'Mühlheimer Freiheit & Interessante Bilder aus Deutschland' ('Mühlheimer Freiheit and Interesting Pictures from Germany').

The artists of the *Mühlheimer Freiheit* were Hans Peter Adamski, Peter Bömmels, Walter Dahn, Jiří Georg Dokoupil, Gerard Kever and Georg Naschberger while the paintings by Ina Barfuss, Thomas Wachweger, Werner Büttner, Georg Herold and Albert Oehlen were included in the exhibition as 'the (other) interesting pictures from Germany'.

In 1980, Paul Maenz had 'discovered' the Cologne group at the exhibition 'Auch

wenn das Perlhuhn leise weint ...' ('Even if the Guinea-fowl quietly weeps ...') at the Hahnentorburg, Cologne, where Adamski, Dahn, Dokoupil and Bömmels showed their works. Maenz named them — by then also Naschberger and Kever had joined the group — after the address where they had their collective studio, Mühlheimer Freiheit 110.

Some of the artists had already known each other before. Dokoupil, Kever and Naschberger had studied under the German conceptual artist Hans Haacke at the Cooper Union College in New York. Adamski, on the other hand, was already a well-known conceptual artist and Walter Dahn had been master-class student under Joseph Beuys at the Staatliche Kunstakademie in Düsseldorf. Only Peter Bömmels, who had studied sociology, politics and educational theory and who was working in a kindergarten was a kind of outsider.

Compared to the artists from Berlin as well as to Martin Kippenberger, Werner Büttner, Albert and Markus Oehlen who dominated the art scene in Hamburg with their anarchic and satirical provocations, the painters of the *Mühlheimer Freiheit* never shared an aesthetic concept. Rather, the group was born of financial necessity. Their self-confident approaches have always been distinctly idiosyncratic as it becomes apparent in the artist profiles of Adamski, Bömmels and Dahn on the following pages. Nevertheless, the *Mühlheimer Freiheit*, which had existed since around the second half of the 1970s and which broke up in the summer of 1982 when several of the artists became successful as individuals, was one of the most influential collectives which also contributed significantly to Cologne's change into one of the leading centres of the German art scene in the 1980s.

Like many West German artists, several painters, who were living and working in the former German Democratic Republic, a country which had often tried to suppress these artistic approaches, in the 1970s and 1980s, moved towards more individualism, towards a rather more expressive pictorial language.

The early years of the art scene of the former GDR were still characterised by an active commitment of many artists to an independent, humane, sometimes socialist

orientated art. Yet, already towards the end of the 1950s, at the beginning of the Cold War, the government began to put pressure on the artists. Those, who did not follow the doctrine of the new 'Socialist Realist' style which took soviet art as a model, were often left for years without support and acknowledgement. Others, like Baselitz (1957) and Richter (1960) moved to the West.

In the 1960s, many artists began to show their aversion to the imposed style and themes in debates, in conferences and in congresses held by the artist associations as well as in their artworks. Many artists began to regained their self-confidence and as a result, a rapid increase of independent developments can be noticed. It was during this decade, that Wolfgang Mattheuer developed his metaphorical themes and that Hartwig Ebersbach began to paint expressively. Also, at this time, A.R. Penck (Ralf Winkler) painted the first 'System Paintings' and the 'World Paintings', established 'Standart'(-East) and exhibited in West Germany as did Carlfriedrich Claus and Gerhard Altenbourg.

Finally, in 1972, the 'VII Art Exhibition' at Dresden, marked a decisive, almost revolutionary change in direction. Undoubtedly it was here, that the end of the imposed 'true socialist art' was announced. Already at the VIII Party Conference of the SED in 1971, Erich Honecker had officially authorised the artists to experiment and to explore the 'range and diversity of the creative possibilities', an invitation which was supported by a remark of Kurt Hager — chief ideologist of the SED party — that 'uniformity and clichés, as they are still and often to be found, reduce the effectiveness of the artists. The search for new forms, means, techniques is indispensable …'[15] Yet, the resulting stylistic plurality was not always approved of by the GDR regime, a fact which has to be kept in mind.

Evidence for this plurality can be found in the works by Wolfgang Mattheuer, Volker Stelzmann and Arno Rink, which took the images of the 'New Objectivity' as a model, in the pictures created by, for example, Nuria Quevedo, Harald Metzkes, Rolf Händler, Max Uhlig and Wolfgang Petrovsky as well as in the paintings by Bernhard Heisig and by several of his student, including Sighard Gille, which reflect the

gestural handwriting of Max Beckmann, Lovis Corinth, Otto Dix and Oskar Kokoschka.

In addition, non-realist and non-conformist art was demanded by an even younger generation of artists, like Michael Morgner, Thomas Ranft, Gregor Torsten Kozik (Schade) and many more.

Also during this time, interdisciplinary art forms, performances and installations as well as the combination of dance and music, painting, sculpture and film began to become of major interest to several artists. These were, to name a few only, Lutz Dammbeck, Hans-Hendrik Grimmling, Frieder Heinze, Günther Huniat, Gregor Torsten Kozik (Schade), Eberhard Göschel, Peter Herrmann, Michael Morgner and Hartwig Ebersbach, who played the most significant role.

While the 'conflict paintings' of the 1970s, which had discussed viable social changes, decreased, the stylistic diversity as well as the interdisciplinary art forms were continued in the 1980s, a decade in which the individual and the self became more and more the focus of many artist in the former GDR, too.

Non-conformist approaches were also maintained but were still disapproved of by the GDR. Ralf Kerbach, Helge Leiberg and Cornelia Schleime left the country (1983/84) since they did not see any possibility of independently developing their creativity.

Other artists, like Michael Morgner, kept on acting in performances and developing his very own intimate and symbolical paintings while Hartwig Ebersbach continued to paint expressively. A spontaneous and gestural painting was also developed by Trakia Wendisch, Angela Hampel and Werner Liebmann as well as by Hubertus Giebe, Johannes Heisig and Walter Libuda, who were propagated in the early 1980s by the GDR art market for their closeness to the West German neo-expressionist tendencies, which is, after all, only superficial.

Since the German reunification, many critics have tried to evaluate the art, created in the former German Democratic Republic. At times, different standards — east and west — have been applied. Also 'official' painters and outsiders have

already been separated from each other. Yet, not always do we know what exactly happened and how the artists have felt during the past decades. It might take at least another ten years until we together will be able to appropriately summarise and analyse this part of German art history.

CONCLUSION

By the mid 1980s, sculpture, performance art, installations, photography, video and film, that is art forms which had all existed side by side with painting during the 1980s in both East and West Germany, came again to the fore and removed painting — particularly neo-expressionist painting — from its position of supremacy in the galleries and on the art market.

This does not mean that painting ceased to exist. Rather, it has often taken on a new form. Today, more artists than ever before — noticeably many women artists — combine different approaches and techniques, fuse spontaneity with calculation, figuration with abstraction, draw on the canvas and paint and draw on paper, on photographs and post-cards, create installations with their paintings or transform them into sculptures. In addition, many painters have continued to work as sculptors and musicians, performance artists, video and film makers, gaining experience which in turn influences their painting.

The end of the supremacy of the 'hunger for — especially wild — paintings' now also allows us to view the often very idiosyncratic works, created in the 1980s, works, which on one hand, were previously misrepresented as being 'neo-expressionist' and, on the other hand, those, which never fitted under the 'expressionist' heading.

And the paintings by the 'New Wilds'? They, for example, have become more subdued since the shrill colourfulness has been reduced. Although they have continued to paint gesturally, many of them have refined their style and have created

works which now display a more mature, thoughtful and complex approach, replacing the earlier spontaneous directness.

As it becomes apparent when looking at the following 48 artist profiles, the concerns and techniques employed are most diverse. Together with many others these painters have contributed to a rich and varied contemporary German art scene.

1 Wolfgang Max Faust/Gerd de Vries, *Hunger nach Bildern*, DuMont Buchverlag, Cologne, 1982, p. 10.
2 Karl Ruhrberg, 'German Art since 1945. Historical Background', in: exhibition catalogue *Wild Visionary Spectral: New German Art*, Art Gallery of South Australia, Adelaide, Australia, Art Gallery of Western Australia, Perth, Australia, National Art Gallery, Wellington, New Zealand, 1986, p. 12.
3 Heinz Mack/Otto Piene (ed.), Zero 3, Düsseldorf (1961), reprinted in: Faust/de Vries, *op. cit.*, p. 12.
4 *Ibid.*
5 Ruhrberg, *op. cit.*, p. 15.
6 *Ibid.*, p. 13.
7 *Ibid.*, p. 14.
8 Christos M. Joachimides, in: exhibition catalogue *Die wiedergefundene Metropole. Neue Malerei in Berlin*, Palais des Beaux-Arts, Brussels, Culture Department of the Bayer AG, Leverkusen, 1984, p. 12.
9 Georg Baselitz in an interview with Johannes Gachnang, reprinted in: *Georg Baselitz*, Benedikt Taschen Verlag, Cologne, 1990, p. 27.
10 Karin Thomas, *Zweimal deutsche Kunst nach 1945*, DuMont Buchverlag, Cologne, 1985, pp. 137/139.
11 *Ibid.*, p. 209.
12 Stephan Schmidt-Wulffen, 'Alles in allem — Panorama "wilder" Malerei', in: exhibition catalogue *Tiefe Blicke*, DuMont Buchverlag, Cologne, 1985, p. 22.
13 Christos M. Joachimides, 'Achill und Hector vor den Mauern von Troja', in: exhibition catalogue *Zeitgeist*, Martin-Gropius-Bau, Berlin, 1982, p. 10.
14 Wolfgang Max Faust, 'Hunger for Images and Longing for Life: Contemporary German Art', in: exhibition catalogue *Wild Visionary Spectral: New German Art*, Art Gallery of South Australia, Adelaide, Australia, Art Gallery of Western Australia, Perth, Australia, National Art Gallery, Wellington, New Zealand, 1986, p. 23.
15 Reprinted in: Karin Thomas, *op. cit.*, p. 171.

HANS PETER ADAMSKI

Although in the 1980s he achieved international acknowledgement with the artist group *Mülheimer Freiheit*, Hans Peter Adamski's works are, compared to many of his colleagues, rather un-expressionist. Even though he says 'I'm only concerned with myself not with the piece of canvas', he also once stated 'I want to become unfamiliar with myself — contradicting feelings attract me enormously' (in: *Kunstforum International*, vol. 114, 1991, p. 370 and vol. 68, 1983, p. 76). Adamski demands that the artist, like any person, should be allowed to decide anew every day, what he or she wants to do. And unquestionably, he takes his chance.

The artist, who lives and works in Cologne, was born in 1947 in Kloster Oesede near Osnabrück and between 1970 and 1974 studied at the Staatliche Kunstakademie, Düsseldorf. At that time, Adamski's working method was clearly influenced by conceptual art. In his works today, chance and arbitrariness are still mirrored, yet, in a very different form.

Style and technique, materials and subjects have always been inconsistent in Adamski's oeuvre. We discover figurative depictions and gesturally executed portraits as well as abstract and half-abstract tendencies, while all kinds of motifs are delineated, reminiscent of whatever triviality, banality, kitsch, mythology, ornaments, art from Japan or eroticism offer. The materials Adamski employs for his ideas, are equally copious. He has made silhouettes and sculptures in iron and wood, designer-like objects as well as book objects. He takes photographs and paints gouaches, works in oil or with dispersion and draws. He has also contributed to the world's largest watercolour painting.

Adamski, who tries to evade any categorisation, creates additional difficulties for the viewer by combining disparate imagery. This might be perceived as symbolic of the multitude of objects the viewer is visually confronted with daily. It might also be a metaphor for the missing sense of wholeness in contemporary life. At times, though, the amalgamations result in absurd and weird paintings which are hermetically closed to any answer or interpretation, as for example the work *Gekreuzigter mit Ostereiern / Crucified with Easter Eggs* from 1983.

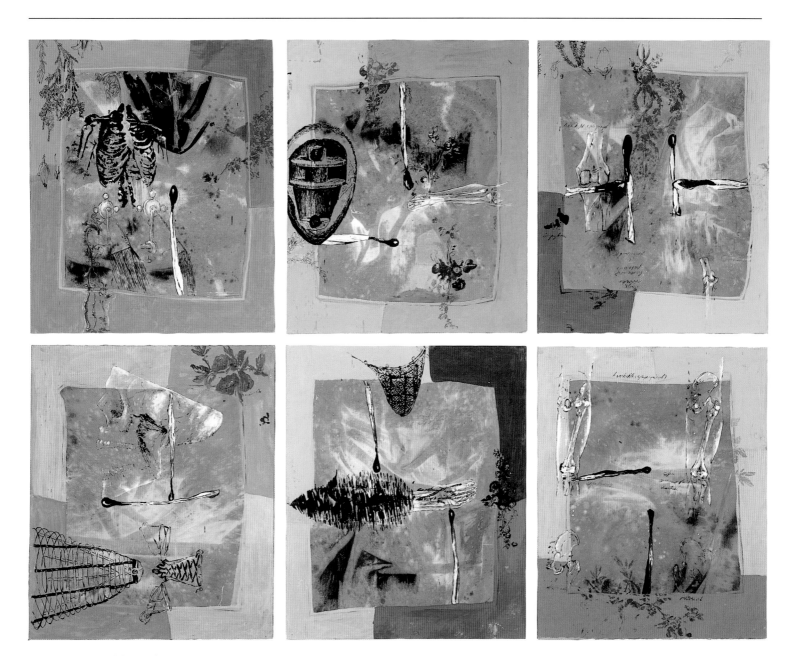

Welthözer / World Matches, 1990,
Acrylic and oil on untreated cotton cloth, 330 x 430 cm,
Courtesy the artist

Adamski, whose attitude towards the content and meaning of his works is also characterised by indifference, approaches the theme of death with ambivalent and ironic images, indicative of tragedy as well as of black humour, with which the former is defeated.

In the series of *Welthölzer / World Matches* paintings, all from 1990, parts of a skeleton continue to reappear. These images — bony hands, a skull or a torso — which are taken from an anatomical book, are combined with the depiction of burnt matches — the world they lit is indubitably burnt, too. Adamski has concerned himself with pyromania — the urge to set something on fire — since the early 1980s, and similarly, symbols of death frequently appear in his paintings. It seems that the tragedy of death is overcome in the *Welthölzer* paintings by the use of kitschy pinks, greens and blues and dirty browns as background colours and the ornamental depictions of flowers which partly surround the matches and skeletons.

Platon und die Schule von Athen /
Plato and the School of Athens, 1982,
Dispersion on paper-canvas,
215 x 450 cm,
Collection Kunstmuseum Berne,
Switzerland
Courtesy the artist

Gekreuzigter mit Ostereiern / Crucified with Easter Eggs, 1983,
Acrylic and oil on jute,
240 x 190 cm,
Courtesy the artist

ELVIRA BACH

Elvira Bach has become internationally known for her female figures which emanate both eroticism and self-confidence. They can be understood as a subjective, mirror-like reflection of the artist's vigorous pleasure in life as well as of her desires and fears. They also reflect the 'Zeitgeist', the spirit of the early 1980s, which was characterised by a highly fashionable, apolitical attitude towards life.

Bach, who was born in Neuenhain in 1951, studied under Hann Trier at the Hochschule der Künste, Berlin, between 1972 and 1979. During this time, she filled countless sketch books and diaries and worked to finance herself for a public theatre, the Schaubühne am Halleschen Ufer. Then, in 1978, she herself organised an exhibition entitled 'Elvira zeigt Verschiedenes in einem Metzgerladen in Berlin' ('Elvira shows various things at a butcher's shop in Berlin'), where she presented her earliest, independent works. By 1979, her 'Bath-tub paintings' were exhibited at the legendary *S.O. 36*, where a year before Martin Kippenberger had become business director.

Already in 1978, the artist had created the work *Immer ich/Always I*. It clearly announced the theme and motif which was to become central to her oeuvre — herself. Like *Immer ich*, however, her first self-portraits did not yet delineate the female figure pictured in many of her later works. Instead, she painted still lifes which depicted her daily 'female accessories', as, for example, a handbag, lipstick and powder compact, car keys, red shoes, cigarettes and glasses filled with red wine, a telephone, strawberries — reminiscent of her childhood — a heart and the word 'amore'. Stylistically, however, these works already show the expressive and dynamic, fast and aggressive brush work, we discover throughout her oeuvre.

Almost at the same time, Bach began to develop her first female figure, which simultaneously became the prototype for many of her works. What we perceive is a woman almost covering the complete pictorial surface. She is partly seen from the front, partly from the side, akin to old Egyptian depictions of figures. She wears a short, low-cut dress and high-heel shoes. Her face shows make-up and is surrounded

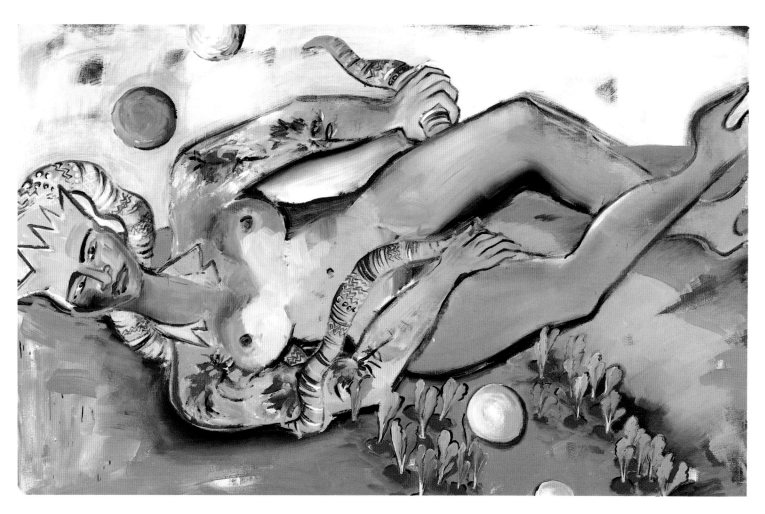

Untitled, 1992,
Synthetic resin on canvas, 165 x 280 cm,
Courtesy Galerie Fahlbusch, Mannheim

by hair in the shape of a crescent moon. Her shoulders are remarkably broad and her arms point towards the ground. Her fingers are spread and her red painted fingernails are razor-sharp.

By contrast, in the untitled painting from 1992, Bach shows herself nude laying on green grass near a stream. Her head is crowned and her arms are tattooed with roses. A snake — a motif which she introduced to her art in 1983/84 — winds out of her head and around her body. The nakedness of the figure, combined with the snake motif, leads us to think of the woman as Eve while the snake growing out of the head of the figure, recalls Medusa. On the other hand, the posture and the roses — as a symbol for love — allude to Venus. Undoubtedly, Bach understands all of them as parts of her identity as woman, identifying herself with Eve and with Venus as well as with Medusa, since she combines the art-historical motifs and symbols from Christian iconography in such a way that the image cannot be traced back to a specific source.

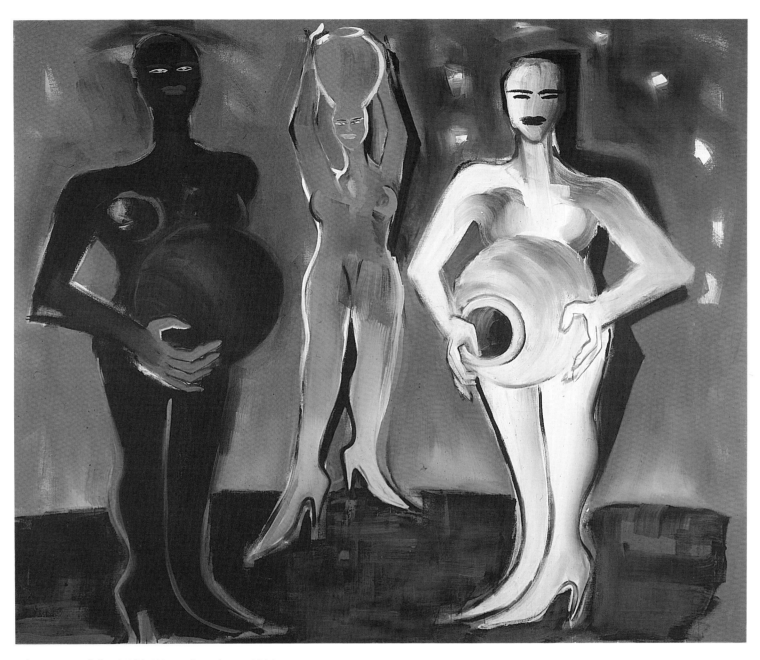

Mit Wassergefäßen / With Water Containers, 1991,
Synthetic resin on canvas, 190 x 230 cm,
Courtesy Galerie Fahlbusch, Mannheim

FRANK BADUR

For more than two decades, Frank Badur has based his artistic work on the investigation of colours and the possibilities of their variation and combination. Although his paintings have changed gradually during this time, they have always retained their characteristic intriguing liveliness and sensuous presence.

Badur, who was born in Oranienburg near Berlin in 1944, studied at the Hochschule für bildende Künste, Berlin, from 1963 to 1969. Influenced by Kandinsky's book *Point and line to plane*, he had begun already during his time as a student to analyse colour qualities and in 1967 created oval and circular paintings. Then, in 1968, Badur started to develop paintings depicting vertical colour stripes or zones. These have become the most typical feature of his works. They are still visible in *Streetfire* from 1992 which is a prominent example of several aspects of his painting.

It is evident that Badur's works are influenced by those of Richard Paul Lohse and Josef Albers as well as those by Barnett Newmann, Ad Reinhart, Mark Rothko and Clyfford Still. His paintings, too, are all without any literary or anecdotal allusion. They are without any narrative and so are in complete contrast to the new wild and neo-expressionist painting which became popular in the 1980s. What we perceive is undoubtedly concrete art, which is created 'through its own most basic means and rules — without the outer appearance of nature or its transformation, that is, not through abstraction.' (Max Bill)

Neither do Badur's paintings depict an illusionary space. Nevertheless, his works are, for several reasons, multidimensional. Clearly, the different qualities of brightness of the parallel colour zones give the impression of depth. Badur's painting process also contributes to this notion. In a lengthy procedure, he covers the canvas with numerous — sometimes more than thirty — layers of paint. The vertical stripes are taped off only during the application of the first layer of paint. Afterwards, Badur applies the paint freely, accepting minimal irregularities which prevents the pictures from appearing sterile. As a result, a kind of rhythmical breathing of the colour is achieved which is enhanced by the tension created between the different textures of

Streetfire, 1992,
Oil on canvas, 120 x 100 cm,
Photograph: Hermann E. Kiessling, Berlin
Courtesy the artist

the colour zones and their strict vertical division. This tension is further reinforced in Badur's works on handmade paper, where the irregular edges also contrast the vertical zones.

Since about 1982, when Badur stayed in New York on a DAAD Grant, his painting has become more relaxed and the choice of colours wider. More recently, he has also begun to alter the formerly strict proportions, which were often chosen according to the golden rule. Although he has not completely abandoned the works with vertical colour zones, some of his collages, multiples and paintings now show angle-like forms, placed next to each other or short vertical or horizontal zones which do not run right through the work. Additionally, squares or rectangles are cut off at the borders of some of the works, so that sometimes the rectangular format is no longer maintained.

Untitled, 1990,
Graphite on paper,
Courtesy the artist

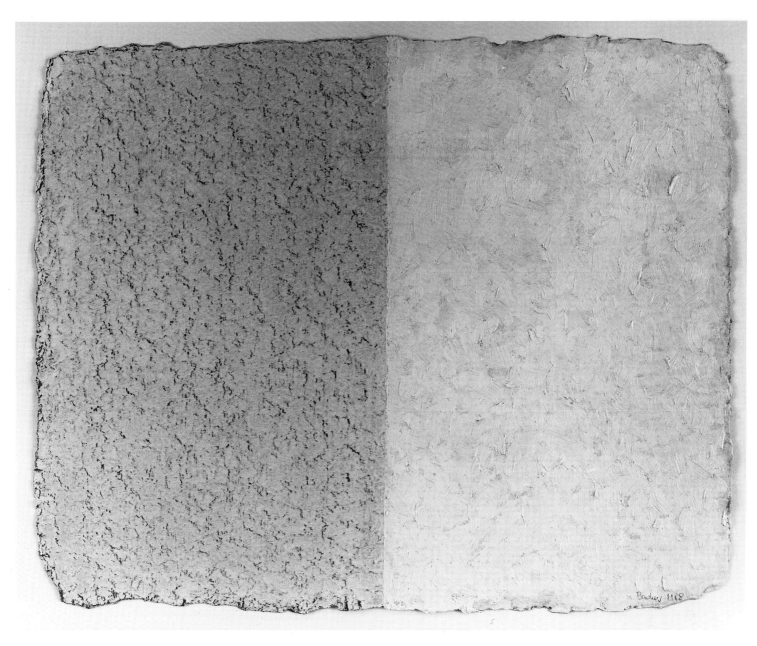

Untitled, 1988,
Oil on handmade paper, 24 x 32 cm,
Courtesy the artist

CHARLY BANANA / RALF JOHANNES

Charly Banana alias Ralf Johannes has always been concerned with the different appearances of life, of existence. He expresses himself in diverse media — trivial literature, performances, drawings and paintings — pointing at the flood of images surrounding us. He ironises the terror of consumption and exposes the glimmer and glitter of advertisements. *Do I disturb you ...* is the title of a painting created by the artist in 1980. Being about disturbance and interruption, about shaking people out of their apathy, the title expresses best his intention to provoke viewers into thinking about their situation in life making them more aware, more conscious of life.

The artist, born in Cologne in 1953, studied at the Fachhochschule für Kunst und Design, Cologne, and at the Staatliche Kunstakademie, Düsseldorf. The 'double-name', reflected in his signature, 'Charly Banana in co-operation with Ralf Johannes', ironises the usage of pseudonyms, as he once noted. It also indicates the inner split of people (e.g. work-hobby) and, in particular, that of the artist, who has to manage daily life and at the same time find complete fulfilment in his creativity.

Banana/Johannes uses for his works the journals and advertisements, pornographic magazines and comic strips we are confronted with wherever we go. He then shows us, Annelie Pohlen aptly noted, 'the tip of an iceberg which is concerned with the escalation of seduction, alienation and exploitation threatening the whole human society — a situation which turns the individual, regardless of his status on the social ladder, into a measurable, seductable numbered code, alienated by manipulation and only useful to the social system as an individual for as long as he serves it as a consumer.' (in: exh. cat. *Charly Banana in Zusammenarbeit mit Ralf Johannes*, Cologne, 1984, p. 18)

Sonderangebot / Special Offer from 1990 is one example of this kind of work. It is, however, no longer as overloaded with images and words as were the artist's paintings of the early and mid 1980s. During this time, Banana/Johannes also created the so-called white paintings, which offered a distinctive contrast, since he exchanged the black background of the advertising paintings for a white surface on

Der Frosch / The Frog, 1987,
Acrylic on canvas, neon tube,
200 x 150 cm,
Photograph: Friedrich Rosenstiel,
Cologne
Courtesy the artist

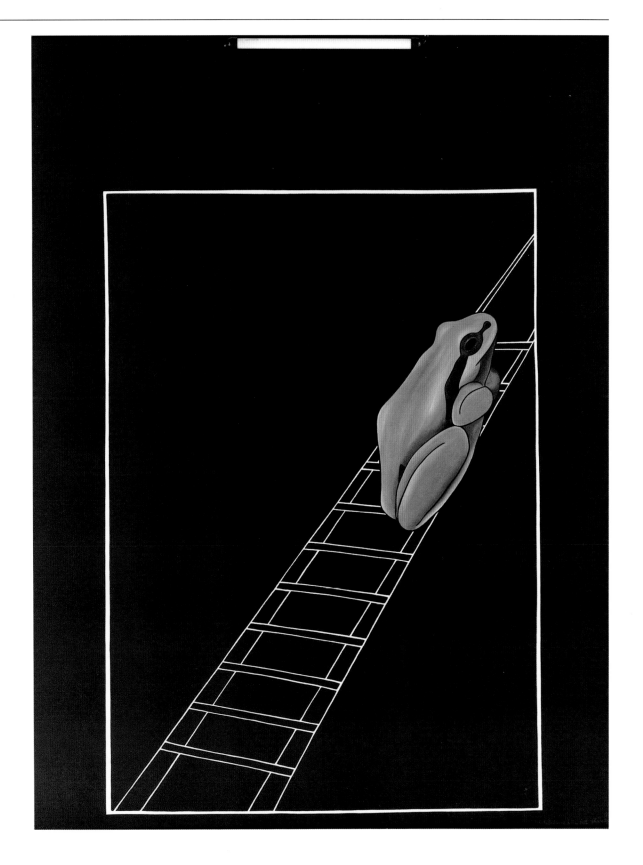

to which he painted linear, schematised thin black stick figures, expressive of feelings of emptiness, of isolation and distance.

Then, in 1986, the accident at Chernobyl motivated the artist to create five paintings which directly refer to a political situation. *Das Gemüse schlägt zurück / The Vegetables Fight Back*, the forth work of the group, depicts vegetables as ammunition. It undoubtedly reflects the state of uncertainty after the accident and the lack of information about the radioactive contamination of food and, in particular, of vegetables.

By contrast, the painting *Der Frosch / The Frog* from 1987, is anything but shrill. What does it represent, the viewer might ask. Is it a picture of the weather frog or an image of human behaviour. Is it the fairy-tale prince not yet transformed or is it just a picture of a frog on a ladder?

Banana's/Johannes' works often do ask questions, trying to get us thinking about ourselves and the world surrounding us, whether real or surreal. The answers, however, are surely not to be found in the pictures themselves.

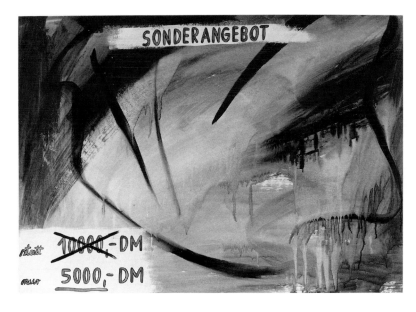

Sonderangebot / Special offer, 1990,
Mixed media on paper, 70 x 100 cm,
Courtesy the artist

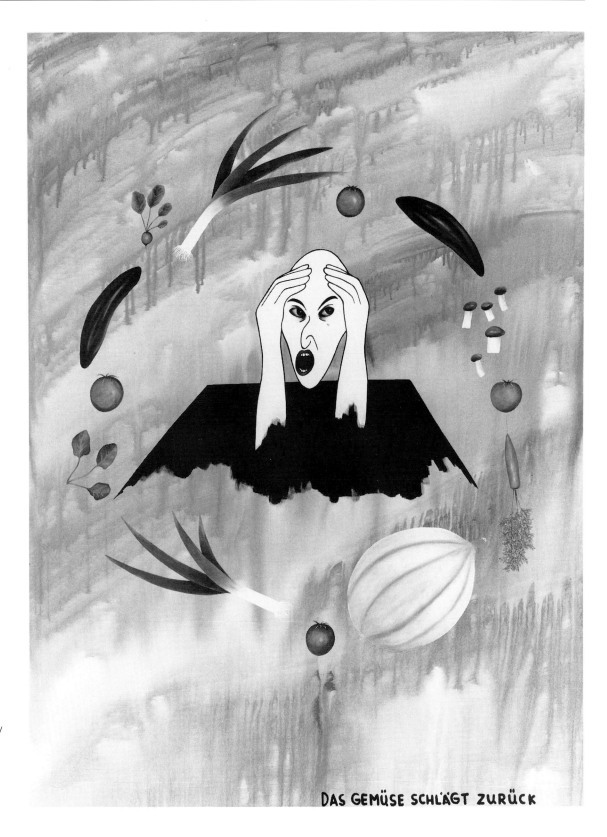

Das Gemüse schlägt zurück /
The Vegetables Fight Back,
1986,
Acrylic on canvas,
200 x 150 cm,
Courtesy the artist

DAS GEMÜSE SCHLÄGT ZURÜCK

INA BARFUSS

Ina Barfuss, born in Lüneburg in 1949, studied painting at the Hochschule für Bildende Künste, Hamburg, from 1968 to 1974. Since 1978 she has been living and working in Berlin.

Barfuss' paintings of the early 1980s are characterised by deformed and distorted figures, eerie, nightmare-like creatures, often part human, part animal, which are involved in absurd and violent actions. Her pictorial themes include isolation and senselessness, relationships and dependencies, as well as any kind of power structures. In these works, obsessions, aggressions and fears take on allegorical and symbolical form. Also, they expose strategies of oppression through clichés and the mediocrity and triviality of bourgeois life. Although Barfuss' more recent paintings have become less sarcastic, more 'tempting', they still, even if indirectly, confront the viewer with political and historical truths.

Kopfgeld / Reward from 1987, which literally translates as 'head-money', exemplarily reveals various facets of Barfuss' approach: Formally, the painting is restricted to only the depiction of the relationship between figures (heads, hands, arms) and objects (coin, hammer, nail). Although a certain degree of depth is obtained naturally through the intersections of the figures and objects, a decisive creation of an illusionist space is avoided. Also, in contrast to many contemporary artists, Barfuss does not create 'colour-explosions'. Instead, the colours appear bold and dull, clearly supporting the depicted unpleasant event. Barfuss also presents us with ambiguous forms, that is doubts arise for example with regard to the reading of the six oval head-forms (to the left). Since they could be heads or coins with faces painted on, 'head-money' in Barfuss' oeuvre, the chosen titles have evidently an explanatory function. With satirical means and without any pathos, Barfuss in this way portrays the cold-blooded, mad desire and striving for money and power, the loss of humanity amidst human society.

For about 20 years, Barfuss has also been creating paintings together with Thomas Wachweger. Neither artist is interested in depicting a pre-defined theme or motif, but in painting as process. The starting-point for these works can be a line,

Kopfgeld / Reward, 1987,
Acrylic on canvas, 222 x 187 cm,
Courtesy Galerie Springer, Berlin

drawn on the painting surface, a colour area or a figure from which the paintings then develop partly through automatism, partly through control. Any unambiguity is strictly avoided, resulting in works without a continuous narrative, works which are open to multiple interpretation.

Clearly, the experiences both artists have made through this partnership are reflected in their individual works. Yet, they also continue their idiosyncratic ways of expression, too.

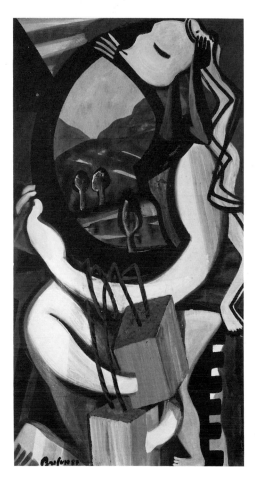

Teamwork, 1987,
Acrylic on canvas, 222 x 118 cm,
Courtesy Galerie Springer, Berlin

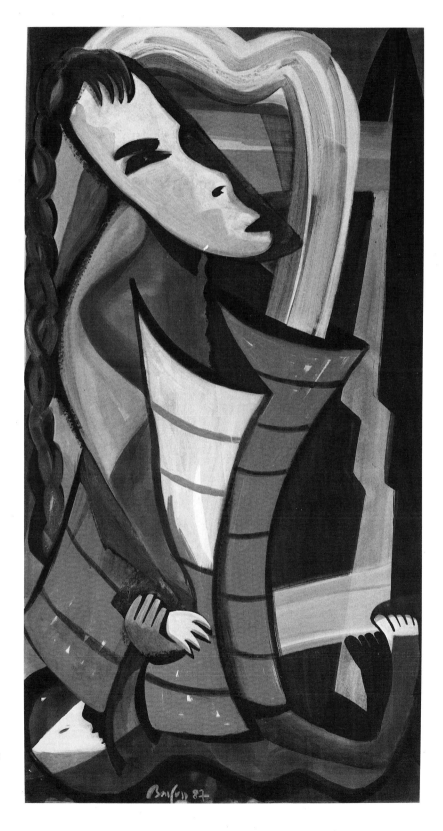

*Generationsvertrag (weiblich) / Generation
Contract (female)*, 1987,
Acrylic on canvas, 222.5 x 118 cm,
Courtesy Galerie Springer, Berlin

GEORG BASELITZ

The artist Hans-Georg Kern, born in 1938 in Deutschbaselitz, Saxony, in 1961 adopted the name Georg Baselitz. He became known internationally for paintings with inverted motifs which he has been creating since 1969.

Baselitz' first independent paintings and drawings originate from the late 1950s. Between 1960 and 1963, he was most impressed by the works of the French writer Artaud and by Prinzhorn's investigation into the drawings of mentally ill people. He wrote his manifesto *Pandämonium* (1961/1962) and created works like *Die große Nacht im Eimer/Big Night Down the Drain* from 1962/1963, which reflect Artaud's obsession for the body, sexuality and the erect penis.

In 1965, Baselitz considerably changed direction, producing a series of paintings titled *Neue Typen/New Types*. Its prototype is the work *Die großen Freunde/The Great Friends*. Two men with large bodies and small heads, taking up almost the entire painting surface, walk barefooted across a ploughed field filled with a roughly drawn plough, traps and a broken off flag post with a flag.

A year later, the formal aspect of the paintings starts to become more significant. The images are first divided into two parts, then into three, and one part is placed upon the other, resulting in an agitated and disharmonious work which is off-balance and contradicts natural ordering systems (for example *B For Larry*).

Finally, in 1968/69 the inversion of the motif as a stylistic method emerges. Baselitz chooses familiar themes like portraits of friends, landscapes or his studio, and here the image still dominates the form. Then, towards the mid 1970s, he eliminates illusionistic elements and intensifies the colour application which results in a compact, yet barely discernible image. Between 1976 and 1980, he also uses as motifs still lifes, the eagle, figures, basic postures and gestures leading to the *Straßenbild/Street Painting* of 1979/1980, which consists of eighteen separate paintings, each depicting a gesticulating figure.

Although the inversion of the motif has been used before by Giuseppe Arcimboldo, for example, or, in the 20th century, Smithson (*Upturned Tree*) and Kosuth (*Cathexis*), Baselitz' approach is different, in so far as he claims that the motif

Die Mädchen von Olmo/The Girls from Olmo, 1981,
Oil on canvas, 250 x 248 cm,
Collection: Musée national d'Art Moderne, Centre George Pompidou, Paris
Courtesy Galerie Michael Werner, Cologne

becomes insignificant when turned upside down. Reality is the painting and nothing but the painting since the motif, when inverted, ceases to exist. Thus, he saves the object of the depiction, while simultaneously negating it by painting it upside down.

As in *Die Mädchen von Olmo/The Girls from Olmo* from 1981, through the inversion new orders of meaning are created and our attention is directed towards a completely different system of values. Baselitz' method does not allow for any literary interpretation since painting is treated as autonomous. It is primarily a decorated surface, form dominating content. Polemically and provokingly, he therefore terms his works 'ornaments'.

For the last ten years, Baselitz has been striving for a clarification, refinement and extension of the ornamental status of his work, for a mixture of sensuality and elegance, aggression and calculation in his paintings, an aspiration which has been supported since 1980 by the creation of wooden sculptures. Developing alternately with the paintings, these works are aggressively crafted with an axe and saw, and in turn influence the paintings, their format, motifs, style and composition.

Bilddrei/Picture Three, 1991,
Oil on canvas, 285 x 457 cm,
Photograph: Frank Oleski, Cologne
Courtesy Galerie Michael Werner, Cologne

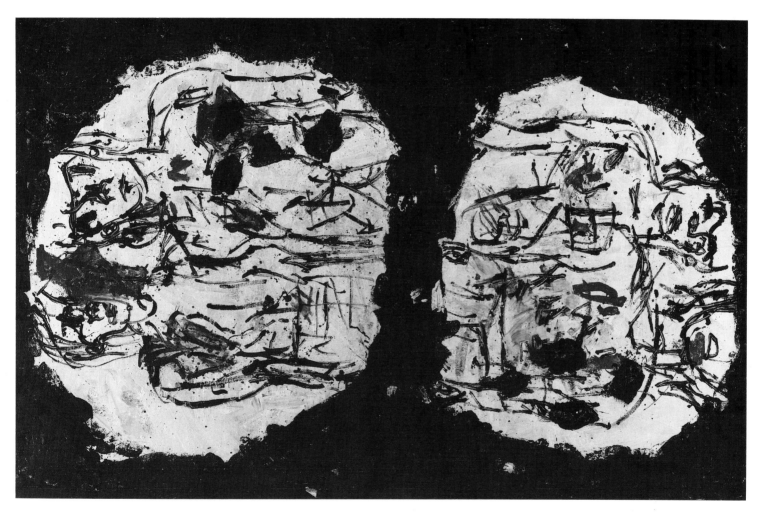

Bildsechs / Picture Six, 1991,
Oil on canvas, 285 x 457 cm,
Photograph: Frank Oleski, Cologne
Courtesy Galerie Michael Werner, Cologne

PETER BÖMMELS

Peter Bömmels, born in Frauenberg in 1951, studied sociology, politics and educational theory from 1970 to 1976. Afterwards he worked in a kindergarten. Since 1980, he is co-editor of the rock music magazine *SPEX*. At the beginning of the 1980s, Bömmels, a self-taught painter and sculptor, was a member of the artist group *Mülheimer Freiheit*. Compared to works of other members like H.P. Adamski or Walter Dahn, Bömmels' paintings reflect neither a specifically humorous nor an ironical or cynical approach. Instead, he is concerned with questions about life and death on a very personal, subjective level. Frequently, his depictions are characterised by puzzling images which seem to float and meander across the canvas, resulting in dynamic pictorial spaces, which draw the attention of the viewer directly towards them.

Like *Ein König fällt nicht vom Himmel / A King Doesn't Fall from Heaven* from 1980, Bömmels' works generally present us with recognisable images. Yet, his depictions, which are often simultaneously appealing and repellent, make an interpretation difficult, since what we perceive are usually fragmentary images only, grown from the imagination, the memories and/or the unconscious of the artist. They are sketched in drawings and notes by means of free association and daydreaming and brought onto the canvas spontaneously. Bömmels' working method, however, is neither indebted to surrealism nor to art brut. Rather, the continuous chain and change of thoughts and images is understood as metamorphosis.

Often, the delineated images are combined and/or situated on the canvas in a way which contradicts our daily and concrete experiences. For example, *Eine Braut kehrt zurück (rechtzeitig) / A Bride Returns (in Time)* from 1983, at first glance seems to depict a woman skiing, just arriving at the finishing-line. Yet, the female figure is delineated with four breasts and without feet. The hand appears crippled and the neck as if twisted several times. Her body winds vertically through the painting and she is holding something which looks like an oversized needle. Almost counterdirectional, two strings of hair — Bömmels used human hair and oil on cotton canvas — cut through the work. Stephan Schmidt-Wulffen once noted, that the lines,

Ein König fällt nicht vom Himmel /
A King Doesn't Fall from Heaven, 1980,
Dispersion on untreated cotton cloth,
193 x 140 cm,
Courtesy the artist

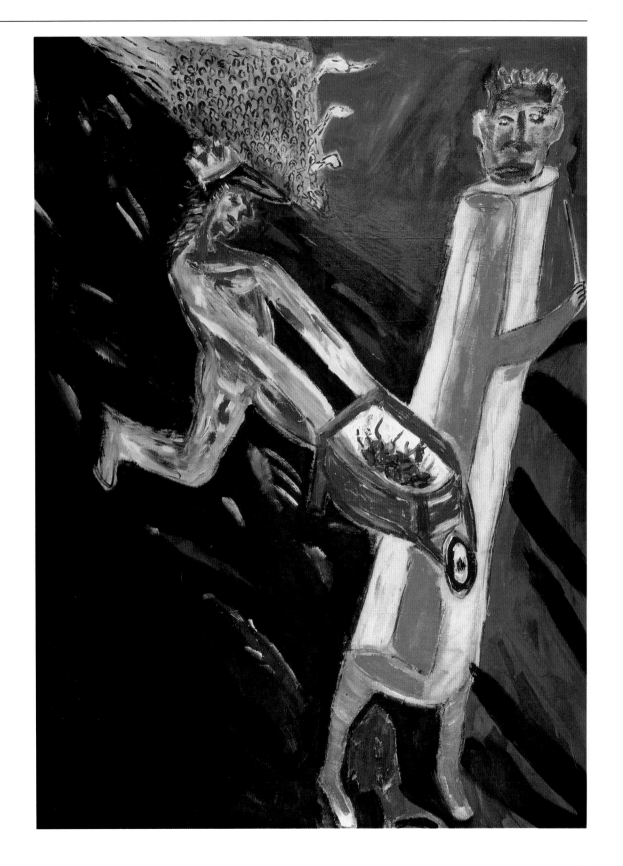

connecting the figures in Bömmels' paintings, might be perceived as illustrating the artist's flow of thoughts which lead to the depictions. Taken further, they might also hint at the chain of associations created by the viewer when approaching the work.

The early painting *Ein König fällt nicht vom Himmel*, on the other hand, has generally been seen as reflecting Bömmel's childhood memories. At its centre, the work shows a running figure, which we identify as the mentioned king. He is pushing a wheelbarrow filled with burning coal or wood. To the right of the work, we see a tall figure, who is dressed in yellow and is holding a thin stick. At the top left corner, we can recognise a crowd of people.

We might guess that the painting depicts a race. More specifically, the starting-point for this work has undoubtedly been Bömmel's recollection of the wheelbarrow races at Frauenberg, his birthplace. Yet again, the viewer, without this knowledge, has to draw on his or her own associations.

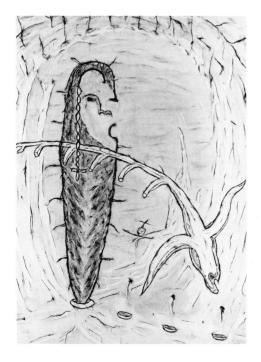

Genoveva, 1983,
Human hair and oil on untreated cotton cloth,
240 x 180 cm,
Courtesy the artist

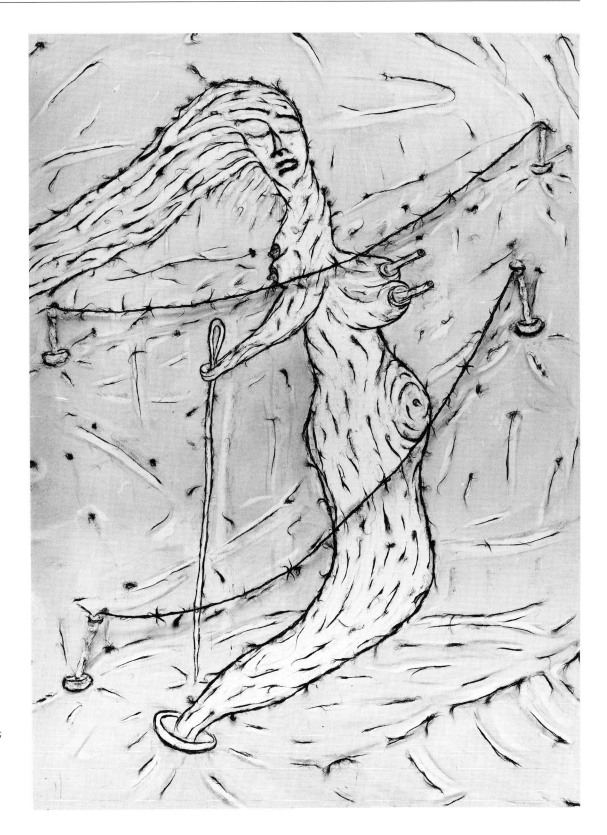

*Eine Braut kehrt zurück
(rechtzeitig)/A Bride Returns
(in Time)*, 1983,
Human hair and oil on
untreated cotton cloth,
240 x 180 cm,
Courtesy the artist

WERNER BÜTTNER

Werner Büttner continuously explores modern art and its possibilities and his works have always attacked our long established and deeply rooted ways of seeing and thinking. Next to Albert Oehlen, Martin Kippenberger and Georg Herold, the self-taught artist has proved in past years to be one of the most witty and cunning representatives of contemporary German painting.

Born in 1954 in Jena, Thuringia, Büttner originally studied law. Through the initiative of his friend Albert Oehlen, he came to the fine arts. In 1976 in Berlin, he and Oehlen founded the 'League to contest contradicting behaviour'. A year later, both artists moved to Hamburg.

Büttner's works clearly show that he never settles with the prevailing social and cultural conditions. Yet, neither does he attempt to offer the viewer ways out or new options. Instead, he persistently exposes these conditions, reveals the crippling self-satisfaction of the middle-class as well as the states of mental and psychic disorientation.

Büttner's works, are also about the potentials in art — *Die Probleme des Minigolf in der europäischen Malerei / The Problems of Minigolf in European Painting* from 1984 — about Germany — *Schrecken der Demokratie / The Horror of Democracy* from 1983 — and against the embellishment of advertising and other, in his eyes, boasting art forms — *Defending Kiefer against his Devotees* (with Albert Oehlen 1985/86).

In contrast to recent works, Büttner's paintings of the early and mid 1980s are characterised by the use of dark, subdued colours. Black, dark browns and greens as well as shades of dirty grey and yellow recall camouflage colours. The brush work is heavy, yet not wild. Often these paintings were executed with broad, parallel brush strokes. More than the works themselves, the depictions in connection with their titles reflect Büttner's liking for the closeness of normal and abnormal, of real and macabre situations, as in *So geht es allen Kinderfickern / That's what happens to all children fuckers* from 1983 or in *Kaiserschnitt durch Explosion / Caesarian Section through Explosion* from 1986.

Ruhm und Ehre dem neuseeländischen Afrikakorps (Schwirrholz und Goldhelm) / Glory and Tribute to the New Zealand Africa Corps (whir wood and gold helmet), 1990,
Oil on canvas, 190 x 150 cm,
Courtesy the artist

Büttner obviously also likes to play with language. He constructs sentences, completely accurate considering their formal structure, yet uses words, which lead to an aggressive or paradox content, generally uttered in another style, in slang, for example. Also, the viewer is puzzled by titles which contain a sudden change into a completely different direction as in *Studie Arschloch Vier und Fünf/Arsehole Study Four and Five* from 1984.

Büttner's painting *Ruhm und Ehre dem neuseeländischen Afrikakorps (Schwirrholz und Goldhelm)/Glory and Tribute to the New Zealand Africa Corps (whir wood and gold helmet)* from 1990, recalls this method. However, in contrast, to earlier works, the title seems rather ironic than paradox. The central image of the painting is an abstract form which looks like a woodcut. On one hand, the title of the work could be understood as being as abstract as the depicted form. On the other hand, this form is undoubtedly reminiscent of Maori sculpture. In connection with the title, we might then recall the 28th (Maori only) Battalion which fought for Great Britain in World War II and was treated more like whir wood than honoured with gold helmets.

Rote Lippen unter Nase/Red Lips below Nose, 1990,
Oil on canvas, 190 x 190 cm,
Courtesy the artist

Der Künstler reißt sich als Baby die Windeln vom Leib/The Artist as Baby Tearing off his Nappies, 1990,
Oil on canvas, 150 x 150 cm,
Courtesy the artist

WALTER DAHN

Walter Dahn, was born in St. Tönis near Krefeld in 1954. Between 1971 and 1977, he studied at the Staatliche Kunstakademie in Düsseldorf where he became a master-class student under Josef Beuys. The artist, who lives and works in Cologne, started his career with conceptual and photographic art works. At the beginning of the 1980s, he became known as one of the protagonists of the Cologne group *Mühlheimer Freiheit*.

Dahn's works are neither painted expressively nor impulsively although the initial idea might have arisen spontaneously. Instead, his painting practice is based on conceptual calculation and often the works are created only after multiple sketches have been made. Afterwards, successive conceptual decisions and careful considerations about form and content of the works lead to images which emanate a strong physical presence.

That Dahn is not concerned with the 'search for identity' also becomes evident with the works he created together with Jiří Georg Dokoupil. 'In their co-operative pictures, on which they both work at once,' Wolfgang Max Faust once asserted, 'individuality is made redundant. A "third person" comes into being, who paints with "one brush". This way of working and the notion of the "multiple-self" is clearly set against the specific preoccupations of the Berlin "Wilds" such as Fetting.' (in: Exh. cat. *Wild Visionary Spectral*, Art Gallery of South Australia et al., 1986, p. 24)

Dahn's paintings of the early 1980s are often humorous or disturbing. Sometimes they appear to be both at the same time. The work *Trinker/Drinker* from 1982, for example, depicts a person with a bottle as head, holding its own head with the hand and filling it with the contents of the bottle. Here, the term 'drinker' has found a humorous, funny portrayal. On the other hand, the painting presents us with an alarming truth about alcoholism.

Trinker also clearly reflects Dahn's awareness of the spirit of the time. Yet, although he is concerned with the immediate present he is not a moralist. Instead, he creates surprising and unexpected images while employing well-known signs, clichés, idiomatic expressions and quotes. For example, the painting *Einen Besen fressen/*

Trinker/Drinker, 1982,
Dispersion on untreated cotton cloth,
200 x 150 cm,
Photograph: Schaub, Cologne
Courtesy Galerie Monika Sprüth,
Cologne

Eating a Broom (the German version of 'I'll eat my hat if that's right') from 1981, exactly depicts what the title promises, that is, somebody who eats a broom.

By contrast, the work *Selbst / Self* from 1982, already alludes to Dahn's paintings of the mid 1980s, which were executed in acrylic on canvas and characterised by monochrome backgrounds and emblematic and figurative, linear depictions.

Walter Dahn has always been keen to experiment. He aims at making language unnecessary since he understands painting itself as a kind of language. Also, he has continuously been interested in 'the true motives', in the motif for painting, for example. It also has always been important for him, to present us with a picture, which 'in this form', as he once said 'does not yet exist … That is an invention. An invention, which naturally merges with the images, concepts and signs already existing in the world, because otherwise the picture would not be readable' (in: Exh. cat. *Walter Dahn. Gemälde 1981–1985*, Wilfried Dickhoff [ed.], Kunsthalle Basel et al., 1986/87, p. 71).

It might be for these reasons, that Dahn's paintings have been always of distinctive inimitable character.

Selbst / Self, 1982,
Mixed media on untreated cotton cloth,
200 x 150 cm,
Photograph: Schaub, Cologne
Courtesy Galerie Monika Sprüth, Cologne

CHRISTA DICHGANS

During the last thirty years, Christa Dichgans' paintings, characterised by a boisterous swirling dynamic, a distinctive and highly individual style, have always reflected her ongoing interest in still lifes, patterns, ornaments and texture.

Dichgans, born in 1940 in Berlin, studied at the Hochschule der Künste in Berlin from 1960 to 1965. Her still lifes and toy worlds of this period are partly indebted to pop art (daily and trivial objects) and photorealism (an exact representation). Around 1969 they were succeeded by serial images which follow the pictorial principles of accumulation, montage and layering. Here, items of practical use, toys, paper aeroplanes or sausages are stacked and piled up, their proportions distorted in such a way that they seem unfamiliar, partly surreal or even threatening. They are still lifes, that is, in the truest sense of the word, *natura morta* of a throw-away society with the frenetic urge to spend. The most complex montage composition of this time, its final result is the monumental work *New York* (1980), partly recalling the photomontages of the 1920s by Hannah Höch or Paul Citroen for example.

Between 1980 and the mid 1980s, Dichgans chose the human figure, more specifically the self-portrait and the portraits of her friends A.R. Penck and Markus Lüpertz, as a starting point for questions about the artistic existence and the possibilities of painting today. Yet, patterns and ornamentations remain stylistic means, generating works with a strikingly dense network of linear elements, body contours, silhouettes. The viewer sees through them as if they were invisible only to find numerous metamorphoses of the same figure appear again and again.

Since the mid 1980s, the human figure has receded in importance while objects are reintroduced. Their proportions are distorted, their contours dissolve. They seem to act, fall and float on the painting surface like drift wood. The still lifes now are more turbulent, more apocalyptic, the pictorial atmosphere is often more sinister, seemingly hopeless.

Rotes Wunderknäul / Red Wonder Ball of Wool from 1990 contrasts many former works (for example, *Red Purse*, 1990) in so far as the objects are not scattered across

Rotes Wunderknäul / Red Wonder Ball of Wool, 1990, Oil on canvas, 300 x 200 cm, Courtesy Galerie Springer, Berlin

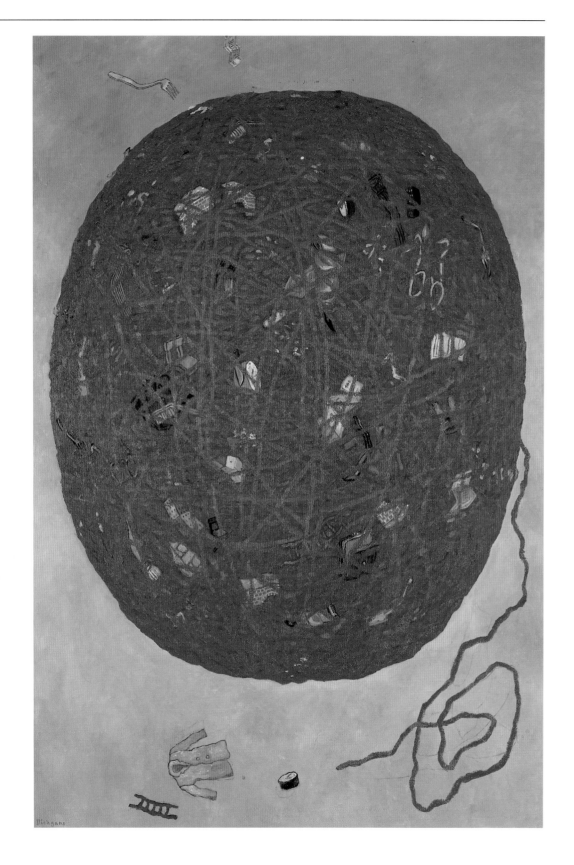

the painting's surface. Its symbolism, however, is unchanging: objects are tied up, fixed through an oversized ball of red wool. This ball seems to prevent mass produced articles from being spread all over the world and, on the other hand, traps the objects in the same way as the human being is imprisoned by a consumer society.

Yet, although threat and grief, human weakness and megalomania again are made an issue, Dichgans' approach is not moralising. Her paintings are, therefore, always ironic and funny, too.

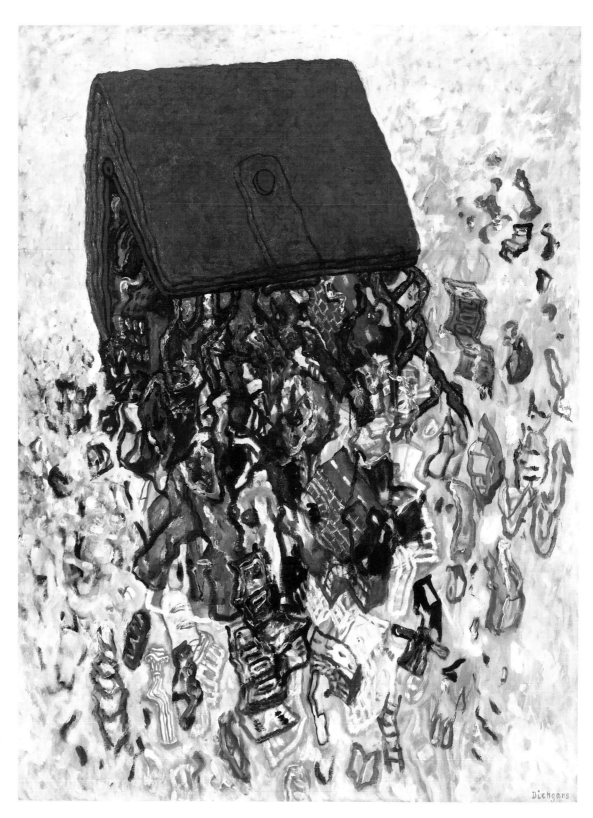

Rotes Portemonnaie /
Red Purse, 1990,
Oil on canvas, 160 x 120 cm,
Photograph: Littkemann,
Berlin
Courtesy Galerie Springer,
Berlin

HARTWIG EBERSBACH

Hartwig Ebersbach, born in Zwickau in 1940, between 1959 and 1964 studied under Bernhard Heisig at the Hochschule für Grafik und Buchkunst, Leipzig.

Ebersbach, who lives in Leipzig, became internationally acknowledged in the late 1970s through the music and media theatre/performance *Missa Nigra*, which he created together with the composer Friedrich Schenker and the *Gruppe Neue Musik Hanns Eisler*, Leipzig. Between 1979 and 1983, he taught experimental art forms at the art school in Leipzig. During this time, he was also a member of the experimental *Gruppe 37,2*.

Ebersbach, known since the mid 1960s as the *enfant terrible* of the art scene of the former GDR, is its most expressionist painter. His works are characterised by short, speedy brush-strokes, flowing colours, impulsive movements fixed in thick layers of paint.

His painting grounds are hardboards, which are first framed with squared timber, then laid on the ground and approached from above with brushes fixed to bamboo sticks. The artist prefers using oil paints which are not restricted in their flow by the frame but in fact often cover it too. Into more recent works, he has also incorporated used paint tubes and their white caps, reflecting his urge for spontaneity, restrained only by closed tubes.

Ebersbach's paintings of the mid 1960s were still traditional, old-masterly and indicative of the program of the art school in Leipzig. But in the 1970s, he found a motif, the 'Kaspar', which he used until the late 1980s. The 'Kaspar' (known as the Punch from the Punch and Judy theatre) for Ebersbach can be clown, fool or golem. It is a mirror image and a figure to play with, it is the artist's alter ego, though not independent. Through the Kaspar, *Kaspar and I* or *I, the 'Kaspar'*, the artist communicates his emotions, fears and worries. In this way, painting becomes a means for self-expression and self-analysis, the Kaspar portraying the different psychic states as in *Kaspar – the Violent* or *Kaspar – the Kissed*, *Kaspar – the Strong* or *Kaspar – the Defenceless*. Kaspar, pointing, flying, burning, encompasses both

Kaspar (aus 'Kaspar selbst im eigenen Arm')/
Kaspar (from 'Kaspar — Self, Embraced'), 1986,
Oil on hardboard, 175 x 63 cm,
Photograph: Roland Dressler, Weimar
Courtesy the artist

negative and positive, strengths and weaknesses of the painter. Since the 1980s, he also has accompanied his works with poems and short texts on the Kaspar theme.

Ebersbach is able to concern himself with disturbing and irritating events and to articulate them in his works. He was taught psycho-drama by a psychologist in the *Gruppe 37,2*. Also, he has learnt to remember and record his dreams, which became another source for his paintings.

However, the artist often conceals what he has just revealed, controls the chaos and covers it with layers of paint. This method results in works from which images emerge only to disintegrate again in a constant oscillation between stability and flux, giving them a nervousness that is distinctive.

Kaspar – Selbst im Eigenen Arm (which might translate *Kaspar – Self, Embraced*), a seven-piece installation from 1986, also represents Ebersbach's continuous breaching of the boundaries between painting and sculpture.

During the last three years, the artist has developed a new pictorial motif, the dragon, which he encountered during the exhibition 'Malerei und Grafik der DDR', shown in several cities in Japan. His new subject is at least as changeable and complex as the Kaspar.

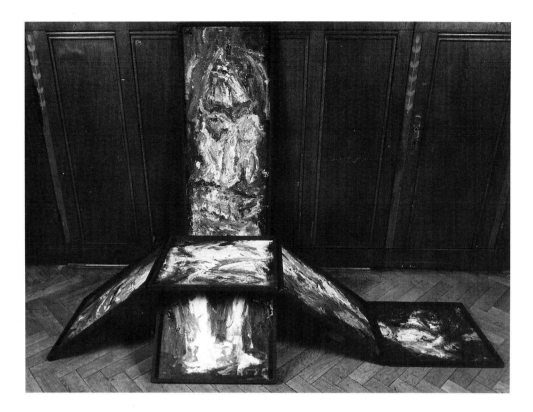

Kaspar selbst im eigenen Arm / Kaspar –
Self Embraced, 1986,
Oil on hardboard, seven-piece installation,
175 x 250 x 140 cm,
Photograph: Roland Dreßler, Weimar
Courtesy the artist

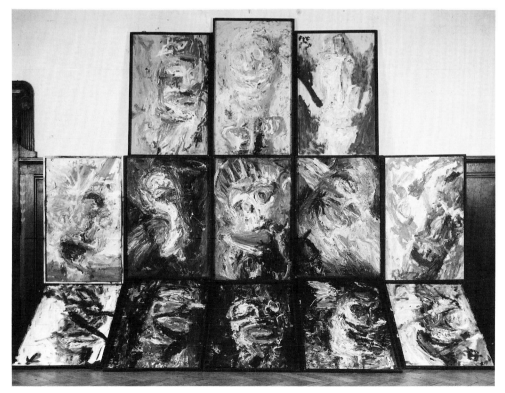

Symposion I – Abendmahl / Symposion I –
Last Supper, 1986,
Oil on hardboard, thirteen-piece
installation, 350 x 450 x 100 cm,
Photograph: Roland Dreßler, Weimar
Courtesy the artist

RAINER FETTING

Rainer Fetting, born in 1949 in Wilhelmshaven, studied painting under Professor Jaenisch at the Hochschule der Künste, Berlin (West), from 1972 to 1978. Together with Helmut Middendorf, Salomé, Bernd Zimmer and others, he established the self-help Galerie am Moritzplatz, Berlin, in 1977. Between 1978 and 1979, Fetting lived in New York on a DAAD Scholarship.

Like many artists of his generation, Fetting works in different media, makes films and music and creates sculptures which are internationally acknowledged.

Fetting's paintings are a response to what he sees, his day by day experiences, a reaction to what he perceives as significant, but the works do not only document his subjective emotions. They portrait a fragmented and ambiguous, yet not enigmatic reality. Here, the viewer is confronted with a careful and purposeful presentation of the present, exposed to representations of objects or scenes which are factually observable for everybody.

Fetting, who is at home both in the mercurial New York and the comparatively placid Berlin, finds his themes in the backyards of Berlin-Kreuzberg as well as in the New York subway. Trendy discos and the gay subculture offer motifs as do depraved piers and parks at night and, not to forget, the drawings at the former Berlin Wall.

As well, Fetting has continuously honoured his 'mentor' Vincent van Gogh with paintings like *Van Gogh by The Wall* or *Van Gogh at 23rd Street*, or with self-portraits as Van Gogh, works which are to be found throughout his painterly oeuvre.

In Fetting's paintings, figures (or self-portraits) — his major motifs — and landscape or eccentric city atmosphere are mixed. Reality and the dream of present-day life are fused while the vibrant and intense colours he uses indicate the paintings potential of subdued poetic sensuality.

Stephen Barber recently noted that 'Rainer Fetting's images of the city and its figures go straight to the heart … These paintings hold the life blood of the city. They are the immediate projection of its exhilarations, joys and threats.' (Stephen Barber, in: Exh. cat. *Fetting 1990–1991*, Raab Galerie, Berlin/London, Berlin 1991)

Evidently, the painting *N.Y. Taxi* from 1991 (note the 'RF 91' number-plate)

N.Y. Taxi, 1991,
Oil on canvas, 152 x 122 cm,
Private collection, Munich
Courtesy Raab Galerie, Berlin

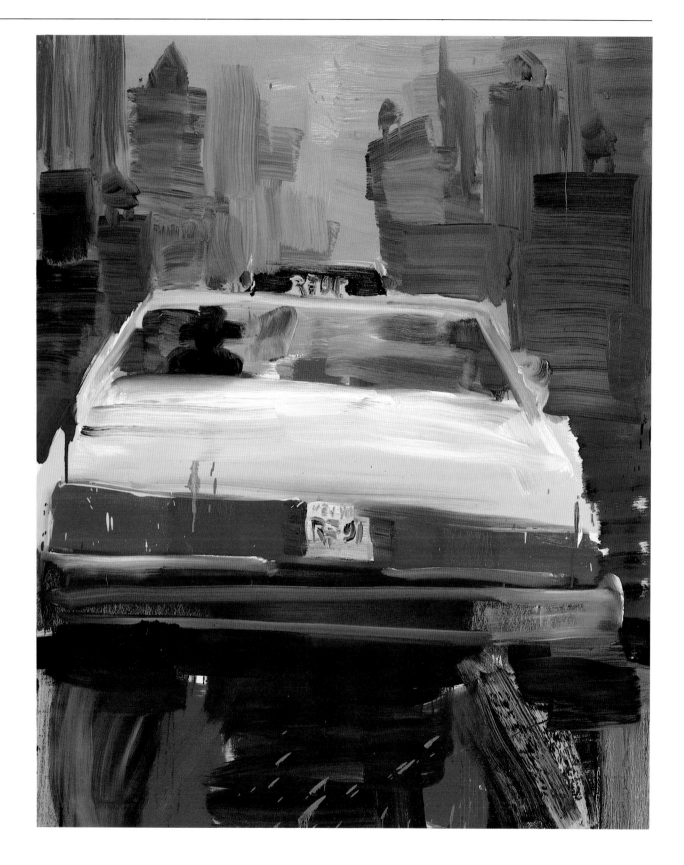

conveys the dazzle and thrill of the city. More exactly, the image of the yellow taxi immediately recalls diverse conceptions or memories of New York and functions as a symbol for the perpetual motion of this city, for the hyper-activity of its inhabitants.

The painting belongs to a series of taxi/cab depictions, which Fetting executed in New York. One of his working principles is to repeatedly depict specific subject matter. Through this method, he allows the image to exude a maximum of emotional energy, an intensity and vitality we do not only encounter in *N.Y. Taxi* but in many of his works.

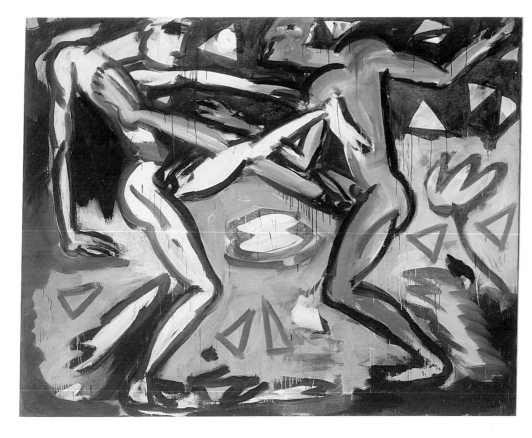

Tanz b-w / Dance b-w, 1982,
Dispersion on canvas, 210 x 270 cm,
Courtesy Raab Galerie, Berlin

Durchgang Südstern, 1988,
Oil/sand on canvas, 300 x 200 cm,
Private collection, Berlin
Courtesy Raab Galerie, Berlin

GALLI

In the contemporary German art scene, the oeuvre of the Berlin artist Galli takes on an exceptional position. Galli, who was born in Heusweiler in 1944, studied at the Werkschule Saarbrücken between 1962 and 1967. From 1969 to 1976, she continued her studies at the Hochschule der Künste, Berlin, in the course of which she became master-class student under Martin Engelman. In 1984, the artist received a working grant by the Kunstfond e.V. and in 1989 the Will-Grohmann-Prize. In 1990, she was awarded the Villa Romana Scholarship to live in Florence. Galli, who taught at the summer academy, Berlin in 1989, has held a professorship at the School of Fine Arts, Münster, since 1992.

Particularly in the context of Galli's earlier paintings, which were conceived from copious impressions, contradictions and paradoxes, reference has often been made to a stylistic tradition perceptible in Berlin since the 1950s. It is summed up with the terms 'figuration-expression-defiguration', a description which has also been attributed to the works of Galli's teacher, Martin Engelman, to Rainer Küchenmeister, Walter Stöhrer, the sculptor Rolf Szymanski, and to Max Neumann. As put by Eberhard Roters, what they have in common is 'that their work does not divulge whether the figurative subject is extracted by association from the gesture language of the painting's creation, or whether a firm creational vision first exists which eventually becomes defigured in the course of the work process.' (in: Exh. cat. *Galli. Arbeiten aus den Jahren 1977 bis 1982*, Berlin, 1982)

And indeed, Galli's earlier paintings and drawings display seemingly self-developing messages, are characterised by scenes which appear simultaneously vital and playful, absurd and macabre, ironic and cheeky, cryptic and humorous. During this time, Galli was drawing daily, approaching the paper unreservedly, intuitively and quickly while employing a mixed media technique which made use of pencils and colour pencils, chalk and charcoal, watercolour and gouache. In this way, the idea for the form and content of her paintings developed.

Since about 1982, when Galli changed to larger painting formats, the narrative aspect of her works has diminished in favour of a more conscious composition and

Stifter, Gotthelf + Homer, 14.12.87–05.01.88,
Mixed media on canvas, 150 x 185 cm,
Courtesy the artist

the importance of figures or subjects. The latter, which recall paintings by Francis Bacon, are polymorphous, often deformed human figures or animals as it can be seen in the work *Stifter, Gotthelf + Homer*, created between December, the 14th, 1987 and January, the 5th, 1988. Sometimes the images are both human and animal-like and most frequently they are fragmented and obscured, reduced to only the body and the extremities which are caught in contortions.

Undoubtedly, these works are hermetically closed to any interpretation and yet, on the other hand, open to multiple associations. They are characterised by a high degree of dynamism and also emanate a meditative tranquillity which is clearly a result of Galli's oscillations between representational and non-objective painting, between figurative and non-figurative depictions, real and surreal elements, between a spontaneous approach and deliberate decisions.

Ohne Titel (Wasserspeier)/
Untitled (Gargoyle), 1986,
Tempera on canvas, 100 x 80 cm,
Courtesy the artist

GISELA GENTHNER

Gisela Genthner was born in 1945 in Peking, China. Between 1972 and 1979, she studied at the Hochschule der Künste, Berlin and became master-class student under Professor Bachmann. In 1976, she acted as co-founder of the self-help gallery Fundus in Berlin. Genthner has been awarded numerous scholarships, which led her to the Dominican Republic in 1982/83, for example, and to New Zealand in 1989. The artist lives and works in Berlin.

Genthner's abstract paintings offer a distinctive contrast when compared to the oeuvre of many other artists living in Berlin. Her works stand partly in the tradition of the *de stijl* movement, yet the primary colours and geometric shapes she employs are often complemented with greens and grey as well as swinging lines and amorphous forms. Moreover, the use of diverse materials — thick, brown wrapping paper, cardboard, accordion-pleated paper and accurately cut collage elements — reflects her attraction to experiments.

The untitled collage on hardboard from 1986 depicts at the centre of the work a blue, somewhat trapezoid form, framed with a thick black stroke which in turn is enveloped by a area of red paint. The red seems to come forward, towards the viewer, since it is placed in between the blue and black at the bottom and the black colour area which almost totally covers the top and left side of the painting.

On the red area, white, black and blue lines seem to copy the shape of the blue zone. In addition, scattered spots of mainly yellow paint on the red area and red spots on the blue break the rigidity of the two rather geometrical forms. A further red line, appearing like an open wound, is inserted into the blue.

Despite the heavy, almost oppressive black zone at the top and side of the work, the red and blue clearly dominate, since 'the multiplicity of abstract forms, often with absurd contours distracts colour while the archetypical forms like square or circle let colour emerge uninfluenced.' (Rupprecht Geiger)

Also, both are highly symbolical colours: red is the colour of life. It symbolises energy and vitality, love and warmth. It can stand for power as well as for strength. Its opposite is blue, experienced as being calm and inviting meditation. Blue is the

Ohne Titel / Untitled, 1986,
Collage on cardboard, 90 x 90 cm,
Courtesy the artist

colour of melancholy — I'm feeling blue. It is cosmic and tells of eternity. Blue is restful and also stands for spirituality. Where red comes forward, blue recedes. Where red offers a feeling of down to earth, blue represents air and sky.

As well, the delineated dabs, lines and forms tell of an equivalent contrast. While the geometric shapes embody a static equilibrium, the flickering spots and dots all over the work introduce dynamism. Whereas the former appear heavy and stable, solid and dense, the latter are light and floating, tumbling and crumbly.

In Genthner's collage, the opposition of red and blue and the contradicting linear elements together create a stimulating field of tension which draws the viewer centrifugally into the work.

Recently, Genthner has reduced her palette and now paints on paper with white and black paint only. Like columns, long scrolls, which portray a calligraphic approach, are placed next to each other. Here, dark areas are inscribed with white, emotionally charged scribbles and subtle lines, which also diminish the oppressive quality of the black. The untitled work from 1990 is a prominent example of the new procedure.

Ohne Titel/ Untitled, 1991,
Acrylic on paper, 83 x 89 cm,
Courtesy the artist

Ohne Titel/ Untitled, 1990,
Acrylic on paper, 350 x 430 cm,
Courtesy the artist

HUBERTUS GIEBE

Hubertus Giebe, born in Dohna in 1953, studied at the Hochschule für Bildende Künste in Dresden and in 1978, became master-class student under Bernhard Heisig at the Hochschule für Grafik und Buchkunst, Leipzig. Since 1987, Giebe has held a lectureship for painting and graphic arts at the art school in Dresden.

Giebe's works can be closely linked to the artistic tradition of the city he lives in. Being characterised by depictions alluding to the art works of the 1920s, and being executed in a stylistic mixture of realism and expressionism, they immediately recall the art of the earliest expressionist group, Die Brücke, founded in Dresden in 1905. Their paintings feature pure colours, a dynamic play with strong colour contrasts and the fusion of depictions of reality with a gestural, very fast execution of the works.

Further, the artworks of two of the most prominent lecturers at the art school in Dresden come to mind: Oskar Kokoschka's (1919–1924) and Otto Dix' (1927–1933). Both, Kokoschka's heavy impasto application, the baroque vitality of his images and the fierce pictorial rhythms, as well as Dix' documentation of an epoch in all its appearances, his absorption of all impressions, life offered, his merciless delineation of the physiognomy of society, find a parallel in Giebe's works. The artist's sharp pictorial analysis of people and friends recall the paintings by both Kokoschka and Dix, too. Also, paintings like Giebe's portrait of Willi Münzenberger, the most important proletarian publisher, one of the heads of the anti-Stalinistic communist opposition and for this reason a persona non grata for a long time in the GDR, not only reflect the person but the situation in the former GDR.

Also, Giebe had learnt from Bernhard Heisig how to combine masses and figures into monumental and unified compositions. Moreover, his knowledge of the Old Masters (particularly Grünewald and Dürer), his interest in the art of Max Beckmann and James Ensor, as well as the inspirations he draws from literature (Günter Grass, Carl Einstein, Walter Benjamin and Gottfried Benn), have found expression in his art. One series of graphical works, for example, was stimulated by Günter Grass' novel *The Tin Drum*, which is set in the bourgeois environment of Danzig between 1925 and 1955 and which criticises the madness and failure of Third Reich fascism.

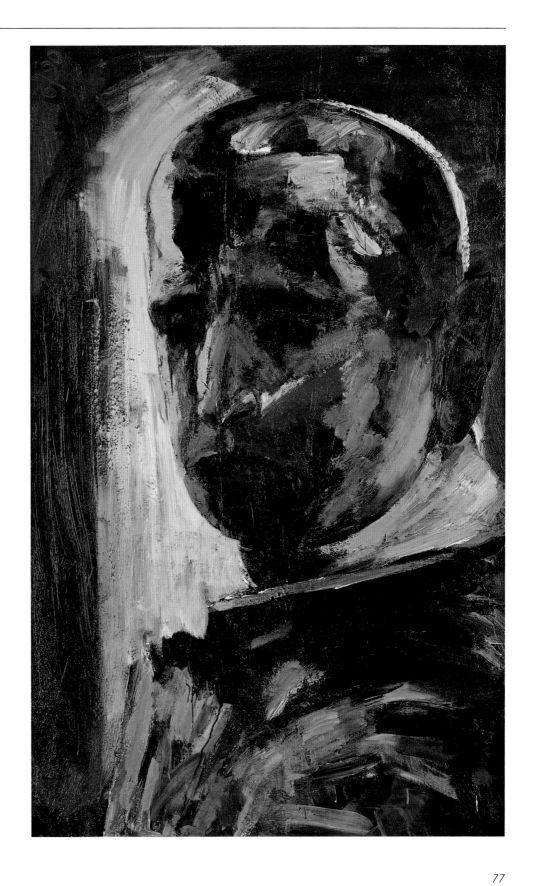

Selbstbildnis / Self-Portrait, 1990,
Oil on hardboard, 132 x 82 cm,
Photograph: Angelika Weidling, Berlin
Courtesy Raab Galerie, Berlin

From 1980 onwards, Giebe, who has always been interested in and inspired by relics from pre-war and wartime Germany (everything from cigarette cards to rusty helmets and weapons attract his attention), has been producing allegorical depictions of historical themes. One series of works, for example, inspired by the Spanish Civil War, simultaneously incorporates an implied attack of the Stalinist social system of the former GDR.

The large, figurative composition *Zwei Gekreuzigte Männer VI / Two Crucified Men VI* from 1990 presents the viewer with the dynamic diagonals and the distortions of scale Giebe frequently employs to depict 'militarism, the violent abuse of power and the systematic brutalisation of the individual'. (Leaflet *Hubertus Giebe*, Raab Gallery, London 1990). Again, the composition is reminiscent of Kokoschka's works — the cross-like linking of bodies in space — and Dix' paintings of the late 1920s — the depiction of somehow floating, over-sized and distorted figures and their marked unorganic movements.

On the other hand, Giebe's expressive and colourful *Selbstbildnis / Self-portrait*, from 1990 is clearly reminiscent of Max Beckmann's paintings like *Self-portrait with Green Curtain* (1940) or *Self-portrait in Black* (1944).

Zwei Gekreuzigte Männer VI / Two Crucified Men VI, 1990,
Oil on canvas, 160 x 200 cm,
Photograph: Angelika Weidling, Berlin
Private collection
Courtesy Raab Galerie, Berlin

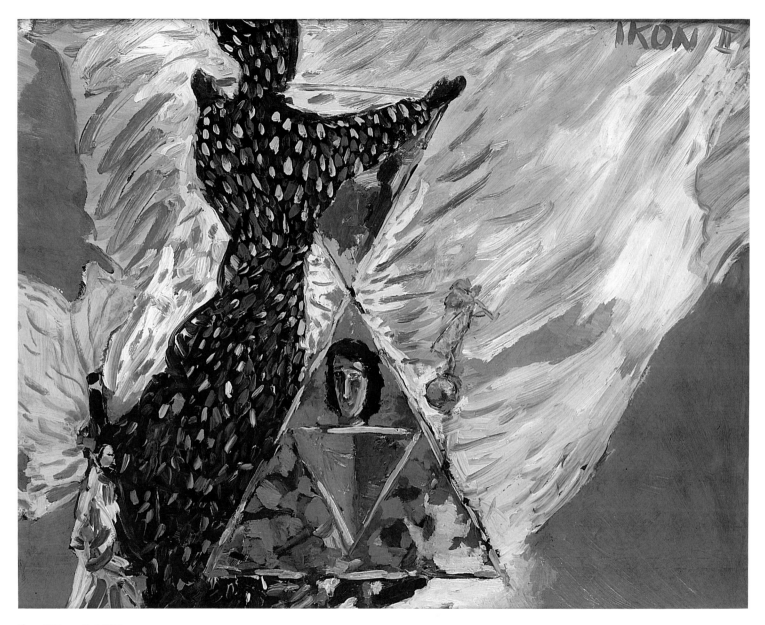

Ikon II / Icon II, 1990,
Oil on canvas, 101 x 81 cm,
Photograph: Angelika Weidling, Berlin
Private collection
Courtesy Raab Galerie, Berlin

FRIEDEMANN HAHN

Friedemann Hahn was born in Singen/Hohentwiel in 1949. His works of the 1970s — the first oil painting dates from 1972 — feature movie stars in single or double portraits based on black and white still photographs, film posters and advertising placards, which are painted over, a method distinctly different from photorealism. This way, aura and myths of and around the pictured stars are dismantled while the viewers' phantasy gains unknown freedom. Until about 1977, Hahn playfully depicts in different sizes and materials the banal, trivial and the cliché in his very own language of colours and forms.

In the early 1980s, he started to work on artist's portraits, taking the experience of having seen Francis Bacon's portrait studies after van Gogh at the Westkunst exhibition in Cologne in 1981 as a challenge for his own works. Starting point for the new, central motif, Vincent van Gogh, is again still photographs and documentary images. The oil paintings are based on images from the movie *Lust for Life* from 1956, directed by Vincente Minelli, starring Kirk Douglas as the Dutch artist. In addition, Hahn creates extensive series of drawings and watercolours. Compared to the paintings, these works are sometimes completely independent of the photographs and much more expressive in their execution. Yet, even the former reflect the formal change Hahn's works indicate from 1979/80 onwards: the depicted figures are partially covered with dots and marks, sometimes to the extent that the photograph is almost undetectable.

Hahn's occupation with van Gogh was soon extended to portraits of other artists such as Edvard Munch, Paul Cézanne or Ernst Ludwig Kirchner for example, all of them inspired by either documentary photographs or paintings.

The triptych *Claude Monet, Giverny um 1920* from 1982 belongs to the earliest phase of artist portraits. The central canvas depicts Monet — as shown on a photograph from about 1920 taken at Giverny — holding a palette in his left and a brush in his right hand. The background of the Monet image is yellow. The canvases to the left and right, which are shorter and not as broad as the centre piece, are coloured blue and red respectively. Recalling works by Piet Mondrian, Barnett

Claude Monet, Giverny um 1920, 1982,
Oil on canvas, triptych, total size 180 x 405 cm,
Collection Städtische Kunsthalle Mannheim
Courtesy the artist

Newmann and Yves Klein, these monochrome colour fields are created with swirling brush strokes. Yet, they appear somehow flat and textureless when compared with the figure of Monet, composed of short brush strokes, reminiscent of the pointillism of the Impressionists and in particular of Monet's own *Nymphéas* paintings. The colours and the outer form of the painting refer to three historical art epochs: to the art of the twentieth century and particularly to the works of the named artists (primary colours), to its beginning (Monet and the Impressionists) and to the art of past centuries (triptych and yellow/gold). Simultaneously, Hahn fuses his own painting process with historical time, moments of art history and with the instant the photograph of Monet was taken. Due to his working method, which is characterised by theoretical clarity, order and free expression, these layers of meaning are not confused and therefore are equally appealing and stimulating.

Kirk Douglas in 'Lust for Life, 1956',
1981,
Oil on canvas, five-piece, total size
195 x 177 cm,
Photograph: Hartmut W. Schmidt
Collection Böckmann, Berlin
Courtesy the artist

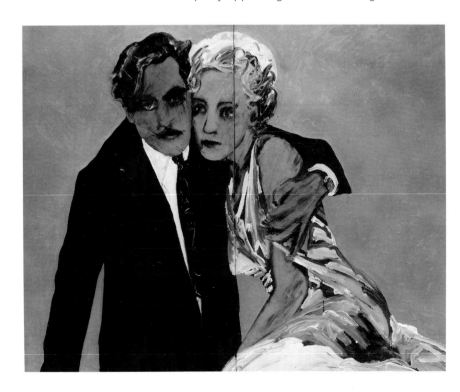

*Carole Lombard und John Barrymore in
'Twentieth Century, 1934'*, 1978,
Oil on canvas, two-piece, 160 x 200 cm,
Photograph: Hartmut W. Schmidt
Collection Städtische Galerie Wolfsburg
Lent by Collection Bönsch
Courtesy the artist

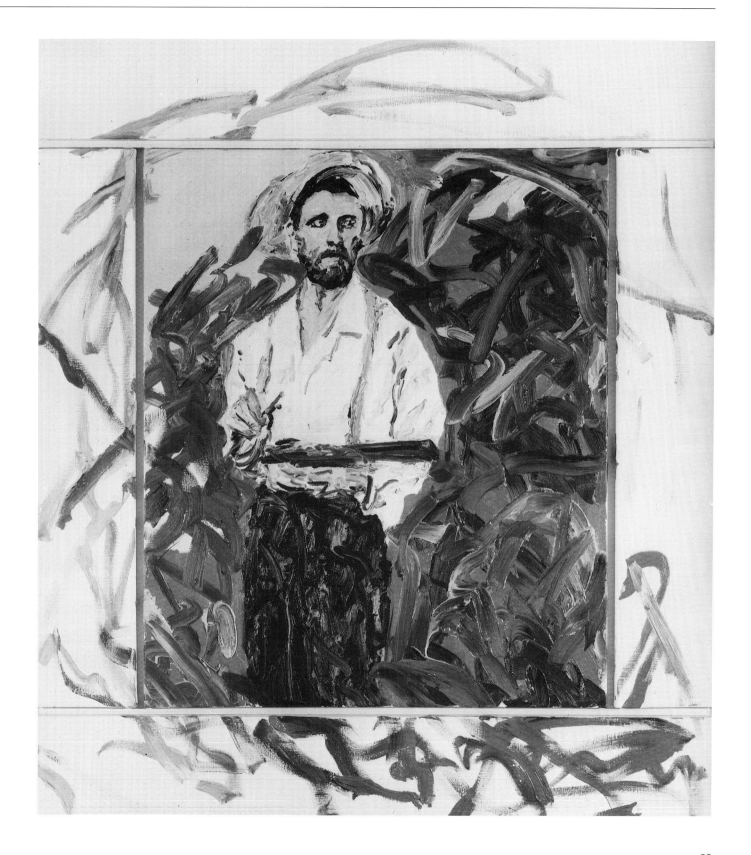

ANGELA HAMPEL

Angela Hampel, born in Räckelwitz in 1956, studied under Jutta Damme and Dietmar Büttner at the Hochschule für Bildende Künste, Dresden, from 1977 to 1982. Since 1982 she has been living and working as an independent artist in Dresden.

Since 1984, Hampel has also been working in the ceramic workshop of Wifriede Maaß in Berlin and has created books, combining image and text, together with the author Elke Erb. From 1987 onwards, Hampel has contributed to installations and exhibitions with, for example, Steffen Fischer, Eva Anderson and Ulrike Rösner — artists who worked together in the former GDR in the late 1980s, emphatically believing in the power and effectiveness of images. In 1989, Hampel was one of the founders of the *Dresdner Secession '89*.

Hampel's paintings are characterised by the depiction of usually one or two, frequently unclothed, female bodies, and by intensive, pure colour which covers, surrounds and envelops these figures. These images appear simultaneously androgynous, without any individualistic features, and even partly deformed. Some of Hampel's figures are equipped with highly symbolic objects like the snake or a fish. Others are provided with a white fur coat with black dots, partly revealing, partly concealing their sexual nature.

In Hampel's oeuvre, the female figures represent the exploration and confrontation of herself as a woman as well as alternative depictions of women in contrast to traditional male painting. Titles like Medea, Penthesilea, Cassandra or Salome, referring to famous mythological women, offer possible models for the identification of herself and others. Also, the generally accepted oppositions, which are deeply embedded in our consciousness, are addressed and their artificial and unsubstantiated construction is revealed. Man/woman, strong/weak, action/passion, it is, Hélène Cixous once noted, 'Always the same metaphor: we follow it, it transports us, in all of its forms, wherever a discourse is organised. The same thread, or double tress leads us, whether we are reading or speaking, through literature, philosophy, criticism, centuries of representation, of reflection. Thought has always

Aber was soll ich denn in Spanien,
undated,
Mixed media on capok, 150 x 150 cm,
Photograph: Götz Schlötke, Berlin
Courtesy the artist

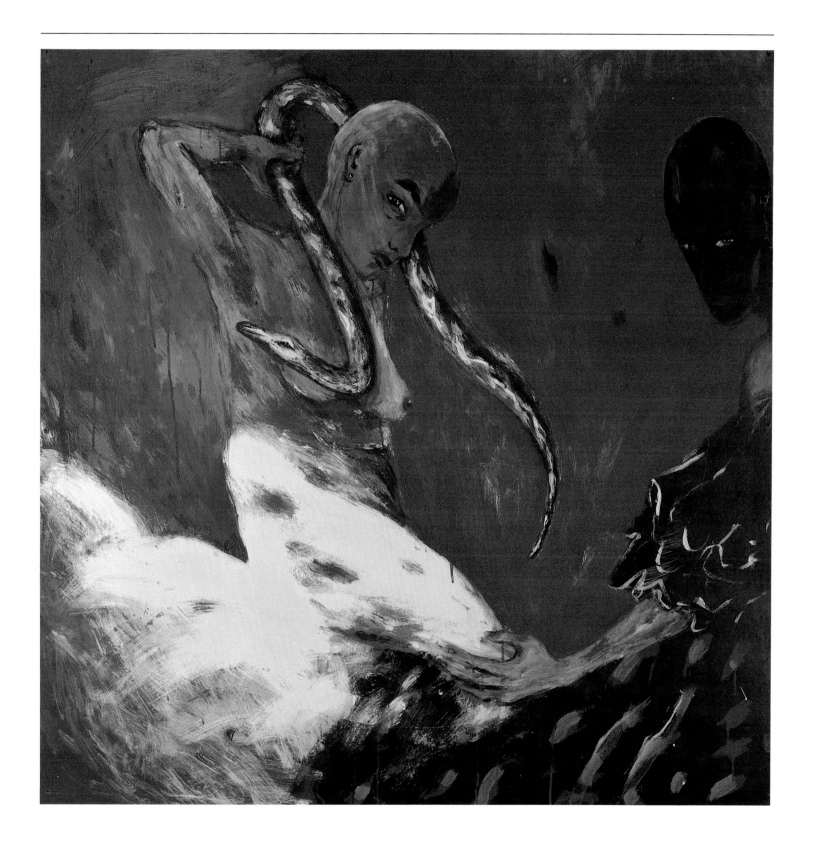

worked by opposition, Speech/Writing, High/Low. By dual *hierarchised* oppositions. Superior/Inferior.' (in: Marks/de Courtivron (eds), *New French Feminism*, New York, 1981, p. 90)

Hampel's figures generally indicate anger, grief and aggression regarding the inferior position of women and the prevailing hierarchies. Therefore, the painting *Aber was soll ich denn in Spanien?/But, What Shall I do in Spain? (... go to Spain for?*), might be seen as displaying women trying to emancipate themselves from the image of the seductress, the image of being the object of the male gaze and male desires, since the female figure to the left of the work is obviously in the process of freeing herself of the snake around her neck, while confronting the viewer with a simultaneously aggressive and provocative look.

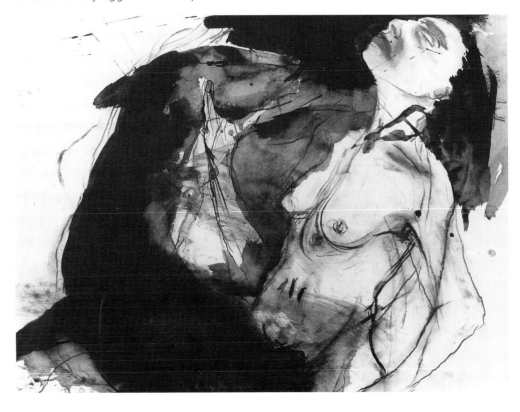

Frau mit Tier/ Woman with Animal,
undated,
Charcoal/mixed media on paper,
65 x 75 cm,
Photograph: Götz Schlötke, Berlin
Courtesy the artist

Paar / Couple, undated,
Pencil on paper, 31 x 43 cm,
Photograph: Götz Schlötke, Berlin
Courtesy the artist

JOHANNES HEISIG

Johannes Heisig, born in Leipzig in 1953 studied painting and graphic art at the Hochschule für Grafik und Buchkunst in Leipzig. Between 1974 and 1979, he worked in the studio of his father, the artist Bernhard Heisig, and from 1978 to 1980 he was master-class student under Gerhard Kettner at the Hochschule für Bildende Künste, Dresden. Heisig, who in 1991 resigned from his position as director of the Hochschule für Bildende Künste in Dresden, lives and works in Dresden as an independent artist.

While alternating between an expressive spontaneity, a careful approaching of a problem and an experienced, cool execution, Heisig's artistic practice is characterised by a perpetual seeking for and assessing of variations of the once painted images. Also, the always new experiences he gains, often lead to an alteration of earlier works — 'art is life and life is transformation', the painter Antonio Tàpies once said. In a procedure, somewhat comparable with a montage or collage, Heisig frequently paints over parts of images or completely covers paintings (even those, which have already been exhibited like *Beach*, 1981, changed into *Beach*, 1983, and into *Boat*, 1985). Often, he leaves fragments of the earlier shapes and structures, which merge with the new composition and also function as tracks and traces of his working process.

Therefore, Heisig's works rarely presents us with a coherent, monological message. While their narrative is neither linear nor continuous, their syntax persistently evades resolution, frustrating the viewer's wish that the images be directly translatable. Also, through this method, Heisig is able to bring together multiple impressions into one space, infusing the works with a similar simultaneity and multiplicity as is found in contemporary life. By painting over the images, their significance becomes relative, while the value of the art works, ephemeral and impermanent as they are, is located more in the act of making them.

The painting *Ein Abend in der Oper / An Evening at the Opera* from 1990 not only reflects this procedure — although in a different way to that just discussed — but also refers to two themes, recurrent in Heisig's oeuvre. One motif in his art is the city,

COLLEGE LIBRARY

**Please return this book by the date stamped below
- if recalled, the loan is reduced to 10 days**

Ein Abend in der Oper / An Evening at the Opera, 1990,
Mixed media on canvas, 190 x 270 cm,
Photograph: Christoph Sandig, Leipzig
Private collection, Hamburg
Courtesy the artist

more specifically townscapes, road networks, street ravines, as can be seen in the work *Balkonszene / Balcony Scene* from 1983, where a man, standing on a balcony at vertiginous height, looks down onto the far away, turbulent street life. The other subject, which interests Heisig, is music. He refers to this in the titles of paintings (such as *At the Opera*), by an expressive imitation of speed and characteristics of certain types of music (as in some paintings on rock music), or by the depiction of musical instruments, as in the painting *Das Sofa / The Sofa* from 1987, where a soprano saxophone is delineated.

Also, music, or rather the sometimes discovered prescript *da capo*, the 'Play it again, Sam', seems equivalent to Heisig's method of painting over imagery. *Ein Abend in der Oper* was painted over too, though not by the artist. At an exhibition, somebody (anonymously) painted a swastika — the wrong way round —onto one of the tiles depicted at the bottom of the work. On one hand, this clearly is an act of destructive frenzy. On the other hand, Heisig, who sees it as a document of contemporary time, might have painted the swastika onto this or another work himself one day, to express his concern about the growing Neo-Nazi violence. Today, this consideration seems even more imaginable.

Das Sofa / The Sofa, 1987,
Mixed media on canvas, 105 x 180 cm,
Photograph: Jürgen Buchhold, Freital,
Collection Kunsthalle Rostock
Courtesy the artist

Balkonszene/Balcony Scene, 1983,
Lithograph (edition of 25), 55 x 74 cm,
Photograph: Jürgen Buchhold, Freital,
Courtesy the artist

K.H. HÖDICKE

K.H. (Karl Horst) Hödicke, born in Nürnberg in 1938, studied under Fred Thieler at the Hochschule für Bildende Künste, Berlin, between 1959 and 1964. Together with Georg Baselitz, Markus Lüpertz, and Bernd Koberling, to name only a few, Hödicke belongs to a group of artists who, in the mid 1960s, laid the foundation-stone for the so-called neo-expressionist painting in Germany which became known and acknowledged internationally in the 1980s.

In contrast to many artists of the same generation, Hödicke, who first showed his works in public in 1964, left the framework of traditional painting early. For the past, almost three decades, he has been proving his proficiency in different media and different stylistic approaches, has produced objects, multiples and installations and has employed photography, film and video in his works. As significant to his oeuvre as his paintings are his combinations of *objects trouvés* and ready-mades as in *Europäischer Reisekoffer / European Travel Case* from 1967–76, directly referring to Duchamp's *The Box in a Valise* (1941), and processual sculptures such as *Kalter Fluß / Cold River* or *Cold Flow* from 1969, featuring a tin of tar emptying slowly, as well as the sculptures created since the mid 1980s. Analogously, the sources of Hödicke's works are manifold. His objects and multiples necessarily recall those by Marcel Duchamp, Man Ray and the DADA movement and, whereas his early paintings are inspired partly by pop art, later works stand in the tradition of German expressionism (Max Beckmann, Ernst Ludwig Kirchner).

As well, the inspiration for Hödicke's paintings has most often and right from the beginning, derived from the daily life, the glamour and glitter of the big city (Berlin) which surrounds the artist, its people, fast running cars and neon lights, its places of relaxation as well as its hectic and high speed. The observed objects and figures, expressively depicted with equally gleaming and sparkling colours, are organised into partly abstract, partly representational compositions, are modified, transformed and alienated. Evidently, Hödicke is not merely delineating what he sees, but rather takes perception itself, the way the world is perceived, as theme of his works (see also Jörg Merkert, in: exh. cat. *K.H. Hödicke. Gemälde, Skulpturen, Objekte, Filme*,

Himmelfahrt / Ascent to Heaven,
1983/84,
Synthetic resin on canvas,
290 x 200 cm,
Private collection
Courtesy Galerie Gmyrek, Düsseldorf

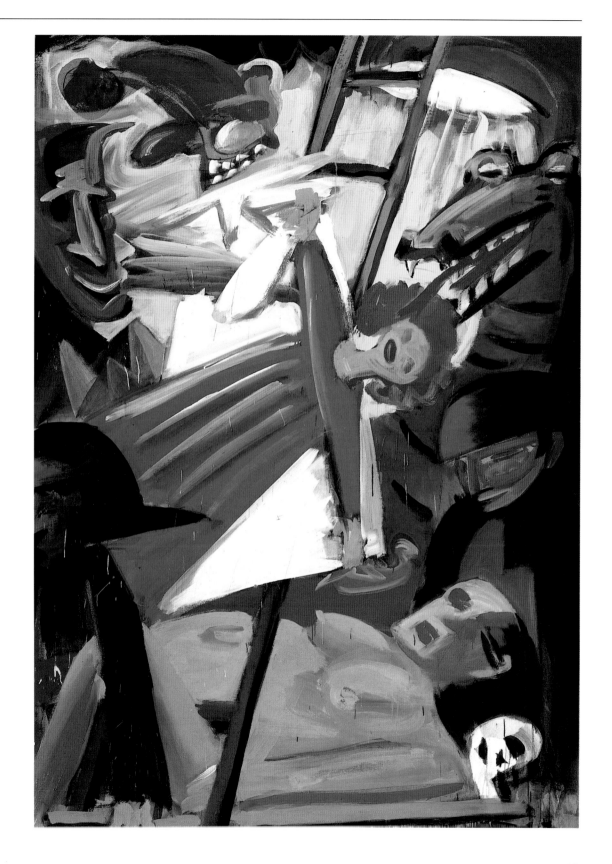

Kunstsammlung Nordrhein-Westfalen, Düsseldorf, 1986, p. 12).

In the early 1980s, Hödicke, who is much travelled (North and South America, Asia and India), also began to invest his paintings with references to foreign religions, myths and rites and to convert images, pre-given by art history, such as Picasso's *Women Running on the Beach* (1922) into lively and explosive works.

It is noticeable in the painting *Himmelfahrt / Ascent to Heaven* from 1983/84, that Hödicke's images of the last decade have become more violent and aggressive. Filled with symbolic signs, they oscillate between a joyful intimacy and a threatening unfamiliarity, between 'reality and fiction'. (Erika Billeter in: *op. cit.*, p. 78).

Selbst und Fremdenlegionär / Self and Legionnaire, 1982,
Synthetic resin on canvas,
170 x 230 cm,
Courtesy Galerie Gmyrek, Düsseldorf

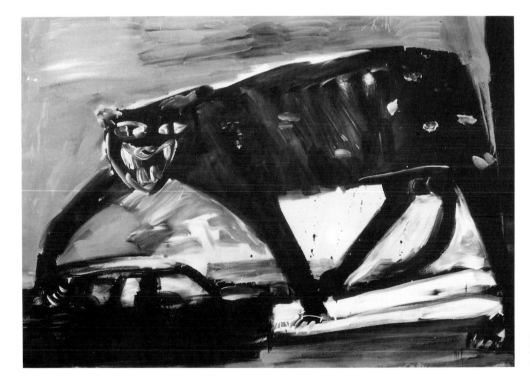

Nocturno, 1983,
Synthetic resin on canvas, 200 x 290 cm,
Courtesy Galerie Gmyrek, Düsseldorf

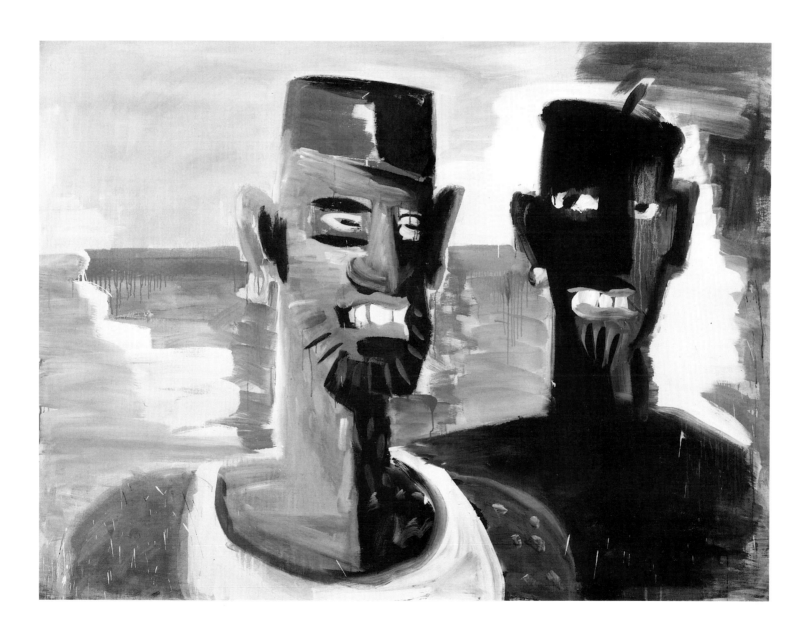

LEIKO IKEMURA

The painter and sculptor Leiko Ikemura was born in 1951 in Tsu Mie, Japan. After having lived for several years in Spain, studying at the art school in Sevilla, in 1979 the artist moved to Zurich, Switzerland. Today, Ikemura lives and works in Cologne and Berlin and holds a professorship at the Hochschule der Künste, Berlin.

During the last ten to fifteen years, Ikemura's artworks have changed distinctively. Her paintings of the early 1980s, like for example *Hasenfang/Rabbit Catching* from 1983, depict clear-cut forms, objects, figures and androgynous creatures. The paint is applied densely, not smeared, and set in place by the forms. In addition, these works most obviously portray the amalgamation of eroticism, violence and threat, which characterises Ikemura's art.

The fusion of Asian and western art becomes most apparent in the completely different paintings with which Ikemura surprised us a few years later. *Mamma Buddha* from 1986, for example, appears like a combination of colour field painting with an expressive paint application. Here, layered zones of red, blue and yellow paint, executed with broad brush strokes, are linked with delicately delineated images. The latter undoubtedly recalls the attraction to drawing we discover in Asian art. It also directs us towards a major constituent in Ikemura's oeuvre, the drawings. 'In advance to reflexions, I draw', she once said, 'because the drawing is the vehicle for the images passing by. I'm living timeless, placeless, not directed anywhere … In a way, the drawings save me from being detached from the world, save me from being alienated. For me, the drawings are *now*, while painting, because of the resistance, means *ways*. The drawing is the better device to express thoughts, because painting is more complex and an organic occupation. Before the 20th century, only few Europeans had cultivated drawing as an autonomous language in art. And also today, drawings are often only sketches of ideas. Unfortunately.' (in: *Kunstforum International*, Vol. 83, 1986, p. 246)

Ikemura's most recent works again are completely different. In contrast to *Hasenjagd*, for example, the untitled paintings from 1991 are executed with broad

Ohne Titel/ Untitled, 1991,
Distemper on wood, 44 x 33 cm,
Photograph: Lothar Schnepf, Cologne
Courtesy the artist

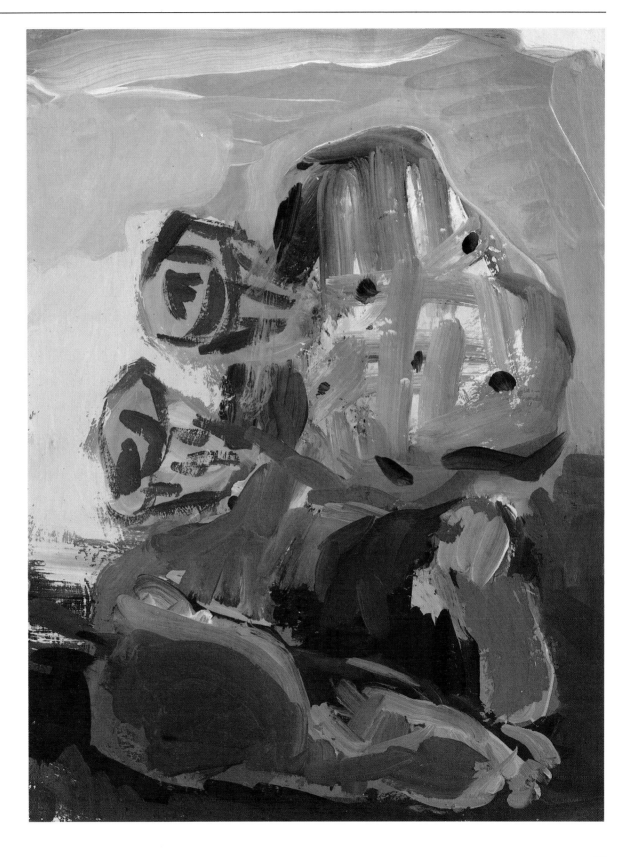

and fierce brush strokes. The colour here seems in a state of liberating itself from the all-enclosing form, a process which was already noticeable in *Mamma Buddha*.

Further, we can no longer recognise identifiable figures or objects when looking at the paintings shown here. More than ever before, Ikemura has achieved with these works the creation of ambiguous images which can not be explained with words.

Ohne Titel/Untitled, 1991,
Distemper on canvas, 29 x 26 cm,
Courtesy the artist

Ohne Titel/ Untitled, 1991,
Distemper on canvas,
47.5 x 36 cm,
Courtesy the artist

JÖRG IMMENDORF

Jörg Immendorff, born in 1945 in Bleckede near Lüneburg, studied theatre arts under Teo Otto at the Staatliche Kunstakademie in Düsseldorf between 1963 and 1964 and became one of Joseph Beuys' students in 1964. His attitude during this time is expressed in the self-contradicting picture *Hört auf zu Malen / Stop Painting* from 1966, illustrating his concern about a self-satisfying and uncritical art and his opposition to academic conformism. In the same year, Immendorff began to use the baby as an iconographical motif, as a sign for love and peace.

In 1967, the *baby art* initiated LIDL, first interpreted as the phonetic transcription of the sound made by a baby's rattle, later understood as a sign defined through actions. LIDL manifested itself through protest marches, rebellion against institutions, the opening of the LIDL-space (a space for information, cooperation and action), the foundation of the LIDL-academy in Düsseldorf in 1968 and the LIDL-sports team a year later.

The provocations and neo-dadaist LIDL-actions, however, did not achieve the effect Immendorff had intended. Neither did the communist agit-prop art he propagated between 1970 and 1976 change the social and political situation.

In 1977, Immendorff therefore developed a new kind of political and allegorical painting, creating a series of works on the theme of Germany's past and present entitled *Café Deutschland* of which the *Café Deutschland I* (1977/78) is one example. The series refers to Renato Guttuso's *Caffè Greco*, a painting Immendorff was able to see during an exhibition of Guttuso's work in Cologne. However, in contrast to Guttuso, who presents us with a portrait of Italian middle-class society in the atmosphere of the well-known Roman café, the starting point for Immendorff was the political constellation in Germany at that time. His café is fictitious, crowded with props and personalities like the flags of East and West Germany and next to them Helmut Schmidt and Erich Honecker or the swastika held by an eagle. Central to the painting is the Berlin Wall through which the artist himself sticks his hand, trying to connect West and East Germany and, more specifically, himself and the East German artist A.R. Penck (mirrored as standing in front of the Brandenburg Gate in the

Café Deutschland I, 1978,
Oil on canvas, 282 x 320 cm,
Courtesy Galerie Michael Werner, Cologne

column above the wall piece) whom he met for the first time in 1976.

Obviously, Immendorff's paintings are not easy to decode without any previous knowledge. In contrast to many contemporary artists, he readily fuses personal and collective history, a history which often appears both as heritage and as nightmare. Moreover, Immendorff has always shown a strong political involvement and regularly confronts his viewers with paintings reflecting present political aspects: 'I conceive of myself as a political painter, because the political engagement is the central theme in my life and work. For me, art still is *the* means to clarify and represent my position …', he once said in an interview with Jörg Huber (in: exh. cat. *Immendorff*, Kunsthaus Zürich, 1983, p. 38). Today, the simultaneity of everyday reality and banal elements is still to be found in his art, although the relationship between the painter and history has, with regard to recent political developments, become more subtle.

Untitled, 1990,
Oil on canvas, 270 x 180 cm,
Courtesy Galerie Michael Werner, Cologne

3 Oktober '90, 1990,
Oil on canvas, 270 x 220 cm,
Courtesy Galerie Michael Werner, Cologne

TINA JURETZEK

Based on spontaneity and reflection, on an expressionist approach combined with logical precision, Tina Juretzek's works convey a dynamic balance between intensity and sensibility, between objectiveness and abstraction.

Juretzek, born in Leipzig in 1952, studied under Günther Grote from 1971 to 1978 at the Staatliche Kunstakademie, Düsseldorf. The artist has lived and worked independently in Düsseldorf since 1983.

Juretzek's earliest works, inspired by the art of Paul Klee and Asian calligraphy, are drawings only. At first, she executed them solely in black and white, later with coloured pencils and pastels.

Especially before 1990, her paintings still revealed the graphic constituent, but it became less prevalent as additional components found their way into her works. The result was a combination of painting, collage and drawing, pictures for which the linear element provided the rhythm and structure and interlocked separate parts into an entity.

All of Juretzek's works are, with the exception of her ink drawings created on paper or cardboard, based on a mixed media technique, producing a lively surface structure of the paintings. She uses acrylic and oil paint as well as lacquer. She also employs coloured papers and, lately, fragments of her own drawings and paintings as collage elements, which since they have become more and more integrated into the works are, in recent images, hardly detectable.

Juretzek's depictions are without exception based on her personal experiences and the essential motifs of her works have always been the figure and the landscape, or rather, space.

After a journey to Italy in 1983, the paintings mainly depicted glasses, bottles, figures and abstract forms, which were extricated from their familiar surroundings becoming in this way like hieroglyphic signs. In these works, the colour blue, often referred to in the titles, dominates, while white and a bright yellow illuminate the setting.

Again, specifically the colour yellow acts as a light bringing force in a series of

Riese / Giant, 1991,
Painting/collage on canvas,
220 x 190 cm,
Courtesy the artist

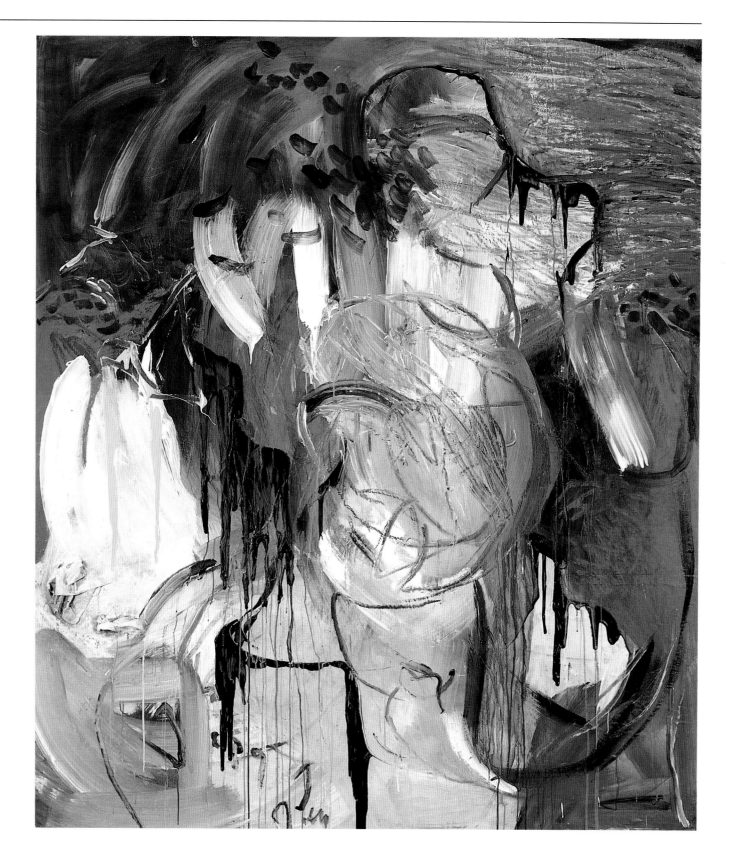

paintings of which one example is *Riese / Giant* from 1991.

For eighteen months during the years 1990/1991, Juretzek concentrated on the colour purple, while blue was reduced and red and green disappeared completely. In these paintings, purple, the symbolical colour of the ominous, the secret, the unconscious and, in the Christian tradition, the colour symbol for penitence, is experienced as both threat and sign of change. It is contrasted by yellow, the symbol for knowledge and enlightenment. The yellow that Juretzek uses is luminous and often breaks through the purple and brown darkness like a flash, creating an atmosphere of spaciousness.

In most of these works, Juretzek painted circularly either from the centre towards the edges of the canvas, or from the outside towards the centre of the work. While this procedure endows her paintings with dynamism and depth, it also reflects her ongoing occupation and concern with inside and outside, openness and closeness, space and restriction.

Glas und Krug / Glass and Jug,
1989,
Painting/collage on cardboard,
70 x 100 cm,
Courtesy the artist

Person mit Krug / Person with Jug,
1989,
Painting/collage on cardboard,
70 x 100 cm,
Courtesy the artist

CLEMENS KALETSCH

Clemens Kaletsch was born in Munich in 1957 and has been living and working in Cologne since 1989. *Skulptur Nr. 2/Sculpture No. 2* from 1982/83 is the earliest of the three presented works. Broad areas of colour cover a photograph of, we can guess, a person, who's hair is still visible in the upper right quarter of the painting. The work clearly refers to Kaletsch's studies, more explicitly to the work of one of his teachers.

Between 1976 and 1986 the artist lived in Innsbruck and Vienna. In Vienna, he also studied at the Hochschule für Angewandte Kunst and at the Akademie der Bildenden Künste under Oberhuber and Rainer. During this time, Arnulf Rainer, known for his painting over of images, portraits and figures, began to paint over icons. Art on art was the theme and Christ, women and death were the motifs Rainer expressively covered with paint. Yet, Kaletsch was obviously only inspired by Rainer's technique, since his work is neither reminiscent of Rainer's iconography nor of his expressivity. Instead, Kaletsch's painting depicts half abstract, half figurative elements and despite the broad brush strokes and thick application of paint it does not seem to be emotionally charged.

In contrast to *Sculpture No. 2*, the work *U.S.W.* (1984) appears more airy, more delicate due to the technique employed, watercolour and pencil on paper, and the increase of filigreed figurative elements. It is a prime example of Kaletsch's works on paper, i.e. drawings and watercolours, which are to be found throughout his oeuvre. Generally, these works might be divided into two groups: those which show mainly figures and heads, delineated with strong, broad lines, characterised by an expressive immediacy in their execution; and those, which depict linear scribbles, networks of lines, often seemingly unintentional scrawls which envelop a figurative element or reluctantly define a contour.

Undoubtedly *U.S.W.* belongs to the latter group of works. Although, as with any non-abstract work associations immediately come to mind, an unambiguous reading of the depiction is impossible. We recognise five figures, yet are they male or female? Each stands on a disc — or are they dancing? Is the work a portrait of five musical

Griffe / Handles, 1987,
Oil on canvas, 146 x 93 cm,
Private collection, New York
Courtesy the artist

clocks or is it picturing a peep-show?

The abbreviation *U.S.W.* allows for any combination of three words in any language. It could, for example, be read as 'Und so weiter' — the standard abbreviation is 'usw.' — which means 'and so forth'. The title of the work therefore clearly indicates its openness to multiple readings and also characterises the artist's basic approach to art.

By contrast, *Griffe/Handles* from 1987, seems to unmistakably depict what its title promises and this seeming unambiguity instantly blocks any intellectual exercises, restricts any possible associations. This might have been one reason for the artist to again create less obvious works, pictures which are, since the late 1980s, rather abstract and surreal like *Rote Übermalung/Red Painting Over* from 1989 or from the same year *Wollen und Nehmen/Wanting and Taking*.

Skulptur Nr. 2/Sculpture No. 2,
1982/83,
Painting over photograph,
17,8 x 23,7 cm,
Courtesy Fred Jahn, Munich
Photograph lent by: Clemens Kaletsch

U.S.W.,
Watercolour and pencil on paper,
33 x 48 cm,
Courtesy Fred Jahn, Munich
Photograph lent by: Clemens Kaletsch

Skul——ptur Nr. 2 *R. Verland*

AXEL KASSEBÖHMER

Axel Kasseböhmer, born in Herne in 1952, has lived and worked as independent artist in Düsseldorf since 1976. In 1977, he visited for several months Gerhard Richter's art class at the Staatliche Kunstakademie, Düsseldorf. Since the end of the 1970s, he has become known for quoting and appropriating the art of the past in a distinctly idiosyncratic way.

Kasseböhmer choses his motifs from reproductions of paintings by, for example, Fra Angelico and Tintoretto, Bosch and van Eyck, Cranach, Rubens and Caravaggio, Botticelli, Poussin and Zurbaran, de Chirico and Picasso. He then combines the most diverse and often, for the original paintings, rather unimportant details. Also, he handles his models with a certain degree of casualness and irony as can be seen in the work *Landschaft mit Figuren/Landscape with Figures* from 1984. For example, the second figure from the left is one of the three graces from Botticelli's well known *Spring* painting. Kasseböhmer, however, depicts her with a fashionable short haircut.

Trying to create an alternative depiction to the prevailing image of woman and man has surely been one reason for *Landschaft mit Figuren*. In Kasseböhmer's oeuvre, this work is quite an exception not only for its size (2 m x 6 m) but also for the theme since the artist usually paints landscapes or still lifes without figures.

The work *Häuser/Houses* from 1980, for example, shows the enlargement of a small detail of the background townscape of Fra Angelico's altar-piece *Descent from the Cross* (1435/40) at S. Trinita in Florence. 'It was in a way quite touching', Kasseböhmer once said, 'because it [Fra Agelico's painting] was produced at a time when progressive spirits had long since started painting quite differently. I simply enjoyed it because it had something open and honest about it, something which has a great deal to do with the image of man and with concepts of morality.' (in: exh. cat. *Deutsche Kunst der späten 80er Jahre. Binationale*, Cologne, 1988.)

Towards the mid 1980s, Kasseböhmer's still lifes became most prominent. Again, he combined and contrasted different styles. In his still lifes with vases, he was also interested in the individual traces left by the manufacturing process. 'When I look at a baroque still-life, I know that the depicted objects were made in just the same way

as a picture is made', that is by hand. Painting an industrially fabricated vase today 'bestows upon it a content, a meaning, an individuality that it doesn't really have. That's why it's so difficult to paint still-lifes nowadays.' (in: *op. cit.*, p. 199)

It is evident that the combination of different images and styles in most of Kassebőhmer's paintings, has resulted in works which are heterogeneous, pictures which display no simple harmony. Instead, the chosen images indicate several and sometimes most disparate points of view, values and attitudes. In addition, the stylistic incoherence clearly reflects the complexity and pluralistic atmosphere of the post-modern world in which we live.

Landschaft mit Figuren / Landscape with Figures, 1984,
Oil on canvas, 200 x 600 cm,
Courtesy Galerie Monika Sprüth, Cologne

ANSELM KIEFER

Born in 1945 in Donaueschingen, the artist Anselm Kiefer has achieved world renown for his huge paintings with motifs and symbols taken from German history, mythological tales, alchemy, biblical history and philosophy.

The book *Du bist Maler/You're a Painter* from 1969 and the series of photographs, known as *Occupations* from the same year, which show the artist in various places in the Nazi *Sieg heil* pose, are the earliest evidence for the direction his art was going to take. Kiefer was to examine his identity as an artist and as a German. He was to play with propaganda methods and ambiguities, while simultaneously seeking to expand the boundaries of art and attempting to confront his viewers with historical events, often suppressed or forgotten.

From 1974 onwards, many series of works which are interconnected by the repetition of similar motifs or symbols began to emerge. One of these motifs is the palette as we discover it in the painting *Bilderstreit/Iconoclastic Struggle* from 1976/77. 'The palette', Kiefer once said, 'represents the art of painting; everything else which can be seen in the painting — for example the landscape — is, as the beauty of nature, annihilated by the palette. You could put it this way: the palette wants to abolish the beauty of nature. It is all very complicated, because it actually does not become annihilated at all.' (in: Mark Rosenthal, exh. cat. *Anselm Kiefer*, Chicago and Philadelphia 1987, p. 60). The palette appeared first in 1974 in the paintings *Nero Paints* and *Painting-Burning*. It is a formal motif with numerous meanings depending on the pictorial context. In *Bilderstreit* — the title also reflects a central topic in Kiefer's oeuvre — the palette symbolises the loss of culture through war; its form contours a plateau for which tanks battle.

A further concept of Kiefer's work has been the archetypal landscape as it is seen in *Bilderstreit*: the ground is dark in tonality, the earth of the landscape is scorched, the event seems to happen at night. A third aspect is the words he inscribes on the surface of his paintings. In *Bilderstreit* names can be detected, Theophila and Artavasdas for example — words we only can place in their historical context when knowing that the painting's title refers to the Byzantine iconoclastic controversy of

Bilderstreit / Iconoclastic Struggle, 1976/77,
Oil, acrylic, emulsion, shellac on canvas, 325 x 330 cm,
Courtesy the artist

the eighth and ninth century. Its main issue was the question as to whether the painter-monks should be allowed to depict Christian personages. In turn, the words — the names of the debates' heroes — locate the image, are the key to its interpretation.

During the last twenty years, Kiefer has also created artist books, which show his conceptualist bent, and large sculptures, portraying his liking for diverse materials, as do his paintings of the 1980s in which he used straw, sand or lead, for example.

Belonging to the older generation of artists, like Jörg Immendorff and A.R. Penck, who are concerned with history and, more specifically, Germany's past, Kiefer's work particularly regained its actuality with regard to the recent Neo-Fascist acts of destruction in this country.

Wege der Weltweisheit / Ways of Worldly Wisdom, 1976/77,
Oil, acrylic, shellac on burlap, mounted on canvas, 305 x 500 cm,
Photograph: Littkemann, Berlin
Courtesy the artist

Dem Unbekannten Maler/To the Unknown Painter, 1983,
Oil, acrylic, emulsion, shellac and straw on canvas, 208 x 380 cm,
Courtesy the artist

MARTIN KIPPENBERGER

Martin, stand in the corner and be ashamed of yourself is the title of a multiple, Martin Kippenberger created in 1989. Here, as in many of his works, Kippenberger plays satirically on the roles he takes on. Being more than an artist, he is, according to his self-assessment, a 'wastrel, host, self-portrayer, show-off, ringleader and go-between.' (in: exh. cat. *Kippenberger. Durch Pubertät zum Erfolg*, Neue Gesellschaft für Bildende Kunst, Berlin 1981, n.p.)

Kippenberger, who was born in 1953 in Dortmund, is one of the most productive and versatile artists of the contemporary German art scene. Apart from paintings, which he defines as 'The best of the second best', he makes sculptures, draws, takes photographs, publishes books, writes prose texts and poems in catalogues, produces invitation cards and records, holds lectures and issues editions of exhibition posters for himself and his artist friends. The copious national and international shows of his works in dealer galleries and museums since the late 1970s break all records. He also organises exhibitions for friends, arranges performances and film shows and collects and introduces the works of other artists. Kippenberger finds support for these achievements in a battalion of advisers and commentators, assistants and friends he recruits all over the world.

Rather than seeking for personal expression through the individual brush stroke, a path many of his colleagues pursue, Kippenberger has sometimes left the putting of his ideas into practice up to others, supplying brief sketches only, like the series *Lieber Maler, Male Mir/Dear Painter, Paint for Me*, from 1981, executed by a professional poster painter.

Since 1981, Kippenberger has been painting commonplace subjects, whole series of pictures in which no theme, no style is missing. This way, painting might be seen as reduced to being only a carrier of any possible idea. Yet, Kippenberger simultaneously exposes the subjects he paints, reveals the false pretences and hypocrisy often surrounding us. Most frequently, his paintings have titles or painted on sentences like *Down with the Bourgeoisie* (1983) or *Life is crap — no work 1 Seek 2 and ye 3 shall 4 find — Jesus* from the series *Buggered for Ideas* (1982/83).

We don't have problems with friends, we sleep with them, 1986, Oil on canvas, 180 x 150 cm, Courtesy Büro Kippenberger

121

In a group of works from 1986, titled *Die No Problem Bilder/The No Problem Paintings*, he satirises the phrase 'simple problems call for simple solutions', finding solutions of 'truly astonishing simplicity': *We don't have problems with friends, we sleep with them* or *We don't have problems with disco door-waiters, if they don't let us in, we don't let them out* or *Nous n'avons pas de problemes avec la guerre, car la guerre vient a la fin* for example.

Kippenberger provokes with his anarchical and cynical, sometimes absurd and ludicrous statements, attacking and disregarding long-established social norms, as do his artist friends Werner Büttner and Albert Oehlen. Strictly according to his mottos 'Truth is work' and 'Paint them down', he lets the viewers feel insecure, violates their anticipated feeling of pleasure and annoys critics. Nevertheless, Kippenberger's approach of bold uprightness seems a possible way to again legitimise art, and painting in particular.

Untitled, 1988,
Oil on canvas, 240 x 200 cm,
Courtesy Büro Kippenberger

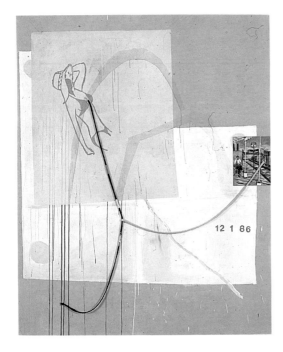

Garota De Ipanema I, 1986,
Acrylic, silicon on canvas,
180 x 150 cm,
Courtesy Büro Kippenberger

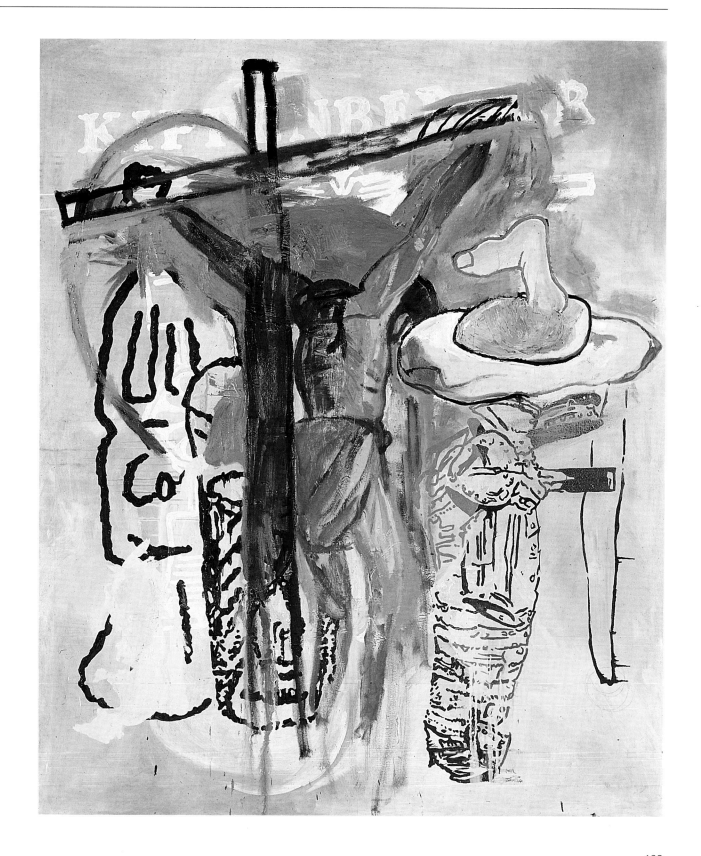

IMI KNOEBEL

olf Knoebel, born in Dessau in 1940, studied under Joseph Beuys from 1964 to 1971 at the Staatliche Kunstakademie, Düsseldorf. He has become better known as Imi Knoebel since 1968, when in Copenhagen he first exhibited his works together with his partner Rainer Giese under the title *IMI + IMI (= Ich mit ihm/I with him)*.

Exemplary, we might recall some of his most prominent works which clearly reflect his understanding of art.

For the forty minutes long, black and white video *Projection X* (1971/72), Knoebel fixed a video camera and a slide projector on to the roof of a truck. The only slide he used showed an X-shape cut out at the slide's centre. The video then tells of the ride through the city of Darmstadt at night, showing only the X-projections on house facades and other objects, as well as the street lights and neon signs. Later on, Knoebel extended this method for exhibitions. He coloured slides with a small brush and tinting colour which were then projected on to the white walls of galleries and museums. Through the projection, the parts of the slide which were not covered with paint became visible. This undoubtedly opposes our general experience of looking *at* the paintings hung on walls.

Between 1970 and 1975, Knoebel also created *250.000 A4* drawings which depicted the systematic alteration of two lines. During the exhibition, they were hidden in six huge cabinets, to be opened only on individual request. This naturally caused trouble since people expect an exhibition to show art which is easily accessible and not locked away.

Since 1967, Knoebel has also constructed minimalistic sculptures made of hardboard or chipboard, as for example *Papa look at the mountain* from 1987. Pieces are put next, into or on top of each other, are arranged to form cubes, are hung on to walls and windows or laid on the floor. Some of these boards are used as painting surfaces and Knoebel covers them with runny, dripping paint applied with a broad brush. In this way, they become simultaneously painting and object. Occasionally, multiple elements are used together for installations such as *Raum 19* or the *Genter*

View of the exhibition at the Rijksmuseum Kröller-Müller, Otterlo,
from left: *Kadmiumrot RR / Cadmium red RR*, 1975/85; *Weißes Kreuz / White Cross*, 1970; *Schwarzes Kreuz / Black Cross*, 1968,
Photograph: Nic Tenwiggenhorn
Courtesy Carmen and Imi Knoebel

Raum or diverse materials are arranged in assemblages as for the work *Sachsen I* (1981).

Knoebel's radical reduction of his artistic means and his specific interest in the interaction of space, carrier material and colour also becomes manifest in his paintings. *Schwarzes Kreuz/Black Cross* from 1968 and *Weißes Kreuz/White Cross* from 1970 are two examples of his early monochrome puristic paintings in black or white, which at times recall the works of the Russian painter Kasimir Malewitch.

Like his drawings and sculptural works, Imi Knoebel's paintings emanate an intensive presence, an impenetrable silence, which leaves the viewers completely to themselves. Undoubtedly, his works are diametrically opposed to any realist or neo-expressionist painting since no figure, no object offers a clue for orientation. Instead, faced with these artworks, we have to reflect on questions about the perception of forms, planes and colours in space and to analyse the ways we generally use to find meaning.

Papa look at the mountain, 1987,
315 x 412 x 120 cm,
Photograph: Nic Tenwiggenhorn
Courtesy Carmen and Imi Knoebel

View of the exhibition at the Rijksmuseum Kröller-Müller, Otterlo: *Richard die Erste* and *Die Endliche*
Photograph: Nic Tenwiggenhorn
Courtesy Carmen and Imi Knoebel

BERND KOBERLING

Bernd Koberling, born in Berlin in 1938, studied at the Hochschule für Bildende Künste, Berlin, between 1958 and 1960. He has held a professorship at the Hochschule für Bildende Künste in Hamburg and, since 1988, in Berlin. He lives and works in Berlin and in Iceland during the summer.

Since the 1960s, Koberling, who approaches nature from the outside, from the city, has been impressed by the closed-system nature offers, by the individual elements which all compound to a unified whole. The northern landscape in particular, with its environment not yet conquered, constrained and destroyed by human forces, has had a distinctive effect on his art.

Early works from the 1960s, like the *Hüttenbilder/Hut Paintings* or *Der Angler/The Angler* from 1963, still depict nature in relation to the human being. These paintings offer the viewer a frontal position, for example a look through a window, as in the *Hüttenbild* from 1964, a gaze onto a landscape, shaped by a darker and a lighter trapezoid form placed horizontally on top of each other, separated only by a white wiggly line suggesting clouds. Human habitation is indicated by cups and glasses at the foreground of the painting.

In the 1970s, Koberling starts to free himself from a descriptive depiction of reality, begins to abolish the references to the horizon as well as to the human being, and directs his view to such details as flowers, blossoms, buds, seed capsules or stones. Now, the formerly detached position of the artist and of the viewer has shifted to being 'inside' nature.

Since the mid 1980s, Koberling's work has progressed towards less and less unmistakable and unambiguous depictions. In these paintings, proportions and relationships are no longer determinable and the delineated objects are no longer decisively interpretable.

Without knowing its title, the painting shown here, appears rather abstract, a black surface, covered with blue dots and short yellow-orange lines and zigzags. And even when reading its name, *Blaubeeren IV/Bilberries IV*, the work closes itself to a total comprehensibility, retards recognition of the place possibly depicted. Similarly,

Blaubeeren IV / Bilberries IV, 1991,
Oil on canvas, 225 x 210 cm,
Courtesy Galerie Fahnemann, Berlin

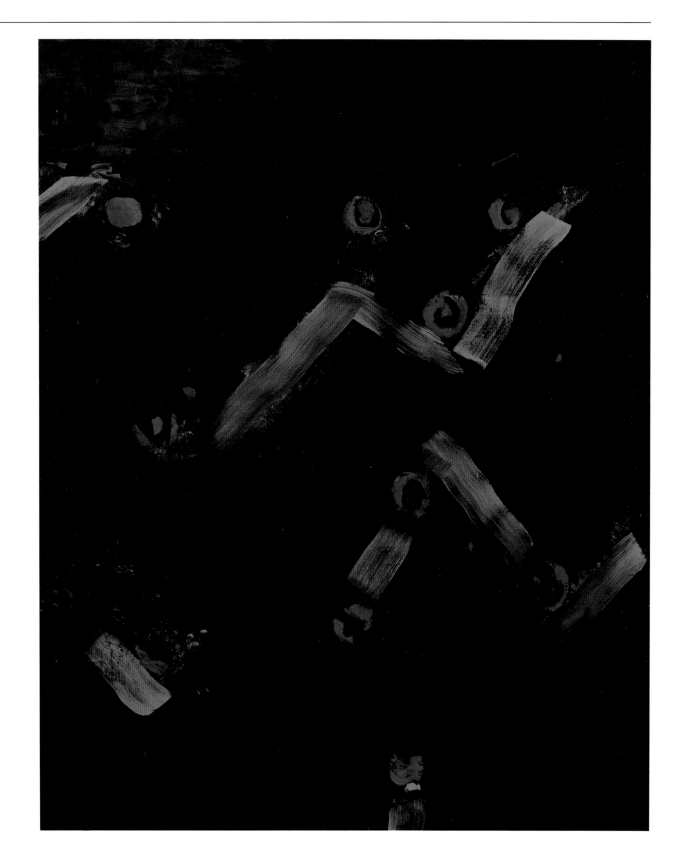

any other associations or direct designations, whether we think of lights in the dark or a microscopic view of bacteria, never matches the painting exactly and therefore has to be revised or rejected. Perception and interpretation seem difficult and subject to change, since Koberling places the viewer in an uncertain location (are we looking on a painted ground from above … ?) in relation to an uncertain landscape (… which is meant to be the soil, the earth on which the bilberries grow?)

Koberling, who is familiar with the subjects he paints, who discovered and has studied them, succeeds in producing paintings with multiple layers of meaning by avoiding any naturalistic depiction, any imitation of nature. On the other hand, he achieves the transposition of the constant flow and metamorphosis of nature into artworks which feature an analogous continuity and change.

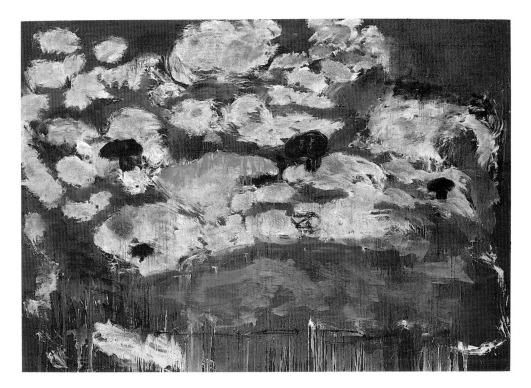

Schwarze Pilze / Black Mushrooms, 1990,
Oil on canvas, 225 x 325 cm,
Courtesy Galerie Fahnemann, Berlin

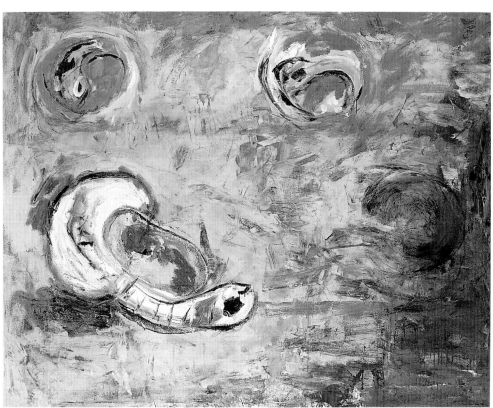

Laichen II / Alevin II, 1988,
Oil on canvas, 210 x 270 cm,
Courtesy Galerie Fahnemann, Berlin

THOMAS LANGE

Thomas Lange, born in Berlin in 1957, studied under Wolfgang Petrick and Herbert Kauffmann at the Hochschule der Künste, Berlin. The painting shown here, *Untitled (1964)*, 1991, belongs to a group of works titled *Erinnerung und Fiktion/Memories and Fiction*, from 1990/1991.

Already earlier works, like *Vater und Sohn/Father and Son* (1983), the group of self-portraits title *Ich/I* (1986) and the large formatted coal drawings *Verkehrte Spiegelbilder/Reversed Mirror Images* (1987) reflect the leitmotifs of Lange's art: existential experiences, self-reflection, and remembrance.

In the series *Memories and Fiction*, memories, associations and consciousness are fused with and connected through fiction because 'There is no realistic memory, there is always only a fictitious self-depiction, a desired ideal, what I was, what I am and what will be. This is memory and this memory is, for me, always a fiction.' (Thomas Lange, in: exh. cat. Thomas Lange. *Erinnerung und Fiktion*, Kunstverein Mannheim, 1991, p. 7.)

Untitled (1964) is based on a photograph of Lange's first day at school in 1964. The scene is blurred, most of the figures are hardly discernible. Only details like heads and hands are visible. In the background a tall figure is added, possibly the teacher, in contrast to the photograph. The artist's memory of this day seems traumatic because the event is flooded with infernal red and ominous black paint. Standing to the right of the painting, a pose taken from a photograph from 1982, the artist himself as painter is present, made detectable, as in other works, through a nimbus.

In 1990, Lange had already created an independent series of 34 drawings — one drawing for each year of his life — works which were also based on old photographs as well as on his memories of the past, of his experiences, of his fears and longings, of his isolation and sexual obsessions, of joyful times and security. Even the material employed for the drawings refers to the past: a yellow distemper grounding simulates the process of aging, fringed edges recall old photographs and a lively surface structure achieved by a mixed media technique indicates the ups and downs in the artist's life.

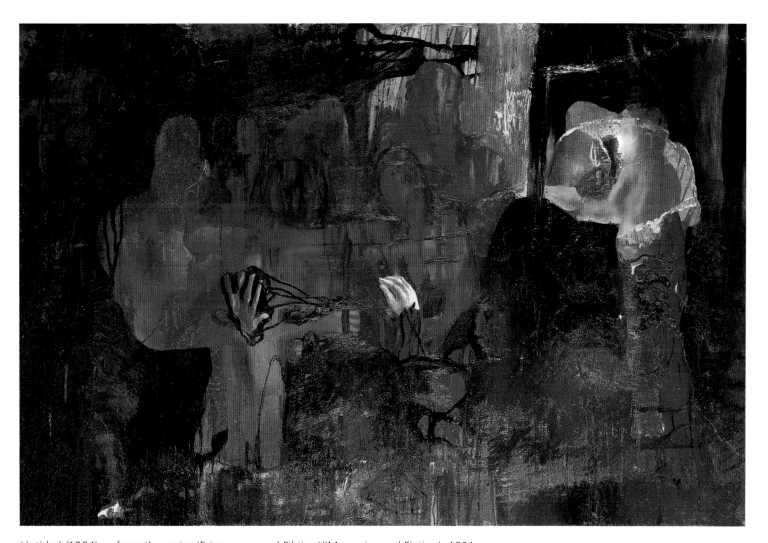

Untitled (1964) — from the series 'Erinnerung und Fiktion'/'Memories and Fiction', 1991,
Oil on canvas, 200 x 300 cm,
Collection Heinrich
Courtesy the artist

Nevertheless, Lange does not intend to autobiographically or journalistically recall his vita. Instead, he is experimentally releasing memories — before he had tried psychoanalysis and hypnosis — recalling events and experiences of his life which also allow the viewer to recall his or her own past since many private aspects are concealed on purpose.

For this reason, Lange's art can not be characterised as artistic exhibitionism. Instead, his works are poetic and vivid images of the human existence in general, the human and animal constituent in all of us becomes visible.

Untitled (1970) — from the series *Erinnerung and Fiktion/Memories and Fiction*, drawings, 1990, Mixed media on paper, 42 x 60 cm Courtesy the artist

Untitled (1969) — from the series *Erinnerung and Fiktion/Memories and Fiction*, drawings, 1990,
Mixed media on paper, 42 x 60 cm
Courtesy the artist

WALTER LIBUDA

Walter Libuda was born in Zechau-Leesen in 1950. From 1965 to 1968 he trained as painter and varnisher in Altenburg where from 1968 to 1971 he continued to work as painter for the national theatre. In 1973 after his military service, Libuda returned to Altenburg for several months. There, he was attracted to the early Italian panel paintings in the collection of the Staatliche Lindenau-Museum. He then began his studies at the Hochschule für Graphik und Buchkunst in Leipzig in the course of which he became master-class student under Bernhard Heisig. However, the works of Beckmann, Kokoschka and Picasso in particular influenced Libuda more than Heisig's method of pre-planning artworks.

Being interested in the material substance of paint, Libuda creates thickly coated impasto reliefs and gives the works texture and rhythm through the tracks and traces he draws with the brush into the wet paint. Since the late 1980s, he also uses spatulas which allow for even more expansion of the colour areas, and also intensifies their radiance. Libuda's pictures therefore, being cast through paint, are primarily landscapes of colours and forms which directly attack the senses of the viewer by their celebration of colours.

Rather than painting to depict 'something', through the working process 'something' becomes visible. The motifs of his works are especially human figures, but also animals and all kinds of objects. These are amalgamated with bizarre and mystical tales, difficult to decode, since the paintings never hold what their titles promise: *The Knife* (1989/1991) is not discernible, *The Garden V.* (1990) is more like a dark cave than a playground, *The Shore* (1990) dissolves in a sea of colour and *Job* (1991) is more dominated by an fiery red coating than by a particular distinguishable figure.

Analogously, the title of the painting *Block und Spange* (1991), shown here, which translates *Block and Clasp* (or does he mean hair-slide or bracelet?) does not offer any clue for reading the painting since neither a distinctive block nor a characteristic clasp is depicted. Yet, the concrete, explicit title draws the viewer towards the work desperately seeking to discover and identify the named objects.

Block und Spange / Block and Clasp, 1991,
Oil on canvas, 160 x 151 cm,
Photograph: Bernd Kuhnert, Berlin
Courtesy the artist

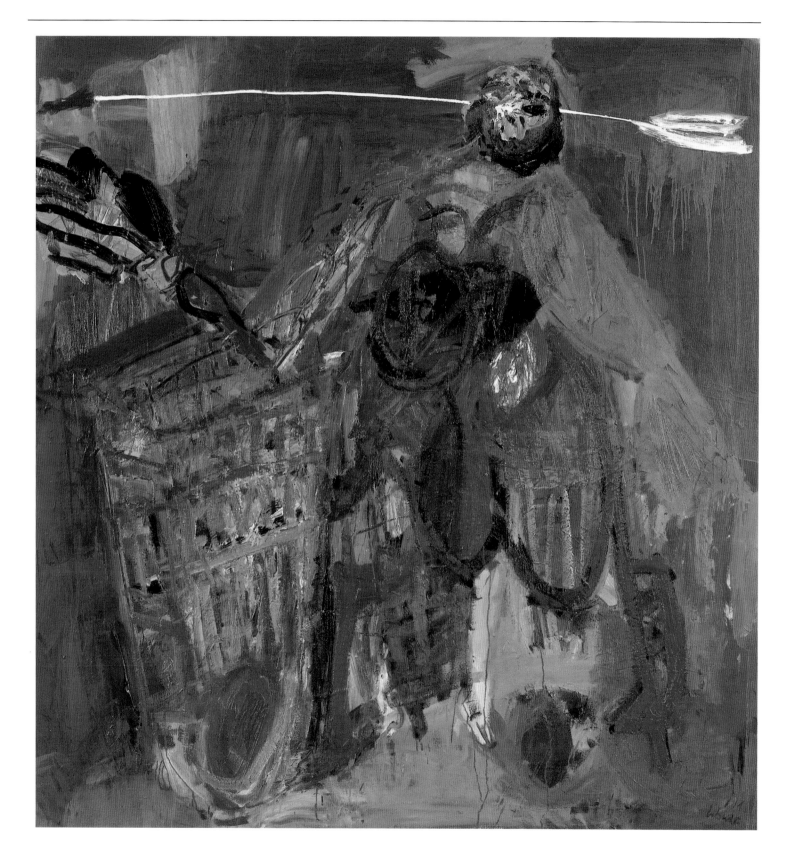

The title functions, too, as the starting point for associations, for the construction of a narrative around its meaning. The work, however, stays somehow inaccessible, isolating the viewer, who might feel frustrated and alienated.

Yet, exactly this feeling is the source for the painting itself. Libuda insists that all of his works derive from existential experiences. Not being interested in the depiction of concrete reality, his works never reflect social conditions or political systems *per se*. Instead, his encounters with isolation and security, depression and excitement, visible and invisible barriers between people, violence and tenderness, loss and death are internalised in his depictions. But rather than conveying an individual dilemma, his paintings exemplify human destiny in general, recognisable for the viewer who can partly relive it.

Girlande / Festoon, 1991,
Oil on canvas, 191 x 151 cm,
Photograph: Bernd Kuhnert, Berlin
Courtesy the artist

Das Kleine Bügeleisen / The Little Iron, 1990,
Oil on canvas, 124 x 97 cm,
Photograph: Bernd Kuhnert, Berlin
Courtesy the artist

JULIA LOHMANN

In Julia Lohmann's *Asrael, Engel will nicht töten /Asrael, Angel does not want to kill* from 1989, the black paint seems to gyrate through the work like a whirlwind and greys like rain clouds conceal the light-coloured zones of the painting. Black and white, grey and yellow fight and pulsate, are in a constant rhythmical dialogue, are captured in a continuous, passionate and trembling flow. Drawn into this expressively painted, spatial work, viewers might suddenly feel they've been caught in a thunderstorm in a desert region.

Lohmann's pictures have not always been non-objective. Although already situated in between abstract colour areas, her paintings, especially until the mid 1980s, still showed objects or silhouettes of figures and heads. Always, however, her works have been infused with a lyrical vitality. *Asrael, Engel will nicht töten*, in particular, also emanates both the transparency and density, the light, permeable and the dense dark zones characteristic of her works. As well, it paradigmatically reflects Lohmann's painting practice.

Most frequently, the artist paints on aluminium. The gleaming aluminium plates are sealed and afterwards coated with a linseed oil grounding. The actual work is then executed with metallic lacquers, oil-based chalks and paint, with fine and thick brushes, with spatulas, rollers or the fingers and ball of the hand. In this way, the surface is cloaked with broad or narrow tracks and traces, small spots, thin trickles of running paint or large colour zones.

Always the viewer is allowed to perceive how the painting has developed, is able to recognise the dynamic paint application — mostly from the outside towards the centre of the work — and to observe the layers of paint placed on top of each other.

More recently, Lohmann has begun to either integrate x-ray photographs into her aluminium works or to utilise them independently, a process during which the mythical energy of her painting is fused with the technical rationality of the photographs. The artist, who has never framed her paintings, also has begun to take them off the wall and to create three dimensional works with both the aluminium plates (since 1987) and the coloured x-ray photographs. This development, however,

Asrael, Engel will nicht töten / Asrael, angel does not want to kill, 1989,
Tempera and oil on anodized aluminium, 200 x 300 cm,
Photograph: Silke Hermerdig
Courtesy the artist

seems only too natural for somebody who has, like Lohmann, always been interested in spatial works as, for example, her *Sketches for Rooms* (1983/84), her screens (1985), or her sculpture *Two dissimilars — one arch* (1989) show.

Julia Lohmann, who was born in Dorsten in 1951, studied under Joseph Beuys and Erwin Heerich at the Staatliche Kunstakademie, Düsseldorf, between 1972 and 1978. In 1984, together with her friends Marcel Hardung, Hilmar Boehle and Robert Knuth she founded the fictitious 'Paul Pozozza Museum' and co-edited the 'museum's' newspaper *P.P.M.* Lohmann has received scholarships from the state North Rhine-Westphalia (1985) and the City of Düsseldorf (1985), from the Foundation Skulpturenpark Seestern, Düsseldorf (1988), and the City of Siegen (1989). In 1989/90, Lohmann lectured at the Staatlichen Kunstakademie in Düsseldorf where she lives and works as an independent artist.

Erfüllung der Romantik III/Fulfilling of Romanticism III, 1991,
Oil, aluminium, x-rays,
67 x 70 x 45 cm,
Photograph: Conny Engber
Courtesy the artist

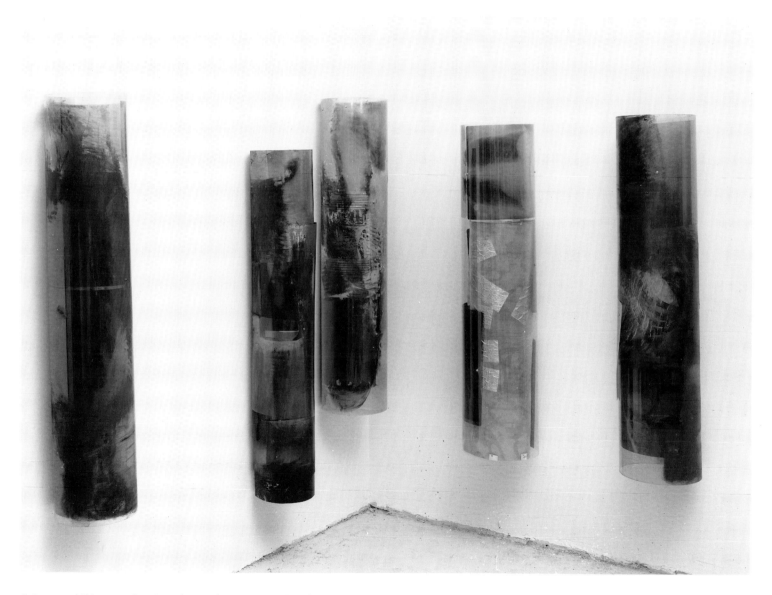

5 Reagenzbilder aus der IG-Farbenmalerei/5 test tubes from IG-Farbenmalerei, 1990,
Oil, paper, x-rays, guttagliss, aluminium, each approx. 125 x 30 cm,
Photograph: Conny Engber, Courtesy the artist

MARKUS LÜPERTZ

The painter and sculptor Markus Lüpertz, born in 1941 in Liberec, Bohemia, belongs to a group of artists who are not only regarded as the founding fathers of the so-called Neo-expressionism but who have also, in combination with an exaggerated self-assessment, fiercely propagate the idea of a *l'art pour l'art*.

By the early 1960s, amidst minimalism and fluxus, Lüpertz had already developed an, until then, unknown object. In 1964 he invented what would become one of his trademarks: the 'dithyrambe', only inadequately describable as a truncated pyramid with two volutes. Initially, Lüpertz utilised the 'dithyrambe', which is neither abstract nor representational, neither real nor surreal, as an emblem for an artistic approach, compatible to his enthusiastic feeling for life, as a vehicle for his self-realisation. Later on, the 'dithyrambe' became more and more a devise which allowed him to paint without having to paint something in particular and so was able to paint anything, *l'art pour l'art*.

Between 1966 and 1971, Lüpertz, who thinks of himself as an abstract painter, fused the dithyrambic form with traditional subjects. These are characterised by simplicity as well as by provocative irrelevance like asparagus fields, corrugated iron or cut-off trunks.

In the early 1970s, Lüpertz then selected, more by chance as he once said, objects which directly refer to German history. While the chosen forms lose their emblematic character through a process of abstraction, nevertheless steel helmets, uniforms and military caps, spades and the ears of corn, are symbols of the Third Reich. Yet, associations are, even if possible, only secondary to Lüpertz. He disagrees that the aim of art is the thematic interpretation of anything whether literary or political. 'I don't paint for the world, I don't paint for my neighbour, I paint because painting is my profession and to make painting happen', he once said in an interview with Werner Krüger in 1982. Consequently, he, who has always been more impressed by formal problems than subject matter, broke away from the German motifs in 1975.

Since then, Lüpertz concentrates on 'style-painting', creates works which distinctively contrast the earlier images. For his 'style-paintings', the artist adopts and

10 Bilder über das mykenische Lächeln: Euridice / 10 Paintings on the Mycenaean Smile: Euridice, 1985, Oil on canvas, 162 x 130 cm, Courtesy Galerie Michael Werner, Cologne

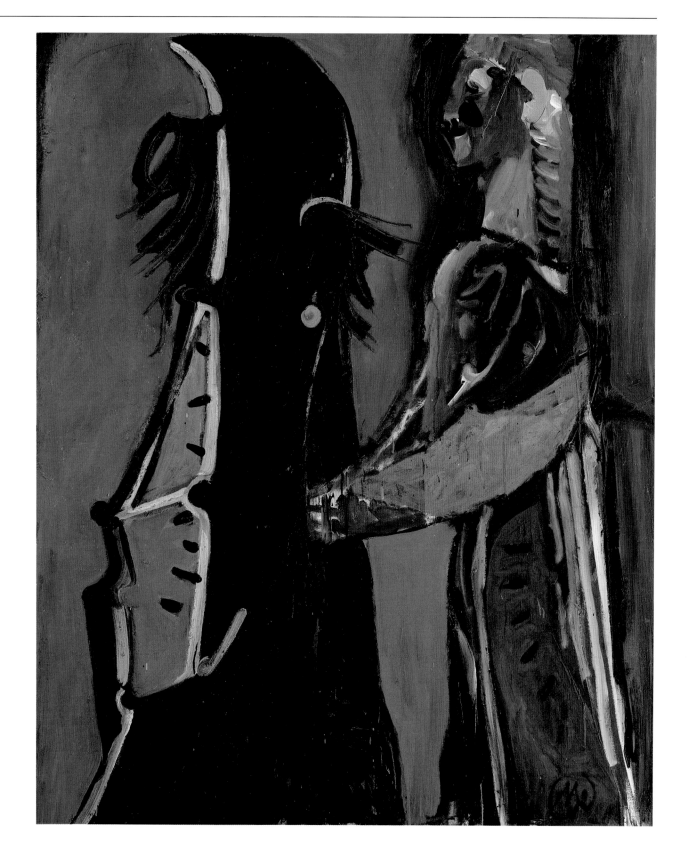

amalgamates stylistic fragments as well as representational and non-objective figurative elements mainly from constructivism, cubism and informel. Notable, for example, is the series *Pierrot Lunaire* and the group of 'Harlequin' paintings, which he created in 1984. They directly reflect his concern with art historical motifs and models, specifically with the works of Picasso. In the late 1980s, Lüpertz also utilised themes and subjects from paintings by Corot, Courbet and Poussin.

Euridice, by contrast, belongs to the series *Ten Paintings on the Mycenaean Smile* from 1985, in which Lüpertz is concerned with images from classical antiquity, partly taking as motifs Greek sculptures from the maturing archaic period. All ten paintings are of relatively small format and were created parallel to the series *Five Paintings on the Mycenaean Smile* (1985). The latter are of monumental size (270 x 400 cm). In all these works, the figurative elements allow for associations, yet not for a decisive interpretation. Here, the mysterious Myceanaen Smile is complemented with works of equally mysterious quality. Simultaneously, these pictures in particular can be understood as some of the best examples of Lüpertz' *l'art pour l'art* approach and as a metaphor for the enigmatic character of painting *per se*.

Frühling (nach Poussin) / Spring (after Poussin), 1989,
Oil on canvas + 10 cm lead frame,
162 x 130 cm,
Photograph: Lothar Schnepf, Cologne
Courtesy Galerie Michael Werner, Cologne

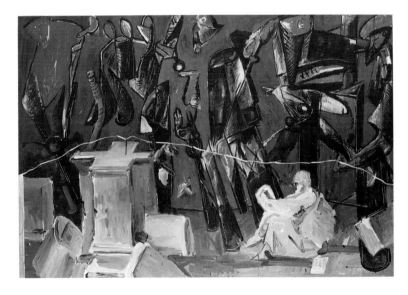

Poussin — Philosoph / Poussin — Philosopher, 1990,
Oil on canvas, 200 x 300 cm,
Courtesy Galerie Michael Werner, Cologne

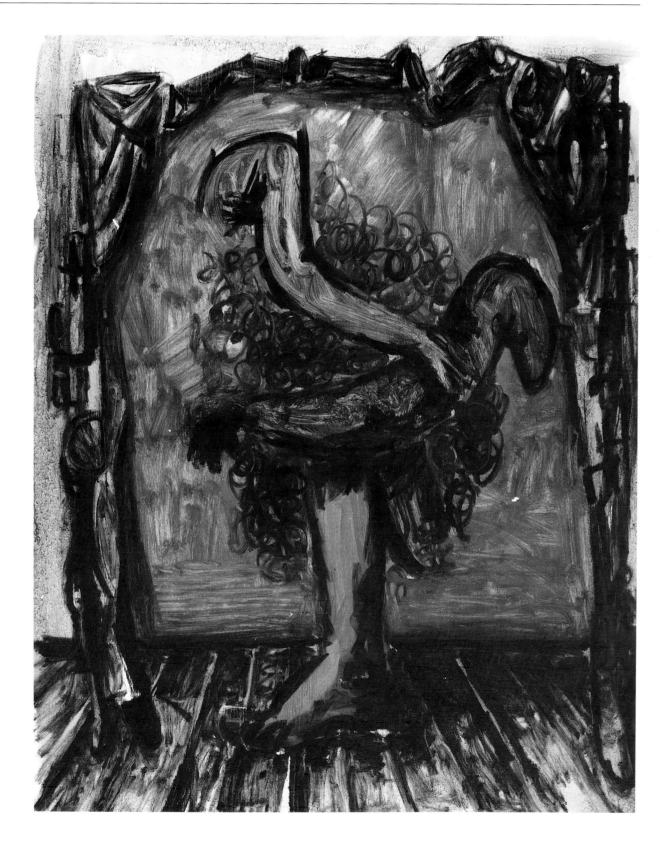

HELMUT MIDDENDORF

Helmut Middendorf, who lives and works in Berlin, was born in Dinklage in 1953. He studied painting under K.H. Hödicke at the Hochschule der Künste, Berlin, between 1971 and 1979. In 1977, he was one of the co-founders of the Galerie am Moritzplatz. Middendorf has taught experimental film at the art school in Berlin and in 1980 he was awarded a DAAD scholarship to live in New York. Like Rainer Fetting, Salóme, Bernd Zimmer and Luciano Castelli, for example, he belongs to the group of artists in Berlin, which became known in the early 1980s for its neo-expressionist painting style.

While Middendorf's paintings of the mid 1970s are still characterised by depictions of hard-edge, geometrically orientated figures, the works of the late 1970s already indicate the style for which he has become internationally acknowledged: expressive and uncomplicated paintings, which, carried by euphoria and bursting of vitality, directly and effectively address the viewers.

Middendorf, who recognises the art historical sources for his works — Kirchner and the German expressionists as well as Matisse and Picasso, whose *Demoiselles d'Avignon* he admires a lot — in contrast to them, often works with dispersion or acrylic paint, which considerably increases the speed of the brush-work.

The subjects of his paintings — 'Without a topic, I can't paint', he once stated — can normally be traced back to the city life, to Berlin, then an island, which never went to sleep. And it is this night life, the night atmosphere, the interaction of the individual and its social environment, which is the central theme of Middendorf's works and which he has investigated in multiple series of paintings.

Most of his pictorial motifs — guitars and drums, huge paint-brushes and aeroplanes, singers and dancing people, tram bridges and blocks of houses — come out of the dark, of the black or dark blue paint surrounding them. *Embrace the Night* (or *Embraced by the Night*) is not only the title of a painting from 1983, but exactly describes this condition.

The work *Der Blaue Sänger/Blue Singer* from 1981, which Middendorf painted in several, slightly different variations, still carries the erratic feeling of the images of

Unter dem Schirm / Under the Umbrella, 1986,
Synthetic resin on canvas,
200 x 160 cm,
Photograph: Jochen Littkemann, Berlin
Courtesy the artist

that time. On the other hand, *Die Gläser in meinem Kopf/The Glasses in my Head*, created in the same year, already signals the shift Middendorf's works underwent in the mid 1980s. It pictures a figure, tiny, compared to the glasses and bottles around it, symbolic of the individual's feeling of loneliness in the big city and the taking of refuge in alcohol.

It is evident that the artist's works have become more gloomy, less expressive. Night atmosphere, however, still envelops the images as in *Unter dem Schirm/Under the Umbrella* from 1986. The work delineates a figure somewhere alone in the night, standing, as the title directly tells us, 'under the umbrella'. The centre of the picture experiences an illumination, comparable to film practice as well as to the paintings by Caravaggio. While Middendorf bathes the dress and the nearer surroundings of the figure in a fiery red, spots of yellow, orange and of blue paint, the match, lit by the figure in the painting, pretends to be the only cause of the light.

Again, the work is, as many of Middendorf's paintings have been up to date, symbolic of our present existence and reflective of the spirit of the time.

Die Gläser in meinem Kopf/The Glasses in my Head, 1981,
Dispersion and oil on coarse, 160 x 130 cm,
Collection Metzger at the Museum Folkwang, Essen
Courtesy the artist

Der blaue Sänger / Blue Singer, 1981,
Synthetic resin on canvas, 190 x 230 cm,
Courtesy the artist

MICHAEL MORGNER

Michael Morgner, born in 1942 in Dittersdorf near Chemnitz (formerly Karl-Marx-Stadt), studied at the Hochschule für Grafik und Buchkunst in Leipzig between 1961 and 1966. Since 1966, he has been living and working as an independent artist in Dittersdorf and later in Einsiedel.

Morgner's art is characterised by a continuous striving for iconographical and conceptual simplicity, while his sources of inspiration have been the rather plain Byzantine and Romanesque art works, medieval stained glass windows, Christian symbolism (in particular the Stations of the Cross), as well as the, mainly graphical, works by the French artist Georges Rouault.

In 1977, together with Carlfriedrich Claus, Thomas Ranft, Dagmar Ranft-Schinke and Gregor Torsten Schade (later Kozik), Morgner founded in Chemnitz the gallery 'Clara Mosch' (which existed for five years). To express themselves, the artists employed action painting, object art, and actions, and Morgner himself realised in 1981, for example, the happening and video film *M. überquert den See bei Gallenthin/M. Crosses the Lake at Gallenthin*. Generally, however, his media are the etching plate and the canvas.

Morgner's works have always reflected, in one way or the other, his particular interest in the way life can simultaneously restrict and activate human forces.

For example, in the late 1970s, he reduced his colours to black and white only and the shapes to simple geometric forms like the cross, the triangle and arrows. In the untitled work from 1977 (see p. 155), we can recognise two arrows which are placed on top of a fringed cross form. Pointing in opposite directions, they are abstract signs of movements, representative of active and passive, rest and motion. The (Greek) cross itself, a universal and archetypal symbol, also introduces oppositions which reach from heaven/earth to space/time and from microcosm/macrocosm to human being/universe.

During the same period, Morgner also began to develop and to combine the abstract signs with human figures, which became *the* distinctive feature of his work. These figures, often reduced to basic contours of the body, crouch, bend, fall down

Schreitender/One who Strides, 1990,
Washed ink, asphalt, embossing,
180 x 130 cm,
Courtesy Galerie Gunar Barthel, Berlin

or stride. *Schreitender/One who Strides* from 1990 best exemplifies Morgner's approach, portraying typical qualities of the figures. Always, the implied forward moves are restricted — here, the body is depicted without feet — and their individuality is eliminated — no gender specific features are visible (although the title implies that it is a male figure). In this way, they become symbolic for both advance and withdrawal, security and threat. The *Schreitender* is usually interpreted as a symbol of resistance (the upper body and head almost looks like a raised fist) and self-assertion. It is also reminiscent of Morgner's 'Ecce Homo' series, created in 1986, and his respect for the priest Dietrich Bonhoeffer, killed in a concentration camp during World War II.

During the last decades, Morgner has constantly reworked and developed further the essential framework of his conception, trying to find forms and expressions for human existence as coherent and essential as possible.

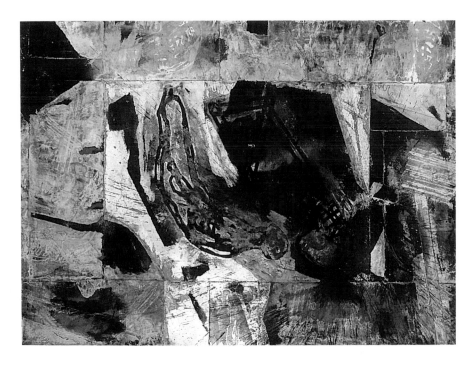

Mensch lauscht Tod, 1989,
Washed ink, asphalt, embossing, paper on canvas,
130 x 180 cm,
Courtesy Galerie Gunar Barthel, Berlin

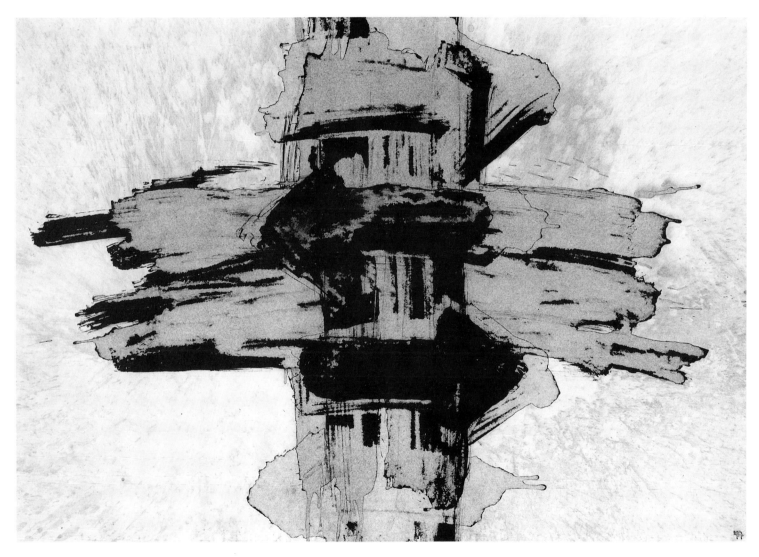

Ohne Titel/ Untitled, 1977,
Ink on paper, 43 x 60 cm,
Courtesy Galerie Gunar Barthel, Berlin

CHRISTA NÄHER

Continuing the heritage of mythological tales, recounted in literature and pictorial representations for centuries, Christa Näher has been surprising her viewers with quite bizarre and uncommon paintings, telling of the archetypical structures of humanity.

Born in Lindau in 1947, Näher studied at the Hochschule der Künste in Berlin from 1971 to 1980. Since 1987 she holds a professorship at the Städelschule in Frankfurt.

Although in their urge for categorisation, critics have often placed Näher's work in the context of the so-called New Figuration of the late 1970s, her oeuvre is incompatible with the large canvases painted in expressionist manner. There is nothing spontaneous nor anything expressive in her works. Nor are they based upon cool rationality and artistic purism. They do not deal with questions of personal self-interpretation, nor are they concerned with a psychological self-analysis. On the other hand, Näher's paintings still tell of the self, though in a different way. As she once said, 'What I paint is the present, now, something concrete, not historical or future situations' and 'When I paint pigs, I paint pigs. When I paint dogs, I paint dogs. When I paint horses, I paint something of myself.' (repr. in: exh. cat. *Christa Näher. Schacht*, Galerie der Stadt Stuttgart, 1991, p. 21 and p. 43.)

Näher's images, frequently in the outer form of a diptych or triptych, are either enigmatic and haunting, reflecting darkness and night, shadows and a foggy atmosphere, or bursting with colours, inflamed like a painting by William Turner. While the diptych *Raum III/Room III*, 1990, and the untitled painting from 1988 are representative of the former, the untitled painting from 1987 exemplifies the latter approach. They reflect tranquillity and anxiety, which are in constant dialogue, the two poles of Näher's work, which are simultaneously supplementary and contradictory.

Since 1987, Näher's themes revolve around the topics *Calvary*, *Hades* and *Three Skeletons of Horses*. Parallel to these, she has created paintings on a *Pair of Dancers* and the *Dance of Death*. Depictions of 'the beauty and the beast' speak of Eros and

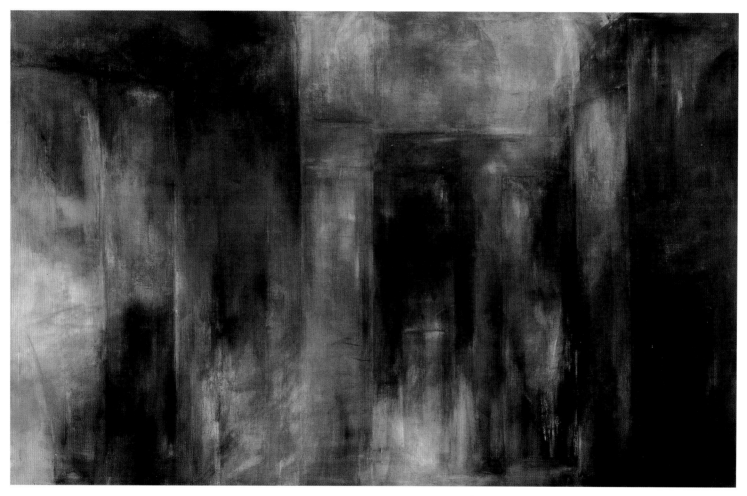

Raum III / Room III, 1990,
Oil on canvas, two-piece, total size 240 x 380 cm,
Courtesy Galerie Grässlin-Ehrhardt, Frankfurt am Main

Thanatos, passion and violence, while classical mythological tales, medieval and baroque thinking as well as the books by, for example, de Sade and Pasolini, constitute the background for many of her works.

Unrelenting and pitiless, the artist this way reveals, yet does not explain, the instincts which have determined human behaviour since the beginning of civilisation. At the same time, figures and objects are concealed under transparent layers of paint, resulting in images which are only discernible when stepping back.

Ohne Titel/ Untitled, 1987,
Oil on canvas, 60 x 50 cm,
Courtesy Galerie Grässlin-Ehrhardt,
Frankfurt am Main

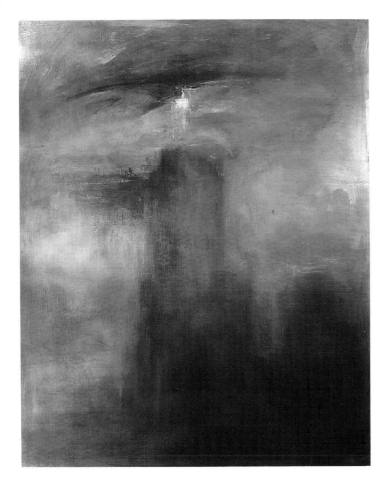

Ohne Titel/ Untitled, 1988,
Dispersion on paper, 105 x 80 cm,
Courtesy Galerie Grässlin-Ehrhardt, Frankfurt am Main

ALBERT OEHLEN

'Art has to be as ugly as the circumstances', Albert Oehlen once stated, announcing a crucial shift from a portrayal of the given situation (reality) through painting to an investigation into painting itself and into the prevailing aesthetic structures.

Born in Krefeld in 1954, Oehlen studied at the Hochschule für bildende Künste in Hamburg under Sigmar Polke and later under Claus Böhmler. In 1976, he founded, together with his friend Werner Büttner, the 'League to contest contradicting behaviour'.

Oehlen, who lives and works in Düsseldorf, has also produced catalogue texts together with Martin Kippenberger and Büttner, essays for which no simple explanation can be found. With regard to Oehlen's paintings of the 1980s, which are concerned with room/space and apartment/home, the text of the *Introduction to Thinking* is of particular interest. Here, it is held that 'truth lies in the apartment'. The largest apartment where truth can be found is the state, the second largest is the museum. Truth, thus, can be sought and found in the surroundings encountered daily as well as in art. A further aspect, Oehlen once pointed out, is that in the home, in the apartment, art and life come together, a 'nice' home is created by the pictures hung on the wall. Yet, by a continuous reinterpretation of the once said, the instability of 'truth' is at once exposed.

Oehlen, whose working method is characterised by spontaneity, draws his inspiration from whatever is offered by television and newspapers, magazines and advertisements, graffiti and industrially mass produced pictures. By presenting the viewers with paintings, badly painted on purpose, a sharpening of the consciousness is instilled, yet no room for interpretation is left. The works are simply there. Simultaneously, the kind of 'negative aesthetics', which are achieved in this way, also reveal the prevailing ideas about what is or is not aesthetic and attack the ivory tower of élitist art. It is therefore also understandable, that the artist thinks that paintings, painted badly by mistake, are wrong.

Oehlen, who considers painting an independent language which does not need

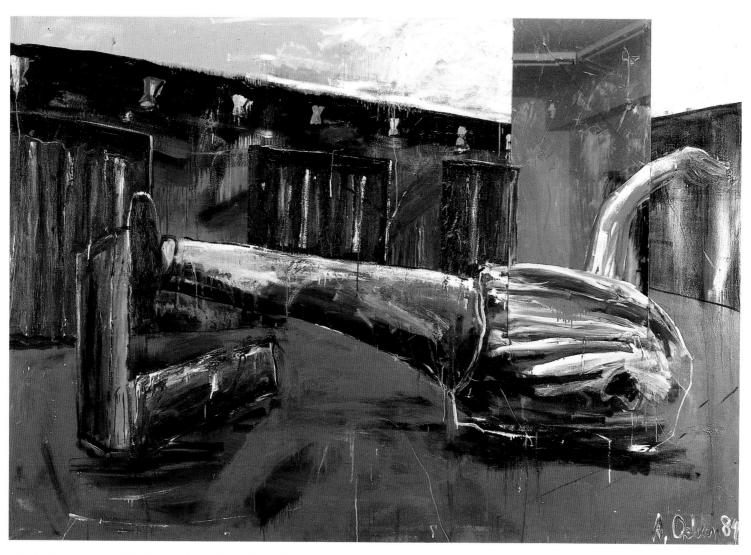

Abschaffung einer Militärdiktatur / Abolition of a Military Dictatorship, 1984,
Mirror, oil on canvas, 180 x 260 cm,
Courtesy Galerie Max Hetzler, Cologne

any written explanations, frequently incorporates words into his paintings. Rather than interpreting the imagery, they are supposed to infiltrate the viewer's visual cognisance: 'I try for example to force the concept "mess" …', depicted on the painting 'onto the observer. My goal is to see that he can't help having the word "mess" in his head.' (in: exh. cat. *Deutsche Kunst der späten 80er Jahre. Binationale*, J. Harten/D.A. Ross [eds], Cologne 1988)

Another device, Oehlen often employs in his works, is the mirror — either painted on, or as an object incorporated into the work as in *Abschaffung einer Militärdiktatur/Abolition of a Military Dictatorship* from 1984.

The paint, which contours the fragmented body on the red floor (which immediately recalls 'blood'), also partly covers the mirror. The existence of the viewer, who can recognise him or herself in this mirror, is confronted with the existence of the figure in the painting as well as with painting itself.

During the last years, Oehlen's works have become more and more abstract, depicting only segments of recognisable objects as, for example, the part of the nose and the pipette in *Fn 19* (1990), which contributes to their puzzling effect.

Ohne Titel/ Untitled, 1989,
Oil on canvas, 240 x 200 cm,
Courtesy Galerie Max Hetzler, Cologne

Fn 19, 1990,
Oil on canvas, 214 x 214 cm,
Courtesy Galerie Max Hetzler, Cologne

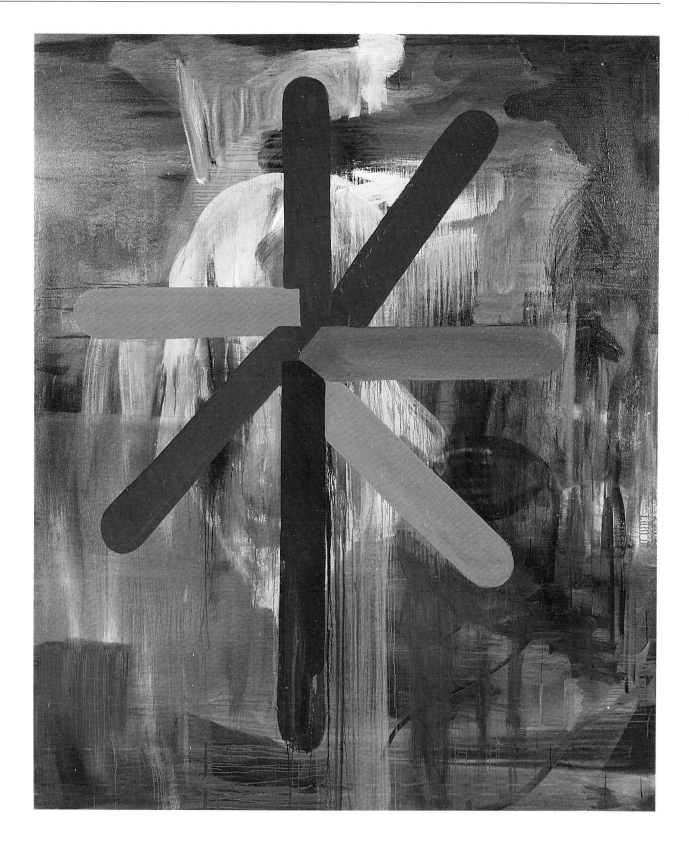

MARKUS OEHLEN

Markus Oehlen, the younger brother of Albert Oehlen, was born in Krefeld in 1956. He was trained in various crafts and in particular, has extensively studied printing techniques. As a painter, however, he is self-taught. Like Walter Dahn, Oehlen also is a gifted musician, who composes and plays several instruments. In 1987, the artist, who lives and works in Hamburg and Krefeld, received the Berlin Art Prize.

In contrast to many contemporary works, Oehlen's paintings are generally neither neo-expressionist nor completely abstract nor are they infused with the humour we find in his brother's works, for example. Although he has worked and exhibited several times with his brother, Werner Büttner and Martin Kippenberger, he does not really belong to this group of artists. Indeed, his very personal style, which combines conceptual calculation and spontaneity, by the 1980s had somehow put him into an outsider position.

In the art scene, Oehlen became known with photocopy-works. Using the unpretentious technique of photocopying, he was able to create pictures which were seemingly anonymous, yet still allowed for a subjective touch. In addition, these works already reflected his ongoing interest in an experimentation with trivial techniques and his continuous searching for new ways of expression as do the two groups of works which succeeded them, the paper-works and the batik paintings.

Examples for the latter group of works are *Atelierszene II/Studio Scene II* from 1981 and *Erst malen dann …/First paint, then …* from 1982. Both paintings are based on the motif of the painter and the model, a motif we find throughout European art. By employing the batik technique, Oehlen's intention is to contrast the so-called trivial (technique) and high art. Simultaneously, he combines them in a way which exposes the negative and positive prejudice usually stuck in our heads.

Stylistically, the two paintings appear clearly Picassoesque. Picasso also seems to have fathered the linear drawing of a woman who seems to sit in front of a mirror in the painting *Ohne Titel (Remake I)/Untitled (Remake I)*. While at the beginning of his career Oehlen drew his inspiration from newspaper and magazine images , later

Ohne Titel (Remake I)/Untitled (Remake I), 1988,
Oil on canvas, two-piece,
250 x 240 cm,
Courtesy the artist

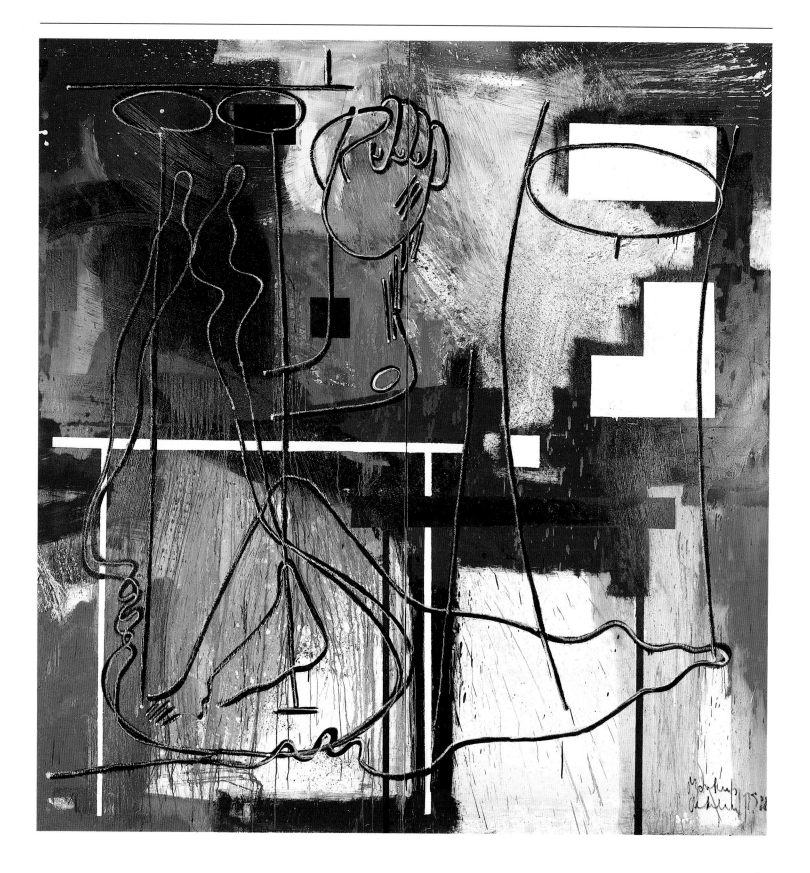

works, as the three shown here, were stimulated by reproductions in art books (rather than by original paintings). Looking at the background structure of *Untitled (Remake I)*, we also discover reminiscences of the abstract and of the expressive tradition. While the former becomes manifest in the white geometrical forms, the latter is recalled by the gesturally painted pink, russet, black, white and grey colour areas.

By amalgamating disparate artistic forms and styles in a slow process of calculated creation, Oehlen wishes to surprise us with always new combinations and images.

Atelierszene II / Studio Scene II, 1981,
Batik, 151 x 189 cm,
Courtesy the artist

Erst malen dann ... / First paint, then ..., 1982,
Batik on canvas, 200 x 294 cm,
Collection Thomas Gräßlin
Courtesy the artist

JÜRGEN PARTENHEIMER

The poetic and complex works of Jürgen Partenheimer constitute a significant contrast to the fashionable art tendencies of the 1980s. Partenheimer, born in Munich in 1947, completed in 1973 his MFA studies at the University of Arizona, Tucson, USA, and in 1976, he gained a PhD in art history, philosophy and history at the University of Munich. The artist has always been a world traveller. Between 1963 and 1968 he spent time in Italy, Greece, Asia, North Africa and North America, and was particularly impressed by the extent of the deserts and the contact with non-european cultures. Since 1979/1980 he has been teaching at various universities in Europe and the USA.

Being simultaneously philosopher and exploring scientist, Partenheimer is an artist who creates paintings and drawings which are of relatively small format. Their content as well as their formal structures can be understood as an investigation into always intangible and unresolvable opposites. These works draw the viewers attention directly towards them and make his or her perception a part of the artistic creation.

Formally, Partenheimer's paintings are based on linear, calligraphical elements which evolve neither from *écriture automatique* nor from intellectual construction. Unlike many paintings of recent years his are not the product of spontaneous emotions. He employs shapes, reminiscent of the square, the rectangle, the circle and the spiral. Yet, they are never identical with these or with each other. They never are simply geometrical nor descriptive of any reality. Instead, they are of rather fragmentary quality, reflecting that the incomplete (that is the fragment) is in fact incompletable.

In each of Partenheimer's works, layers of colours and forms mediate between abstraction and representation, chaos and order, openness and closure, achieving a precarious balance between infinity and finiteness. Confronted with them, the viewer has to choose the points of view, the connections and directions him or herself, has to fill in, add to and built upon the suggestive elements of the paintings.

'The ways of errors, the countless going round on isolated paths, takes him closer

Metaphorische Instrumente III / Metaphorical Instruments III, 1989, Oil, collage on canvas, 154 x 122 cm, Private collection, Switzerland
Photograph: Olaf Bergmann, Witten-Heven
Courtesy the artist

to the things he doesn't know about. The knowledge then leads to the space of imagination where it turns into a picture.' (Jürgen Partenheimer in: exh. cat. *Jürgen Partenheimer. Verwandlung — Heimkehr*, Nationalgalerie Berlin 1988, p. 14)

Partenheimer's aphorisms and prose texts are as poetic and lyrical as the paintings and drawings he creates. The drawings develop parallel to his paintings and are also of small, intimate format. Moreover, by being executed on paper they stress the artist's attraction to graphical techniques as well as his fondness of books.

The painting *Metaphorische Instrumente III / Metaphorical Instruments III* from 1989 is divided into three rectangular areas. The top part shows a club-like element placed between and behind countless black dots. The two rectangular colour fields at the bottom of the work are interconnected by letters. Every single letter of the alphabet is depicted. Linking them with a thought line, we receive a network. This motif of a labyrinth of (thought) paths continuously reappears in Partenheimer's pictorial and literary works.

The title of the painting, too, refers to a central theme in his oeuvre: the combination of pictorial ciphers and sounds has generally led to a location of his paintings, drawings and sculptures somewhere between seeing and hearing, between fine arts and music.

Hamburger Block, 1990.38,
Pencil, felt-pen, collage on paper, 31 x 23 cm,
Photograph: Olaf Bergmann, Witten-Heven
Courtesy the artist

Hamburger Block, 1990.40,
Pencil, felt-pen, on paper, 31 x 23 cm,
Photograph: Olaf Bergmann, Witten-Heven
Courtesy the artist

A.R. PENCK (RALF WINKLER)

The artist A.R. Penck became internationally acknowledged for his large canvases, filled with stick figures which exchange signals and information through symbols, letters and numbers.

Penck, who was born Ralf Winkler in pre-war Dresden in 1939, began to draw and paint as a young child, creating his first landscapes and portraits in oil at the age of ten. In 1956, Penck had his first exhibition in Dresden and met Georg Kern (Georg Baselitz). From 1956 onwards, he was also significantly inspired by the works of Picasso.

At the age of seventeen, Penck became an artist by, as he once said, 'self-appointment'. During the following year, he created the 'Rembrandt-Rekonstruktionen' and in 1961 after being preoccupied with making music for some years, he painted his first 'Systembilder'. In the same year he produced the 'Weltbilder'/'World Pictures' which are based on his concerns with politics, mathematics, cybernetics and theoretical physics.

Then, in 1964, Penck created the first 'Standart' paintings. Standart is based on the English stand and art, encompassing standard as well as to assert, status quo, class(-system), art and artificial. It is understood by Penck as a kind of conceptual art, embodying concept, plan, idea, and strategy.

In 1969, the year of his first exhibition in West Germany, the artist chose the pseudonym A.R. Penck after Albrecht Penck (1858–1945), a geologist and researcher of the ice age. The letter R stands for his own first name, Ralf. The name 'Penck' can be seen as a symbol of a concept concerned with information and a kind of chronological and archaeological excavation of art historical epochs. At the end of the 1960s, the East German artist, exhibiting in the West, also used it as camouflage. Other names, Penck chose for himself and for a series of paintings were Mike Hammer and TM, which meant Tancred Mitchell or Theodor Marx.

During the next decade, Penck published records and several books, created his first wooden sculptures, made films and music, had his first major retrospective at the Art Museum in Berne, Switzerland, took part in the documenta 5 and the

R-Problem 3, 1983,
Synthetic resin on canvas,
200 x 200 cm,
Courtesy Galerie Michael Werner,
Cologne

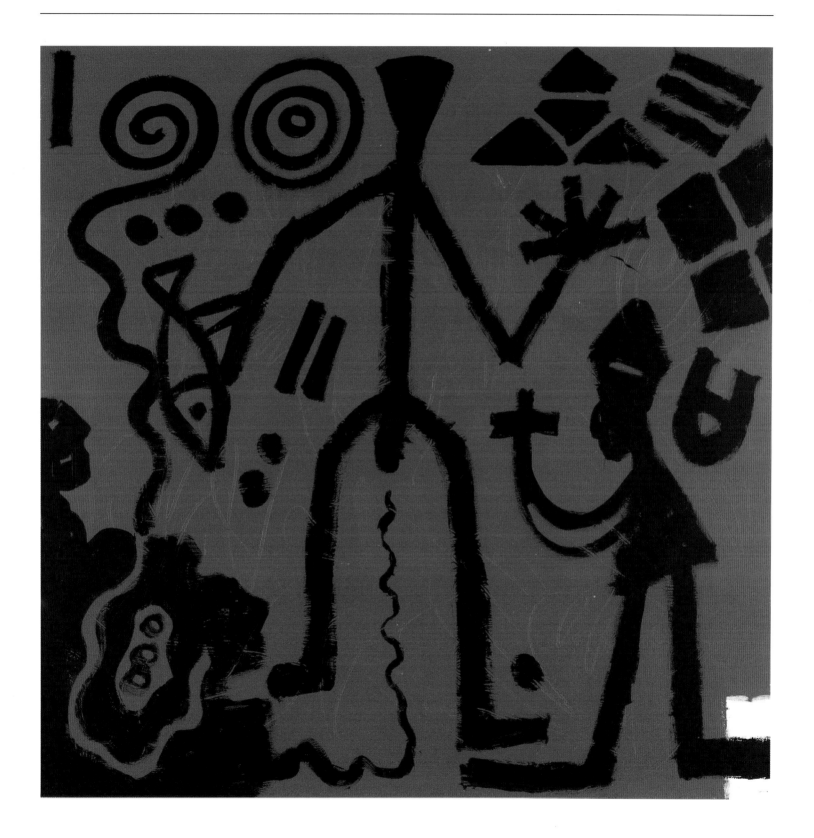

documenta 6 in Kassel and met Jörg Immendorff in East Berlin.

Then, in 1980, Penck moved to West Germany. As a signature, he began to use the letter combination a.Y., signifying a change of identity, the change from being an inhabitant of the GDR into being an inhabitant of the FRG. During the following year, Penck again started working on Standart paintings — Standart-West emerged. As before, Penck develops an independent pictorial language. The main motif of standart is the stick figure often seen from the front and placed at the central axis of the work as in *R-Problem 3* from 1983. Surrounded by a multi-layered system of signs and symbols, it is generally depicted with raised arms, implying both a self-assured 'Here I am' and a humble 'Here I am naked and defenceless'. (See Lucius Grisebach, in exh. cat. *A.R. Penck*, Berlin 1988, p. 79).

Since 1980, Penck's works have changed considerably. The canvases, for example, are often huge and they are clearly more colourful than before. Nevertheless, his concerns, concepts and principle, his fusion of an analytical approach with a vital way of painting, have always remained the same.

Der Golfkrieg / The Gulf War, 1991,
Oil on canvas, 300 x 500 cm,
Courtesy Galerie Michael Werner, Cologne

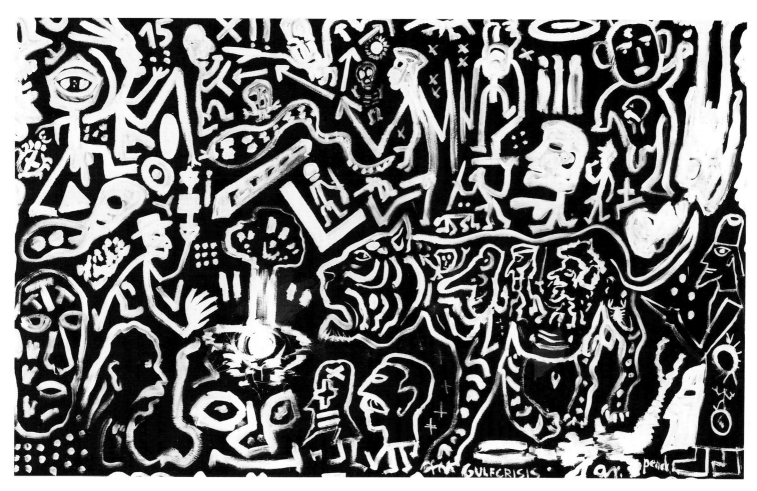

Die Golfkrise/The Gulf Crisis, 1991,
Oil on canvas, 300 x 500 cm,
Courtesy Galerie Michael Werner, Cologne

INGE PROKOT

'Encyclopaedic painting' is the term Inge Prokot chose for a series of copious paintings she started to work on in 1985. These paintings display and combine a wide selection of motifs and forms taken from the fine arts from all over the world and of shortened texts from all kinds of literary, religious, philosophical, historical and scientific sources.

Inge Prokot was born in 1933 in Cologne and studied art and design at the Werkkunstschulen in Cologne from 1949 to 1955. Initially, she was working as a sculptor and designer.

Since the late 1960s Prokot has been creating soft-sculptures, assemblages of diverse materials and montages of disparate objects. She became known particularly for her steles which combine the archaic material wood with vestiges of our throw-away society. Usually the steles were made of 1–2 m sized trunks wrapped, mantled, and coated with hemp ropes, furs, rubber plates, coarse, metal, roofing-felt or even jam. Others steles were supporting *objets trouvés* like phones, numberplates, daisy wheels, frying pans, bones and so on.

Then, in the early 1980s, Prokot began to nail irregularly onto the trunks brass, copper and aluminium plates, in contrasting colours. The metal was inscribed with primitive symbols or Shaman emblems respectively and afterwards the signs were filled with wax. Shamanism and old religions are a specific source of inspiration for Prokot, from the mid 1980s becoming manifest in the group of Shaman coats and the series of 'scroll paintings', each several meters long. Particularly the latter already showed the combination of painting and text (linear abbreviations of primitive symbols) which we again discover in the 'Encyclopaedic paintings'.

Principally, encyclopaedias attempt to offer a comprehensive and complete A to Z listing of data, facts, and information, an endeavour necessarily condemned to failure. Prokot obviously is aware of the problems and although her paintings try to make André Malraux's 'musée imaginaire' visible by depicting a wide selection of references and confronting figures and texts which have never before been connected — as, for example, in the work *Femme!* from 1992 — the excerpts are still

Femme!, 1992,
Mixed media, 200 x 135 cm,
Courtesy the artist

subjectively chosen parts of an entirety. Preferably, the pictorial elements are details from paintings by Picasso, Matisse and Klee but also from works by Jawlensky, Heckel, de Vlaminck, Dix and others. Often, the quotes are from texts by Hegel and Nietzsche, Arno Schmidt, Proust, Rilke, Baudelaire, Thomas Bernhard, Gottfried Benn, and in particular from the works of James Joyce, from *Ulysses* but even more from his *Finnegan's Wake*.

Prokot's paintings show a remarkable structural resemblance to *Finnegan's Wake*, since they are also based on an elaborate montage technique, leaving room for manifold and most diverse associations. Also this approach is supported by the material chosen, that is matt oil-paint, contrasting glossy lacquer and sparkling metallic spray-paint.

Once more, Prokot, who is an enthusiastic collector, proves with these works that she is able to synthesise her finds into something completely new.

Dadaserie in drei Bildern. Bild I / Dada Series of Three Paintings. Painting I, 1989,
Mixed media, 180 x 150 cm,
Courtesy the artist

Dadaserie in drei Bildern. Bild III / Dada Series of Three Paintings. Painting III, 1989,
Mixed media, 180 x 150 cm,
Courtesy the artist

BARBARA QUANDT

'Art is my weapon, my withdrawal, reflection, my going outwards, the security but also the new path', Barbara Quandt once said, 'It is my unity, my power, my life, my love, my philosophy. It is also a field for experimentation, a continuous self-testing, a process never finished.' (repr. in: exh. cat. *Barbara Quandt. Her-zeigen — Herz-zeigen*, Galerie Huber-Nissing, Frankfurt/M., 1990, p. 10)

Accordingly, Quandt has, for many years now, varied colours, techniques and styles in her work and created a diversity of paintings which are distinctly influenced by her personal experiences and, in particular, by her travels abroad. Appropriately, Jeff Abell once noted: '… the division between Quandt's art and the events of her life is thinner than the canvas on which she paints.'(in: exh. cat. *Barbara Quandt. In between*. Walter Bischoff Gallery, Chicago 1987, p. 5).

Barbara Quandt, born in Berlin in 1947, studied between 1970 and 1976 under Hans Kuhn and K.H. Hödicke at the Hochschule der bildenden Künste, Berlin. Only one year after her diploma, she received a DAAD grant which led her to London in 1978 and 1979, in a time when the punk movement was at its height. Being surrounded by wild music and fashion, she recognised for the first time her ties to Berlin and to German tradition. Back in Berlin, the female body, preferably with herself as model, became the main subject of her paintings and performances.

In 1982, Quandt went to New York on a grant with PS1. In her works of that period, she mixed personal impressions — the profound impact made on her by black and urban culture — with an overall conception of America. While the paintings depict individuals caught in restrictive interior spaces of the city, Quandt narrates her encounters with people and sites in short stories and puns. The latter were then collected in picture books, together with drawings, collages and photographs.

On her return, for a short while figuration disappeared from her works. In the series 'In between moons', for example, former realistic etchings with erotic depictions, a continuous thread in her work, were painted over with abstract elements.

Then, in 1986, her next journey took Quandt to Central Africa, to Tanzania. Confronted with a culture and society enormously different from her own, she seems

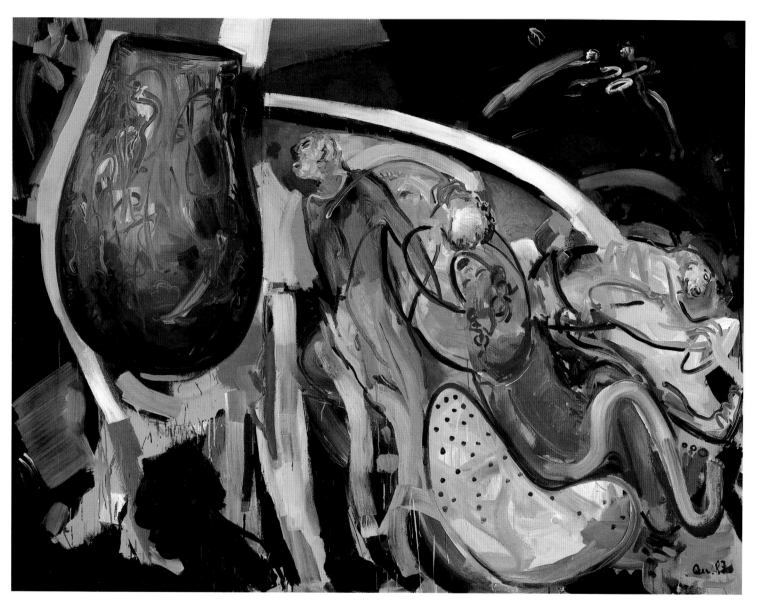

On the Road with Skip — Spitzer — Trayvis, 1987,
Acrylic on canvas, 170 x 224 cm,
Courtesy the artist

to wistfully plunge into this strange world. Her paintings, becoming again more direct and colourful, portray this interaction of strangeness and familiarity. They reflect, as she noted in her diary, that Tanzania is a country 'where language is not only coming through the lips, but where the body speaks, too.' (repr. in: ext. cat. *Barbara Quandt. Tam Tam*, Neuer Berliner Kunstverein, Berlin, 1989, n.p.) Here, it appears, she felt totally at home.

By contrast, *On the road with Skip — Spitzer — Trayvis*, and other paintings from around 1987, is based on a trip to Chicago financed through a scholarship awarded by the Berlin Senate. They still, however, seem to consolidate both Quandt's experience of the American lake district and that of Africa, since pictorial elements, reminiscent of both continents can be detected in almost every work.

In 1988, Quandt stayed in California. Like many artists, she, too, was inspired by the hot Californian sun, by the pools and the blue sky, filling her canvases with depictions in soft pinks, greens, reds, blues and yellows.

Surely, many trips and travels are still to take place and undoubtedly new paintings will emerge and indicate the new experiences again and again.

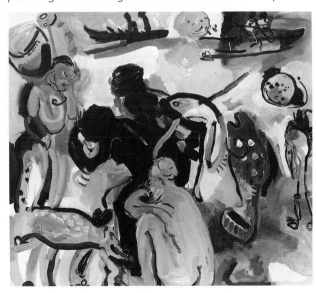

Am Fluß / At the River,
Acrylic on coarse, 170 x 190 cm,
Courtesy the artist

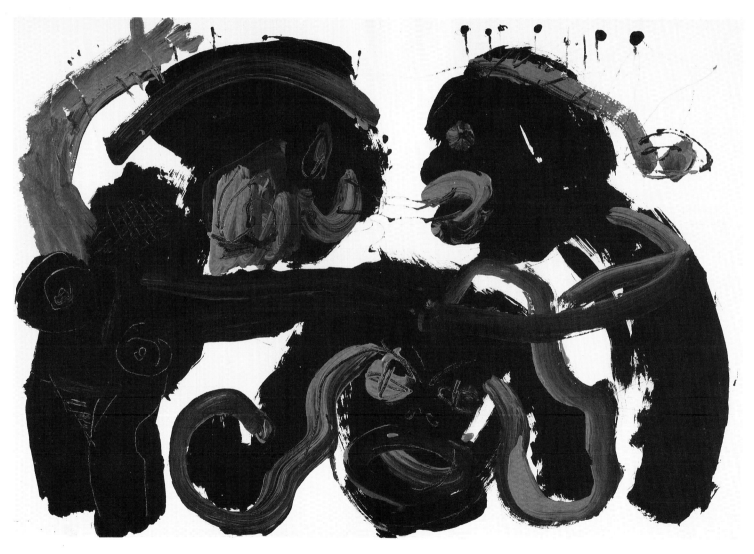

Ohne Titel/Untitled, 1988,
Dispersion on paper, 27 x 42 cm,
Courtesy the artist

GERHARD RICHTER

The works of Gerhard Richter, born in Dresden in 1932, do not fit into any single category. Since the early 1960s, Richter has continuously surprised his audience with new, completely different approaches, has perpetually explored the nature of painting, ironically rejecting the once found solutions and therefore creating the most disparate, heterogeneous works.

Hardly any other painter has shown a similar proficiency in the most diverse styles than Richter, who formulated as early as 1966 his basic attitude: 'I do not pursue any particular intentions, system, or direction. I do not have a programme, a style, a course to follow. I have brought not being interested in specialist problems, working themes, in variations towards mastery. I shy away from all restrictions, I do not know what I want, I am inconsistent, indifferent, passive; I like things that are indeterminate and boundless, and I like persistent uncertainty.' (repr. in: exh. cat. *Gerhard Richter*, Tate Gallery, London, 1991, p. 109)

Richter, who studied at the Kunstakademie, Dresden, between 1951 and 1956, moved to Düsseldorf in 1961, two months before the Berlin Wall was erected. At the Staatliche Kunstakademie, Düsseldorf, he continued his studies under K.O. Götz until 1963.

Already in the early 1960s, the artist had consciously begun to project pictures from newspapers and magazines on to the canvas. Towards the end of the decade, he started to base his paintings exclusively on his own photographs. Challenged by the visual perfection of the photographs, Richter found with them both a motif and a mute colour range for an unemotional painting.

In 1973, Richter's attempts to reduce the personal touch in his works unquestionably culminated in the monochrome *Grey Paintings* which take the paint application itself as their theme and which were 'the most complete ones, which I could imagine'.

For some years, the grey of these works became for him 'the welcome and only possible correspondence to indifference, opinionlessness, refusal to testify, amorphousness. [Yet,] After the grey pictures, after the dogma of a "fundamental

Gestell / Rack [580/3], 1985,
Oil on canvas, 260 x 200 cm,
Collection: Galerie Löhrl,
Mönchengladbach
Courtesy the artist

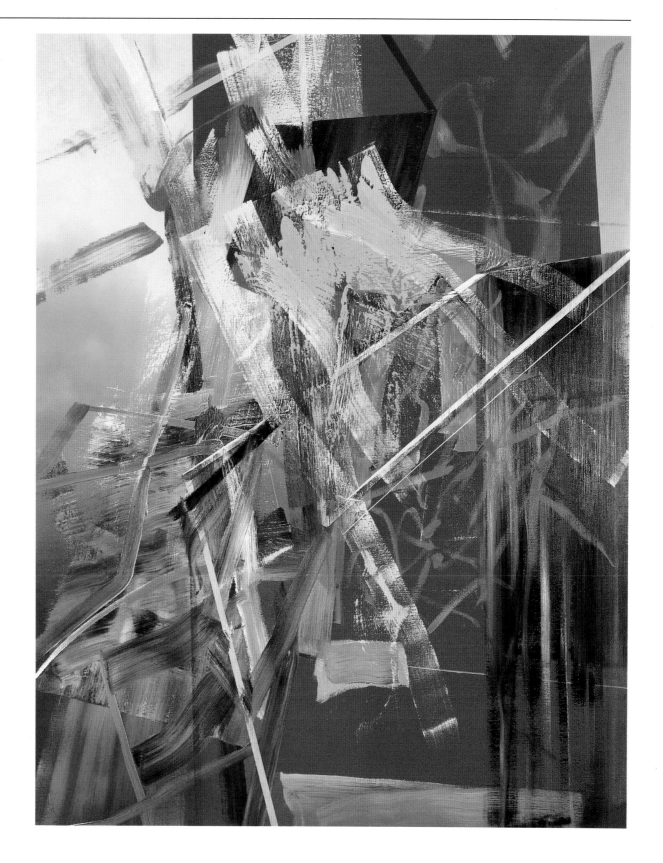

painting", whose puristic, moralising aspect fascinated me to the point of self-denial, there remained for me only a completely new beginning. In this way, the first colour sketches originated in uncertainty and straightforwardness under the premise "multicoloured and complicated", thus the counterpart of anti-painting and painting, which doubts its legitimacy.' (repr. in: exh. cat. *Gerhard Richter. Abstrakte Bilder 1976–1981*, Bielefeld/Mannheim 1982, p. 21)

Clearly, the so-called *Abstract Paintings*, which, since 1976 Richter developed from and parallel with the smaller sketches, diametrically oppose the previous monochrome grey works. They are colourful and bizarre, complex constructions, achieved by three different layers of paint application. While the first thin layer of still wet oil paint is imposed with a usually impasto layer of paint applied more spontaneously (sometimes rubbed with a wiper or a large spatula), the third layer is again a more decisive attack of the surface. This results in a homogeneous entity and idiosyncratic density which combines both a conscious and conceptual approach with a certain degree of spontaneity.

Grau / Grey [247/4], 1970,
Oil on canvas, 200 x 150 cm,
Collection: Städtisches Kunstmuseum, Bonn
Courtesy the artist

Wiesental [572/4], 1985,
Oil on canvas, 90 x 95 cm,
Collection: Sperone Westwater Gallery, New York
Courtesy the artist

HEIKE RUSCHMEYER

Since the 19th century, a significant change in our attitude towards death has taken place. For almost two thousand years, the fact that everybody will die in the end had been accepted and seen as a natural part of life. Today, people are afraid to die isolated from family and friends, are afraid of death, which is therefore continuously suppressed.

In the 1980s, the artist Heike Ruschmeyer presents us with paintings, which tell of death in such a way that which we cannot withdraw, cannot escape what we see, cannot avoid thinking about death, works which rather have to be *felt* than analysed rationally.

Heike Ruschmeyer was born in Uchte, Lower Saxony, in 1956. Between 1976 and 1979, she studied under Emil Cimiotti and Alfred Winter-Rust at the Hochschule der Bildenden Künste, Braunschweig. From 1979 to 1982 she was master-class student under Wolfgang Petrick at the Hochschule der Künste in Berlin. In 1983 Ruschmeyer received the Bernhard-Sprengel-Prize for Fine Arts and in 1985 a support scholarship for young students of the fine arts from the Hochschule der Künste, Berlin. She lives and works in Berlin as independent artist.

For several years, the starting-point for Ruschmeyer's paintings were photocopies taken of pictures from a forensic medical magazine, which showed the victims of rapes, murders, suicides, and other crimes. The artist transposed these austere images into large, at times huge, and impressive paintings. The sometimes still visible grid structure gives evidence of this procedure. Afterwards the canvases were covered with a gestural and expressive colourfulness, flowing and dripping paint which almost endows the corpses with a second life. Yet, their stiff postures, their entangled and alienated mortal remains, their strangled and slit-open bodies, reveal that they are dead, that they have lost their last battle.

Heike Ruschmeyer's paintings undoubtedly meditate on the horror and give a mute voice to the death cry which had already died away. These pictures seem eerie and terrifying, yet only as long as the viewer feels in a voyeuristic position. Changing from an active approach to the position of the victim — as is done also by the artist

Nachruf/Obituary, 1989,
Synthetic resin, tempera, oil on untreated cotton cloth, 240 x 190 cm,
Courtesy the artist

herself — we are then able to emphatically feel the grief and suffering, to experience the fear and violence mirrored by these works.

'There is a continuous collecting of figures in my head,' Ruschmeyer once said, 'they gather and become a huge battle field. They repeat murderous conversations with me; conversations in which I haven't had a chance to talk, or, if I said something, it was wrong. Either I kill them, or they kill me; anyway, I'll try as long as I can.' (repr. in: *Heike Ruschmeyer. Der Doppelgänger*, Brusberg Dokumente 16, Berlin 1987, p. 11)

Der Stimmeninitator I / The Voice Imitator, 1988,
Synthetic resin, tempera, oil on untreated cotton cloth,
195 x 150 cm,
Courtesy the artist

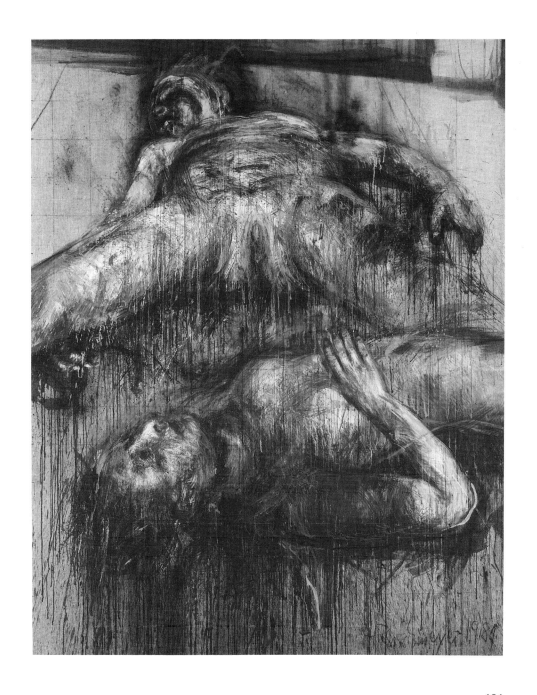

Froschkönigin / Frog Princess, 1981,
Synthetic resin, tempera, oil on untreated
cotton cloth, 240 x 190 cm,
Courtesy the artist

EVA-MARIA SCHÖN

In the contemporary German art scene, Eva-Maria Schön's 'paintings', her installations and performances with them offer yet another example of a very idiosyncratic way of working.

Schön, who was born in 1948 in Dresden, served an apprenticeship in photography under Lore Bermbach in Düsseldorf from 1966 to 1969. Between 1974 and 1978 she studied under Klaus Rinke at the Staatliche Kunstakademie, Düsseldorf. In 1982, Schön was awarded the Villa Romana Scholarship to live in Florence and a year later she received the Karl-Schmidt-Rottluff-Scholarship. In 1989, she held a guest professorship at the Hochschule der Künste, Berlin.

During the past decade, Schön has created copious variations of simple pictorial structures which are the result of the very basic technique she has progressively developed.

Generally Schön's only tool is the finger. It replaces pen or brush and moves and pushes the paint or ink on the paper. At the beginning, the often black paint is thick and heavy. It is then driven with the finger in straight forward or circular movements to the point where it almost becomes transparent. Finally, at the end of the procedure which is determined by the amount of paint used, the last finger print is left when the artist takes her hand off the paper.

Yet, the actual finger print can no longer be identified as such, although the viewer can reconstruct the movements which have taken place.

Again and again Schön has practised this method, also in the darkroom: 'In the darkroom I do the same with the hypo-solution as I do in the light with the paint. With my fingers, I squeeze the liquid onto the paper. My sense of touch creates shades of grey, which are still invisible, since the silver is hidden in the prepared layer. The salt fixes the silver at those spots which had been pressed by my fingers for a moment. The short stopping, the vibration, marks the seconds. The light is like a viewer, who registers every movement of the finger.'

The image of such works only appears after the photographic paper has been exposed, developed, fixed and washed. Sometimes a similar procedure is performed

Ohne Titel / Untitled, 1991,
Installation: wallpaper, table; finger
and spatula on paper,
Photograph: Werner Zellien, Berlin
Courtesy the artist

with fixer on unexposed paper or with retouching colour on a negative.

Schön chose the term 'parallel nature' to describe her work. Yet, the artist does not intent to copy nature although the images she creates, are most often reminiscent of worms, unicellular organisms, tentacles or horse-tails. Instead, her creative process and its results rather parallel nature, the standstill and movement, the time involved in organic growth.

Many of Schön's works show very little and hardly discernible deviations. These attract the viewer since 'the eye', as the artist once stated 'has to come very close to recognise these differences. And with this coming close the microscopic viewing begins.'

Installation at Het Apollohuis, Eindhoven
1992,
Two projections (enlargement 900%),
Courtesy the artist

Installation for the exhibition 'Tastsinn
Sehsinn', Schwäbisch Hall 1991,
Ink on paper, 600 x 600 cm,
Courtesy the artist

STEFAN SZCZESNY

Stefan Szczesny once described painting as 'contradictions in the present — live extremes — weapon against the bureaucratised world — passion and clarity of consciousness — light and colour — joy — luxury — beauty, happiness and most of all love in a thousand different forms. Like the amazed eyes of a child — painting — ecstatic love — timeless beauty — styleless in space — imagined worlds spread out on the screen — complex images in between abstraction and figuration — multilayered synthesis — big city bustle — rhythm in the heat of the night — day dreams — tenderness and enchantment — painting — the adventure of my life.' (repr. in: *Stefan Szczesny. Immagine Romane*, Munich 1983)

Szczesny, who has been one of the protagonists of the neo-expressionist, wild painting in Germany, was born in Munich in 1951. He studied from 1967 to 1969 at the Fachschule für Freie und Angewandte Kunst, Munich, and between 1969 and 1975 at the Akademie der Bildenden Künste, Munich. Since 1985, Szczesny has also been editor of the artist magazine *Malerei-Painting-Peinture*. He lives and works in Cologne and in Croix-Valmer, near St. Tropez, France.

In his paintings, Szczesny has continuously combined different artistic styles and ideas, stolen and borrowed from every era of art history and amalgamated his finds into new images as it can be seen in *Paul Gauguin* from 1991, which undoubtedly recalls Paul Gauguin's Tahitian paintings from around 1890. The work belongs to the series 'Idole-Mythen-Leitbilder'/'Idols-Myths-Models', a group of about sixty portraits, created by Szczesny since 1989, which represent well-known personalities like Charlie Chaplin and Marilyn Monroe, James Joyce and Franz Kafka, Titian and Rembrandt, Mozart and Glenn Gould.

In Szczesny's oeuvre, early works such as *Breakfast after Manet* (1969) and *Slaughtered Ox after Rembrandt* (1969) already prove his impartial and straightforward appropriation of traditional art works. However, it was not before 1975 that the artist broke with the minimalist and conceptual art he was taught at the art academy in Munich.

Since then, Szczesny has drawn from his day-to-day experiences and his

Paul Gauguin, 1991,
Acrylic on canvas, 200 x 160 cm,
Photograph: Lothar Schnepf, Cologne
Courtesy Galerie Karl Pfefferle, Munich

encounters with art history, from books and contemporary music. In his works he includes images from ancient history, like the goddesses of fertility, as well as those from classical antiquity, as, for example, temples, palaces and Roman churches. His works are inspired by Renaissance and baroque pictures as well as by the paintings of the 19th and 20th century, like those by Delacroix, Cézanne, Picasso and Matisse, Braque, Picabia, Max Ernst and de Chirico.

His synthesis of a multiplicity of images results in pictures which are often characterised by a linear over-layering of these elements as we know it from the art of Picabia and more recently from David Salle's paintings. In this way, Szczesny is able to simultaneously depict fragments of paintings and art-historical concepts, creating hierarchies by the different sizes of the images.

It is clear that our day-to-day experience of perceiving and assimilating anything and everything which surrounds us is given a lively representation with these works.

Faust 6/Fist 6, 1987,
Acrylic/oil on canvas, 200 x 250 cm,
Courtesy Galerie Karl Pfefferle, Munich

Schwarzer Frühling/Black Spring, 1983,
Acrylic/oil on canvas, 200 x 300 cm,
Courtesy Galerie Karl Pfefferle, Munich

VOLKER TANNERT

Volker Tannert, born in Recklinghausen in 1955, studied from 1975 to 1979 under Klaus Rinke and Gerhard Richter at the Kunstakademie Düsseldorf. In 1979, he was awarded the Max Ernst scholarship to live in New York, a stay which he once considered the most important experience of his life.

Typical of Tannert's earliest works are the 'anthropological' paintings, created between 1980 and 1982. They might be divided, as suggested by Barbara Straka, into three different phases. (in: exh. cat. *Volker Tannert, Evolutionen*, Berlin 1982, pp. 21–25)

The earliest paintings until 1981 depict shadowy figures, delineate the human being as an amorphous image, enclosed in labyrinthic and imagined caves and tunnels. Works like *Selbsthilfe/Self-help* or *Organwechsel/Organ Exchange*, reflect the intention to defy and repulse any threat or, respectively, to free oneself of memories and history and to become receptive to new experiences and knowledge.

The works of the second stage depict figures with enormously long extremities, intertwined and amalgamated into ornaments and spirals. Inspired by Tatlin's model for the monumental *Memorial for the III. Internationale*, which was supposed to wind in a large spiral towards the sky, Tannert created, for example, the works *Posing for Tatlin I–III*. Like Tatlin's sculpture, which was never built, Tannert's paintings carry a notion of utopia and, through the spiral, the idea of infinity. This rather positive image is contrasted by the work *Unsere Wünsche wollen Kathedralen Bauen/Our Wishes want to Build Cathedrals* from 1982. It is based on the *Light Dome* by Albert Speer, a large kind of stadium of the Third Reich, functionally built to integrate the masses of people as ornamental structure into the surrounding architecture. The work, which was on show at the Zeitgeist exhibition, can also be conceived as the beginning of the artist's concern with landscapes.

The last phase of Tannert's 'anthropological' themes, is characterised by depictions of fragmented bodies, symbolic of vulnerability, destruction and the experience of the human existence as incomplete, an aspect which occupies a large number of artists today. *Gedächtnistraining/Memory Training*, is one example of that period.

Bausatz für erhebende Gefühle / Kit for uplifting emotions, 1983,
Oil and synthetic resin on untreated cotton cloth, 220 x 300 cm,
Photograph: Lothar Schnepf, Cologne
Private collection, Cologne
Courtesy the artist

Since 1983, Tannert has been committed to landscape painting. The art historical sources for his 'romantic' paintings, as he calls them, are the works by Caspar David Friedrich.

In *Bausatz für Erhebende Gefühle/Kit for Uplifting Emotions* from 1983, we are confronted with four arrow-shaped columns, reaching like spotlights into the dark blue night sky, illuminating faraway objects like a temple and a cannon. Again, as in the 'anthropological' images, the objects might be perceived as symbolising the destruction of the past, which need not necessarily be understood as a negative process since through it, a way is given to new thoughts and fantasies. Both past and present are also implied in the columns, which recall the menhirs from Stonehenge as well as Greek temple columns, the spotlights of the 'Light Dome' as well as the buildings of New York as seen from below.

Tannert's paintings always evolve compositionally from an initial idea. The surface of the painting is then continuously reworked, while smaller versions of the work are used to test a thought. The final works then display a lively surface structure which equals the dynamism of the depicted motifs.

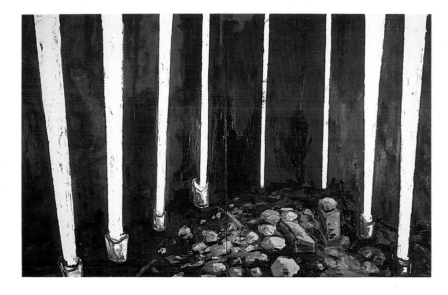

Unsere Wünsche wollen Kathedralen bauen / Our Wishes want to Build Cathedrals, 1982, Oil on untreated cotton cloth, 270 x 440 cm, Courtesy the artist

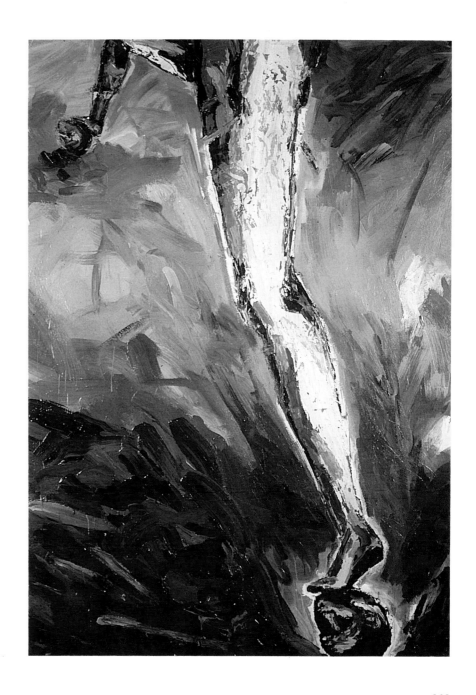

Gedächtnistraining / Memory Training, 1982,
Oil and synthetic resin on untreated cotton cloth,
220 x 160 cm,
Photograph: Lothar Schnepf, Cologne
Courtesy the artist

THOMAS WACHWEGER

Thomas Wachweger, born in Breslau in 1943, studied painting at the Hochschule für Bildende Künste, Hamburg, between 1963 and 1970. Since 1978 he has been living and working in Berlin.

As are Ina Barfuss' paintings of the late 1970s and early 1980s, Wachweger's are characterised by an ironical and polemical depiction of social conditions. While his themes are sexuality, oppression and power structures, he shows the human being as dependent on and trusting in money, religion, gender and society. Since 1983, Wachweger has, like Barfuss, turned to less overt, rather psychological depictions of love and death, agony and struggle, despair and isolation, the feeling of apathy and the illusion of security. In this way, he creates works which at first sight seem unambiguous, but which are, after all, difficult to decipher.

A short assessment of the painting *Heroisch (vom einen Land zum andern)/ Heroic (From Country to Country)* shows paradigmatically, yet only to a degree, the numerous meanings, indicated by the works Wachweger creates.

We recognise a red figure, walking towards the right side of the painting. The left and right side of the work are divided by four black wiggly lines and connected through three colour stripes, placed in a semicircle at the top of the painting. The left side of the painting is coloured with different shades of red paint, the right side shows grey elements painted over with thin and short, comb-like red marks. The reading of the work depends solely on how the viewer interprets these colours and forms. On one hand, the picture could tell about the waging of a war. The 'hero', carrying a flag, moves from one country to another, crosses the border — possibly a river — carrying the spoils of war and leaving blood and destruction behind. On the other hand, the work could portray an emigrant, leaving his or her own country for another while being unable to get free from the cultural baggage. The red, heart-shaped area at the lower left of the painting appears almost like the iron weight slaves and prisoners had chained to their feet. Further, the flag could indicate that the basic principals and fundamental rules of any country are the same, since the colours used for the semicircular form are identical (red, brown and white), only their

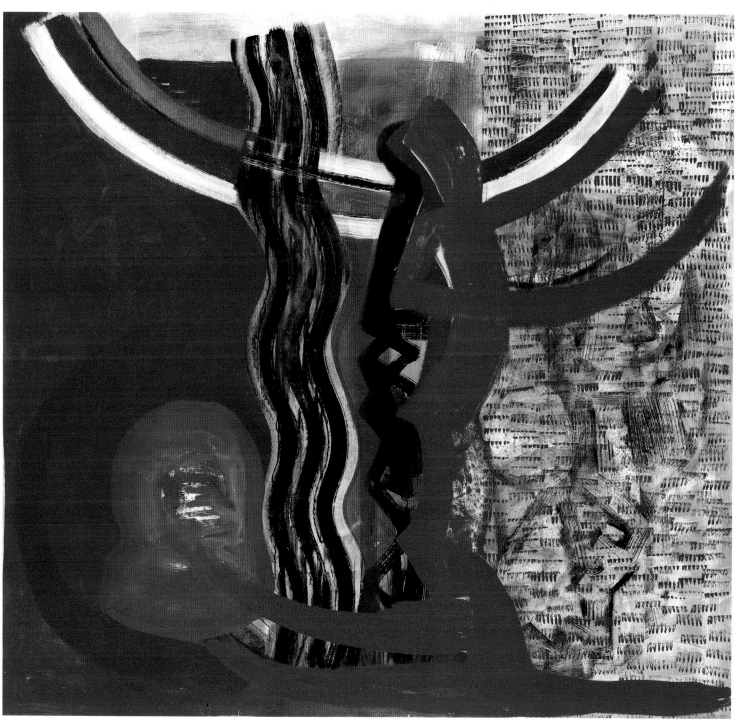

Heroisch (vom einen Land zum andern) / Heroic (From Country to Country), 1988,
Acrylic on canvas, 205 x 220 cm,
Courtesy Galerie Springer, Berlin

combination changes 'from country to country'. Therefore, leaving one country for another becomes senseless. In turn, the general living situation appears hopeless, because there is no way out.

Which ever reading we choose, the central themes of Wachweger's work are inherent in either of them. Even the colours symbolically convey these topics: red for love or blood or aggression, black for hate or death, black and white as the most extreme contrast, for good and bad, for hopelessness and confidence.

Compared to the joyous paintings of the 'New Wildes', Wachweger's works offer a distinctive contrast, confronting the viewer with the rather unpleasant conditions of life.

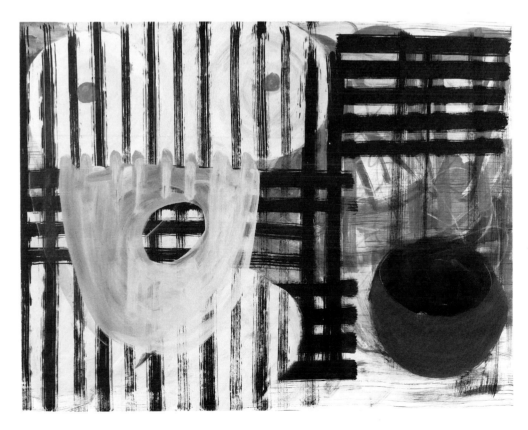

Abrahams Schoß (Eiserne Frau), 1988,
Gouache on paper, 110 x 142 cm,
Courtesy Galerie Springer, Berlin

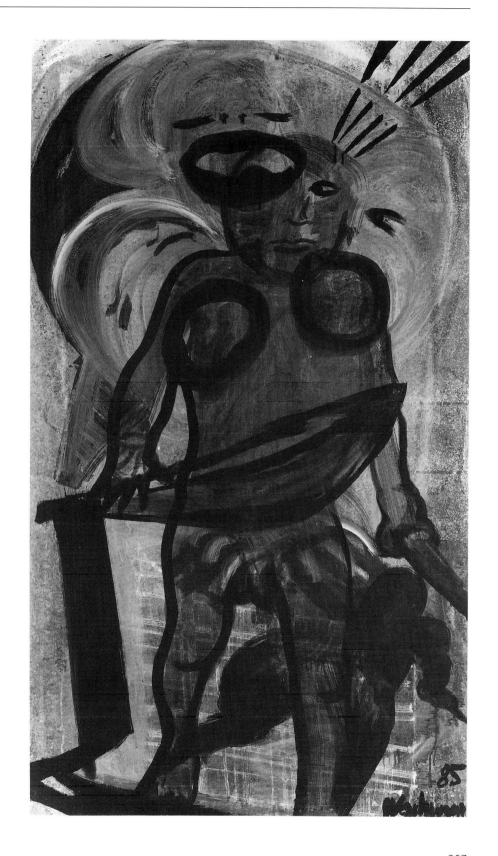

Sirenenmast / Siren Pole, 1985,
Ink on canvas, 170 x 100 cm,
Courtesy Galerie Springer, Berlin

BERND ZIMMER

Bernd Zimmer, who was born in 1948 in Planegg, near Munich, is an autodidactical painter. He lives and works in Polling, near Munich. During the late 1970s and early 1980s, he was, like Rainer Fetting, Helmut Middendorf and Salóme, an active member of the group around the self-help 'Galerie am Moritzplatz'.

In contrast to many of his fellow artists, who are inspired by the cityscape, sub-cultural living and rock music, Zimmer is concerned with landscape and nature. Like Bernd Koberling and Volker Tannert, he courageously approaches the centuries-old theme and has found, through elaborate pictorial investigations, new ways to picture this subject.

Zimmer's works are particularly characterised by the depiction of fragments of nature. Landscape is taken apart and nature's unity is split and broken up. Mountains and lakes, rocks and trees, fields and clouds are all explored separately. In this process, nature provides the rhythm for his gestural play with colours, while the landscape is turned into landscapes of colours and forms. As he stated in an interview: 'I love nature, also in its outer form of the landscape. For me it is the reason to paint: not sentimentally and emotionally but in a process of reflection. When exploring nature, I discover forms, the form of nature, which I want to give to my painting. While working on the painting, while painting, this form changes, becomes its own nature, becomes an independent work. Invented nature. My perception of nature but simultaneously my conception of painting as such.' (repr. in: exh. cat. *Bernd Zimmer. Werkgruppen 1977–1990*, Darmstadt 1990, pp. 16–17)

The artist also works in series, each based on a different viewpoint. In the series 'Von Oben'/'From Above', for example, fields, as seen from above, figure as motif. While the earlier paintings still show the horizon, although placed quite high in the work, in later works this feature completely disappears. Due to the fact that all paintings of this group are of square format and that Zimmer continuously turns the canvas when painting, any hierarchies are eliminated and a high degree of abstraction is achieved. As a result, the fields became pure colourfields.

Morgen. (Himmelbilder)/ Morning. (Sky/Heaven paintings), 1990/91,
Acrylic on canvas, 170 x 260 cm,
Courtesy Galerie Holtmann, Cologne and the artist

Earlier works, by contrast, reflect a closer connection to the depicted scenery, as for example the paintings *Haldensee*, from 1979, and *Eis. Berge/Ice. Mountains*, from 1983. Specifically the latter is immediately recognised as portraying a small lake, surrounded by trees and huge mountains. The work also reveals some rather harsh contours. These references as well as this kind of brushwork have now vanished entirely.

Morgen. (Himmelbilder)/Morning. (Sky/Heaven paintings) from 1990 belongs to a group of works executed in 1990/1991. Here, the subject of depiction is the sky 'seen from below' at different times of the day. In these pictures, the colours blue and yellow clearly dominate. Zimmer also uses shades of earthy colours, of greens and pinks, greys and whites. All works display an intensive, almost explosive quality of colour, since the paints are applied directly, and mixed, if at all, only on the canvas.

All of them are extremely abstract, almost non-objective and without knowing the titles, none of them could be identified. Sky and clouds have dissolved in waves of paint, in the rhythmical and dynamic brushwork, have become truly atmospheric.

Eis. Berge / Ice. Mountains, 1983,
Dispersion on canvas, 160 x 200 cm,
Private collection, San Francisco
Courtesy the artist

Haldensee, 1979,
Distemper on canvas, 205 x 300 cm,
Courtesy Barbara Gladstone Gallery, New York
and the artist

BIOGRAPHIES

HANS PETER ADAMSKI

Photograph: Karin Hieronymi

Born in Kloster Oesede near Osnabrück in 1947.
Lives and works in Cologne.
1970–74 Studied at the Staatliche
Kunstakademie, Düsseldorf.
1983 Support Prize of the Bundesverband
der deutschen Industrie.

Selected exhibitions
1972 Mercer Store, Stefan Eins Gallery,
New York, USA.
1973 Yellow Now Gallery, Lüttich (Liège),
Belgium.
1974 Arno Kohnen in Konrad Fischers
Raum, Düsseldorf, FRG.
1981 Galerie Paul Maenz, Cologne, FRG.
1982 Galerie Buchmann, St. Gallen,
Switzerland; Galerie Toni Gerber,
Berne, Switzerland; '10 Junge
Künstler aus Deutschland', Museum
Folkwang, Essen, FRG.
1983 Galerie Ascan Crone, Hamburg, FRG;
Galerie Heinrich Erhard, Madrid,
Spain; Galerie Six Friedrich, Munich;
'Mülheimer Freiheit — Proudly
Presents The Second Bombing',
Fruitmarket Gallery, Edinburgh, UK,
and Institute of Contemporary Arts,
London, UK.
1984 'Mister Flokati', Bonnefantenmuseum,
Maastricht, Netherlands; Ado Gallery,
Bonheiden, Belgium; Städtisches
Kunstmuseum, Bonn, FRG;
'Zwischenbilanz: Neue Deutsche
Malerei', Neue Galerie am
Landesmuseum Joanneum, Graz,
Austria; Museum Villa Stuck, Munich,
FRG; Galerie Krinzinger, Innsbruck,

Austria; Rheinisches Landesmuseum,
Bonn, FRG.
1985 Reinhard Onnasch Galerie, Berlin,
FRG; Asperger & Bischoff Gallery,
Chicago, USA; Sonnabend Gallery,
New York, USA; Galerie Pfefferle,
Munich, FRG; 'Das Menschenbild',
Galerie Pfefferle, Munich, FRG.
1986 Reinhard Onnasch Galerie, Berlin,
FRG; Galerie Pfefferle, Munich, FRG;
Antwerpen — Köln, Cultureel
Centrum, Kortrijk, Belgium;
'Mülheimer Freiheit Group',
Milwaukee Art Museum, Milwaukee,
USA.
1987 Galerie Triebold, Basel, Switzerland;
'Skulpturen von Malern', Kunstverein,
Mannheim, FRG.
1988 European Institute of Public
Administration, Maastricht,
Netherlands; Galerie Kicken &
Pauseback, Cologne, FRG; Galerie A.
Nisple, St. Gallen, Switzerland;
Galerie Pfefferle, Munich, FRG;
Galerie Pentagon, Cologne, FRG; 'Art
Against Aids', Cologne, FRG.
1989 Galerie Arnesen, Copenhagen,
Denmark; Goethe-Institut, Rotterdam,
Netherlands; Galerie Pfefferle,
Munich, FRG; Kunstverein, Pforzheim,
FRG.
1990 Städtische Galerie, Heerlen,
Netherlands.
1991 Galerie Trans Art, Cologne, GER;
Nationalgalerie, Dakar, Senegal;
Kunstverein, Mannheim, GER; Galerie
Pfefferle, Munich, GER.

Collections
Paintings, graphical works and sculptures in
major national and international, private and
public collections.

Selected bibliography
1975 Exh. cat. *Seven Cologne Artists*,
Mercer Store — Stefan Eins Gallery,
New York.
1976 Hans Peter Adamski, *Neun Gesichter*,
Cologne.
1977 Hans Peter Adamski, *Five Men in

Paris*, Cologne.
1981 Exh. cat. *Bildwechsel. Neue Malerei in
Deutschland*, Akademie der Künste,
Berlin; Exh. cat. *Mülheimer Freiheit,
die Seefahrt und der Tod*, Kunsthalle
Wilhelmshaven, Kunstverein
Wolfsburg.
1982 Exh. cat. *10 Junge Künstler aus
Deutschland*, Museum Folkwang,
Essen; Exh. cat. *12 Junge Künstler aus
Deutschland*, Kunsthalle Basel,
Museum Boysmans-van-Beuningen,
Rotterdam.
1984 Exh. cat. Wilfried W. Dickhoff (ed.),
*Hans Peter Adamski. Arbeiten
1980–1984*, Städtisches
Kunstmuseum, Bonn; Exh. cat. *Mister
Flokati/Fressen zum Denken*,
Bonnefanten Museum, Maastricht,
Gesellschaft für aktuelle Kunst,
Bremen.
1985 Exh. cat. *Hans Peter Adamski.
Arbeiten 1980–1985*, Edition
Pfefferle, Munich.
1986 Stefan Szczesny (ed.), *Malerei/
Painting/Peinture*, no. 2, no. 4,
Edition Pfefferle, Munich
(1986/1987).
1988 Exh. cat. *Zeitgenössische Kunst*,
Galerie Thomas, Munich.
1989 Exh. cat. *Multiples*, Goethe-Institut,
Rotterdam.
1991 Stefan Szczesny (ed.), *Maler über
Malerei*, DuMont Verlag, Cologne;
Hans Peter Adamski, *Vorlesungen
über Mytholgie — Ein Skizzenbuch
für Dakar*, Cologne.

ELVIRA BACH

Born in Neuenhain in 1951.
Lives and works in Berlin.
1967–70 Studied at the Staatliche
Glasfachschule, Hadamar.
1972–79 Studied under Hann Trier at the
Hochschule der Künste, Berlin.
1982 Artist in residence, Santo Domingo,
Dominican Republic.

Selected exhibitions

1978 'Elvira zeigt Verschiedenes in einem Metzgerladen in Berlin', Berlin, FRG.
1979 S.O. 36, Berlin, FRG.
1981 'Bildwechsel — Neue Malerei aus Deutschland', Akademie der Künste, Berlin, FRG.
1982 Galerie Petersen, Berlin, FRG; Galerie Schoof, Frankfurt/M.; Galerie Catherine Issert, Saint Paul de Vence, France; documenta 7, Kassel, FRG.
1983 Galerie Jurka, Amsterdam, Netherlands; Galerie Raab, Berlin, FRG; Galerie Arno Kohnen, Düsseldorf, FRG; Galerie Pfefferle, Munich, FRG; Galerie Meduza, Piran, Yugoslavia; Edward Totah Gallery, London, UK.
1984 Deweer Art Gallery, Zwevegem-Otegem, Belgium; Galerie Catherine Issert, Saint Paul de Vence, France; Galerie Raab, Berlin, FRG; 'Zwischenbilanz II — Neue Deutsche Malerei', Neue Galerie Joanneum, Graz, Austria; Museum Villa Stuck, Munich, FRG; Rheinisches Landesmuseum, Bonn, FRG.
1985 Augustiner Museum, Freiburg, FRG; Gabrielle Bryers Gallery, New York, USA; Galerie Pierre Huber, Geneva, Switzerland; Kunstverein, Kassel, FRG.
1986 Galerie Raab, Berlin, FRG; Deweer Art Gallery Zwevegem-Otegem, Belgium; Catherine Issert, Saint Paul de Vence, France; Galerie Capricorno, Venice, Italy; 'Eva und die Zukunft', Kunsthalle, Hamburg, FRG.
1987 Charles Cowles Gallery, New York, USA; Galerie Raab, Berlin; Raab Gallery, London, UK; Galerie Pfefferle, Munich, FRG; Kunstverein, Bremerhaven, FRG; Hillman Holland Gallery, Atlanta/Georgia, USA; 'Berlin Art', Dorsky Gallery, New York, USA.
1988 Galerie Holtmann, Cologne, FRG; Galerie Fahlbusch, Mannheim, FRG.
1989 Galerie Jordan, Cologne, FRG; Galerie Herbert Weinand, Berlin, FRG; Galerie Pfefferle, Munich, FRG.
1990 Kunstverein, Mannheim, FRG; Galerie Fahlbusch, Mannheim, FRG; Galerie Joachim Becker, Cannes, France; Galerie Raab, Berlin, FRG; 'Blau — Farbe der Ferne', Kunstverein, Heidelberg, FRG.

Collections

Paintings in major national and international, private and public collections.

Selected bibliography

1981 Exh. cat. *Bildwechsel, Neue Malerei aus Deutschland*, Interessenge-meinschaft Berliner Kunsthändler, Berlin.
1983 Exh. cat. *Elvira Bach — Bilder und Gouachen*, Galerie Raab, Berlin; Exh. cat. *Elvira Bach. Bilder*, Galerie Pfefferle, Munich.
1984 Exh. cat. *Elvira Bach*, Deweer Art Gallery, Zwevegem-Otegem; Exh. cat. *Elvira Bach — Schlangenakte*, Galerie Raab, Berlin.
1985 Exh. cat. *Elvira Bach*, Galerie Pfefferle, Munich; Peter Stepan, 'Inside — Europe/Germany', in: *Art News* (February); Robert G. Edelman, 'Elvira Bach', in: *Art in America* (July); Donald Kuspit, 'Elvira Bach', in: *Artforum International* (June/August).
1987 Exh. cat. *Malerei 1980–1986*, Kunstverein, Augsburg; Kuspit, Donald, 'Elvira Bach', in: *Artforum International* (Summer).
1989 Exh. cat. *Neue Figuration. Deutsche Malerei 1960–1988*, Munich; Kunstmuseum Düsseldorf; Schirn Kunsthalle Frankfurt; Exh. cat. *Refigured Painting. The German Image 1960–1988*, New York.

FRANK BADUR

Photograph: Hermann E. Kiessling, Berlin

Born in Oranienburg near Berlin in 1944. Lives and works in Berlin.

1963–69 Studied at the Hochschule für Bildende Künste, Berlin.
1973 Established a permanent studio in Finland.
1982 Fellowship of the Hand-Hollow-Foundation, East Chatham, New York; DAAD Scholarship to live in New York.
1984 Art Prize TetraPak; Working grant by the Kunstfond Bonn; Mülheimer Bürgerpreis for Fine Arts.
1985– Professor at the Hochschule der Künste, Berlin.

Selected exhibitions

1973 Galerie Diogenes, Berlin, FRG.
1974 Kunstverein, Naantali, Finland.
1977 Galerie Bossin, Berlin, FRG.
1978 Galerie Christel, Stockholm, Sweden; Galerie Larsson, Gävle, Sweden.
1979 Galerie Schlégl, Zurich, Switzerland; Galerie Schoeller, Düsseldorf, FRG; Galerie Bossin, Berlin, FRG; Galerie Jesse, Bielefeld, FRG.
1980 Overbeck-Gesellschaft, Lübeck, FRG; Amos-Anderson-Museum, Helsinki, Finland; Galerie Christel, Stockholm, Sweden; Schloß Bellevue, Kassel, FRG; Galerie Hoffmann, Friedberg, FRG.
1981 Galerie Seestraße, Rapperswil, Switzerland; Galerie Walser, Munich, FRG; Galerie Slominsky, Mühlheim, FRG; Galerie Peters, Lübeck, FRG.
1983 Kunsthalle, Bremen, FRG; Galerie Konstruktiv Tendens, Stockholm,

Sweden; Mönchehaus Museum, Goslar, FRG.

1984 Galerij Jeanne Buytaert, Antwerpen, Belgium.

1985 Galerie Walser, Munich, FRG; Neuer Berliner Kunstverein, Berlin, FRG.

1986 Galerie Schlégl, Zurich, Switzerland; Galerie Jesse, Bielefeld, FRG; Städtische Galerie, Villingen-Schwenningen, FRG; Galerie Schöller, Düsseldorf, FRG; Arnold & Porter, Washington D.C., USA; Galerie Repéres, Paris, France.

1987 Galerie Hör, Nürnberg, FRG; Galerij Jeanne Buytaert, Antwerpen, Belgium.

1988 Galerie Hoffmann, Friedberg, FRG; Akademia Sztuk Pieknych, Warschau, Poland.

1989 Galerie Konstruktiv Tendens, Stockholm, Sweden; Galerie Rupert Walser, München, FRG; Galerie Carla Fuehr, Munich, FRG; Graf & Schelble Galerie, Basel, Switzerland; Synagoge, Kunstverein, Oerlinghausen, FRG.

1990 Kunsthalle, Kiel, FRG; Edward Thordén Gallery, Goeteborg, Sweden; Galerie Walzinger, Saarlouis, FRG; Galerie Schlégl, Zurich, Switzerland.

1991 Museum Schloß Morsbroich, Leverkusen, GER; Haus am Waldsee, Berlin, GER; Galerie Gutsch, Berlin, GER; Ersgard Gallery, Los Angeles, USA; Wilhelm-Hack-Museum, Ludwigshafen, GER.

1992 Galerie Schoeller, Düsseldorf, GER; Galerie Wack, Kaiserslautern, GER; Galerie am See, Zug, Switzerland; Galerij Jeanne Buytaert, Antwerpen, Belgium; Thordén Gallery, Goeteborg, Sweden.

(as well as many group exhibtions)

Collections

Paintings, graphical works and sculptures in all major national and international, private and public collections.

Selected bibliography

1978 Exh. cat. *Frank Badur*, Galerie

Christel, Stockholm.

1981 Exh. cat. *Frank Badur*, Galerie Slominsky, Mühlheim.

1985 Heiner Stachelhaus, 'Frank Badur — Stille Sensationen', in: *Auf den Punkt gebracht*, Verlag Aurel Bongers, Recklinghausen; Exh. cat. *Frank Badur*, Neuer Berliner Kunstverein, Berlin.

1988 Willy Rotzler, *Konstruktive Konzepte*, ABC-Verlag, Zurich.

1990 Exh. cat. *Frank Badur*, Kunsthalle, Kiel; Exh. cat. *Berliner Kunststücke*, Museum der bildenden Künste, Leipzig; Exh. cat. *Frank Badur. Gemälde und Collagen*, Verlag für moderne Kunst, Nürnberg.

1991 Exh. cat. *Frank Badur*, Galerie Gutsch, Berlin; Prinz, Ursula, 'New Constructive and Conceptual Art', in: exh. cat. *The Berlinische Galerie Art Collection Visits Dublin*, Berlin/Dublin; Exh. cat. *Frank Badur. Malerei*, Studio A, Otterndorf; Exh. cat. *Interferenzen — Kunst aus Westberlin 1960–1990*, Verlag Dirk Nishen, Berlin.

CHARLY BANANA / RALF JOHANNES

Photograph: the artist walking down Hallo Treppe / Hello Staircase, *a sculpture he created in 1990.*

Born in Cologne in 1953.
Lives and works in Cologne.
Studied painting at the Fachhochschule für Kunst und Design, Cologne (Master-class student) and at the Staatliche Kunstakademie, Düsseldorf.

1978 Grant from Deutsch-Französisches Jugendwerk.

1979 Friedrich-Vordemberge-Scholarship, Cologne.

1980–81 PS 1 Scholarship to live in New York.

1982 Working grant from Kunstfond e.V., Bonn.

1987 Guest visitor at the Villa Romana, Florence, Italy.

1988 Guest visitor at the Künstlerhaus Bethanien, Berlin

Selected exhibitions

1977 Galerie Kümmel, Cologne, FRG.

1978 Harlekin Art Galerie, Wiesbaden , FRG; Galerie Schlinkhoven, Bergisch Gladbach, FRG; 'Performance-Symposion', Neue Galerie, Aachen, FRG.

1979 Galerie Ha.Jo. Müller, Cologne, FRG; Galerie Toni Gerber, Berne, Switzerland; 'Schlaglichter', Rheinisches Landesmuseum, Bonn, FRG.

1980 Galerie Brusten, Wuppertal, FRG; 'Biennale de Paris', Musee d'art Moderne de la Ville de Paris, Paris, France.

1981 PS1 Gallery, New York, USA; Galerie 'T Venster, Rotterdam, Netherlands.

1982 Galleria Pellegrino, Bologna, Italy; Galerie Holtmann, Hannover, FRG; Galerie Dany Keller, Munich, FRG; 'La Giovane Trasavanguardia Tedesca', Galleria Nazionale D'Arte Moderne, San Marino, Italy.

1983 Galerie Holtmann, Cologne, FRG; Galerie Camomille, Brussels, Belgium; Galerie Bama, Paris, France; Neue Gesellschaft für bildende Kunst, Berlin, FRG; Galerie Fahnemann, Berlin, FRG; Galerie Maier-Hahn, Düsseldorf, FRG; 'Neue Malerei in Deutschland/dimension IV'; Nationalgalerie, Berlin, FRG (travelled to Munich and Düsseldorf); 'Ansatzpunkte kritischer Kunst heute', Kunstverein, Bonn, FRG (travelled to Berlin).

1984 Galerie Peter Noser, Zurich, Switzerland; Kunstverein, Bochum,

FRG; ART 15, Basel, Switzerland;
Galerie Holtmann, Cologne, FRG.
1985 Galerie Jurka, Amsterdam,
Netherlands; Galerie Dany Keller,
Munich, FRG; Galerie Steinek, Vienna,
Austria.
1986 Galerie Camomille, Brussels, Belgium;
Galerie Bama, Paris, France; Galerie
Holtmann, Cologne, FRG.
1988 Galerie Thieme-Lotz, Darmstadt, FRG;
Galerie Hartmut Beck, Erlangen, FRG;
Galerie Wewerka, Berlin, FRG;
'Augenblicke', Kölnisches
Stadtmuseum, Cologne, FRG;
Museum Villa Stuck, Munich, FRG.
1989 Galerie Holtmann, Cologne, FRG;
Galerie Brusten, Wuppertal, FRG; 'Die
Kölner', Galerie Littmann, Basel,
Switzerland.
1990 Galerie Thieme-Lotz, Darmstadt, FRG;
Artothek im Bonner Kunstverein,
Bonn, FRG.
1991 Galerie Holtmann, Cologne, GER;
'Köln Kunst 3', Josef-Haubrich-
Kunsthalle, Cologne, GER.

Collections
Paintings, graphical works and sculptures
represented in national and international,
private and public collections.

Selected biliography
1979 Exh. cat. *Schlaglichter. Eine
Bestandsaufnahme aktueller Kunst im
Rheinland*, Rheinisches
Landesmuseum, Bonn.
1980 Annelie Pohlen, 'Irony, Rejection and
Concealed Dreams. Some Aspects of
"Painting" in Germany', in: *Flash Art*
(Milano), no. 96–97, p. 34.
1982 Exh. cat. *Deutsche Zeichnungen der
Gegenwart*, Museum Ludwig,
Cologne.
1983 Exh. cat. *Neue Malerei*, Kunstfond
Kunstraum, Bonn; Exh. cat. J. Harten,
D. Honisch, H. Kern (eds), *Neue
Malerei in Deutschland/dimension IV*,
Prestel Verlag, Munich; Exh. cat.
Ansatzpunkte kritischer Kunst heute,
Kunstverein Bonn.

1984 Exh. cat. *Charly Banana in
Zusammenarbeit mit Ralf Johannes*,
Verlag Heinz Holtmann, Cologne;
Annelie Pohlen, 'Obsessive Pictures or
Opposition to the Norm', in: *Artforum*
(New York), May, pp. 46–7; Heinz
Thiel, 'Kunstlandschaft
Bundesrepublik', in: *Kunstforum
International*, vol. 73/74, p. 237.
1986 Exh. cat. *Charly Banana in
Zusammenarbeit mit Ralf Johannes.
Das Gemüse schlägt zurück*, Galerie
Holtmann, Cologne.
1990 Exh. cat. *Der Humor ist der
Regenschirm der Weisen*, Fluxeum
Wiesbaden.
1991 Exh. cat. *Köln Kunst 3*, Josef-
Haubrich-Kunsthalle, Cologne.

INA BARFUSS

Born in Lüneburg in 1949.
Lives and works in Berlin.
1968–74 Studied at the Hochschule für
Bildende Künste, Hamburg.

Selected exhibitions
1974 Galerie Silvio R. Baviera, Zurich,
Switzerland.
1981 Galerie Petersen, Berlin, FRG;
'Gegenbilder', Kunstverein, Karlsruhe,
FRG.
1983 Galerie Monika Sprüth, Cologne, FRG;
Galerie Six Friedrich, Munich, FRG.
1984 Galerie Springer, Berlin, FRG; Galerie
Munro, Hamburg, FRG;
'Zwischenbilanz', Joanneum Graz,
Austria; Villa Stuck, Munich, FRG;
Rheinisches Landesmuseum, Bonn,
FRG.

1985 'Die Kunst der Triebe' (with Thomas
Wachweger), Museum am Ostwall,
Dortmund, FRG; Galerie Springer,
Berlin, FRG; Art Cologne, Cologne,
FRG; 'Kunst mit Eigen-Sinn', Museum
moderner Kunst, Vienna, Austria.
1986 'Ina Barfuss/Thomas Wachweger —
Ausstellung in 2 Folgen', Haus am
Waldsee, Berlin, FRG; 'Perspectives 5:
New German Art', Portland Art
Museum, Portland, USA; 'Eva und die
Zukunft', Kunsthalle, Hamburg, FRG.
1987 Galerie Monika Sprüth, Cologne, FRG;
Goethe-Institut, Paris, France; Galerie
Silvio R. Baviera, Zurich, Switzerland;
Galerie Springer, Berlin, FRG; Institut
of Contemporary Arts, London, UK;
'Momentaufnahme', Staatliche
Kunsthalle, Berlin, FRG; 'Berlinart
1967–1987', Museum of Modern Art,
New York, USA; San Francisco
Museum of Modern Art, San
Francisco, USA; 'Wechselströme',
Kunstverein, Bonn, FRG.
1988 Galerie Silvio R. Baviera, Zurich,
Switzerland; Satani Gallery, Tokyo,
Japan; 'Refigured Painting: The
German Image 1960–1988', Toledo
Museum of Art, Toledo, Ohio, USA.
1989 'Refigured Painting: The German
Image 1960–1988', Guggenheim
Museum, New York, USA; William
College Museum of Art,
Williamstown, Massachusetts, USA;
'Neue Figuration. Deutsche Malerei
1960–1988', Kunstmuseum,
Düsseldorf, FRG; Schirn Kunsthalle
Frankfurt/M., FRG; Barbara Gross
Galerie, Munich, FRG; 'Neue
Tendenzen der späten 80er Jahre',
Padiglione d'arte contemporanea,
Milano, Italy; 'Das Verhältnis der
Geschlechter', Kunstverein, Bonn, FRG.
1990 Corner House, Manchester, UK.
1991 Galerie ARTcurial, Paris, France;
'Interferenzen — Kunst aus
Westberlin 1960–1990', Museum für
ausländische Kunst, Riga, Latvia.

Collections
Paintings in major national and international, private and public collections.

Selected bibliogaphy
1985 Exh. cat. *Ina Barfuss*, Galerie Springer, Berlin; Exh. cat. Wolfgang Max Faust (ed.), *Die Kunst der Triebe. Ina Barfuss/Thomas Wachweger*, Berlin; Museum am Ostwall, Dortmund, Ulmer Museum.

1986 Exh. cat. Werner Hoffmann (ed.), *Eva und die Zukunft*, Prestel-Verlag, Munich; Exh. cat. Thomas Kempas (ed.), *Ina Barfuss — Thomas Wachweger. Gemälde, Zeichnungen, Gemeinschaftsarbeiten 1978 bis 1986*, Berlin (Haus am Waldsee); Stephan Schmidt-Wulffen, 'Hübsch-häßlich', in: *Kunstforum International*, vol. 83, pp. 262–4.

1987 Exh. cat. *Ina Barfuss. Bilder 1987 sowie Gemeinschaftsarbeiten mit Thomas Wachweger*, Galerie Springer, Berlin; Stephan Schmidt-Wulffen, *Spielregeln: Tendenzen der Gegenwartskunst*, DuMont Buchverlag, Cologne.

1989 Exh. cat. *Neue Figuration. Deutsche Malerei 1960–1988*, Munich; Kunstmuseum Düsseldorf; Schirn Kunsthalle Frankfurt; Exh. cat. *Refigured Painting. The German Image 1960–1988*, New York; Christos M. Joachimides (ed.), *Aufbruch in die neunziger Jahre. Neun Künstler in Berlin*, Milano.

1991 Exh. cat. *Interferenzen — Kunst aus Westberlin 1960–1990*, Verlag Dirk Nishen, Berlin.

GEORG BASELITZ

Born Hans-Georg Kern in Deutschbaselitz, Saxony, in 1938.

Lives and works in Derneburg and Imperia, Italy.

1956 Studied painting under Professor Womaka and Professor Behrens-Hangler at the Hochschule für Bildende und Angewandte Kunst in East Berlin. Expelled after two terms for 'social and political immaturity'.

1957 Continued studies under Hann Trier at the Hochschule der Bildenden Künste, Berlin.

1961 Master-class student under Hann Trier.

1965 Scholarship to Villa Romana, Florence.

1978–83 Professorship at the Staatliche Akademie der Bildenden Künste, Karlsruhe.

1983–88 Professorship at the Hochschule der Künste, Berlin.

1986 Received Kaiserring Prize from the city of Goslar.

Selected exhibitions
1961 Schaperstr. 22 am Fasanenplatz, Berlin, FRG.

1964 Galerie Michael Werner, Berlin, FRG.

1970 Kunstmuseum, Basel, Switzerland.

1972 Kunsthalle Mannheim, FRG; Kunstverein Hamburg, FRG.

1976 Kunsthalle Bern, Switzerland; Kunsthalle Cologne, FRG.

1979 Stedelijk Van Abbemuseum, Eindhoven, Netherlands.

1980 'La Biennale di Venezia', German Pavillon, Venice, Italy (with Anselm Kiefer).

1981 Städtische Kunsthalle, Düsseldorf, FRG (with Gerhard Richter), Stedelijk Museum, Amsterdam, Netherlands.

1982 Sonnabend Gallery, New York, USA; Young Hoffmann Gallery, Chicago, USA; Galerie Michael Werner, Cologne, FRG; Kunstverein, Göttingen, FRG.

1983 Studio d'Arte Cannaviello, Milano, Italy; Whitechapel Art Gallery, London, UK; The Museum of Modern Art, New York, USA (with Rolf Iseli); Los Angeles County Museum of Art, Los Angeles, USA.

1984 Stedelijk Museum, Amsterdam; Kunstmuseum, Basel, Switzerland; Kunsthalle, Basel, Switzerland; Mary Boone/Michael Werner Gallery, New York, USA; Städtisches Kunstmuseum, Bonn, FRG; Kunstverein, Freiburg, FRG; Kunsthalle, Nürnberg, FRG; Vancouver Art Gallery, Vancouver, Canada.

1985 Kunstverein, Hannover, FRG; College of Fine Arts, Pittsburgh, USA; Badischer Kunstverein, Karlsruhe, FRG; Kunsthalle, Bielefeld, FRG.

1986 Kunstmuseum, Winterthur, Switzerland; Mönchehaus — Museum für Moderne Kunst, Goslar, FRG.

1987 Kestner-Gesellschaft, Hannover, FRG; Museum Ludwig, Cologne, FRG; Galerie Michael Werner und Graphische Räume, Cologne, FRG.

1988 Akira Ikeda Gallery, Tokyo, Japan; Instituto Alemán, Madrid, Spain; Galerie Beaubourg, Paris, France; Salone Villa Romana, Florence, Italy; Sala d'Arme di Palazzo Vecchio, Florence, Italy; Städtische Galerie im Städel, Frankfurt/M., FRG; Chateau Grimaldi, Musée Picasso, Antibes, France; Kunsthalle, Hamburg, FRG; Kunsthalle, Bremen, FRG.

1989 Galerie Michael Werner, Cologne, FRG; Kunstmuseum, Basel, Switzerland; Museum Schloß Morsbroich, Leverkusen, FRG; L.A. Louver Gallery, Venice, California, USA; Kunsthalle, Bielefeld, FRG.

1990 Staatliche Museen zu Berlin, Altes Museum, Berlin, FRG; Kunsthaus, Zurich, Switzerland; Städtische, Kunsthalle, Düsseldorf, FRG; Michael Werner Galerie, Cologne, FRG and New York, USA.

(as well as copious group exhibitions)

Collections
Paintings, graphical works and sculptures in all major national and international, private and public collections.

Selected bibliography
1973 Exh. cat. *Georg Baselitz: Ein Neuer Typ — Bilder 1965/66*, Galerie Neuendorf, Hamburg.

1981 Exh. cat. *Georg Baselitz/Gerhard Richter*, Kunsthalle Düsseldorf.

1983 Collin Mattew, 'Georg Baselitz: Effluents and Invent-ions', in:

Artscribe, no. 43 (october), pp. 20–25.

1984 Exh. cat. *Georg Baselitz. Zeichnungen 1958–1983*, Kunstmuseum Basel/Van Abbemuseum, Eindhoven; Exh. cat. *Georg Baselitz: Paintings 1960–83*, The Whitechapel Art Gallery, London.

1985 Exh. cat. *Georg Baselitz: Selected Prints 1963–1985*, The Alpha Gallery, Boston.

1987 Carl Haenlein (ed.), *Georg Baselitz — Skulpturen und Zeichnungen 1979–1987*, Kestner-Gesellschaft, Hannover.

1988 Exh. cat. *Georg Baselitz: Der Weg der Erfindung — Zeichnungen, Bilder, Skulpturen*, Städtische Galerie im Städelschen Kunstinstitut, Frankfurt/M. (includes Baselitz' *Pandämonisches Manifest I*, Version 1 and 2 and *Pandämonisches Manifest II*); Exh. cat. *Georg Baselitz — Das Motiv*, Kunsthalle Bremen; Exh. cat. *Georg Baselitz — Bilder 1965–87*, Kunsthalle Hamburg.

1990 Exh. cat. *Georg Baselitz Paintings. Bilder 1962–1988*, Runkel-Hue-Williams/Grob Gallery, London; Exh. cat. *Georg Baselitz*, Kunsthaus Zürich & Städtische Kunsthalle Düsseldorf, Zurich

1991 *Georg Baselitz 45*, Reihe Cantz, Stuttgart; Exh. cat. *Georg Baselitz — Neue Arbeiten*, Galerie Michael Werner, Cologne.

PETER BÖMMELS

Photograph: Michael Dannemann, Düsseldorf.

Born in Frauenberg/Euskirchen in 1951.
Lives and works in Hamburg.

1970–76 Studied Sociology, Politics and Educational Theory.
1977–80 Worked in a kindergarten.
1980– Co-editor of the music-magazine *SPEX*.
1986–87 Guest professorship at the Hochschule für Bildende Kunst, Hamburg.
1990–92 Guest professorship at the Hochschule der Künste, Berlin.

Selected exhibitions

1980 'Auch wenn das Perlhuhn leise weint', Hahnentorburg, Cologne, FRG (with Adamski, Dahn and Dokoupil); 'Mühlheimer Freiheit und interessante Bilder aus Deutschland', Galerie Paul Maenz, Cologne, FRG.

1981 'Bildwechsel — Neue Malerei aus Deutschland', Akademie der Künste, Berlin, FRG.

1982 Galerie Paul Maenz, Cologne, FRG; 10 Künstler aus Deutschland, Museum Folkwang, Essen, FRG.

1983 Galerie Paul Maenz, Cologne, FRG; Museum am Ostwall, Dortmund, FRG; 'Expressionisten — Neue Wilde', Museum am Ostwall, Dortmund, FRG.

1984 Kunstmuseum Hannover mit Sammlung Sprengel, Hannover, FRG; Ileana Sonnabend Gallery, New York, USA; Ulmer Museum, Ulm, FRG; Galerie Reinhard Onnasch, Berlin, FRG; 'Zwischenbilanz — Neue Deutsche Malerei', Galerie Krinzinger, Insbruck, Austria; Museum Villa Stuck, Munich, FRG; Rheinisches Landesmuseum, Bonn, FRG

1985 Galerie Paul Maenz, Cologne, FRG; Galerie Buchmann, Basel, Switzerland; '7000 Eichen', Kunsthalle, Tübingen, FRG; Kunsthalle, Bielefeld, FRG; Fridericianum, Kassel, FRG;

1986 Ileana Sonnabend Gallery, New York, USA; Galerie Wanda Reiff, Maastricht, Netherlands; Galerie Reinhard Onnasch, Berlin, FRG; 'Wild Visionary

Spectral: New German Art', Art Gallery of South Australia, Adelaide, Australia; Art Gallery of Western Australia, Perth, Australia; National Art Gallery, Wellington, New Zealand.

1987 Galerie Fahlbusch, Mannheim, FRG; Galerie Paul Maenz, Cologne, FRG; Galerie Arnesen, Copenhagen, Denmark; Galerie Artinizing, Munich, FRG.

1988 Galerie Harald Behm, Hamburg, FRG; 'Refigured Painting: The German Image 1960–1988', Toledo Museum of Art, Toledo, Ohio, USA.

1989 Galerie Paul Maenz, Cologne, FRG; 'Refigured Painting: The German Image 1960–1988', Guggenheim Museum, New York, USA; William College Museum of Art, Williamstown, Massachusetts, USA; 'Neue Figuration. Deutsche Malerei 1960–1988', Kunstmuseum, Düsseldorf, FRG; Schirn Kunsthalle, Frankfurt/M., FRG.

1991 Galerie Wanda Reiff, Maastricht, Netherlands (with Walter Dahn and Jiri Georg Dokoupil); Galerie Christian Gögger, Munich, GER; Galerie Hermeyer, Munich, GER;

1992 Galleria d'Arte Emilio Mazzoli, Modena, Italy.

Collections

Paintings, graphical works and sculptures in national and international, private and public collections.

Selected bibliography

1981 Exh. cat. *Bildwechsel — Neue Malerei in Deutschland*, Interessenge-meinschaft Berliner Kunsthändler, Berlin. Exh. cat. *Mülheimer Freiheit, die Seefahrt und der Tod*, Kunsthalle Wilhelmshaven, Kunstverein Wolfsburg.

1982 Exh. cat. *10 junge Künstler aus Deutschland*, Museum Folkwang, Essen; Exh. cat. *12 junge Künstler aus Deutschland*, Kunsthalle Basel, Museum Boysmans-van-Beuningen, Rotterdam; Wolfgang Max Faust/Gerd

de Vries, *Hunger nach Bildern*,
DuMont Verlag, Cologne.

1985 Exh. cat. *Kunst in der Bundesrepublik Deutschland 1945–1985*,
Nationalgalerie Berlin.

1987 Stephan Schmidt-Wulffen,
Spielregeln: Tendenzen der Gegenwartskunst, DuMont
Buchverlag, Cologne.

1989 Exh. cat. *Neue Figuration. Deutsche Malerei 1960–1988*, Munich;
Kunstmuseum Düsseldorf; Schirn
Kunsthalle Frankfurt; Exh. cat.
Refigured Painting. The German Image 1960–1988, New York.

WERNER BÜTTNER

Born in Jena/Thuringia in 1954.
Lives and works in Hamburg.
1990 Professor at the Hochschule der
Bildenden Künste, Hamburg.

Selected exhibitions
1981 Galerie Max Hetzler, Stuttgart, FRG.
1982 Galerie Max Hetzler, Stuttgart, FRG;
Realismusstudio 21 der Neuen
Gesellschaft für Bildende Kunst,
Berlin, FRG (with A. Oehlen).
1983 Maximilian Verlag — Sabine Knust,
Munich, FRG; Galerie Ascan Crone,
Hamburg, FRG; Galerie Helen van der
Meij, Amsterdam, Netherlands;
Galerie Max Hetzler, Cologne, FRG.
1984 Galerie Ehrhardt, Madrid, Spain;
Galerie Max Hetzler, Cologne, FRG;
Maximilian Verlag — Sabine Knust,
Munich, FRG.
1985 CADA, Munich, FRG; Forum Kunst,
Rottweil, FRG; Evangelische

Akademie, Hamburg, FRG; Galerie
Thomas Borgmann, Cologne, FRG;
Metro Pictures, New York, USA;
Galerie Peter Pakesch, Vienna,
Austria; Galerie Max Hetzler,
Cologne, FRG; Galerie Ascan Crone,
Hamburg, FRG; Galerie Wanda Reiff,
Maastricht, Netherlands; Galerie Paul
Andriesse, Amsterdam, Netherlands.
1986 Galerie Grässlin-Erhardt, Frankfurt/M.,
FRG; Galerie Crousel-Hussenot, Paris,
France; Metro Pictures, New York,
USA; Galerie Borgmann-Capitain,
Cologne, FRG; Institute of
Contemporary Arts, London, UK.
1987 Galerie Max Hetzler, Cologne, FRG;
Kunstverein München im Museum
Villa Stuck, Munich, FRG; Maximilian
Verlag — Sabine Knust, Munich, FRG;
Galerie Peter Pakesch, Vienna,
Austria; Palais Lichtenstein, Vienna,
Austria; Galerie Ursula Schurr,
Stuttgart, FRG; Kunstverein,
Oldenburg, FRG; Galerie Susan Wyss,
Zurich, Switzerland.
1988 Galerie Ascan Crone, Hamburg, FRG;
Galerie Grässlin-Ehrhardt,
Frankfurt/M., FRG; Galerie Gisela
Capitain, Cologne, FRG; PPS. Galerie
F.C. Grundlach, Hamburg, FRG.
1989 Galerie Max Hetzler, Cologne, FRG;
Galerie Brandt, Fredensborg,
Denmark; Galerie Gisela Capitain,
Cologne, FRG.
1990 Jänner Galerie, Vienna, Austria;
Galerie Ascan Crone, Hamburg, FRG.
1991 Galerie Peter Pakesch, Vienna,
Austria; Galerie Max Hetzler,
Cologne, GER; Galerie Grässlin-
Ehrhardt, Frankfurt/M., GER.
(as well as many group exhibitions)
Collections
Paintings and graphical works in major national
and international, private and public collections.
Selected bibliography
1983 Exh. cat. *Wer diesen Katalog nicht
gut findet muß sofort zum Arzt* (with
M. Kippenberger, A. Oehlen and M.,

Oehlen), Galerie Max Hetzler,
Stuttgart; Exh. cat. *Die Probleme des
Minigolfs in der europäischen
Malerei*, Galerie Max Hetzler,
Cologne.
1984 Exh. cat. *Wahrheit ist Arbeit* (with A.
Oehlen and M. Kippenberger),
Museum Folkwang, Essen; *Von hier
aus — Zwei Monate neue deutsche
Kunst*, DuMont Verlag, Cologne;
Annelie Pohlen, 'Werner Büttner', in:
Artforum, 1/84.
1985 Exh. cat. *Werner Büttner*, Annemarie-
und-Wilhelm-Grohmann-Stipendium,
Kunsthalle Baden-Baden; Exh. cat.
Tiefe Blicke, Hessisches
Landesmuseum, Darmstadt; DuMont
Verlag, Cologne; Reagan Upshaw,
'Werner Büttner at Metro Pictures',
in: *Art in America* (November).
1986 Exh. cat. *Macht und Ohnmacht der
Beziehungen*, Museum am Ostwall,
Dortmund; Exh. cat. *What about
having our mother back!*, Institute of
Contemporary Art, London.
1987 Exh. cat. *Auf der Spur — Sammlung
Stoher*, Haus am Waldsee, Berlin.
1988 Exh. cat. *Arbeit in Geschichte —
Geschichte in Arbeit*, Kunsthaus
Hamburg, Hamburg.
1989 Exh. cat. *Refigured Painting: The
German Image 1960–1988*, Salomon
R. Guggenheim Museum, New York;
Roberta Smith, 'Art That Doesn't Care
Too Much About Its Looks', in: *The
New York Times*, 22.01.1989.

WALTER DAHN

Born in St. Tönis near Krefeld in 1954.
Lives and works in Cologne.
1971–77 Studied at the Staatliche
Kunstakademie, Düsseldorf. Master-
class student under Josef Beuys.
Selected exhibitions
1982 Galerie Maenz, Cologne, FRG; Galerie
Helen van der Meij, Amsterdam,
Netherlands; Galerie 't Venster,
Rotterdam, Netherlands (co-operative

paintings with Jiri Georg Dokoupil);
Galerie Hetzler, Stuttgart, FRG.

1983 Galerie Chantal Crousel, Paris, France; Produzentengalerie, Hamburg, FRG; Mary Boone Gallery, New York, USA; Galerie Silvia Menzel, Berlin, FRG.

1984 Galerie Six Friedrich, Munich, FRG; Groninger Museum, Groningen, Netherlands (Co-operative paintings with Jiri Georg Dokoupil); Galerie Maenz, Cologne, FRG; Mary Goodman Gallery, New York, USA; Galerie Crousel-Hussenot, Paris, France.

1985 Galerie Maenz, Cologne, FRG; Barbara Jandrig Galerie, Krefeld, FRG; Galerie Vera Munro, Hamburg, FRG (Co-operative paintings with Jiri Georg Dokoupil); Paule/Anglim Gallery, San Francisco, USA; Asher/Faure Gallery, Los Angeles, USA; Rheinisches Landesmuseum, Bonn, FRG.

1986 Kunsthalle, Basel, Switzerland; Museum Folkwang, Essen, FRG; Museum für Gegenwartskunst, Basel, Switzerland; Kaiser-Wilhelm-Museum, Krefeld, FRG; Galerie Schurr, Stuttgart, FRG; Galerie Munro, Hamburg, FRG; Galerie Maenz, Cologne, FRG; Musée de Grenoble, France; Galerie Six Friedrich, Munich, FRG.

1987 Stedelijk Van Abbemuseum, Eindhoven, Netherlands; Galerie Wanda Reiff, Maastricht, Netherlands; Galerie Roger Pailhas, Marseille, Paris; Galleri 16, Stockholm, Sweden; Badischer Kunstverein, Karlsruhe, FRG; Galerie Swart, Amsterdam, Netherlands; Neuer Aachener Kunstverein, Aachen, FRG.

1988 Galerie Maenz, Cologne, FRG; PPS-Galerie Gundlach, Hamburg, FRG; Galerie Six Friedrich, Munich, FRG; Galerie Elisabeth Kaufmann, Zurich, Switzerland; Österreichisches Fotoarchiv im Museum Moderne

Kunst, Vienna, Austria; Galleria Il Capricorno, Venice, Italy.

1989 Galerie Swart, Amsterdam, Netherlands; Kunstverein, Munich, FRG; Galeria Leyendecker, Santa Cruz de Tenerife, Tenerife; Galerie Meyer-Ellinger, Frankfurt/M., FRG.

1990 Akira Ikeda Gallery, Nagoya, Japan; Barbara Gladstone Gallery, New York, USA; Galerie Schurr, Stuttgart, FRG; Galerie Fred Hoffman, Santa Barbara, USA.

(as well as many group exhibtions)

Collections
Paintings and graphical works in all major national and international, private and public collections.

Selected bibliography

1981 Exh. cat. *Die Heimliche Wahrheit-Mülheimer Freiheit*, Kunstverein, Freiburg; Wolfgang Max Faust, 'Mühlheimer Freiheit', in: *Flash Art*, no. 106, Editione Italiana.

1982 Wolfgang Max Faust/Gerd de Vries, *Hunger nach Bildern — Deutsche Malerei der Gegenwart*, DuMont Buchverlag, Cologne; Exh. cat. *10 Künstler aus Deutschland*, Museum Folkwang, Essen; Exh. cat. *12 Künstler aus Deutschland*, Kunsthalle, Basel/Museum Boymans-van Beuningen, Rotterdam.

1985 Exh. cat. *Tiefe Blicke — Kunst der achtziger Jahre*, DuMont Buchverlag, Cologne; Exh. cat. *Kunst in der Bundesrepublik 1945–1985*, Nationalgalerie, Berlin.

1986 Exh. cat. *Walter Dahn: Gemälde 1981–85*, Kunsthalle, Basel; Museum Folkwang, Essen; Stedelijk Van Abbemuseum, Eindhoven; Exh. cat. *Walter Dahn: Peintures 1986*, Grenoble. Stedelijk Museum, Amsterdam, Netherlands; *Wild Visionary Spectral: New German Art*, Art Gallery of South Australia, Adelaide and Art Gallery of Western Australia, Perth, Australia; National

Art Gallery, Wellington, New Zealand.

1987 Exh. cat. *Walter Dahn — Bilder und Skulpturen 1987*, Neuer Aachener Kunstverein, Aachen.

1989 Exh. cat. *Walter Dahn*, Kunstverein, Munich.

CHRISTA DICHGANS

Photograph: Christiane Hartmann

1940 Born in Berlin (West).
1960–65 Studies painting at the Hochschule der Künste, Berlin. Master-class student under Fred Thieler.
1966/67 DAAD Scholarship for residence in New York.
1971 Scholarship to Villa Romana, Florence, Italy.

Lives and works in Berlin.

Selected exhibitions

1970 'Actuel Kunt fra Vesterblin', Pa Genthofte Radhous, Kopenhagen, Denmark.
1971 Villa Romana, Florence, Italy.
1972 Christa Dichgans. Bilder 1967–1972. Galerie Springer, Berlin, FRG
1975 Galerie Lerner-Heller, New York, USA; Kunstverein Ludwigsburg, FRG.
1977 'Neuerwerbungen', Berlinische Galerie, Berlin, FRG; 'Manscape', Oklahoma Art Center, Oklahoma City, USA; 'Zur Kunstförderung in Deutschland', Kunsthalle Baden-Baden, FRG; 'Villa Romana Florenz', Kunsthalle Recklinghausen, Germany.
1978 'Arte Fiera 78', Bologna, Italy; Galerie Springer, Berlin, FRG; 'Museum des Geldes', Kunsthalle Düsseldorf, FRG; 'International Exhibition of Art-

1979 Promoting Posters', Tel Aviv, Israel.
'Malerei in Berlin 1970–heute', Städtisches Kunstmuseum, Bonn, FRG.

1980 'Women from Berlin — The Exchange Show', San Francisco, USA.

1982 Galerie Springer, Berlin, FRG; 'Realistinnen', Hochschule der Künste, Berlin, FRG.

1983 Galerie Hans Strelow, Düsseldorf; 'Mensch und Landschaft in der Zeitgenössischen Malerei und Graphik in der Bundesrepublik', Moskau and Leningrad, Russia; 'All over', Städtisches Museum Schloß Hardenberg, Velbert, FRG.

1984 'Christa Dichgans. Bilder 1981–1983', Galerie Springer, Berlin, FRG; Galerie Hans Neuendorf, Hamburg, Germany; Raab Galerie, Berlin, FRG; 'Zukunftsräume', Kassel, FRG; Orangerie Karlsruhe, FRG; Städtische Galerie Erlangen, FRG; Palais Stuterheim, Graz, Austria.

1985 'Der Stand der Dinge', Kunstverein Mannheim, FRG; Städtische Galerie, Viersen, FRG.

1986 'Christa Dichgans. Köpfe und Masken', Galerie Springer Berlin, FRG; Galerie Joachim Becker, Cannes, France.

1990 'Christa Dichgans — Bilder 1988 bis 1990', Kunstverein Göttingen, FRG.

1991 'Interferenzen — Kunst aus Westberlin 1960–1990', Museum für ausländische Kunst, Riga, Latvia; 'PARIS BAR'; Galerie Artcurial Paris, France.

1992 Haus am Waldsee, Berlin, GER.

Collections
Paintings in major national and international, private and public collections.

Selected bibliography
1972 Exh. cat. *Christa Dichgans, Bilder 1967–1972*, Galerie Springer, Berlin.

1977 Exh. cat. *Neuerwerbungen*, Berlinische Galerie, Berlin; Exh. cat. *Manscape*, Oklahoma Art Center, Oklahoma City; Exh. cat. *Zur Kunstförderung in Deutschland*, Kunsthalle Baden-Baden; Exh. cat. *Villa Romana Florenz*, Kunsthalle Recklinghausen.

1978 Exh. cat. *Museum des Geldes*, Kunsthalle Düsseldorf.

1979 Exh. cat. *Malerei in Berlin 1970–heute*, Städtisches Kunstmuseum, Bonn.

1980 Exh. cat. *Women from Berlin — The Exchange Show*, San Francisco.

1984 Exh. cat. *Christa Dichgans. Bilder 1981–1983*, Galerie Springer, Berlin.

1985 Exh. cat. *Christa Dichgans. Köpfe und Masken*. Galerie Springer, Berlin; Friedrich W. Kasten (ed.), exh. cat. *Der Stand der Dinge*, Kunstverein Mannheim and Städtische Galerie Viersen.

1987 Neue Gesellschaft für Bildende Kunst e.V. (ed.), *Das verborgene Museum*, Edition Hentrich, Berlin.

1989 Exh. cat. *Christa Dichgans. Neue Bilder*, Galerie Springer, Berlin.

1990 Exh. cat. *Christa Dichgans — Bilder 1988 bis 1990*, Kunstverein Göttingen.

1991 Exh. cat. *Interferenzen — Kunst aus Westberlin 1960–1990*, Verlag Dirk Nishen, Berlin.

HARTWIG EBERSBACH

Photograph: Udo Hesse, Berlin

Born in Zwickau in 1940.
Lives and works in Leipzig.
1959–64 Studied at the Hochschule für Grafik und Buchkunst, Leipzig, under Bernhard Heisig.

1985 Art Prize awarded by the artists of Düsseldorf.

Selected exhibitions
1969 Galerie Wort und Werk, Leipzig, GDR.

1973 Galerie Kunst der Zeit, Leipzig, GDR.

1979 'Missa Nigra' (première), Leipzig, GDR.

1981 Galerie West, Dresden, GDR (broken off after opening).

1982 Galerie Oben, Karl-Marx-Stadt, GDR; Staatliches Lindenau-Museum, Altenburg, GDR.

1983 Kleine Galerie, Meerane, GDR.

1984 'Durchblick', Städtische Galerie Schloß Oberhausen, Ludwig-Institut für Kunst der DDR, Oberhausen, FRG.

1985 Galerie am Thomaskirchhof, Leipzig, GDR.

1986 Galerie Hochschule für Bildende Künste, Dresden, GDR; Torgalerie, Neubrandenburg, GDR; Galerie Gierig, Leinwandhaus, Frankfurt/M., FRG; Galerie Zimmer, Düsseldorf, FRG; 'Art Cologne', Cologne, FRG; Galerie Gierig, Frankfurt/M., FRG; 'Durchblick II', Städtische Galerie Schloß Oberhausen, Ludwig-Institut für Kunst der DDR, Oberhausen, FRG.

1987 'X. Foire d'Art Actuel', Brussels, Belgium; Galerie de Maere, Brussels, Belgium; Galerie Raab, Fulda, FRG; Galerie Vogtland, Plauen, GDR; Greifengalerie, Greifswald, GDR; 'La Grande Parade', Galerie Brusberg, Berlin, FRG; Galerie unter den Linden, Berlin, GDR; 'X. Kunstausstellung der DDR', Dresden, GDR; 'Die Aktdarstellung in der Kunst der DDR', Galerie Gierig, Frankfurt/M., FRG.

1988 Studio Bildende Kunst, Berlin, GDR; Galerie Zimmer, Düsseldorf, FRG; Gallery Prakapas, New York, USA; Produzentengalerie Eigen+Art, Leipzig, GDR; Galerie Mauer, Berne, Switzerland; 'Zeitvergleich '88', Neues Kunstquartier im T.I.P., Berlin, FRG.

1989 Galerie Unter den Linden, Berlin, GDR; Galerie Gierig, Frankfurt/M.,

FRG; 'Menschenbilder — 13 Maler aus der DDR', Kunsthalle, Emdem, FRG; Kunstmesse, Frankfurt/M., Galerie Gierig; 'Zeitzeichen — Malerei & Grafik aus der DDR', Tokyo/Nagano/Kumamoto/Kamakura/Kobe/Hakodate, Japan.

1990 Galerie Radetzky+Gierig, Munich, FRG; Kabinett am Goetheplatz, Stadtmuseum, Weimar, GDR; Neue Berliner Galerie im Alten Museum, Zentrum für Kunstausstellungen der DDR, GDR; Kunstsammlung, Chemnitz, GDR; 'Bilder aus Deutschland — Kunst aus der DDR', Museum Ludwig, Cologne, FRG.

1991 Kloster Unser Lieben Frauen, Magdeburg, GER; Galerie Zimmer, Düsseldorf, GER; Galerie Berlin, Berlin, GER.

Collections
Paintings in mainly national, private and public collections.

Selected bibliography
1977 Günter Meißner, *Leipziger Künstler der Gegenwart*, Leipzig.
1982 Exh. cat. *Hartwig Ebersbach*, Staatliches Lindenau-Museum, Altenburg.
1984 Exh. cat. *Tradition and Renewal*, Oxford/Coventry/ Sheffield/Newcastle/London; Exh. cat. *Durchblick*, Ludwig-Institut für Kunst der DDR, Oberhausen.
1985 Exh. cat. *Tiefe Blicke*, Darmstadt.
1986 Exh. cat. *Katalog, H.E.*, Galerie Timm Gierig, Frankfurt/M.; Exh. cat. *Durchblick II*, Ludwig-Institut für Kunst der DDR, Oberhausen.
1987 Exh. cat. *Die Aktdarstellung in der Kunst der DDR*, Galerie Timm Gierig, Frankfurt/M.
1988 Exh. cat. Ulrich Eckhardt/Dieter Brusberg (eds), *Zeitvergleich '88. 13 Maler aus der DDR*, Berlin; Ursula Feist, 'Kaspar und Jaspar, Kain-Abel und Sisyphos. Selbstbildnisse und Ego-Vexierbilder im Werk von Hartwig

Ebersbach, Walter Libuda, Max Uhlig und Wolfgang Mattheuer', in: *Niemandsland* (July).

1990 Eckhart Gillen/Rainer Haarmann (eds), *Kunst aus der DDR*, Verlag Kiepenhauer & Witsch, pp. 383–5; *Bilder aus Deutschland. Kunst der DDR aus der Sammlung Ludwig. Malerei, Skulptur, Grafik*, Edition Braus, Cologne.

1991 Exh. cat. *Hartwig Ebersbach: Ich-Kaspar-Drache*, Kulturabteilung Bayer AG, Leverkusen; Galerie Zimmer, Düsseldorf.

RAINER FETTING

The artist in his studio Hasenheide 61, Berlin with the painting Seekuh, June 1989. Photograph: Manfred Hamm, Berlin

Born in Wilhelmshaven in 1949.
Lives in Berlin and New York.
1972–78 Studied painting under Hans Jaenisch at the Hochschule der Künste, Berlin.
1978–79 DAAD Scholarship for residence in New York.

Selected exhibitions
1977 Galerie am Moritzplatz, Berlin, FRG.
1980 'Junge Kunst aus Berlin', Travelling Art Exhibition, Goethe-Institut, Munich, FRG.
1981 Anthony d'Offay Gallery, London, UK; Mary Boone Gallery, New York, USA; 'A New Spirit in Painting', Royal Academy of Arts, London, UK.
1982 Anthony d'Offay Gallery, London, UK; Galerie Paul Maenz, Cologne, FRG; 'Berlin — das malerische Klima einer Stadt', Musée des Beaux-Arts, Lausanne, Switzerland; Museum

Folkwang, Essen, FRG, Kunsthalle, Basel, Switzerland; 'Zeitgeist', Martin-Gropius-Bau, Berlin, FRG.

1984 'An International Survey of Recent Painting and Sculpture', Museum of Modern Art, New York, USA.

1985 Raab Galerie, Berlin, FRG; Galerie Thomas, Munich, FRG; 'Kunst in der Bundesrepublik Deutschland 1945–1985', Nationalgalerie, Berlin, FRG.

1986 Museum Folkwang, Essen, FRG; Kunsthalle, Basel, Switzerland; Marlborough Gallery, New York, USA; 'Wild Visionary Spectral: New German Art', Art Gallery of South Australia, Adelaide, Australia, Art Gallery of Western Australia, Perth, Australia; National Art Gallery, Wellington, New Zealand.

1987 'Berlinart 1967–1987', Museum of Modern Art, New York, USA; San Francisco Museum of Modern Art, San Francisco, USA.

1988 Raab Galerie, Berlin, FRG; Galerie Pfefferle, Munich, FRG; 'Refigured Painting: The German Image 1960–1988', Toledo Museum of Art, Toledo, Ohio, USA.

1989 Museo di Barcelona, Centro S. Monica, Spain; Waddington & Shiell Galleries, Toronto, Canada; 'Refigured Painting: The German Image 1960–1988', Guggenheim Museum, New York, USA; William College Museum of Art, Williamstown, Massachusetts, USA; 'Neue Figuration. Deutsche Malerei 1960–1988', Kunstmuseum, Düsseldorf, FRG; Schirn Kunsthalle, Frankfurt, FRG.

1990 Nationalgalerie, Berlin (East), FRG; Stadtmuseum Weimar, FRG.

1991 Raab Galerie, Berlin, GER, Raab Gallery, London, UK; Galerie Pfefferle, Munich, GER; Galerie Mönch, Bremen, GER; 'Interferenzen — Kunst aus Westberlin 1960–1990', Museum für ausländische Kunst, Riga, Latvia.

Collections

Paintings and sculptures in major national and international, private and public collections.

Selected bibliography

1981 Exh. cat. *A New Spirit in Painting*, Royal Academy of Arts, London; Exh. cat. *Bildwechsel — Neue Malerei in Deutschland*, Interessengemeinschaft Berliner Kunsthändler, Berlin.

1982 Lisa Liebman, 'Rainer Fetting at Mary Boone', in: *Art in America*, February 1982, New York.

1986 Tony Godfrey, *The New Image — Paintings in the 80s*, Abbeville Press, New York.

1987 John Yau, 'Rainer Fetting. Marlborough Gallery', in: *Artforum International*, January, New York; in: *New York Times*, January, New York.

1988 Donald B. Kuspit, 'Rainer Fetting: The Melancholy, Sensual Self', in: *Contemporanea*, vol. I, no. 2, July/August, New York.

1989 Exh. cat. *Vierzig Jahre Kunst in der Bundesrepublik Deutschland*, Städtische Galerie, Schloß Oberhausen, Berlin. Exh. cat. *Neue Figuration. Deutsche Malerei 1960–1988*, Munich; Kunstmuseum Düsseldorf; Schirn Kunsthalle Frankfurt; Exh. cat. *Refigured Painting. The German Image 1960–1988*, New York.

1990 Donald B. Kuspit, 'Rainer Fetting', in: *Arts Magazine*, January, New York. Exh. cat. *Rainer Fetting. Berlin/New York*, Staatliche Museen zu Berlin/GDR, Nationalgalerie; Stadtmuseum Weimar (Bertuchhaus), Kabinett am Goethehaus.

1991 Exh. cat. *Fetting 1990–1991*, Raab Galerie, Berlin; Raab Gallery, London.

GALLI

Photograph: Heidrun Melinski-Frank, Berlin

Born in Heusweiler in 1944.
Lives and works in Berlin.

1962–67 Studied at the Werkschule Saarbrücken.

1969–76 Studied at the Hochschule der Künste, Berlin. Became master-class student under Martin Engelman.

1984 Working grant awarded by Kunstfond e.V.

1989 Received Will-Grohmann-Prize.

1990 Received Villa Romana Scholarship to live in Florence.

1992– Professorship at the School of Fine Arts, Münster.

Selected exhibitions

1974 Galerie d'Eendt, Amsterdam, Netherlands.

1978 Modersohn-Becker-Haus, Bremen, FRG; Galerie Boutemard, Berlin, FRG.

1979 Exhibition at her studio, Berlin, FRG.

1980 Max-Planck-Institut für Bildungsforschung, Berlin, FRG; Galerie Fundus, Berlin, FRG.

1981 Galerie der Berliner Festspiele, Berlin, FRG.

1982 Galerie Schoof, Heidelberg, FRG; Galerie Nothelfer, Berlin, FRG.

1983 Galerie Maier-Hahn, Düsseldorf, FRG.

1984 Galerie Le Dessin, Paris, France; Kunstforum, Rottweil, FRG; Galerie Lang, Vienna, Austria.

1985 Galerie Baumgarten, Freiburg, FRG; Galerie Georg Nothelfer, Berlin, FRG; Städtisches Bodensee-Museum, Friedrichshafen, FRG; Galerie von Loeper, Hamburg, FRG; Städtische Galerie am Markt, Schwäbisch Hall, FRG.

1986 Galerie Rothe, Heidelberg, FRG; Stadtgalerie, Saarbrücken, FRG; Galerie Sfeir-Semmler, Kiel, FRG; Galerie Kremer-Tengelmann, Gelsenkirchen, FRG.

1987 Galerie Baumgarten, Freiburg, FRG; Galerie Ohse, Bremen, FRG; Galerie Wetter, Stuttgart, FRG.

1988 Galerie Georg Nothelfer, Berlin, FRG; Galerie Kremer-Tengelmann, Cologne, FRG; Galerie Rothe, Heidelberg, FRG.

1989 Salzburger Kunstverein, Künstlerhaus, Salzburg, Austria; Galerie Metta Linde, Lübeck, FRG; Galerie Baumgarten, Freiburg, FRG.

1990 Villa Romana, Florence, Italy.

1991 Galerie Rothe, Heidelberg, GER; Galerie Georg Nothelfer, Berlin, GER; Galerie Rothe, Frankfurt/M., GER.

1992 Galerie Academia, Salzburg, Austria.

(as well as participation at several group exhibitions)

Collections

Paintings and drawings in national and international, private and public collections.

Selected bibliography

1982 Exh. cat. *Galli. Arbeiten aus den Jahren 1977 bis 1982*, Galerie Georg Nothelfer, Berlin.

1985 Exh. cat. *Galli*, Galerie Georg Nothelfer, Berlin.

1987 Neue Gesellschaft für Bildende Kunst e.V. (ed.), *Das verborgene Museum*, Edition Hentrich, Berlin.

1988 Exh. cat. *Galli. Bilder, Oskar Pastior. Anagramme*, Galerie Georg Nothelfer, Berlin.

1991 Exh. cat. *Galli. Unerwünschte Wirkung. Bilder und Zeichnungen 1988–1991*. Berlin-Florenz-Berlin, Galerie Georg Nothelfer, Berlin.

GISELA GENTHNER

Photograph: Ahmad Saidi-Azar

Born in Peking/China in 1945.
Lives and works in Berlin.
1972–79 Studied at the Hochschule der Künste, Berlin. Master-class student under Professor Bachmann.
1982–83 Scholarship to live in the Domenican Republic.
1988 Scholarship awarded by the Gemeinschaft der Deutschen Künste e.V., Berlin.
1989 Financial support from the Berlin Senate to exhibit in New Zealand.
1989 Working scholarship awarded by the Senate for cultural concerns, Berlin.

Selected exhibitions
1979 Galerie Fundus, Berlin, FRG.
1980 Galerie Mönch, Berlin, FRG.
1982 Galerie am Chamissoplatz, Berlin, FRG; Galerie Fundus, Berlin, FRG.
1983 Galeria Pricipal, Altos de Chavon, Dominican Republic.
1984 'Neuerwerbungen der Artothek', Neuer Berliner Kunstverein, Berlin, FRG; 'Landschaften', Galerie Meyke, Berlin, FRG; 'Positionen Berlin', Frauenmuseum, Bonn, FRG.
1985 Off Galerie, Berlin, FRG; Galerie Mönch, Berlin, FRG; Galerie Mora, Berlin, FRG; 'Bericht 85', Kunsthalle, Berlin, FRG.
1986 Galerie von Loeper, Hamburg, FRG (with A. Tapies, E. Bach and M. Köhler); Berlin, FRG; 'Images of Shakespeare', Nationalgalerie, Berlin, FRG.
1987 Off Galerie, Berlin, FRG;

'Fahnenausstellung', Galerie Mönch, Berlin, FRG.
1988 Star Art Gallery, Auckland, New Zealand; Northland Gallery, Wangerei, New Zealand; Karo Galerie, Berlin, FRG; Deplana Mezzano, Berlin, FRG; '5. Nationale der Zeichnung', Atelier Galerie, Augsburg, FRG; 'Arbeiten zeitgenössischer Künstlerinnen', Das verborgene Museum, Berlin, FRG; 'Christmas Exhibition', Louise Beale Gallery, Wellington, New Zealand.
1989 Canterbury Society of Art, Christchurch, New Zealand; 'Das kleine Format', Galerie Pels Leusden, Berlin, FRG; 'Combined Abstract Painting', Star Art Gallery, Auckland, New Zealand; 'Gelb-Rot-Blau', Kunstamt Tiergarten, Obere Galerie, Berlin, FRG; '9 Berliner Künstler', Europaparlament Strassbourg, France.
1990 'Kunstszene Berlin (West) 86–89. Erwerbungen des Senats von Berlin', Berlinische Galerie im Gropius Bau, Berlin, FRG; 'Berliner Tendenzen', Kulturzentrum Nicosia, Goethe Institut, Cyprus; 'Zweitakt', Bildende Kunst aus Berlin Ost und West, Ausstellungszentrum am Alexanderplatz, Berlin, GDR.
1991 Galerie Gleditsch, Berlin, GER; Städtische Galerie, Schwalenberg, GER; Lippischer Kunstverein, Lippe, GER; 'Beständig', Galerie Mönch, Berlin, GER;
1992 Sassen Galerie, Berlin, GER; 'Seh Stücke', Überseemuseum, Bremen, GER; Galerie am Körnerpark, Berlin, GER; Kulturforum, Leonberg, GER.

Collections
Paintings in national and international private and public collections.

Selected bibliography
1983 Exh. cat. *Gisela Genthner*, Galeria Principal, Altos de Chavon, Dominican Republik.
1984 Heinz Ohf, 'Poetische

Konstellationen', in: *Tagesspiegel*, Berlin (December); Exh. cat. *Positionen Berlin*, Frauenmuseum Bonn.
1985 Thomas Wulfen, 'Abstrakt und Beständig', in: *Zitty*, 2/85
1986 'Künstler mittenmang und jotwede', in: *Geo Spezial 'Berlin'* (June); Ursula Prinz, 'Gisela Genthner', in: exh. cat. *Gisela Genthner. Collagen und Bilder*, Off Galerie, Berlin.
1987 Exh. cat. *Zur Physiologie der Bildenden Kunst. Berlin 1985–87*, Huber/Müller Ladengalerie, Berlin.
1988 Exh. cat. *5. Nationale der Zeichnung*, Atelier Galerie, Augsburg.
1991 Ursula Frohne, 'Gisela Genthner. Bildgebäude. Von der Mischtechnik zur Imagination', in: *Artist*, 2/91; Elke Melkus, 'Künstlerportrait', in: *Prinz*, 2/91; Exh. cat. *Gisela Genthner*, Lippischer Landesverband, Lippe.
1992 Eike Gebhardt, 'Und ewig lockt das Schwarz', in: Exh. cat. *Gisela Genthner. Arbeiten von 1988–1991*, Berlin.

HUBERTUS GIEBE

Born in Dohna in 1953.
Lives and works in Dresden.
1969–72 Attended evening classes at the Hochschule für Bildende Künste, Dresden.
1974–76 Studied painting and graphic arts at the Hochschule für Bildende Künste, Dresden.
1978–79 Master-class student under Bernhard Heisig at the Hochschule für Grafik und Buchkunst, Leipzig.
1979–82 Assistant lecturer together with Johannes Heisig at the Hochschule für Bildende Künste, Dresden.
1987– Lecturer for painting/graphic arts at the Hochschule für Bildende Künste, Dresden.
1990– Artistic Pro-director at the Hochschule für Bildende Künste, Dresden.

Selected exhibitions

1978 Wissenschaftliche
Allgemeinbibliothek, Potsdam, GDR
(with Uli Richter).
1980 Galerie Comenius, Dresden, GDR.
1981 Galerie of the Hochschule für Bildende
Künste, Dresden, GDR; Galerie des
Damastmuseums, Großschönau, GDR;
'Europäische Triennale der
Radierkunst', Grado, Italy.
1982 'V. Triennale India', New Dehli, India.
1983 Studio Bildende Kunst, Berlin, GDR;
Galerie Schmidt-Rottluff, Karl-Marx-
Stadt, GDR (with Johannes Heisig and
Walter Libuda).
1984 'DDR Heute', Kunsthalle, Worpswede,
FRG; 'Tradition and Renewal',
Museum of Modern Art, Oxford, UK
(travelled to Coventry/Sheffield/
London, UK).
1985 Galerie Unter den Linden, Berlin,
GDR; 'Expressivität Heute',
Nationalgalerie, Berlin, GDR.
1986 'Dresden Heute' (travelling
exhibition), Ulm/Singen/
Ravensburg/Gelsenkirchen, FRG and
Riehen/Basel, Switzerland; 'Kunst der
80er Jahre in der DDR', Galerie der
Stadt Esslingen, Esslingen; 'Durchblick
II', Städtische Galerie Schloß
Oberhausen, Ludwig-Institut für
Kunst der DDR, Oberhausen, FRG.
1987 Studentenclub der Technischen
Universität 'Bärenzwinger', Dresden,
GDR.
1988 Hans-Grundig-Klub, Riesa, GDR;
Galerie Sunnen, Bech-Kleinmacher,
Luxemburg (with Johannes Heisig);
'Zeitvergleich '88', Neues
Kunstquartier im T.I.P., Berlin, FRG.
1989 Junge Kunst der 80er Jahre aus der
DDR, Kunstmuseum, Solothurn,
Switzerland; 'Zeitzeichen — Malerei &
Grafik aus der DDR', Tokyo/Nagano/
Kumamoto/Kamakura/Kobe/
Hakodate, Japan; Kunst der letzten
10 Jahre, Museum Moderner Kunst,
Vienna; Konturen, Nationalgalerie,
Berlin, FRG.
1990 Galerie Carl Blechen, Cottbus, GDR;
Neue Dresdner Galerie, Dresden,
GDR; 'Biennale di Venezia', GDR
Pavillon, Venice, Italy (with Walter
Libuda); 'International Art Exposition',
Chicago, USA; 'Leipziger Schule'
(travelling exhibition), Berlin/
Oberhausen/Hannover, FRG;
'Neuerwerbungen', Städtische Galerie
Schloß Oberhausen, Ludwig-Institut
für Kunst der DDR, Oberhausen, FRG.

Collections

Paintings and graphical works mainly in
national, private and public collections.

Selected bibliography

1978 Eva Strittmatter, 'Hubertus Giebe', in:
*Mir scheint, der Kerl lasiert. Dichter
über Maler*, Berlin.
1981 Diether Schmidt, 'Weg vom schönen
Schein ästhetischer Wohligkeit', in:
exh. cat. *Junge Dresdner Kunst*,
Dresden.
1983 Christoph Tannert, 'Hubertus Giebe',
in: *Kontakte*, 5/83.
1984 Exh. cat. *Hubertus Giebe*, Galerie
Schmidt-Rottluff, Karl-Marx-Stadt;
Hubertus Giebe, 'Über Max
Beckmann', in: *Bildende Kunst*, 3/84,
Berlin; Gert Claußnitzer, 'Hubertus
Giebe', in: *Künstler in Dresden*, Berlin.
1985 Exh. cat. *Hubertus Giebe*, Galerie
Unter den Linden, Berlin; Exh. cat.
Expressivität heute, Nationalgalerie/
Altes Museum, Berlin.
1986 Exh. cat. *Dresden heute. Malerei und
Graphik nach 1945*, Galerie Döbele,
Ravensburg; Exh. cat. *Durchblick II*,
Städtische Galerie Schloß
Oberhausen, Ludwig-Institut für
Kunst der DDR, Oberhausen.
1988 Exh. cat. *Hubertus Giebe, Johannes
Heisig*, Galerie Sunnen, Bech-
Kleinmacher, Luxemburg; Exh. cat.
Junge Kunst aus der DDR,
Niedersächsische Sparkassen Stiftung.
1989 Exh. cat. *Konturen*, Nationalgalerie,
Berlin.
1990 Exh. cat. *Geschichtsbilder*, Neue
Dresdner Galerie, Dresden; Exh.
leaflet *Hubertus Giebe*, Raab Gallery,
London, based on the introduction by
Henry Schumann: *Hubertus Giebe*,
Bienale Di Venezia, 1990.

FRIEDEMANN HAHN

Born in Singen/Hohentwiel in 1949.
Lives and works in Brandenberg near Todtnau,
Black Forest.
1970–74 Studied under Peter Dreher at the
Staatliche Akademie der Bildenden
Künste (Karlsruhe), Freiburg branch.
1974–76 Studied under Karl Otto Götz at the
Staatliche Kunstakademie, Düsseldorf.
1974–76 Scholarship awarded by
Studienstiftung des deutschen Volkes.
1977–79 Scholarship awarded by Karl-Schmidt-
Rottluff-Foundation.
1977 Art Prize 'Junger Westen' from city of
Recklinghausen.
1979 Scholarship to Villa Romana, Florence,
Italy.
1980 Art Prize awarded by Kulturkreis im
Bundesverband der deutschen
Industrie.
1981 Guest lecturship at the Fachhoschule
für Gestaltung, Pforzheim. Received
Villa-Massimo-Prize.
1982 Art Prize awarded by Kreissparkasse
Esslingen-Nürtingen.
1984 Support Prize awarded by
Internationaler Preis für Bildende Kunst
des Landes Baden-Württemberg.
1988 Guest lecturship at the Internationale
Akademie für Kunst und Gestaltung
der Fachhochschule, Hamburg.

1988–89 Guest professorship at the Staatliche Akademie der Bildenden Künste, Karlsruhe.
1991 Guest professorship for painting at the Johannes Gutenberg Universität, Mainz.

Selected exhibitions
1976 Städtische Galerie, Wolfsburg, FRG; Kunstverein, Wolfenbüttel, FRG.
1979 'Schmidt-Rottluff-Stipendium', Mathildenhöhe, Darmstadt, FRG; Villa Romana, Florence, Italy.
1980 Kunstverein, Freiburg, FRG; 'Forms of Realism Today — Federal Republic of Germany', Musée d'Art Contemporain, Montréal, Canada.
1981 Kunstverein, Braunschweig, FRG; Städtische Galerie, Ravensburg, FRG; Enzo Cannaviello, Milano, FRG.
1983 Villa Massimo, Rome, Italy.
1984 Städtische Galerie, Würzburg, FRG; Städtische Galerie, Schwäbisch Hall, FRG; Kunstverein, Lüneburg, FRG; Staatliche Kunsthalle, Baden-Baden, FRG.
1985 Kunstverein, Pforzheim, FRG; Galleria Lillo, Mestre-Venice, Italy; Städtische Galerie, Innsbruck, Austria.
1986 Galerie Fred Lanzenberg, Brussels, Belgium; Angela Flowers Gallery, London, UK; Museum für Neue Kunst, Freiburg, FRG.
1987 Kunstverein, Ludwigsburg, FRG; Hans Thoma-Gesellschaft, Reutlingen, FRG; Galerie Hans Barlach, Cologne, FRG.
1988 Kunstverein Singen FRG; Galerie Hans Barlach, Hamburg, FRG; Galerie Lavignes-Bastille, Paris, France; Angela Flowers Gallery, London, UK; Städtische Galerie, Wolfsburg, FRG; 'Refigured Painting: The German Image 1960–1988', Toledo Museum of Art, Toledo, Ohio, USA.
1989 Forum Kunst, Rottweil, FRG; Landesmuseum, Oldenburg, FRG; Städtische Galerie, Göppingen, FRG; 'Refigured Painting: The German Image 1960–1988', Guggenheim Museum, New York, USA; William College Museum of Art, Williamstown, Massachusetts, USA; 'Neue Figuration. Deutsche Malerei 1960–1988', Kunstmuseum, Düsseldorf, FRG; Schirn Kunsthalle, Frankfurt/M., FRG.
1990 Oberhessisches Museum, Gießen, FRG; Kunstkreis Südliche Bergstrasse Kraichgau, Wiesloch, FRG; Städtische Galerie Bietigheim, Bietigheim-Bissingen, FRG; Galerie Lavignes-Bastille, Paris, France; Galerie Heinz Wenk, Dortmund, FRG.
1991 Galeria Masha Prieto, Madrid, Spain; Flowers Graphics, London, UK; Kunstverein, Uelzen, GER; Kunstmuseum, Heidenheim, GER; Ulmer Kunststiftung 'Pro Arte', Ulm, GER; Zeppelin Museum, Friedrichshafen, GER.
1992 Städtische Kunsthalle, Mannheim, GER.

Collections
Paintings and graphical works in major national and international, private and public collections.

Selected bibliography
1976 Exh. cat. *Friedemann Hahn: Gemälde, Zeichnungen, Aquarelle, Druckgrafik*, Städtische Galerie Wolfsburg.
1980 Exh. cat. *Friedemann Hahn: Malerei auf Leinwand und Papier*, Kunstverein Freiburg.
1984 Exh. cat. *Friedemann Hahn — Szenen aus 'Lust for Life'*, Staatliche Kunsthalle Baden-Baden.
1985 Exh. cat. *Friedemann Hahn: Bilder aus den Jahren 1973–1984*, Kunstverein Pforzheim und Galerie Hermeyer, Munich.
1987 Exh. cat. *Friedemann Hahn: Aquarelle und Tuschzeichnungen*, Hans Thoma-Gesellschaft, Reutlingen.
1989 Exh. cat. *Friedemann Hahn. Bilder*, Landesmuseum Oldenburg, Städtische Galerie Göppingen, Oberhessisches Museum Gießen.
1990 Exh. cat. *Friedemann Hahn: Zeichnungen und Aquarelle*, Kunstkreis Südliche Bergstraße Wiesloch, Städtische Galerie Bietigheim-Bissingen, Städtische Galerie Villingen-Schwenningen, Stadtmuseum Ratingen, Kunstmuseum Heidenheim; Hans Barlach/Edition Cantz (ed.), *Friedemann Hahn. Werkverzeichnis der Radierungen 1976–1990*, Stuttgart.
1991 Exh. cat. *Friedemann Hahn: Wortbilder. Auf dem Weg zum Motiv*, Kunstmuseum Heidenheim.
1992 Exh. cat. *Friedemann Hahn: Wege zum Motiv*, Städtische Kunsthalle Mannheim.

ANGELA HAMPEL

Photograph: Tina Bara

Born in Räckelwitz in 1956.
Lives and works in Dresden.
1977–82 Studied under Jutta Damme and Dietmar Büttner at the Hochschule für Bildende Künste, Dresden.
1986 Received prize from the Staatliche Kunsthandel der DDR '100 ausgewählte Grafiken'.
1990 Received Marianne-Werefkin-Prize.

Selected exhibitions
1984 Galerie Mitte, Dresden, GDR; '14 Künstlerinnen aus dem Bezirk Dresden', Städtisches Museum, Göttingen, FRG.
1985 '30 Leporellos', Obergrabenpresse, Dresden, GDR; 'Expressivität Heute', Altes Museum, Berlin, GDR; 'Young Artists for Peace', International Art

Competition, Torun, Poland.

1986 Galerie Eigen+Art, Leipzig, GDR;
Galerie Linneborn, Bonn, FRG;
'Femme-Artistes de la R.D.A.', Centre
de la R.D.A. Paris, France.

1987 Galerie Comenius, Dresden, GDR;
Galerie Döbele, Ravensburg, FRG;
Galerie Grimm, Munich, FRG; A-ORT-
A, Galerie Nord, Dresden, GDR;
'Havet — Tema med Variationer',
Stockholm, Sweden; 'Biennale', San
Paulo, Brasil.

1988 Kleine Galerie, Hoyerswerda, GDR;
Klub der Intelligenz, Chemnitz, GDR;
Galerie erph, Erfurt, GDR;
'Värimaailmoja, Kunst aus der DDR',
Ioensuum Taidemuseo, Helsinki,
Finland; 'Zeitvergleich '88 — 13 Maler
aus der DDR', Neues Kunstquartier im
T.I.P., Berlin, FRG; 'XVIII. Biennale',
Venice, Italy.

1989 Galerie Catherine Mauer, Bern,
Switzerland; Konturen,
Nationalgalerie, Berlin, FRG; 'Junge
Malerei der 80er Jahre',
Kunstmuseum, Solothurn,
Switzerland; 'Zwischenspiele',
Kunstamt Kreuzberg, Haus Bethanien,
Berlin, FRG; 'Zeitzeichen', Malerei und
Grafik aus der DDR; Tokyo,
Kumamoto, Kamakura, and others,
Japan.

1990 Schloß Salzau, Schleswig-Hostein,
FRG; Neue Dresdner Galerie, Dresden,
GDR; 'Selbst-Bild, Dredner Sezession
'89', Galerie Mitte, Dresden, GDR;
'Angela Hampel, Wolfgang Smy',
Galerie Bodenschatz, Basel,
Switzerland; 'New Territory: Art from
East Germany', School of the
Museum of Fine Arts, Boston, USA;
'Bilder aus Deutschland', Kunsthalle,
Cologne, FRG.

1991 Galerie Döbele, Stuttgart, GER; Kleine
Galerie, Straßburg, France; Galerie
Friedländer Tor, Neubrandenburg,
GER; Galerie Comenius, Dresden,
GER; Galerie am Hauptmarkt, Gotha,

GER; Galerie Refugium, Neustrelitz,
GER, Festspielgalerie, Berlin,GER;
'Außerhalb von Mittendrin', Neues
Quartier im T.I.P., Berlin, GER; 'Bilanz
— Deutsche Kunst aus Ost und West
1945–1990', Ludwig-Institut-
Oberhausen, Museum Saarlouis, GER;
'Das Tier, der Mensch', Dresdner
Sezession '89, Galerie Comenius,
Dresden, FRG; 'New Territory: Art
from East Germany', University of
Maryland, Museum of Fine Arts,
Kansas, USA.

Collections
Paintings and graphic works in national private
and public collections.

Selected bibliography
1986 Gunhild Brandler, 'Aus einem
Gespräch zwischen der Malerin
Angela Hampel …', in: exh. cat.
Angela Hampel, Galerie Comenius,
Dresden.

1987 Angela Hampel, Galerie Comenius
(ed.), 'Meine Hand ziehe ich von Dir',
in: *Leaflet for the exhibition A-ORT-A*,
Dresden.

1988 Eberhardt Roters, 'Vom Dialekt in der
Malerei', in: exh. cat. *Zeitvergleich*,
Berlin, and in: *Brusberg Dokumente*
no. 19, Berlin (1989), p. 114f.; Ingrid
Wetzkat, 'Psycholand A-ORT-A', in:
Union 43, no. 8, Dresden.

1989 Angela Hampel, 'Androgyn — eine
Wirklichkeit in uns', in: *Bildende
Kunst*, no. 5, pp. 57 f.; Angela
Hampel, 'Ich krieche zwischen Steinen
umher', in: exh. cat. *Zwischenspiele*,
NGBK, Berlin.

1990 Angela Hampel, 'Vom Geheimnis im
Bild', in: *Sondeur*, no. 5, Berlin,
p. 47 f.; Elke Erb, 'Wie ich zu den
Malern kam', in: Andreas
Koziol/Reiner Schedlinski (eds), *Abriß
der Ariadnefabrik*, Edition Galrev,
Berlin, p. 318; Günter Feist/Eckhart
Gillen, *Kunstkombinat DDR — Eine
Dokumentation 1945–1990*, Berlin;
Eckhardt Gillen/Rainer Haarmann

(eds), *Kunst in der DDR*, Cologne.

1991 Angela Hampel, 'Neun Jahre', in: exh.
cat. *Sächsische Druckwerkstätten*,
Dresden, p. 43; Claus Bach, 'New
Territory: Art from East Germany', in:
Bildende Kunst, no. 1, Berlin, p. 11 f.;
Gunhild Brandler, 'Aber die Künstler
sind weiblich', in: *Außerhalb von
Mittendrin*, Berlin, p. 12 f.

JOHANNES HEISIG

Photograph: Wilfried Melzer, Dresden

Born in Leipzig in 1953.
Lives and works in Dresden.

1973–77 Studied painting and graphic arts at
the Hochschule für Grafik und
Buchkunst, Leipzig.

1978–80 Master-class student under Gerhard
Kettner at the Hochschule für
Bildende Künste, Dresden.

1980– Taught at the Hochschule für
Bildende Künste, Dresden.

1989–91 Director of the Hochschule für
Bildende Künste, Dresden.

1991 Guest lecturer at the Kunstakademie
Trondheim, Norway.

Selected exhibitions
1980 Justinusheim der
Auslandsstipendiaten, Zurich,
Switzerland; 'Junge Künstler der
DDR', Frankfurt/Oder and Halle, GDR.

1981 'Meisterschüler stellen aus', Neue
Dresdner Galerie, Dresden, GDR.

1982 Galerie im Heimatmuseum,
Markkleeberg, GDR; Kleine Galerie im
Kulturpalast Maxhütte,
Unterwellenborn, GDR;
Buchhandlung 'Le Roi des Aulnes',

Paris, France (with W. Libuda); 'Selbstbildnisse Leipziger Künstler', Museum für Bildende Künste, Leipzig, GDR.

1983 Galerie im Leibniz-Club des Kulturbundes, Leipzig, GDR; 'Junge Künstler des Bezirkes Leipzig', Staatliches Lindenau-Museum, Altenburg, GDR.

1984 Galerie der Hochschule für Bildende Künste, Dresden, GDR; Galerie Schmidt-Rottluff, Karl-Marx-Stadt, GDR (with W. Libuda and H. Giebe); 'DDR heute', Kunsthalle, Worpswede, FRG; 'Durchblick', Ludwig-Institut für Kunst der DDR, Oberhausen, FRG; 'Musik in der Bildenden Kunst der DDR', Centre Culturel de la R.D.A., Paris, France (travelled to Kuwait, Egypt and Yemen).

1985 'Expressivität Heute — 6 Junge Maler der DDR', Nationalgalerie, Berlin, GDR.

1986 Planned exhibition was cancelled due interference of the art historian Christoph Tannert and the state department; 'Durchblick 2', Ludwig-Institut für Kunst der DDR, Oberhausen, FRG.

1987 Galerie erph, Erfurt, GDR; Galerie Junge Kunst, Frankfurt/Oder, GDR; Studio Galerie, Hamburg, FRG (with W. Liebmann).

1988 Galerie der Stadt Esslingen, Bahnwärterhaus, Esslingen, FRG; Galerie Sunnen Bech-Kleinmacher, Luxemburg (with H. Giebe); Galerie der Universität Dortmund, Dortmund, FRG.

1989 'Zeitzeichen — Malerei & Grafik aus der DDR', Tokyo/Nagano/Kumamoto/Kamakura/Kobe/Hakodate, Japan.

1990 Galerie Rähnitzgasse 8, Dresden, GDR; Galerie erph, Erfurt, GDR; 'Bilder aus Deutschland — Kunst aus der DDR', Museum Ludwig, Cologne, FRG.

1991 Galerie am Chamissoplatz, Berlin, GER; Frankfurter Kunstkabinett Hanna Bekker vom Rath GmbH, Frankfurt/M., GER.

1992 Studio Galerie Heinz Maschmann, Hamburg, GER.

Collections
Paintings and graphical works in mainly national private and public collections.

Selected bibliography

1983 Exh. cat. *Johannes Heisig*, Gottfried-Wilhelm-Leipniz-Klub, Leipzig.

1984 Exh. cat. *Johannes Heisig*, Galerie der Hochschule für Bildende Künste, Dresden.

1985 Johannes Heisig, 'Referat auf der 6. Tagung des Zentralvorstandes des VBK der DDR' (excerpt), in: *Bildende Kunst*, vol. 33, 10/85, p. 434.

1987 Johannes Heisig, 'Neue Medien und traditionelle Malerei-Ausbildung', in: *Synthesis Visual Arts in the Electronic Culture. Beiträge zum internationalen UNESCO Seminar an der Hochschule für Gestaltung*, Offenbach/Main, pp. 204–15; Exh. cat. *Johannes Heisig*, Galerie Erph, Erfurt; Johannes Heisig, 'Gedanken zur Malerei auf der X. Kunstausstellung der DDR', in: *Bildende Kunst*, vol. 35, 10/87, pp. 476–7; Exh. cat. *Kunst aus der DDR. Johannes Heisig, Walter Liebmann*, Studio Galerie Heinz Maschmann, Hamburg; Exh. cat. *Johannes Heisig*, Kabinett der Galerie Junge Kunst, Frankfurt/Oder.

1988 Exh. cat. *Johannes Heisig*, Galerie der Stadt Esslingen, Bahnwärterhaus, Esslingen; Exh. cat. *Hubertus Giebe, Johannes Heisig*, Galerie Sunnen Bech-Kleinmacher, Luxemburg.

1990 Exh. cat. *Johannes Heisig*, Galerie Rähnitzgasse 8, Dresden.

1991 Exh. cat. *Johannes Heisig*, Frankfurter Kunstkabinett Hanna Bekker vom Rath GmbH, Frankfurt/M.

K.H. HÖDICKE

Photograph: Felver

Born in Nürnberg in 1938.
Lives and works in Berlin.

1959–64 Studied under Fred Thieler at the Hochschule für Bildende Künste, Berlin.

1964 Art Prize for Young Artists, Mannheim.

1968 Villa Massimo Scholarship to live in Rome.

1974– Professor at the Hochschule für Bildende Künste, Berlin.

1983 Prize of the German Critics Association.

Selected exhibitions

1964 Galerie Großgörschen 35, Berlin, FRG.

1969 Galerie René Block, Berlin, FRG.

1972 Neuer Berliner Kunstverein — Videothek, Berlin, FRG.

1976 René Block Gallery, New York, USA.

1977 Badischer Kunstverein, Karlsruhe, FRG; René Block Gallery, New York, USA.

1980 Gallerie Springer, Berlin, FRG; DAAD — Galerie, Berlin, FRG.

1981 Haus am Waldsee, Berlin, FRG; Annina Nosei Gallery, New York, USA.

1982 L.A. Louver Gallery, Los Angeles, USA; Galerie Folker Skulima, Berlin, FRG.

1983 Galerie Gmyrek, Düsseldorf, FRG; Galerie Munro, Hamburg, FRG; Galerie Ehinger-Schwarz, Ulm, FRG; Forum Kunst, Rottweil, FRG; 'New Figuration: Contemporary Art from Germany', Frederick S. Wight Art Gallery, Los Angeles, University of California, USA.

1984 Boibrino Gallery, Stockholm, Sweden; Galeria Fernando Vijande, Madrid, Spain; Kunstverein, Hamburg, FRG; Galerie Gmyrek, Düsseldorf, FRG; Galerie Silvia Menzel, Berlin, FRG; Kunstverein, Freiburg, FRG; Galerie Folker Skulima, Berlin, FRG; 'Die wiedergefundene Metropole', Palais des Beaux-Arts, Brussels, Belgium.

1985 Studio d' Arte Cannaviello, Milano, Italy; 'German Art in the 20th Century: Painting and Sculpture 1905–1985', Royal Academy of Arts, London, UK (Staatsgalerie, Stuttgart, FRG, 1986).

1986 Galerie Joachim Becker, Cannes, France; Galerie Emmerich-Baumann, Zurich, Switzerland; Kunstsammlung Nordrhein-Westfalen, Düsseldorf, FRG; Galerie Folker Skulima, Berlin, FRG; Galerie Gmyrek, Düsseldorf, FRG; Städtische Kunsthalle, Mannheim, FRG; Städtische Galerie Wolfsburg, FRG; Kunstverein, Wolfsburg, FRG.

1987 Galerie Gmyrek, Düsseldorf, FRG; Marisa del Re Gallery, New York, USA; L.A. Louver Gallery, Venice (California), USA; Galerie Folker Skulima, Berlin, FRG.

1988 Berlinische Galerie, Berlin, FRG.

1989 Galerie Gmyrek, Düsseldorf, FRG.

1990 Studio d' Arte Cannaviello, Milano, Italy.

1991 Galerie Gmyrek, Düsseldorf, GER.

1992 Raab Galerie, Berlin, GER and London, UK.

Collections

Paintings, sculptures and graphical works in major national and international, private and public collections.

Selected bibliography

1977 Exh. cat. *K.H. Hödicke*, Badischer Kunstverein, Karlsruhe.

1981 Exh. cat. *K.H. Hödicke: Bilder 1962–1980*, Haus am Waldsee, Berlin.

1984 K.H. Hödicke, *Purzelbaum: Bilder und Gedichte*, Rainer Verlag, Berlin/

Kunstverein Freiburg.

1986 Exh. cat. *K.H. Hödicke: Gemälde, Skulpturen, Objekte, Filme*, Kunstsammlung Nordrhein-Westfalen, Düsseldorf; Jörn Merkert, 'K.H. Hödicke. La foire de la réalité: sur l' art de K.H. Hödicke, in: *Artstudio 2*, pp. 72–9.

1987 Dirk Schwarze, 'K.H. Hödicke. Gemälde, Skulpturen, Objekte, Filme', in: *Kunstforum International*, vol. 87, pp. 331–3; Walter Grasskamp, 'K.H. Hödicke', in: *Artefactum*, vol. 4, no. 17, pp. 33–8.

1988 Exh. cat. *K.H. Hödicke*, Berlinische Galerie, Berlin.

1989 Exh. cat. *K.H. Hödicke: Fuchsien*, Galerie Gmyrek, Düsseldorf; Peter Winter, 'Fuchsien — neue Bilder. Galerie Gmyrek, Düsseldorf', in: *Das Kunstwerk*, 42, no. 3, p. 95.

1990 Exh. cat. *K.H. Hödicke: Tiger*, Studio d'Arte Cannaviello, Milano.

1991 Exh. cat. *K.H. Hödicke: 89/90 MATERIALIEN*, Galerie Gmyrek, Düsseldorf.

1992 Exh. cat. *K.H. Hödicke malt Elvira*, Raab Galerie, Berlin/London.

LEIKO IKEMURA

Born in Tsu Mie, Japan, in 1951.
Lives and works in Cologne and Berlin.

1970–72 Studies at the University of Osaka, Japan.

1973–78 Studied at the art academy in Sevilla, Spain.

1981 Received grant by City of Zurich and by the Kiefer-Hablitzel-Foundation, Berne.

1982 Received Kaiserwerther Art Prize, Düsseldorf, 2nd Prize of the International Drawing Triennale of Young Artists, Nuremberg, and Prize of the Foundation for graphic art in Switzerland, ETH Zurich.

Selected exhibitions

1980 Galerie Pablo Stähli, Zurich, Switzerland.

1981 Galerie Toni Gerber, Berne, Switzerland.

1982 Galerie Paul Maenz, Cologne, FRG; Galerie van Krimpen, Amsterdam, Netherlands.

1983 Kunstverein, Bonn, FRG; Galerie Pablo Stähli, Zurich, Switzerland; Galerie Toni Gerber, Berne, Switzerland; 'Aktuell 83 — Kunst aus Mailand, München, Wien und Zürich', Städtische Galerie im Lenbachhaus, Munich, FRG.

1984 Kunsthalle, Nürnberg, FRG; Galerie Dany Keller, Munich, FRG; Kunstverein, St. Gallen, Switzerland.

1985 Kunsthalle im Waaghaus, Winterthur, Switzerland; Galerie Skulima, Berlin, FRG; 'Kunst mit Eigen-Sinn', Museum des 20. Jahrhunderts, Vienna, Austria; 'Tiefe Blicke — Kunst der achtziger Jahre aus der Bundesrepublik Deutschland, der DDR, Österreich und der Schweiz', Hessisches Landesmuseum, Darmstadt, FRG.

1986 Galerie Toni Gerber, Berlin, FRG; Acht Künstlerinnen. Acht künstlerische Positionen, Staatsgalerie, Saarbrücken, FRG; Sie machen was sie wollen — Junge Rheinische Kunst, Galerie Schipka, Sofia, Bulgaria; Museo de Arte Contemporaneo, Sevilla, Spain.

1987 Galerie Pablo Stähli, Zurich, Switzerland; Galerie Karsten Greve, Cologne, FRG; Galerie Dany Keller, Munich, FRG; Museum für Gegenwartskunst, Basel, Switzerland; Forum Kunst, Rottweil, FRG.

1988 Musée Cantonal des Beaux Arts, Lausanne, Switzerland; Kunstverein, Lingen, FRG; Wolfgang-Gurlitt-Museum, Linz, Austria; Galerie Skulima, Berlin, FRG; Galerie Varisella, Frankfurt/M., FRG.

1989 Kunstverein, Saarbrücken, FRG; Kunstmuseum, Ulm, FRG; Galerie Karsten Greve, Cologne, FRG; Galerie Camille von Scholz, Brussels, Belgium.

1990 Satani Gallery, Tokyo, Japan; 'Blau —
Farbe der Ferne', Kunstverein,
Heidelberg, FRG.
1991 Galerie Karsten Greve, Cologne, GER;
Galerie Pablo Stähli, Zurich,
Switzerland.
1992 Kunstverein, Salzburg, Austria;
Galerie Camille von Scholz, Brussels,
Belgium.

Collections
Paintings, graphical works and sculptures in
national and international, private and public
collections.

Selected bibliography
1983 Exh. cat. *Leiko Ikemura*, Kunstverein,
Bonn; Exh. cat. *Aktuell 83 — Kunst
aus Mailand, München, Wien, Zürich*,
Städtische Galerie im Lenbachhaus,
Munich.
1984 Exh. cat. *Leiko Ikemura*, Kunsthalle,
Nürnberg; Exh. cat. *Leiko Ikemura*,
Kunstverein, St. Gallen.
1985 Exh. cat. *Kunst mit Eigen-Sinn*,
Museum des 20. Jahrhunderts,
Vienna; Exh. cat. *Märchen, Mythen,
Monster*, Rheinisches Landesmuseum,
Bonn; Exh. cat. *Tiefe Blicke — Kunst
der achtziger Jahre aus der
Bundesrepublik, der DDR, Österreich
und der Schweiz*, Hessisches
Landesmuseum, Darmstadt.
1986 Exh. cat. *Andere Blicke*,
Wissenschaftsministerium, Bonn; Exh.
cat. *Sie machen was sie wollen —
Junge Rheinische Kunst*, Galerie
Schipka, Sofia and Museo de Arte
Contemporaneo de Sevilla; 'Leiko
Ikemura', in: *Kunstforum
International*, vol. 83 (March, April,
May), p. 246.
1987 Exh. cat. *Leiko Ikemura*, Museum für
Gegenwartskunst, Basel; Christoph
Schenker, 'Leiko Ikemura', in:
Kunstforum International, vol. 88
(March, April), pp. 312–3.
1988 Exh. cat. *Leiko Ikemura. Von der
Wirkung der Zeit*, Kunstverein, Lingen.
1990 Exh. cat. *Leiko Ikemura. Alpen
Indianer*, Satani Gallery, Tokyo; Exh.
cat. *Blau — Farbe der Ferne*, Hans
Gercke (ed.), Wunderhorn Verlag,
Heidelberg.

JÖRG IMMENDORFF

Born in Bleckede, near Lüneburg, in 1945.
Lives and works in Düsseldorf and Hamburg.
1963–64 Three terms of theatre arts with Teo
Otto at the Art Academy, Düsseldorf.
1964 Participated in classes with Joseph
Beuys.
1981 Visiting lecturer at the College of Art,
Stockholm.
1982–85 Lectureships at the Art Academies of
Hamburg, Munich and Trondheim.
1987/88 Visiting artist in Auckland, New
Zealand, for three months.
1989– Professor at the Städel School,
Frankfurt/M.

Selected exhibitions
1961 New Orleans Club, Bonn, FRG.
1969 Galerie Michael Werner, Cologne, FRG.
1971 Galerie Michael Werner, Cologne,
FRG; Galerie Heiner Friedrich, Munich,
FRG.
1972 Galerie Michael Werner, Cologne, FRG.
1973 Westfälischer Kunstverein, Münster,
FRG; Galerie Michael Werner,
Cologne, FRG.
1974 Daner Galleriet, Kopenhagen,
Denmark; Galerie Michael Werner,
Cologne, FRG.
1976 Venice Biennale, Venice, Italy.
1978 Galerie Michael Werner, Cologne,
FRG.
1979 Kunstmuseum, Basel, Switzerland.
1980 'Les Nouveaux Fauves — Die Neuen
Wilden', Neue Galerie — Sammlung
Ludwig, Aachen, FRG.
1981 'Art Allemagne Aujourd'hui', Musée
d'Art Moderne de la Ville de Paris,
France; 'Westkunst: Zeitgenössische
Kunst seit 1939', Museen der Stadt,
Cologne, FRG.
1982 'Zeitgeist', Martin-Gropius-Bau,
Berlin, FRG; 'documenta 7', Kassel,
FRG; Fourth Biennale of Sydney,
Australia.
1983 Stedelijk Van Abbemuseum,
Eindhoven, Netherlands; Kunsthalle,
Düsseldorf, FRG; 'Expressions: New
Art from Germany', Saint Louis Art
Museum, USA.
1984 'An International Survey of Recent
Painting and Sculpture', Museum of
Modern Art, New York, USA; 'The
Fifth Biennale of Sydney: Private
Symbol, Social Metaphor', Art Gallery
of New South Wales, Sydney,
Australia.
1985 Maison de la Culture et de la
Communication, St. Etienne, France;
Kunstverein, Braunschweig, FRG;
'Kunst in der Bundesrepublik
Deutschland 1945–1985',
Nationalgalerie, Berlin, FRG; '7000
Eichen', Kunsthalle, Tübingen, FRG;
Kunsthalle, Bielefeld, FRG; Pittsburgh
Museum of Art, Carnegie Institute,
USA; 'German Art in the 20th
Century, Painting and Sculpture
1905–1985', Staatsgalerie, Stuttgart,
FRG; Royal Academy of Arts, London,
UK.
1986 Mary Boone/Michael Werner Gallery,
New York, USA; Nigel Greenwood
Gallery, London, UK; 'Wild Visionary
Spectral: New German Art', Art
Gallery of South Australia, Adelaide,
Australia; Art Gallery of Western
Australia, Perth, Australia; National
Art Gallery, Wellington, New Zealand.
1988 Auckland City Art Gallery, Auckland,
New Zealand.
1990 Portikus, Frankfurt/M., FRG; Galeria
Juana de Aizpuru, Madrid, Spain;
Galerie de l'Ecole d'Art, Marseille,
France.

Collections
Paintings in major national and international,
private and public collections.

Selected bibliography
1969 Jörg Immendorff, *Katalog einer
Ausstellung zur Lidl-Woche*,
Düsseldorf.

1973 Jörg Immendorff, *Hier und Jetzt: Das tun, was zu tun ist*, Verlag der Buchhandlung Walter König, Cologne.

1977 Exh. cat. *Jörg Immendorff*, Hedendaagse Kunst, Utrecht.

1978 Siegfried Gohr, 'Das "Café Deutschland" von Jörg Immendorff', in: *Kunst Magazin*, vol. 18, no. 2, p. 48 f.; Siegfried Gohr, 'Jörg Immendorffs "Café Deutschland"' und Johannes Gachnang, 'Jörg Immendorffs "Café Deutschland"', in: *Kunstforum International*, vol. 26, no. 2, p. 238–42.

1979 Exh. cat. *Jörg Immendorff, 'Café Deutschland'*, Kunstmuseum Basel.

1980 Exh. cat. *Jörg Immendorff, Malermut rundum*, Kunsthalle Bern.

1981 Exh. cat. *Jörg Immendorff — Teilbau*, Galerie Neuendorf, Hamburg; Exh. cat. *Jörg Immendorff, Lidl, 1966–1970*, Stedelijk Van Abbe Museum, Eindhoven.

1982 Jörg Immendorff, *Grüsse von der Nordfront*. Poem: A.R. Penck. Galerie Fred Jahn, Munich; Exh. cat. *Jörg Immendorff. Café Deutschland/ Adlerhälfte*, Kunsthalle Düsseldorf; Exh. cat. *Jörg Immendorff. 'Kein Licht für wen?'*, Galerie Michael Werner, Cologne.

1983 Exh. cat. *Immendorff*, Kunsthaus Zürich.

1984 Exh. cat. *Jörg Immendorff: Café Deutschland and related works*, Museum of Modern Art, Oxford.

1985 Exh. cat. *Jörg Immendorff*, Kunstverein Braunschweig.

1987 Exh. cat. *Jörg Immendorff — Neue Arbeiten*, Galerie Michael Werner, Cologne.

1990 Exh. cat. *Immendorff*, Galerie Michael Werner, Cologne.

1991 Exh. cat. *Jörg Immendorff — Early Works and Lidl*, Galerie Michael Werner, New York.

TINA JURETZEK

Born in Leipzig in 1952.
Lives and works in Düsseldorf.

1971–78 Studied under Günter Grote at the Staatlichen Kunstakademie, Düsseldorf.

1983 Support Prize awarded by the Jury, Stadtsparkasse, Karlsruhe.

1984 Kaiserring Scholarship awarded by city of Goslar.

1987 Support Scholarship awarded by Aldegrever-Gesellschaft, Münster.

1989 Bergischer Art Prize.

Selected exhibitions

1979 Kunsthistorisches Institut der Universität Köln, Cologne, FRG.

1981 'Forum Junger Kunst', Städtische Galerie, Wolfsburg, FRG; Kunstmuseum, Düsseldorf, FRG; Kunsthalle, Kiel, FRG.

1982 Galerie Wieghardt, Lüdenscheid, FRG.

1983 Galerie Zimmer, Düsseldorf, FRG; Kunstmarkt Köln, Förderkoje der Galerie Zimmer, Cologne, FRG; 'Exchange', Museum and Art Gallery, Reading, UK; 'Neuerwerbungen und Dauerleihgaben', Museum Ludwig, Cologne, FRG.

1984 Galerie Zimmer, Düsseldorf, FRG; Mönchehaus Museum, Goslar, GDR (in connection with the Kaiserring Scholarship); 'Forum Junger Kunst', Stuttgart/Mannheim/ Baden-Baden, FRG; 'Alles in Ordnung', Kunstverein, Mannheim, FRG.

1985 Kunstverein, Bremerhaven, FRG; Galerie Marghescu, Hannover, FRG; Niederrheinischer Kunstverein, Wesel, FRG; BASF, Ludwigshafen, FRG; Leopold-Hoesch-Museum, Düren, FRG.

1986 '6. Triennale-India', New Dehli, India (Official contribution of the FRG); Galerie Leger, Munich, FRG; Galerie Goma, Einhoven, Netherlands; Kunstmuseum, Düsseldorf, FRG (with H. Boehle and K.M. Rennertz).

1987 Galerie Marghescu, Hannover, FRG; 'Darmstädter Sezession', Mathildenhöhe, Darmstadt, FRG; Kunsthalle, Krakau, Poland.

1988 Galerie Zimmer, Düsseldorf; 'Meine Zeit, mein Raubtier', Ehrenhof, Düsseldorf, FRG; 'Günther Beckers. Tina Juretzek', Galerie Neher, Essen, FRG.

1989 Galerie Napela, Berlin, FRG; Städtische Galerie, Würzburg, FRG; Galerie Marghescu, Hannover, FRG; 'Zeitzeichen — Stationen bildender Kunst in NRW', Landesvertretung NRW, Bonn, FRG; Museum der bildenden Künste und Galerie der Hochschule, Leipzig, GDR; Wilhelm-Lehmbruck-Museum, Duisburg, FRG.

1990 Goethe-Institut, Brussels, Belgium; Verbindungsbüro Nordrhein-Westfalen, Brussels, Belgium; Galerie de Luxembourg, Luxemburg; Galerie Zimmer, Düsseldorf, FRG; 'Blau — Farbe der Ferne', Kunstverein, Heidelberg, FRG; 'Kunstminen', Städtisches Kunstmuseum, Düsseldorf, FRG.

1991 Galerie Nalepa, Berlin, GER; Städtisches Museum Haus Koekkoek, Kleve, GER; Kodama Gallery, Osaka, Japan.

1992 Galerie de Luxembourg, Luxemburg.

Collections
Paintings and graphical works in national and international private, and mainly national public collections.

Selected bibliography

1981 Exh. cat. *Forum Junger Kunst*, Städtische Galerie, Wolfsburg; Kunstmuseum Düsseldorf; Kunsthalle Kiel.

1983 Exh. cat. *Exchange*, Museum and Art Gallery, Reading; Exh. cat. *Forum Junger Kunst*, Stuttgart, Mannheim, Baden-Baden.

1984 Exh. cat. *Alles in Ordnung*, Kunstverein, Mannheim.

1985 Exh. cat. *Tina Juretzek. Malerei, Collage, Zeichnungen*, BASF Feierabendhaus, Ludwigshafen.

1987 Exh. cat. *Malerei 1980–87*, Kunstverein, Augsburg; Exh. cat. *Darmstädter Sezession*, Mathildenhöhe Darmstadt/Kunsthalle Krakau; Exh. cat. *Ein Bild der Gegenwart*, Galerie Zimmer, Düsseldorf.

1988 Exh. cat. *Günther Beckers. Tina Juretzek*, Galerie Neher, Essen.

1989 Exh. cat. *Tina Juretzek. Bilder und Zeichnungen*, Stadt-Sparkasse, Düsseldorf. Exh. cat. *Zeitzeichen — Stationen bildender Kunst in NRW*, Landesvertretung NRW, Bonn; Museum der Bildenden Künste Künste und Galerie der Hochschule, Leipzig; Wilhelm-Lehmbruck-Museum, Duisburg.

1990 Hans Gercke (ed.), exh. cat. *Blau — Farbe der Ferne*, Kunstverein Heidelberg.

1991 Exh. cat. *Tina Juretzek. Die violetten Bilder*, Städtisches Museum, Haus Koekkoek, Kleve.

CLEMENS KALETSCH

Born in Munich in 1957.
Lives and works in Cologne.

1976–86 Lived in Innsbruck and Vienna. Studied at the Hochschule für Angewandte Kunst and at the Akademie der Bildenden Künste, Vienna, under Oberhuber and Rainer.

Selected exhibitions

1980 Galerie Wittenbrink, Regensburg, FRG.

1982 Galerie Ferdinand Maier, Kitzbühel, FRG; Galerie Dany Keller, Munich, FRG.

1983 Kutscherhaus, Berlin, FRG; 'Skulptur und Farbe', Gesellschaft für aktuelle Kunst, Bremen, FRG; 'Aktuell 83', Städtische Galerie im Lenbachhaus, Munich, FRG; 'Neue Malerei in Österreich', Neue Galerie der Stadt Linz, Austria.

1984 Galerie Hofstöckl, Linz, Austria; Galerie Dany Keller, Munich, FRG; Kunstverein, Pforzheim, FRG, 'Heimat deine Sterne', Städtische Galerie, Regensburg, FRG; 'Kunstlandschaft Bundesrepublik', Kunstverein Brühl, FRG; Museum Villa Stuck, Munich, FRG.

1985 Galerie Silvia Menzel, Berlin, FRG; Galerie Fred Jahn, Munich, FRG; Galleria Lillo, Mestre-Venice, Italy; 'Modus Vivendi, 11 Deutsche Maler', Museum Wiesbaden, Wiesbaden, FRG; Landesmuseum, Oldenburg, FRG.

1986 Galerie Hans Barlach, Hamburg, FRG; Galerie Fred Jahn, Munich, FRG.

1987 Galerie Krinzinger, Innsbruck, Austria; Galerie Hans Barlach, Cologne, FRG; Galerie Fred Jahn, Munich, FRG; Galerie Pfefferle, Munich, FRG.

1988 Galerie Fahlbusch, Mannheim, FRG.

1989 Museum Schloß Morsbroich, Leverkusen, FRG; Galerie Pfefferle, Munich, FRG; Lempertz, Brussels, Belgium; Galerie Lempertz, Comtempora, Cologne, FRG; 'Überarbeitete Druckgraphik', Galerie Biedermann, Munich, FRG; 'Rubensfest', Kunststation, St. Peter, Cologne.

1990 Galerie Maria Wilkens, Cologne, FRG; Galerie im Taxispalais, Innsbruck, Austria (with Bernd Zimmer); Galerie Clemens Rhomberg, Innsbruck, Austria; Galerie Borkowski, Hannover, FRG; Galerie Zink, Baden-Baden, FRG.

1991 Galerie Jahn und Fusban, Munich, GER; Galerie Axel Holm, Ulm, GER; Galerie Fred Jahn, Stuttgart, GER.

1992 Galerie Borkowski, Hannover, GER; Kunstverein, Heilbronn, GER; Galerie Fahlbusch, Mannheim, GER; 'Sinnbilder', Fotoforum, Museum für Fotografie und Zeitkunst, Bremen, GER.

Collections

Paintings, graphical works and sculptures in national and international, private and public collections.

Selected bibliography

1980 Exh. cat. *Clemens Kaletsch*, Galerie Wittenbrink, Regensburg.

1983 Exh. cat. *Standpunkte*, Forum für aktuelle Kunst Innsbruck, Galerie Krinzinger und Nächst St. Stephan, Innsbruck and Vienna; Exh. cat. *Clemens Kaletsch*, Dany Keller Galerie, Munich.

1984 Exh. cat. *Heimat deine Sterne* (Künstler aus Oberbayern), Städtische Galerie, Regensburg.

1985 Exh. cat. *Clemens Kaletsch — Bernd Zimmer*, Galerie Lillo, Mestre-Venice; Exh. cat. *Clemens Kaletsch*, Galerie Sylvia Menzel, Berlin.

1986 Exh. cat. *Clemens Kaletsch*, Galerie Hans Barlach, Hamburg; Exh. cat. *Clemens Kaletsch. Keramik 1982–83*, Galerie Fred Jahn, Munich.

1987 Exh. cat. *Clemens Kaletsch. Mir gegenüber*, Galerie Krinzinger, Innsbruck.

1988 *Zeichenkunst der Gegenwart*, Staatliche Graphische Sammlung, Munich (ed.).

1989 Exh. cat. *Clemens Kaletsch. Arbeiten auf Papier*, Museum Schloß

Morsbroich, Leverkusen; Exh. cat.
*Clemens Kaletsch. Gemälde-
Peintures-Schilderijen 1987–1989*,
Lempertz, Brussels; Stefan Szczesny
(ed.), 'Clemens Kaletsch', in: *Maler
über Malerei*, DuMont Buchverlag,
Cologne.

AXEL KASSEBÖHMER

Born in Herne in 1952.
Lives and works in Düsseldorf since 1976.
1977 For several months visited Gerhard
 Richter's art class at the Staatliche
 Kunstakademie, Düsseldorf.
Selected exhibitions
1982 Galerie Rüdiger Schöttle, Munich, FRG;
 Galerie Ursula Schurr, Stuttgart, FRG.
1983 Galerie Arno Kohnen, Düsseldorf,
 FRG; 'Standort Düsseldorf',
 Kunsthalle, Düsseldorf, FRG.
1984 Galerie Monika Sprüth, Cologne, FRG;
 'Tiefe Blicke', Hessisches
 Landesmuseum, Darmstadt, FRG;
 'Von hier aus', Messehallen,
 Düsseldorf, FRG.
1985 Galerie 't Venster, Rotterdam,
 Netherlands; Galerie Rüdiger Schöttle,
 Munich, FRG; Galerie Monika Sprüth,
 Cologne, FRG.
1986 'Der andere Blick', Wissenschafts-
 zentrum, Bonn, FRG and Kunstverein,
 Munich, FRG; 'Europa/Amerika',
 Museum Ludwig, Cologne, FRG;
 Säulen, Galerie Jule Kewenig,
 Frechen, FRG.
1987 Galerie Monika Sprüth, Cologne, FRG;
 'Memory and Imagination', Royal
 Scottish Academy, Edinburgh,
 Scotland; 'Reason and Emotion in
 Contemporary Art', Royal Scottish
 Academy, Edinburgh, Scotland.
1988 Galerie Grässlin-Erhardt, Frankfurt/M.,
 FRG; 'Das Licht von der anderen Seite.
 Teil I: Malerei', Galerie Monika
 Sprüth, Cologne, FRG.
1989 Galerie Rüdiger Schöttle, Munich,
 FRG; Westfälischer Kunstverein,
 Münster, FRG; Galerie Monika Sprüth,

Cologne, FRG; 'Bilderstreit',
Messehallen, Cologne, FRG; 'Graphik
und Zeichnungen', Galerie Grässlin-
Ehrhardt, Frankfurt/M., FRG;
1990 Kunstverein, Munich, FRG; Galerie
 Nelson, Lyon, France.
Collections
Paintings in national and international, private
and public collections.
Selected bibliography
1982 Jörg Johnen, 'Retten, was zu retten ist
 oder: Weiter mit Verstand', in:
 Kunstforum International, vol. 48.
1983 Exh. cat. *Rekonstruktionen*, Städtische
 Galerie, Regensburg.
1987 Exh. cat. *Dreiundzwanzigste
 Ausstellung*, Galerie Grässlin-
 Ehrhardt, Frankfurt/M.; Exh. cat.
 Memory and Imagination, Scottish
 Arts Council, Edinburgh; Exh. cat.
 *Reason and Emotion in Contemporary
 Art*, Scottish Art Council, Edinburgh.
 Jutta Koether, 'Axel Kasseböhmer', in:
 Artforum (December).
1988 Norbert Messler, 'Axel Kasseböhmer',
 in: *Artscribe*, No. 67; Exh. cat.
 *Deutsche Kunst der späten 80er
 Jahre. Binationale*, J. Harten/D.A. Ross
 (eds), DuMont Buchverlag, Cologne.
1989 Exh. cat. *Neue Figuration. Deutsche
 Malerei 1960–1988*, Munich;
 Kunstmuseum Düsseldorf; Schirn
 Kunsthalle Frankfurt; Exh. cat.
 *Refigured Painting. The German
 Image 1960–1988*, New York.
1990 Exh. cat. *Axel Kasseböhmer: Bilder
 1979–89*, Westfälischer Kunstverein,
 Münster, Kunstverein, Munich; Heinz
 Schütz, Heinz, 'Axel Kasseböhmer',
 in: *Kunstforum International*, Vol. 106
 (March/April), pp. 337–8;

ANSELM KIEFER

Born in Donaueschingen in 1945.
Lives and works in Buchen/Odenwald.
1965 Started language and law studies.
1966–68 Art course in Freiburg under Peter
 Dreher.

1969 Studied under Horst Antes at the
 Staatliche Kunstakademie, Karlsruhe.
1970–72 Studied under Joseph Beuys at the
 Staatliche Kunstakademie, Düsseldorf.
1983 Received Hans Thomas Prize.
Selected exhibitions
1969 Galerie am Kaiserplatz, Karlsruhe,
 FRG.
1973 Galerie Michael Werner Cologne,
 FRG; Galerie im Goethe-Institut,
 Amsterdam, Netherlands.
1974 Galerie Felix Handschin, Basel,
 Switzerland; Galerie 't Venster/
 Rotterdam Art Foundation,
 Rotterdam, Netherlands.
1977 Kunstverein, Bonn, FRG; Galerie
 Helen van der Meij, Amsterdam,
 Netherlands; 'documenta 6', Museum
 Fridericianum, Kassel, FRG.
1978 Kunsthalle, Bern, Switzerland.
1979 Stedelijk Van Abbemuseum,
 Eindhoven, Netherlands.
1980 Kunstverein, Mannheim, FRG; West
 German Pavilion, 39th Biennale,
 Venice, Italy; Groninger Museum,
 Groningen, Netherlands.
1981 Marian Goodman Gallery, New York,
 USA; Galleria Salvatore Ala, Milano,
 Italy; Kunstverein, Freiburg, FRG;
 Museum Folkwang, Essen, FRG; 'A
 New Spirit in Painting', Royal
 Academy of Arts, London, UK;
 'Westkunst: Zeitgenössische Kunst
 seit 1939', Museen der Stadt,
 Cologne, FRG.
1982 Mary Boone Gallery, New York, USA;
 'documenta 7', Museum
 Fridericianum, Kassel, FRG; 'Zeitgeist',
 Martin-Gropius-Bau, Berlin, FRG.
1983 Anthony d'Offay Gallery, London, UK;
 Hans-Thoma-Museum, Bernau, FRG;
 'New Figuration: Contemporary Art
 from Germany', Frederick S. Wight
 Art Gallery, University of California at
 Los Angeles, USA.
1984 Städtische Kunsthalle, Düsseldorf,
 FGR; Musée d'Art Contemporain,
 Bourdeaux, France; 'The Fifth

Biennale of Sydney: Private Symbol, Social Metaphor', Art Gallery of New South Wales, Sydney, Australia.

1985 '1945–1985: Kunst in der Bundesrepublik Deutschland', Nationalgalerie, Staatliche Museen, Berlin, FRG.

1986 Stedelijk Museum, Amsterdam, Netherlands; 'Wild Visionary Spectral: New German Art', Art Gallery of South Australia, Adelaide and Art Gallery of Western Australia, Perth, Australia; National Art Gallery, Wellington, New Zealand.

1987 The Art Institute of Chicago, USA and Philadelphia Museum of Art, USA; 'documenta 8', Museum Fridericianum, Kassel, GER.

1991 Neue Nationalgalerie Berlin, FRG.

Selected bibliography

1977 Exh. cat. *Anselm Kiefer*, Kunstverein Bonn; Anselm Kiefer, *Selbstbiographie*, Kunstverein, Bonn.

1978 Anselm Kiefer, *Die Donauquelle*, Cologne; Exh. cat. *Anselm Kiefer: Bilder und Bücher*, Kunsthalle Bern.

1980 Exh. cat. *Anselm Kiefer*, Kunstverein Mannheim.

1981 Anselm Kiefer, 'Gilgamensch und Enkidu im Zedernwald', in: *Artforum*, vol. 19. no. 10, (Summer), pp. 67–74; Exh. cat. *Anselm Kiefer*, Museum Folkwang, Essen, and Whitechapel Art Gallery, London.

1983 Anselm Kiefer, *Nothung*, Baden-Baden; Siegfried Gohr, 'The Difficulties of German Painting with Its Own Tradition', in: exh. cat. *Expressions: New Art from Germany*, The Saint Louis Art Museum, Saint Louis.

1984 Annalie Pohlen, 'The German Situation, or the Other Side of the "Wilden" Coin', in: exh. cat. *The Fifth Biennale of Sydney: Private Symbol, Social Methapor*, Art Gallery of New South Wales, Sydney.

1986 Jacqueline Burckhardt (ed.) *Ein Gespräch/Una discussione: Joseph Beuys, Jannis Kounellis, Anselm Kiefer, Enzo Cucchi*, Zurich.

1987 Exh. cat. *Anselm Kiefer: Bilder 1986–1980*, Stedelijk Museum, Amsterdam; Mark Rosenthal, exh. cat. *Anselm Kiefer*, Chicago and Philadelphia; Stephan Schmidt-Wulffen, *Spielregeln: Tendenzen der Gegenwartskunst*, DuMont Buchverlag, Cologne; Sandy Nairne, with Geoff Dunlop and John Wyver, *State of the Art: Ideas & Images in the 1980s*, London.

MARTIN KIPPENBERGER

Born in Dortmund in 1953.
Lives and works in Cologne.

1972 Studied under Rudolf Hausner and F.E. Walther at the Hochschule für Bildende Kunst, Hamburg.

1978 Moved to Berlin and founded Kippenberger's Office with Gisela Capitain. Became business director of the legendary S.O. 36, a place where events and concerts take place. Founded punk band 'The Grugas'.

1990 Guest professorship at the Städel Schule Frankfurt.

Selected exhibitions

1979 Performance at the Café Einstein, Berlin, FRG; Kippenberger's Office, Berlin, FRG.

1981 Neue Gesellschaft für Bildende Kunst — Realismusstudio 14, Berlin, FRG.

1983 Galerie Max Hetzler, Stuttgart, FRG; Galerie Rudolf Zwirner, Cologne, FRG; Neue Galerie — Sammlung Ludwig, Aachen, FRG.

1984 Galerie Max Hetzler, Cologne, FRG; Museum Folkwang, Essen, FRG; 'Zwischenbilanz', Neue Galerie am Joanneum, Graz, Austria, Villa Stuck, Munich, FRG, Forum für Aktuelle Kunst/Galerie Krinzinger, Innsbruck, Austria, Rheinisches Landesmuseum, Bonn, FRG.

1985 Galerie Ascan Crone, Hamburg, FRG; Metro Pictures, Paris, France; CCD Galerie, Düsseldorf, FRG; Galerie Bärbel Grässlin, Frankfurt/M., FRG; '1945–1985, Kunst in der Bundesrepublik Deutschland', Nationalgalerie, Berlin, FRG, Studio d, Tübingen, FRG.

1986 Hessisches Landesmuseum, Darmstadt, FRG; 'Die No Problem Bilder', Galerie Christoph Dürr, Munich, FRG.

1987 Galerie Susan Wyss, Zurich, Switzerland; 'Berlinart 1961–1987', The Museum of Modern Art, New York, USA, San Francisco Museum of Modern Art, San Francisco, USA; 'Broken Neon' Steirischer Herbst, Forum Stadtpark, Graz, Austria.

1988 Galerie d'arte, Silvio R. Baviera, Cavigliana, Switzerland; 'Refigured Painting: The German Image 1960–1988', Toledo Museum of Art, Toledo, Ohio, USA.

1989 ICA, University of Pennsylvania, Philadelphia, USA; Julie Sylvester, New York; 'Refigured Painting: The German Image 1960–1988', Guggenheim Museum, New York, USA; William College Museum of Art, Williamstown, Massachusetts, USA; 'Neue Figuration. Deutsche Malerei 1960–1988', Kunstmuseum Düsseldorf, FRG; Schirn Kunsthalle Frankfurt/M., FRG.

1990 Galleri Nordanstad-Skarstedt, Stockholm, Sweden; Galerie Bleich-Rossi, Graz, Austria; David Nolan Gallery, New York, USA; Galerie Samia Saouma, Paris, France.

1991 Galerie Samia Saouma, Paris, France; Pace/McGill Gallery, New York, USA; Galerie Max Hetzler, Arco, Madrid, Spain; Carsten Schubert Ltd., London, UK; Kunstverein, Cologne, GER; Galeria Juana de Aizpuru, Madrid, Spain; Von der Heydt-Museum, Wuppertal, GER.

Collections

Paintings, sculptures and objects in major national and international, private and public collections.

Selected bibliography

1977 *Al vostro servizio* (with Achim Duchow, Joachim Krüger), Hamburg (artist's book).

1981 *Was auch immer sei Berlin bleibt frei* (with G. Lamnersberg), Berlin (artist's book); Exh. cat. *Durch Pubertät zum Erfolg*, Neue Gesellschaft für Bildende Kunst, Berlin;

1983 *Wer diesen Katalog nicht gut findet, muß sofort zum Arzt* (with Werner Büttner, Albert Oehlen, Markus Oehlen), Galerie Max Hetzler, Stuttgart.

1984 Exh. cat. *Die I.N.P. — Bilder*, Galerie Max Hetzler, Cologne; Exh. cat. *Wahrheit ist Arbeit* (with Werner Büttner, Albert Oehlen), Museum Folkwang, Essen.

1986 Exh. cat. *Miete Gas Strom*, Hessisches Landesmuseum, Darmstadt; Exh. cat. *No Problem No problème* (with Albert Oehlen), Patricia Schwarz & Galerie Kubinski (eds), Stuttgart.

1989 Exh. cat. *Input-Output*, Galerie Gisela Capitain, Cologne; Jutta Koether, 'Who is Martin Kippenberger and Why Are They Saying Such Terrible Things About Him?, in: *Artscribe*, No. 73, pp. 52–7.

1990 Exh. cat. *Schwarz-Brot-Gold*, Galerie Bleich-Rossi, Graz; Exh. cat. *Eine handvoll vergessener Tauben*, Galerie Grässlin-Ehrhardt, Frankfurt/M.

1991 Exh. cat. *I had a vision*, San Francisco Museum of Modern Art; Angelika Muthesius (ed.), *Martin Kippenberger. Ten years after*, Benedikt Taschen Verlag, Cologne; Jutta Koether, 'Martin Kippenberger (Interview)', in: *Flash Art*, no. 156, pp. 88–93.

IMI KNOEBEL

Selbstportrait mit Pappkarton/Self-portrait with Cardboard Box, *1984. Photograph: Nic Tenwiggenhorn. Courtesy Carmen and Imi Knoebel.*

Born Wolf Knoebel in Dessau in 1940.
Lives and works in Düsseldorf.

1964–71 Studied under Joseph Beuys at the Staatliche Kunstakademie, Düsseldorf.

Selected exhibitions

1968 Charlottenburg, Copenhagen, Denmark.

1969 Art & Projekt, Amsterdam, Netherlands.

1970 De Utrechtse Kring, Utrecht, Netherlands.

1971 Galerie Heiner Friedrich, Munich, FRG.

1972 Stedelijk Museum, Amsterdam, Netherlands; Video-Galerie Gerry Schum, Düsseldorf, FRG; Kabinett für aktuelle Kunst, Bremerhaven, FRG.

1973 Galerie Erhard Klein, Bonn, FRG.

1975 Städtische Kunsthalle, Düsseldorf, FRG.

1976 Galerie Heiner Friedrich, Cologne, FRG.

1977 Galerie Heiner Friedrich, Cologne, FRG.

1981 Galerie Wilma Lock, St. Gallen, Switzerland.

1982 Stedelijk Van Abbe-Museum, Eindhoven, Netherlands.

1983 Dia Art Foundation, Cologne, FRG; Kunstmuseum, Winterthur, Switzerland; Galerie Ascan Crone, Hamburg, FRG.

1984 Städtisches Museum Abteiberg, Mönchengladbach, FRG; Lehmbruck Museum, Duisburg, FRG; Maximilian Verlag Sabine Knust, Munich, FRG.

1985 Le consortium, Dijon, France and Museé Municipal, La Roche sur Yon, France; Rijksmuseum Kröller-Müller, Otterlo, Netherlands; van Krimpen Tekeningen, Amsterdam, Netherlands; Galerie Nächst St. Stephan, Vienna, Austria.

1986 Galerie Hans Strelow, Düsseldorf, FRG; Staatliche Kunsthalle, Baden-Baden, FRG; Galerie Grässlin-Ehrhardt, Franfurt/M., FRG.

1987 Galerie Bruno Bischofsberger, Zurich, Switzerland; Dia Art Foundation, New York, USA.

1988 Galerie Rudolf Zwirner, Cologne, FRG; Galerie Annette Gmeiner, Stuttgart, FRG; Galerie Erhard Klein, Bonn, FRG.

1989 Bonnefantenmuseum, Maastricht, Netherlands; Fred Hoffman Gallery, Los Angeles, USA; Barbara Gladstone Gallery, New York, USA; Kanransha, Tokyo, Japan.

1990 Galerie Jahn und Fusban, Munich, FRG; Primo Piano, Rome, Italy.

1991 Akira Ikeda Gallery, Taura, Japan; Galerie Fahnemann, Berlin, GER; Maximilian Verlag Sabine Knust, Munich, GER; Barbara Gladstone Gallery, New York, USA.

1992 Lempertz, Brussels, Belgium; Kanransha, Tokyo, Japan.

(as well as many group exhibtions)

Collections

Paintings, graphical works and sculptures in all major national and international, private and public collections.

Selected bibliography

1968 Exh. cat. *IMI Art etc.*, Galerie René Block, Berlin.

1971 Exh. cat. *Multiples — The First Decade*, Philadelphia Museum of Art, Philadelphia.

1972 Exh. cat. *Zeichnungen der Deutschen Avantgarde*, Galerie Nächst St. Stephan, Vienna.

1975 Exh. cat. *W. Knoebel*, Städtische Kunsthalle, Düsseldorf; Exh. cat.

Erwerbungen 1962–1976,
Kunstmuseum, Bonn.

1981 Exh. cat. *Imi Knoebel — Tag und Nacht*, Galerie Erhard Klein, Bonn.

1982 Exh. cat. *Imi Knoebel*, Stedelijk van Abbemuseum, Eindhoven.

1985 Exh. cat. *Tiefe Blicke. Kunst der achtziger Jahre*, DuMont Buchverlag, Cologne.

1986 Exh. cat. *Imi Knoebel*, Staatliche Kunsthalle, Baden-Baden; Exh. cat. Armin Zweite (ed.), *Beuys zu Ehren*, Städtische Galerie im Lenbachhaus, Munich; Stephan Schmidt-Wulffen, 'Room as Medium', in: *Flash Art*, No. 131, pp. 74–6.

1987 Exh. cat. *Similia/Dissimilia*, Städtische Kunsthalle, Düsseldorf.

1988 Exh. cat. *The Image of Abstraction*, The Museum of Contemporary Art, Los Angeles; Robert Storr, 'Beuys's Boys — Beuys, Knoebel, Palermo', in: *Art in America*, No. 3, pp. 96, 98, 100, 101.

1989 Exh. cat. *Drawing as Itself*, The National Museum of Art, Osaka, Japan; Exh. cat. *Zeitzeichen — Stationen Bildender Kunst in Nordrhein-Westfalen*, DuMont Buchverlag, Cologne.

1990 Anna Moszynska, *Abstract Art*, Thames and Hudson, London.

BERND KOBERLING

Born in Berlin in 1938.
Lives in Berlin and during summer, in Iceland.

1958–60 Studied at the Hochschule für Bildende Künste, Berlin.

1969–70 Villa Massimo Scholarship to live in Rome.

1970 Received award by the Association of German Critics.

1976–81 Assistant lectureships in Hamburg, Düsseldorf and Berlin.

1981–88 Professor at the Hochschule für Bildende Künste, Hamburg.

1988– Professor at the Hochschule der Künste, Berlin.

Selected exhibitions

1965 Galerie Großgörschen 35, Berlin, FRG.
1966 Galerie René Block, Berlin, FRG.
1968 Galerie Falazik, Bochum, FRG; Haus am Lützowplatz, Berlin, FRG.
1969 Galerie Lichter, Frankfurt/M., FRG; Galerie Michael Werner, Cologne, FRG.
1971 Galerie Art Intermedia, Cologne, FRG.
1972 Galerie Lichter, Frankfurt/M., FRG.
1973 Galerie Magers, Bonn, FRG.
1974 Galerie Abis, Berlin, FRG.
1978 Haus am Waldsee, Berlin, FRG; Städtisches Museum Morsbroich, Leverkusen, FRG.
1980 Galerie Art in Progress, Düsseldorf, FRG.
1981 Nigel Greenwood Gallery, London, UK; 'A New Spirit in Painting', Royal Academy of Arts, London, UK.
1982 Annina Nosei Gallery, New York, USA; Studio d'Arte Cannaviello, Milano, Italy.
1983 Galerie Ascan Crone, Hamburg, FRG; 'New Figuration — Contemporary Art from Germany', Frederick S. Wight Art Gallery, University of California, Los Angeles, USA.
1984 Galerie Buchmann, Basel, Switzerland.
1985 Kunstverein, Bielefeld, FRG; Thomas Cohn, Rio de Janeiro, Brasil; '7000 Eichen', Kunsthalle, Tübingen, FRG; Kunsthalle, Bielefeld, FRG; Fridericianum, Kassel, FRG; 'German Art in the 20th Century', Royal Academy of Arts, London, UK.
1986 Kunstverein, Braunschweig, FRG; Galerie Gmyrek, Düsseldorf, FRG; Århus Kunstmuseum, Århus, Denmark; L.A. Louver, Venice (California), USA; Galerie Delta, Rotterdam, Netherlands; 'Deutsche Kunst im 20. Jahrhundert', Staatsgalerie Stuttgart, Stuttgart, FRG.
1987 Galerie Christian Cheneau, Paris, France; 'Berlinart 1961–1987', The Museum of Modern Art, New York, USA; San Francisco Museum of Modern Art, San Francisco, USA.
1988 Galerie Buchmann, Basel, Switzerland; Galerie Ascan Crone, Hamburg, FRG; Galerie Fahnemann, Berlin, FRG; 'Refigured Painting: The German Image 1960–1988', Toledo Museum of Art, Toledo, Ohio, USA.
1989 Galerie Neuendorf AG, Frankfurt/M., FRG; 'Refigured Painting: The German Image 1960–1988', Guggenheim Museum, New York, USA; William College Museum of Art, Williamstown, Massachusetts, USA; 'Neue Figuration. Deutsche Malerei 1960–1988', Kunstmuseum, Düsseldorf, FRG, Schirn Kunsthalle, Frankfurt/M., FRG
1990 Galerie Fahnemann, Berlin, FRG.
1991 Kunstsammlung Nordrhein-Westfalen, Düsseldorf, FRG.

Collections

Paintings and graphical works in national and international private and public collections

Selected bibliography

1970 Exh. cat. *Bernd Koberling*, Galerie Ursula Lichter, Frankfurt/M.

1974 Exh. cat. *Landschaft — Gegenpol oder Fluchtraum*, Städtisches Museum Morsbroich, Leverkusen; Haus am Waldsee, Berlin.

1981 Exh. cat. *A New Spirit in Painting*, Royal Academy of Arts, London; Exh. cat. *Zeitgeist. Internationale Kunstausstellung*, Martin-Gropius-Bau, Berlin; Exh. cat. *New Figuration — Contemporary Art from Germany*, Frederick S. Wight Art Gallery, University of California at Los Angeles.

1983 Exh. cat. *Mensch und Landschaft in der zeitgenössischen Malerei der BRD*, Moskau/Leningrad, Kunstverein für die Rheinlande und Westfalen, Düsseldorf.

1984 Heiner Bastian, 'Bernd Koberling', in exh. cat. *7000 Eichen*, Kunsthalle Tübingen.

1985 Exh. cat. *German Art in the 20th Century, Painting and Sculpture 1905–1985*, Prestel Verlag, Munich and Royal Academy of Arts, London.

1987 Kynaston McShine, 'Berlin Art, An Introduction', in: exh. cat. *1961 Berlin Art 1987*, Museum of Modern Art, New York, Prestel Verlag, Munich.

1989 Heinrich Klotz, *New German Painting*, Academy Group Ltd., London.

1990 Exh. cat. *Bernd Koberling*, Galerie Fahnemann, Berlin.

1991 Exh. cat. *Bernd Koberling*, Kunstsammlung Nordrhein-Westfalen, Düsseldorf.

THOMAS LANGE

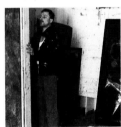

Born in Berlin (West) in 1957.
Lives and works in Berlin.
Studied under Wolfgang Petrick and Herbert Kauffmann at the Hochschule der Künste, Berlin.

1982 Master-class student under Herbert Kauffmann.

1983 Scholarship awarded by the Karl-Schmidt-Rottluff-Foundation.

1986 Visiting lecturer at the University of Marburg.

1988/89 Visiting lecturer at the Hochschule der Künste, Berlin.

Selected exhibitions

1975 Selektion Berlin, Berlin, FRG.

1979 Aral Wailers, Galerie in der Böttcherstraße, Bremen, FRG.

1981 'Ten Young Painters From Berlin', Goethe-Institut, London, UK; 'Bildwechsel', Akademie der Künste, Berlin, FRG; 'Situation Berlin', Musée d'Art Contemporain des Musée de Nice, France.

1982 'Gefühl und Härte', Stockholm, Sweden, and Munich, FRG; 'Germinations', Paris, France, and Braunschweig, FRG.

1983 Galerie Poll, Berlin, FRG; Galerie Zimmer, Düsseldorf, FRG; Städtische Galerie, Regensburg, FRG.

1984 Galerie Zellermayer, Berlin, FRG; Brücke-Museum, Berlin, FRG; 'Kunstlandschaft Bundesrepublik', Kunstverein, Pforzheim, FRG; 'Neue Deutsche Kunst — Die wieder-gefundene Metropole', Palais des Beaux-Arts, Brussels, Belgium;

1985 'Prometheo', Proposte Villa Romana, Florence, Italy; Kunstverein, Braunschweig, FRG.

1986 Kunstverein Bielefeld, FRG; Galerie Hermeyer, Munich, FRG; 'Androgyn', Neuer Berliner Kunstverein in der Akademie der Künste, Berlin, FRG.

1987 'Androgyn', Kunstverein Hannover, FRG; Arte Murale, Frasso Telesino, Italy.

1988 'Schatten der Liebe', Kunstverein Hannover, FRG, and Provinciaal Museum voor Moderne Kunst, Oostende, Belgium; 'Wonnegrauen', Neuer Berliner Kunstverein, Berlin FRG; Hotel Orient, Galerie der Künstler, Munich, FRG; 'Refigured Painting: The German Image 1960–1988', Toledo Museum of Art, Toledo, Ohio, USA.

1989 'Refigured Painting: The German Image 1960–1988', Guggenheim Museum, New York, USA; William College Museum of Art, Williamstown, Massachusetts, USA; 'Neue Figuration. Deutsche Malerei 1960–1988', Kunstmuseum, Düsseldorf, FRG; Schirn Kunsthalle, Frankfurt, FRG; 'Seven Artists '89', Tokyo, Japan; 'Korrespondenzen', Martin-Gropius-Bau, Berlin, FRG.

1990 Galerie Zellermayer, Berlin, FRG; Galerie Deweer, Belgium; 'Erinnerung und Fiktion', Galerie Hermeyer, Munich, FRG; 'Ambiente Berlin', Venice Biennale, Italy.

1991 'Erinnerung und Fiktion', Kunstverein, Mannheim, GER; 'Interferenzen — Kunst aus Westberlin 1960–1990', Museum für ausländische Kunst, Riga, Latvia.

Collections

Paintings in major national and international, private and public collections.

Selected bibliography

1981 Exh. cat. *Ten Young Painters From Berlin*, Goethe-Institute, London; Exh. cat. *Bildwechsel — Neue Malerei in Deutschland*, Interessengemeinschaft Berliner Kunsthändler, Berlin.

1983 Exh. cat. *Thomas Lange. Seestücke*, Galerie Zimmer, Düsseldorf.

1984 Exh. cat. Kasper König (ed.), *Von Hier Aus. Zwei Monate Deutsche Kunst in Düsseldorf*, DuMont Buchverlag, Cologne.

1986 Exh. cat. *Androgyn*, Neuer Berliner Kunstverein in der Akademie der Künste, Berlin.

1988 Exh. cat. *Thomas Lange. Höhlenmenschen. Uomini delle Caverne*, Galerie Hermeyer, Munich.

1989 Exh. cat. *Neue Figuration. Deutsche Malerei 1960–1988*, Munich; Kunstmuseum Düsseldorf; Schirn Kunsthalle Frankfurt; Exh. cat. *Refigured Painting. The German Image 1960–1988*, New York.

1989 Exh. cat. *Thomas Lange. Berglandschaften*, Galerie Zellermayer, Berlin.

1990 Exh. cat. *Thomas Lange. Stadtlandschaften*, Galerie Zellermayer, Berlin; Exh. cat. *Gyula Kurucz/Thomas Lange. 1957–1990. Erinnerung und Fiktion*, Galerie Hermeyer, Munich.

1991 Exh. cat. *Thomas Lange. Erinnerung und Fiktion*, Mannheimer Kunstverein (ed.), Mannheim; Exh. cat. *Interferenzen — Kunst aus Westberlin 1960–1990*, Verlag Dirk Nishen, Berlin.

WALTER LIBUDA

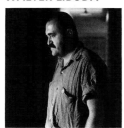

Photograph: Bernd Kuhnert, Berlin

Born in Zechau-Leesen.
Has lived and worked in Berlin since 1985.
1973–79 Studied at the Hochschule für Grafik und Buchkunst, Leipzig; became Master-class student under Berhard Heisig.
1979–80 Assistant lecturer at the Hochschule für Grafik und Buchkunst, Leipzig.
1982–85 Assistant lecturer at the Hochschule für Grafik und Buchkunst, Leipzig.

Selected exhibitions
1979　Grafik-Klub der Intelligenz, Zwickau, GDR.
1980　Staatliches Lindenau-Museum, Altenburg, GDR.
1982　Galerie am Brühl, Karl-Marx-Stadt, GDR; Galerie des Pays de Langue Allemande, Paris, France (with J. Heisig).
1983　Haus der Kultur und Bildung, Neubrandenburg, GDR; Studio Bildende Kunst, Berlin, GDR; Galerie Fischinger, Stuttgart, FRG.
1984　Galerie Nord, Dresden, GDR; Galerie Westphal, Berlin, FRG; 'Durchblick', Städtische Galerie Schloß Oberhausen, Ludwig-Institut für Kunst der DDR, Oberhausen, FRG; 'Tradition and Renewal: Contemporary Art in the German Democratic Republic', Museum of Modern Art, Oxford, UK (travelled to Coventry, Sheffield, Newcastle, London).

1985　Galerie Junge Kunst, Frankfurt/O., GDR; Buchhandlung Tannert, Berlin, GDR; 'Expressivität Heute', Altes Museum, Berlin, GDR.
1986　Galerie am Thomaskirchhof, Leipzig, GDR; Galerie Alvensleben, Munich, FRG; 'Neue Zeichnungen aus Ateliers der DDR', Rathaushalle, Munich, FRG; 'Kunst der DDR in den 80er Jahren', Galerie der Stadt Esslingen, Villa Merkel, Esslingen, FRG.
1987　Galerie Westphal, Berlin, FRG; Kleine Galerie Pankow, Berlin, GDR; Staatliches Lindenau-Museum, Altenburg, GDR; 'Das Meer', Königliche Akademie, Stockholm, Sweden.
1988　Galerie Alvensleben, Munich, FRG; Kleine Galerie des Kulturbundes, Strasbourg, France; 'Zeitvergleich '88', Neues Kunstquartier im T.I.P., Berlin, FRG; 'Zeitzeichen — Malerei & Grafik aus der DDR', Tokyo/Nagano/Kumamoto/Kamakura/Kobe/Hakodate, Japan; 'Junge Malerei der 80er Jahre aus der DDR', Kunstmuseum, Solothurn, Switzerland.
1989　Galerie Sunnen, Bech-Kleinmacher, Luxemburg; '12 Artists from the GDR', Busch-Reisinger Museum, Cambridge, USA (travelling exhibition).
1990　Galerie Rotunde im alten Museum, Berlin, GDR; '44. Biennale di Venezia', Pavillon of the GDR, Venice, Italy (with H. Giebe).
1991　Galerie M, Berlin, GER; Galerie Alvenleben, Munich, GER; Galerie Beethovenstraße, Düsseldorf, GER; 'Ambiente Berlin', Kunsthalle, Budapest, Hungary; 'Die Berlinische Galerie zu Gast in Dublin', The Hugh Lane Municipal Gallery of Modern Art, Charlemont House, Dublin, Ireland.

Collections
Paintings and graphical works in national and international, private and public collections.

Selected bibliography
1984　Exh. cat. *Hubertus Giebe, Johannes Heisig, Walter Libuda*, Galerie Schmidt-Rottluff, Karl-Marx-Stadt.
1985　Exh. cat. *Expressivität Heute. Junge Maler der DDR*, Nationalgalerie Berlin; Karin Thomas, *Zweimal Deutsche Kunst nach 1945. 40 Jahre Nahe und Ferne*, DuMont Verlag, Cologne.
1987　Exh. cat. *Walter Libuda*, Staatliches Lindenau-Museum, Altenburg.
1988　Exh. cat. *Walter Libuda. Malerei*, Galerie Alvensleben, Munich.
1989　Exh. cat. *Walter Libuda. Malerei, Zeichnungen, Gouachen*, Galerie Sunnen, Bech-Kleinmacher; Exh. cat. *Konturen. Werke seit 1949 geborener Künstler der DDR*, Nationalgalerie Berlin; Exh. cat. *Junge Malerei der 80er Jahre aus der DDR*, Kunstmuseum Solothurn.
1990　Exh. cat. *Walter Libuda*, 44. Biennale di Venezia, Venice; Hubertus Gaßner, Eckhart Gillen/Rainer Haarmann (eds), 'Aufbruch ins Unbekannte. Der Maler Walter Libuda', in: *Kunst in der DDR*, Cologne.
1991　Exh. cat. *Walter Libuda. Malerei, Zeichnungen, Graphik, Objekte*, Galerie M, Berlin; Michael Freitag, 'Signale des inneren Berührtseins. Die Malerei von Walter Libuda', in: *Bildende Kunst* 39, 1, pp. 17–21; Exh. cat. *Walter Libuda. Malerei und Arbeiten auf Papier*, Galerie Beethovenstraße, Düsseldorf.

JULIA LOHMANN

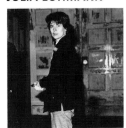

Photograph: Silke Hermerdig.

Born in Dorsten in 1951.
Lives and works in Düsseldorf.
1972–78 Studied under Joseph Beuys and Erwin Heerich at the Staatliche Kunstakademie, Düsseldorf.
1985 Received grants from the State North Rhine-Westphalia and the city of Düsseldorf.
1988 Received Scholarship from the Foundation Skulpturenpark Seestern, Düsseldorf.
1989 Received grant from the city of Siegen.
1989/90 Visiting lecturer at the Staatliche Kunstakademie, Düsseldorf.

Selected exhibitions
1977 'mit, neben, gegen ...', Kunstverein, Frankfurt/M., FRG.
1981 'Malerei' (with Adolf Lechtenberg), Kunstmuseum, Düsseldorf, FRG.
1982 Galerie Schmela, Düsseldorf, FRG.
1983 Kunstverein, Bochum, FRG; Kunsthistorisches Institut, Bonn, FRG; Städtische Galerie, Düsseldorf, FRG; 'Der Letzte Schrei', Kunstmuseum, Düsseldorf, FRG; 'Standort Düsseldorf', Kunsthalle, Düsseldorf, FRG.
1984 Museum Schloß Hardenberg, Velbert, FRG; Galerie Schmela, Düsseldorf, FRG; Städtische Galerie Bahnwärterhaus, Esslingen, FRG; 'Kunstlandschaft BRD', Kunstverein, Karlsruhe, FRG.
1985 Galerie Mautsch, Cologne, FRG; Art Cologne, Cologne, FRG; Galerie Schmela, Düsseldorf, FRG; Städtische Galerie, Düsseldorf, FRG; Bauhütte, Kunsthalle, Düsseldorf, FRG.
1986 Kunstverein, Dorsten, FRG; Galerie Schmela, Düsseldorf, FRG; '5 Artistes de Düsseldorf', Faux Mouvement, Caves St. Croix, Metz, France.
1987 Kunstverein, Oerlinghausen, FRG; Galerie Wilma Tolksdorf, Hamburg, FRG; Staatliche Kunstsammlung, Neue Galerie, Kassel, FRG; 'Fusion', Theatre Gallery, Design Center, Los Angeles, USA.
1988 waschSalon Galerie, Frankfurt/M., FRG.
1989 Galerie Schmela, Düsseldorf, FRG; Städtische Galerie, Siegen, FRG; Galerie 3 am kleinen Markt, Mannheim, FRG; 'Villa Romana', Germanisches Museum, Nürnberg, FRG; 'Bon Angeles', Landesvertretung NRW, Bonn, FRG and Santa Monica Museum of Art, S. Monica, California, USA.
1990 Art Ort, Ingeborg-Drewitz-Gesamtschule, Gladbeck, FRG; Santa Monica Airport-Studios, California, USA; 'Zeitzeichen', Akademie, Leipzig, FRG and Wilhelm-Lehmbruck-Museum, Duisburg, FRG; 'Die Farbe Blau', Kunstverein, Heidelberg, FRG; 'Two from Germany', Sordony Art Gallery, Wilkes-Barre, Pennsylvania, USA.
1991 Galerie Schmela, Düsseldorf, GER; 'Open Box', Kunstbühne, Karl-Ernst-Osthaus-Museum, Hagen, GER; 'Aluminium. Gestalt, Gebrauch, Geschichte', Kölnisches Stadtmuseum, Cologne, GER; 'Prototyp', Gottfried-Hagen Foundation, Cologne, GER.

Collections
Paintings, graphical works and sculptures in national and international, private and public collections.

Selected bibliography
1984 Exh. cat. Julia Lohmann and Stefanie Poley, *Julia Lohmann. Neues Blech*, Düsseldorf; Boehle/Hardung/Knuth/Lohmann (eds), *Fürstenwall 204*, Newspaper of the Pozozza Museums, 1st edition 1/84, Düsseldorf; Exh. cat. *Kunstlandschaft BRD*, Kunstverein, Karlsruhe.
1985 Exh. cat. *Bauhütte*, Städtische Kunsthalle Düsseldorf.
1987 Neue Gesellschaft für Bildende Kunst e.V. (ed.), *Das verborgene Museum*, Edition Hentrich, Berlin.
1988 Helga Meister, 'Farb-Geschichten. Julia Lohmann', in: *Kunst in Düsseldorf*, Verlag Kiepenheuer & Witsch, Hamburg/Cologne/Leck.
1989 Exh. cat. Julia Lohmann, *Julia Lohmann. Ka ma Kan — there was, there was not*, Düsseldorf.
1990 Exh. cat. Hans Gercke (ed.), *Blau-Farbe der Ferne*, Wunderhorn Verlag, Heidelberg.
1991 Heinz-Norbert Jocks, 'Julia Lohmann', in: *Kunstforum International*, vol. 113 (May/June), pp. 356–7. Exh. cat. Julia Lohmann, *Julia Lohmann. mi corazón*, Düsseldorf; Exh. cat. *Marcel Hardung, Adolphe Lechtenberg, Julia Lohmann*, Museo de Bellas Artes, Satander and Ludwig-Forum für Internationale Kunst, Aachen.

MARKUS LÜPERTZ

Born in Liberec, Bohemia, in 1941.
Lives and works in Berlin and Düsseldorf.
1956–61 Studied under Laurens Goosen at the Werkkunstschule, Krefeld, and at the Staatliche Kunstakademie, Düsseldorf.
1970 Villa Romana Scholarship to live in Florence.
1971 Prize awarded by German Critics Association.
1974–86 Professor at the Staatliche Akademie der Bildenden Künste, Karlsruhe
1986– Professor at the Staatliche Kunstakademie, Düsseldorf, whose director he becomes in 1988.
1990 Lovis-Corinth-Prize awarded by Künstlergilde, Esslingen.

Selected exhibitions

1964 Galerie Großgörschen 35, Berlin, FRG.
1968 Galerie Springer, Berlin, FRG; Galerie Michael Werner, Berlin, FRG.
1973 Kunsthalle, Baden-Baden, FRG; Galerie im Goethe-Institut, Provisorium, Amsterdam, Netherlands.
1976 Galerie Michael Werner, Cologne, FRG.
1977 Galerie Neuendorf, Hamburg, FRG; Kunsthalle, Hamburg, FRG; Kunsthalle, Berne, Switzerland; Stedelijk van Abbemuseum, Eindhoven, Netherlands.
1979 Whitechapel Art Gallery, London, UK.
1980 Galerie Michael Werner, Cologne, FRG; Galerie Helen van der Meij, Amsterdam, Netherlands; Galerie Springer, Berlin, FRG; Galerie Friedrich, Munich, FRG.
1981 Galleri Riis, Trondheim, Norway; Marianne Goodman Gallery, New York, USA; Kunstverein, Freiburg, FRG.
1982 Galerie Jahn, Munich, FRG; Galerie Gillespie-Laage-Salomon, Paris, France; Galerie Onnasch, Berlin, FRG.
1983 Stedelijk van Abbemuseum, Eindhoven, Netherlands; Musée d'Art Moderne, Strasbourg, France; Waddington Galleries, London, UK; Galerie Winter, Vienna, Austria; Galerie Maeght, Zurich, Switzerland; Kestner Gesellschaft, Hannover, FRG.
1984 Maximilian Verlag Sabine Knust, Munich, FRG; Wiener Secession, Vienna, Austria; Galerie Thaddäus J. Ropac, Salzburg, Austria; Galerie Ascan Crone, Hamburg, FRG.
1985 Galerie Jahn, Munich, FRG; Galerie Michael Werner, Cologne, FRG; Galerie Meyer-Ellinger, Frankfurt/M., FRG.
1986 Städtische Galerie im Lenbachhaus, Munich, FRG; Galerie Gillespie-Laage-Salomon, Paris, France; Galerie Folker Skulima, Berlin, FRG; Neuer Berliner Kunstverein, Orangerie, Schloß Charlottenburg, Berlin, FRG.
1987 Museum Boymans-van-Beuningen, Rotterdam, Netherlands; Kunstverein, Braunschweig, FRG; Galerie Beaumont, Luxembourg, Luxembourg.
1988 Galleria Due Ci, Artemoderna, Rome, Italy; Kunsthalle zu Kiel und Schleswig-Holsteinischer Kunstverein, Kiel, FRG; Galerie Kaj Forsblom, Helsinki, Finland.
1989 Haus am Waldsee, Berlin, FRG; Galleria IN ARCO, Torino, Italy; Galerie Michael Werner, Cologne, FRG.
1990 Mary Boone/Michael Werner Gallery, New York, USA; Galerie Lelong, Zurich, Switzerland; Galerie Philippe Guimiot, Brussels, Belgium.
1991 Centro de Arte Reina Sofia, Madrid, Spain; Galerie der Stadt Stuttgart, Stuttgart, GER (and other cities), Städtische Galerie im Prinz-Max-Palais, Karlsruhe, GER.
(as well as many group exhibitions)

Collections

Paintings, sculptures and graphical works in all major national and international, private and public collections.

Selected bibliography

1973 Exh. cat. *Markus Lüpertz. Bilder, Gouachen und Zeichnungen*, Kunsthalle Baden-Baden.
1977 Exh. cat. *Markus Lüpertz*, Kunsthalle Hamburg.
1983 Exh. cat. *Markus Lüpertz. Bilder 1970–1983*, Kestner-Gesellschaft, Hannover.
1984 Exh. cat. *Sculptures in Bronze*, Waddington Galleries Ltd., London; Exh. cat. *Markus Lüpertz*, Galerie Ascan Crone, Hamburg; Exh. cat. *Markus Lüpertz*, Mary Boone/Michael Werner, New York.
1986 Exh. cat. *Markus Lüpertz — Belebte Formen und kalte Malerei, Gemälde und Skulpturen*, Städtische Galerie im Lenbachhaus, Munich; Exh. cat. *Markus Lüpertz — Paintings and Bronze Sculptures*, Waddington Galleries Ltd., London.
1987 Exh. cat. *Markus Lüpertz — Arbeiten auf Papier, Bilder und Skulpturen*, Kunstverein Braunschweig; Exh. cat. *Markus Lüpertz — Schilderijen/Bilder 1973–1986*, Museum Boymans-van-Beuningen, Rotterdam.
1988 Exh. cat. *Markus Lüpertz. Bilder 1985–1988*, Schleswig-Holsteinischer Kunstverein, Kiel.
1989 Exh. cat. *Markus Lüpertz — Folgen, Zeichnungen und Malerei auf Papier*, Haus am Waldsee, Berlin; Exh. cat. *Markus Lüpertz — Die 'Bilderstreit-Bilder'*, Galerie Michael Werner, Cologne.
1990 Exh. cat. *Markus Lüpertz*, Mary Boone Gallery, New York.
1991 Exh. cat. *Markus Lüpertz — Retrospectiva 1963–1990*, Centro De Arte Reina Sofia, Madrid; Exh. cat. *Markus Lüpertz, Rezeptionen — Paraphrasen*, Prinz-Max-Palais, Karlsruhe. *Markus Lüpertz — Druckgraphik. Werkverzeichnis 1960–1990*, Maximilian Verlag Sabine Knust, Munich (ed.), Edition Cantz, Stuttgart.

HELMUT MIDDENDORF

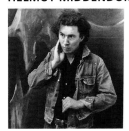

Photograph: Thiede, Berlin

Born in Dinklage in 1953.
Lives and works in Berlin.
1971–79 Studied painting under K.H. Hödicke at the Hochschule der Künste, Berlin. Master-class student.

1980 Received DAAD Scholarship to live in New York.

Selected exhibitions
1977 Galerie am Moritzplatz, Berlin, FRG.
1978 Galerie Nothelfer, Berlin, FRG.
1979 Galerie am Moritzplatz, Berlin, FRG.
1980 'Heftige Malerei', Haus am Waldsee, Berlin, FRG; 'Handzeichnungen II', Galerie am Moritzplatz, Berlin, FRG; 'Junge Kunst aus Berlin', travelling exhibition by the Goethe-Institut, Munich, FRG.
1981 Galerie Gmyrek, Düsseldorf, FRG; Mary Boone Gallery, New York, USA; Galerie am Moritzplatz, Berlin, FRG; 'Situation Berlin', Musée d'art contemporain, Nizza; 'Ten Young Painters from Berlin', Goethe Institut, London, UK.
1982 Galerie Albert Baronian, Brussels, Belgium; Studio d'Arte Cannaviella, Milano, Italy; Galerie Yvon Lambert, Paris, France; Galerie Buchmann, St. Gallen, Switzerland; 'Gefühl und Härte', Kulturhuset Stockholm, Sweden; Kunstverein, Munich, FRG; 'La Giovane Pittura in Germania', Galleria d'Arte Moderna, Bologna, Italy; '10 x Malerei', Westfälischer Kunstverein, Münster, FRG; 'Zeitgeist', internationale Kunstausstellung, Martin-Gropius-Bau, Berlin, FRG.
1983 Bonlow-Gallery, New York, USA; Groninger Museum, Groningen, Netherlands; Kunstverein für die Rheinlande und Westfalen, Düsseldorf, FRG; Staatliche Kunsthalle, Baden-Baden, FRG; 'New Figuration — Contemporary Art from Germany', Frederick S. Wight Art Gallery, University of California, Los Angeles; 'New Painting from Germany', The Tel Aviv Museum, Tel Aviv, Israel; 'Mensch und Landschaft in der Zeitgenössischen Malerei und Grafik der BRD', Moskau and Leningrad, Russia.

1984 Galerie Buchmann, Basel, Switzerland; Annina Nosei Gallery, New York, FRG; Kunstverein, Braunschweig, FRG; 'Zwischenbilanz', Neue Galerie am Landesmuseum Joanneum, Graz, Austria; Villa Stuck, Munich, FRG; Rheinisches Landesmuseum, Bonn, FRG.
1988 'Refigured Painting: The German Image 1960–1988', Toledo Museum of Art, Toledo, Ohio, USA.
1989 'Refigured Painting: The German Image 1960–1988', Guggenheim Museum, New York, USA; William College Museum of Art, Williamstown, Massachusetts, USA; 'Neue Figuration. Deutsche Malerei 1960–1988', Kunstmuseum, Düsseldorf, FRG, Schirn Kunsthalle, Frankfurt, FRG.

Collections
Paintings and graphical works represented in major national and international, private and public collections.

Selected biliography
1978 Helmut Middendorf, *Sechzehn Richtige*, 16 hand-coloured graphics, Rainer Verlag, Berlin (edition of 29).
1980 Exh. cat. *Heftige Malerei*, Haus am Waldsee, Berlin; Ernst Busche, 'Heftige Malerei' in: *Flash Art*, Milano, no. 96–7, March/April, p. 59; Wolfgang Max Faust, 'Heftige Malerei', in: *Kunstforum International*, no. 38, 2/80, Cologne, p. 230.
1981 Exh. cat. *Berlin — Eine Stadt für Künstler*, Kunsthalle Wilhelmshaven; Exh. cat. *Bildwechsel*, Akademie der Künste, Berlin; Exh. cat. *Szenen der Volkskunst*, Württembergischer Kunstverein, Stuttgart; W.M. Faust/Ernst Busche, 'Van Gogh an der Mauer — Die neue Malerei in Berlin — Tradition und Gegenwart; Deutsche Kunst hier, heute', in: *Kunstforum International*, no. 47, 1981/82, Cologne.

1982 W.M. Faust/G. de Vries, *Hunger nach Bildern*, DuMont Verlag, Cologne; Exh. cat. *Gefühl und Härte — Neue Kunst aus Berlin*, Kunstverein München and Kulturhuset Stockholm; Exh. cat. *Zeitgeist*, Martin-Gropius-Bau, Berlin; Exh. cat. *Zehn Junge Künstler aus Deutschland*, Museum Folkwang, Essen; Exh. cat. *Spiegelbilder*, Kunstverein Hannover, Haus am Waldsee, Berlin, and others;
1983 Exh. cat. *La Giovane Pittura in Germania*, Galleria d'arte moderna, Bologna and Museum Folkwang, Essen; Donald B. Kuspit, 'Acts of Agression: German Painting Today — Part II', in: *Art in America*, January, New York, pp. 90–101, 131–5.

MICHAEL MORGNER

Photograph: Matthias Creutziger, Dresden.

Born in Dittersdorf near Chemnitz (formerly Karl-Marx-Stadt) in 1942.
Lives and works in Einsiedel.
1961–66 Studied at the Hochschule für Grafik und Buchkunst, Leipzig
1991 Prize awarded by 'Griffelkunst Hamburg'.

Selected exhibitions
1972 Galerie Wort und Werk, Leipzig, GDR.
1976 Galerie Arkade, Berlin, GDR; 'Junge Künstler aus der DDR', Berlin, GDR; 'Kunst aus der DDR', Stockholm, Sweden.
1978 Galerie oben, Karl-Marx-Stadt, GDR.
1979 Galerie Clara Mosch, Karl-Marx-Stadt, GDR; Galerie am Hansering, Halle, GDR.

1980 Leonhardi-Museum, Dresden, GDR; Galerie am Domhof, Zwickau, GDR (with Hans Brockhage); 'Biennale der Handzeichnugen', Bradford, UK.
1981 Galerie Erph, Erfurt, GDR.
1982 Kunstkabinett, Erfurt, GDR; Museum für Bildende Künste, Leipzig, GDR (with Rolf Münzner); '5 Jahre Clara Mosch', Karl-Marx-Stadt, GDR.
1984 Galerie oben, Karl-Marx-Stadt, GDR; 'DDR Heute', Kunsthalle, Worpswede, FRG.
1985 'Fünf Künstler aus der DDR', Neuer Berliner Kunstverein, Berlin, FRG.
1986 'Neue Zeichnungen aus den Ateliers der DDR', Galerie Alversleben, Munich, FRG.
1987 Galerie im Cranachhaus, Weimar, GDR; Galerie Am Brühl, Karl-Marx-Stadt, GDR.
1988 Sammlung Vogel, Hamburg, FRG; 'Biennale', Sao Paulo, Brasil.
1988/89 '12 Künstler aus der DDR', Busch-Reisinger Museum, Cambridge, USA; Frederick S. Wight Gallery, Los Angeles, USA; Museum for Art, Ann Arbor, USA.
1989 Galerie Maurer, Bern, Switzerland; Angermuseum, Erfurt, GDR (with Friedrich Press); Neue Dresdner Galerie, Dresden, GDR; Galerie Beethovenstraße, Düsseldorf, FRG (with Hans Brockhage); Galerie Schmidt-Rottluff, Karl-Marx-Stadt, GDR; 'Zeitzeichen — Künstler aus der DDR', (travelled in seven cities in Japan).
1990 Thomaskirchhof, Leipzig, GDR; Hugieia Art Gallery, Belgium; Jürgen-Ponto-Stiftung, Dredner Bank, Frankfurt; 'Künstlergruppe "Clara Mosch"', Galerie Gunar Barthel/ Galerie oben, Art Cologne, Cologne, FRG; 'Arbeiten', Galerie Gunar Barthel, Berlin, FRG.
1991 Kunstmuseum, Düsseldorf, GER (with Hartmut Neumann); Galerie Frank Hänel, Frankfurt/M., GER; 'Sammlung Prof. Vogel', Deichtorhallen, Hamburg, GER; 'Sommer 3', Galerie Gunar Barthel, Berlin, GER; 'Material und Form', Schloß Pillnitz, Dresden, GER.

Collections
Paintings and graphical works in national and international, private and public collections.

Selected bibliography
1985 Exh. cat. *Fünf Künstler aus der DDR*, Neuer Berliner Kunstverein, Berlin.
1986 Exh. cat. *Neue Zeichnungen aus den Ateliers der DDR*, Galerie Alversleben, Munich.
1987 Exh. cat. Michael Morgner, *Ecce Homo. Arbeiten auf Papier*, Galerie am Brühl, Städtische Museen Karl-Marx-Stadt;
1988 Inge Ludescher, 'Michael Morgner', in: *Information und Neuerwerbungen*, no. 2, Städtische Galerie Oberhausen;
1990 Exh. cat. *Michael Morgner*, Dresdner Bank AG, Frankfurt/M.; Chemnitzer Kunst auf der Münchner Praterinsel, 'Ein Boot um nicht unterzugehen', in: *Süddeutsche Zeitung*, no. 279 (December)
1991 Michael Morgner im Palais Walderdorff, Trier, 'Leid und Selbstbehauptung', in: *Trierischer Volksfreund*, no. 52 (March); Kunstmuseum zeigt im Kunstpalast am Ehrenhof Bilder von Michael Morgner und Hartmut Neumann, 'Endzeit und erträumtes Paradies', in: *Düsseldorfer Amtsblatt* (20.4.1991); Der Chemnitzer Künstler Michael Morgner stellt bei Linneborn aus, 'Requiem für Dietrich Bonhoeffer', in: *Bonner Rundschau*, Feuilleton (25.4.1991); Ausstellung von Hartmut Neumann und Michael Morgner im Kunstpalast, 'Angstfiguren und Geisterköpfe', in: *Rheinische Post* (27.4.1991); 'Heute in der Galerie: Michael Morgner', in: *Frankfurter Rundschau* (29.6.1991)

CHRISTA NÄHER

Photograph: Walter Kranl, Frankfurt/M.

Born in Lindau in 1947.
Lives and works in Cologne and Wolfegg.
1971–80 Studied at the Hochschule der Künste, Berlin.
1987– Professorship at the Städelschule, Frankfurt/M.
1988 Received Karl-Ströher-Prize, Frankfurt.
1989 Received Art Prize of the city of Konstanz.

Selected exhibitions
1980 'Finger für Deutschland', Atelier Immendorff, Düsseldorf, FRG.
1982 Galerie Arno Kohnen, Düsseldorf, FRG.
1983 Kunstverein, Bonn, FRG; Galerie Arno Kohnen, Düsseldorf, FRG.
1984 'Aus Deutschland ...', Kunstmuseum, Luzern, Switzerland (with Astrid Klein and Isolde Wawrin); Galerie Susan Wyss, Zurich, Switzerland; Galerie Janine Mautsch, Cologne, FRG.
1985 Galerie Susan Wyss, Zurich, Switzerland; Galerie Silvia Menzel, Berlin, FRG; Galerie Bärbel Grässlin, Frankfurt/M., FRG; Galerie Arno Kohnen, Düsseldorf, FRG.
1986 Galerie Arno Kohnen, Düsseldorf, FRG.
1987 Kunstverein, Bielefeld, FRG; Museum Schloß Morsbroich, Leverkusen, FRG; Galerie Grässlin-Ehrhardt, Frankfurt/M., FRG; Galerie Gisela Capitain, Cologne, FRG; Galerie Janine Mautsch, Cologne, FRG; Galerie Juana de Aizpuru, Madrid, Spain.

1988 Galerie Grässlin-Ehrhardt, Frankfurt/M., FRG; Westfälischer Kunstverein, Münster, FRG; 'Refigured Painting: The German Image 1960–1988', Toledo Museum of Art, Toledo, Ohio, USA.

1989 Kunstverein, Konstanz, FRG; Galerie Janine Mautsch, Cologne, FRG; Galerie Silvia Menzel, Berlin, FRG; 'Art from Köln', Tate Gallery, Liverpool, UK; 'Open Mind', Museum van Hedendaagse Kunst, Gent, Belgium; 'Zeitzeichen — Stationen Bildender Kunst in Nordrhein-Westfalen', Bonn, FRG, Leipzig, GDR; 'Refigured Painting: The German Image 1960–1988', Guggenheim Museum, New York, USA; William College Museum of Art, Williamstown, Massachusetts, USA; 'Neue Figuration. Deutsche Malerei 1960–1988', Kunstmuseum, Düsseldorf, FRG, Schirn Kunsthalle, Frankfurt/M., FRG.

1990 Galerie Tanit, Munich, FRG; Galerie Grässlin-Ehrhardt, Frankfurt/M., FRG; Galerie Gisela Capitain, Cologne, FRG; Kunsthalle, Bremen, FRG; 'Zeitzeichen — Stationen Bildender Kunst in Nordrhein-Westfalen', Wilhelm-Lehmbruck-Museum, Duisburg, FRG; Animalia, Haus am Waldsee, Berlin, FRG; 'Vom Haben und vom Wollen', Bayerische Staatsgemäldesammlung, Munich, FRG.

1991 Galerie der Stadt Stuttgart, Stuttgart, GER; Galerie Ursula Schurr, Stuttgart, GER; Galerie Sophia Ungers, Cologne, GER; Systema Galleries, Baarn, Netherlands.

Collections
Paintings and graphical works in major national and international, private and public collections.

Selected bibliography
1983 Exh. cat. *Christa Näher*, Bonner Kunstverein, Bonn.

1984 Exh. cat. *Aus Deutschland …*, Kunstmuseum Luzern; Exh. cat. *Von hier aus — Zwei Monate Neue Deutsche Kunst*, DuMont Verlag, Cologne; Annelie Pohlen, 'Obsessive pictures or oppositions to the norm — noteworthy aspects of the engaged imagination in the new German Art', in: *Artforum*, no. 22, p. 48.

1985 Exh. cat. *Treibhaus*, Kunstmuseum Düsseldorf.

1986 Exh. cat. *Apokalypse*, Wilhelm-Hack-Museum, Ludwigshafen;

1987 Exh. cat. *Christa Näher — Zeichnungen*, Kunstverein Bielefeld;

1988 Exh. cat. *Christa Näher*, Westfälischer Kunstverein, Münster; Exh. cat. *Der Hang zur Architektur in der Malerei der Gegenwart*, Deutsches Architekturmuseum, Frankfurt/M.; Exh. cat. *Refigured Painting. The German Image 1960–88*, Solomon R. Guggenheim Museum, New York; *Contemporary Women Artists*, Phaidon Press Ltd., Oxford.

1989 Exh. cat. *2000 Jahre — Die Gegenwart der Vergangenheit*, Bonner Kunstverein, Bonn; Exh. cat. *Zeitzeichen — Stationen Bildender Kunst in Nordrhein-Westfalen*, DuMont Verlag, Cologne.

1990 Exh. cat. *Christa Näher*, Kunsthalle Bremen; Norbert Messler, 'Christa Näher — Galerie Gisela Capitain', in: *Artforum*, no. 5 (1990/91), p. 140.

1991 Exh. cat. *Christa Näher. Schacht*, Galerie der Stadt Stuttgart; Exh. cat. *Gullivers Reisen*, Galerie Sophia Ungers, DuMont Verlag, Cologne.

ALBERT OEHLEN

Born in Krefeld in 1954.
Lives and works in Düsseldorf.
Studied under Sigmar Polke and later under Claus Böhmler at the Hochschule für Bildende Künste in Hamburg.
Selected exhibitions

1980 'Mühlheimer Freiheit und interessante Bilder aus Deutschland', Galerie Paul Maenz, Cologne, FRG.

1981 Galerie Max Hetzler, Stuttgart, FRG; Galerie Magers, Bonn, FRG; Forum Kunst, Rottweil, FRG; 'Gegen-Bilder', Badischer Kunstverein, Karlsruhe FRG.

1982 Galerie Arno Kohnen, Düsseldorf, FRG; Galerie Max Hetzler, Stuttgart, FRG; Galerie Ascan Crone, Hamburg, FRG; Museum Boymans-van-Beuningen, Netherlands; Galerie Tanja Grunert, Stuttgart, FRG (with M. Kippenberger).

1983 Galerie Rudolf Zwirner, Cologne, FRG; Maximilian Verlag Sabine Knust, Munich, FRG; 'Zwischenbilanz: Neue Deutsche Malerei', Neue Galerie am Landesmuseum Joanneum, Graz, Austria, Museum Villa Stuck, Munich, FRG; Galerie Krinzinger, Innsbruck, Austria; Rheinisches Landesmuseum, Bonn, FRG; Buchhandlung Welt, Hamburg, FRG (with M. Kippenberger).

1984 Galerie Paul Andriesse/Helen van der Meij, Amsterdam, Netherlands; Galerie Max Hetzler, Cologne, FRG; Galerie Peter Pakesch, Vienna, Austria; Galerie Thomas Borgmann, Cologne, FRG (with M. Kippenberger); 'Von hier aus', Messehallen, Düsseldorf, FRG.

1985 Galerie Ascan Crone, Hamburg, FRG; Galerie Six Friedrich, Munich, FRG and Maximilian Verlag Sabine Knust, Munich, FRG; Galerie Silvio Baviera, Zurich, Switzerland (with M. Kippenberger); '7000 Eichen', Kunsthalle, Tübingen, FRG; Kunsthalle, Bielefeld, FRG; Fiedericianum, Kassel, FRG.

1986 Galerie Max Hetzler, Cologne, FRG; CCD Galerie, Düsseldorf, FRG; Sonnabend Gallery, New York, USA; Galerie Six Friedrich, Munich, FRG; Maximilian Verlag Sabine Knust, Munich, FRG; Galerie Borgmann +

Capitain, Cologne, FRG; Galerie Klein, Bonn, FRG; Galerie Ascan Crone, Hamburg, FRG (with M. Kippenberger).

1987 Kunsthalle, Zurich, Switzerland; Kunstverein, Graz, Austria.

1988 'Martin Kippenberger/Albert Oehlen — Dibujós', Galerie Juana de Aizpuru, Sevilla, Spain; 'M. Oehlen, A. Oehlen, M. Kippenberger, W. Büttner', Galerie Susan Wyss, Zurich, Switzerland.

Collections
Paintings in major national and international, private and public collections.

Selected bibliography
1981 Exh. cat. *Gegenbilder*, Badischer Kunstverein, Karlsruhe.

1983 Exh. cat. *Zwischenbilanz: Neue Deutsche Malerei*, Neue Galerie am Landesmuseum Joanneum, Graz; Museum Villa Stuck, Munich; Galerie Krinzinger, Innsbruck; Rheinisches Landesmuseum, Bonn; Klaus Honnef, 'Albert Oehlen', in: *Kunstforum International*, vol. 68, 12/83, pp. 174–7.

1984 Exh. cat. *Wahrheit ist Arbeit* (with M. Kippenberger and W. Büttner), Museum Folkwang, Essen; Exh. cat. *7000 Eichen*, Kunsthalle Tübingen; Exh. cat. *Das Geld*, Galerie Max Hetzler, Hamburg.

1985 Exh. cat. *Farbenlehre*, Galerie Ascan Crone, Hamburg; Exh. cat. *Albert Oehlen — Zeichnungen*, Galerie Peter Pakesch, Vienna.

1986 Exh. cat. *Albert Oehlen*, Galerie Six Friedrich and Maximilian Verlag Sabine Knust, Munich.

1987 Exh. cat. Wilfried Dickhoff (ed.), *Albert Oehlen. Abräumung, Prokrustische Malerei 1982–84*, Kunsthalle Zurich; Exh. cat. *Das Übel*, Kunstverein, Graz.

1990 Klaus Honnef, *Kunst der Gegenwart*, Benedikt Taschen Verlag, Cologne.

MARKUS OEHLEN

Born in Krefeld in 1956.
Lives and works in Hamburg and Krefeld.
1987 Received Berlin Art Prize.

Selected exhibitions
1978 '1. Ausserordentliche Veranstaltung in Bild und Klang zum Thema der Zeit: Elend', Kippenberger's Büro, Berlin.

1977 Konrad Fischers Raum Neubrückstraße, Düsseldorf, FRG.

1979 Galerie Arno Kohnen, Düsseldorf, FRG; Künstlerhaus, Hamburg, FRG.

1981 Galerie Silvio Baviera, Zurich, Switzerland; 'Art Allemagne Aujourd'hui', Musée de la Ville de Paris, Paris, France; 'Gegen-Bilder', Badischer Kunstverein, Karlsruhe, FRG.

1982 Galerie Max Hetzler, Stuttgart, FRG; Galerie Vera Munro, Hamburg, FRG; Galerie Art in Progress, Munich, FRG; 'La Giovane Trasavanguardia Tedesca', Galleria Nazionale d'Arte Moderna, San Marino, Italy.

1983 Galerie Arno Kohnen, Düsseldorf, FRG; Forum Kunst, Rottweil, FRG; Galerie Peter Pakesch, Vienna, Austria; Galerie Max Hetzler, Cologne, FRG.

1984 Reinhard Onnasch Galerie, Berlin, FRG; Galerie Heinrich Ehrhardt, Madrid, Spain; Galerie Max Hetzler, Cologne, FRG.

1985 Kunst RAI 85, Amsterdam (Galerie Max Hetzler), Netherlands; Reinhard Onnasch Galerie, Berlin, FRG; Asperger & Bischoff Gallery Inc., Chicago, USA; Galerie Max Hetzler,

Cologne, FRG; Galerie Richard Foncke, Gent, Belgium; '7000 Eichen', Kunsthalle, Tübingen, FRG; Kunsthalle, Bielefeld, FRG; Fridericianum, Kassel, FRG;

1986 Galerie Arno Kohnen, Düsseldorf, FRG; Galerie Grässlin-Ehrhardt, Frankfurt/M., FRG; Galerie Peter Pakesch, Vienna, Austria.

1987 Galerie Fucares, Madrid, Spain; Galerie Max Hetzler, Cologne, FRG; Galerie Borgmann-Capitain, Cologne, FRG.

1988 Galerie Grässlin-Ehrhardt, Frankfurt/M., FRG; PPS Galerie, Hamburg, FRG; Galerie Ursula Schnurr, Stuttgart, FRG; 'Refigured Painting: The German Image 1960–1988', Toledo Museum of Art, Toledo, Ohio, USA.

1989 'Refigured Painting: The German Image 1960–1988', Guggenheim Museum, New York, USA; William College Museum of Art, Williamstown, Massachusetts, USA; 'Neue Figuration. Deutsche Malerei 1960–1988', Kunstmuseum, Düsseldorf, FRG; Schirn Kunsthalle, Frankfurt, FRG.

1990 Galerie Grässlin-Ehrhardt, Frankfurt/M., FRG; Galerie Peter Pakesch, Vienna, Austria; Ausstellungsraum Hetzler, Cologne, FRG.

1992 Galeria Juana de Aizpuru, Sevilla, Spain.

Collections
Paintings and graphical works in major national and international, private and public collections.

Selected bibliography
1980 Exh. cat. *Finger für Deutschland*, Atelier Jörg Immendorff, Düsseldorf.

1981 Exh. cat. *Gegen-Bilder*, Badischer Kunstverein, Karlsruhe.

1982 Exh. cat. *Über sieben Brücken mußt Du gehn*, Galerie Max Hetzler, Stuttgart.

1983 Exh. cat. *Wer diesen Katalog nicht*

gut findet muß sofort zum Arzt (with
M. Kippenberger, A. Oehlen and M.
Oehlen), Galerie Max Hetzler,
Stuttgart;
1984 *Von hier aus — Zwei Monate Neue
Deutsche Kunst*, DuMont Verlag,
Cologne;
1985 Exh. cat. *Markus Oehlen*, Galerie
Reinhard Onnasch, Berlin; Exh. cat.
Ölsardinen und Pferdefleisch, Galerie
Max Hetzler, Cologne. Exh. cat. *Tiefe
Blicke*, Hessisches Landesmuseum,
Darmstadt; DuMont Verlag, Cologne;
1986 Exh. cat. *Macht und Ohnmacht der
Beziehungen*, Museum am Ostwall,
Dortmund; Exh. cat. *Neue Deutsche
Kunst aus der Sammlung Ludwig*,
Aachen, Haus Metternich, Koblenz;
Jutta Koether, 'Markus Oehlen at
Arno Kohnen, Düsseldorf', in:
Artscribe, (September/October)
1987 Exh. cat. *Markus Oehlen*, Galerie
Reinhard Onnasch, Berlin;
1989 Exh. cat. *Refigured Painting: The
German Image 1960–1988*, Salomon
R. Guggenheim Museum, New York;
1991 Exh. cat. *Timetunnel*, Galerie Gisela
Capitain, Cologne.

JÜRGEN PARTENHEIMER

Born in Munich in 1947.
Lives and works in Nümbrecht.
1973 Completed MFA (master-class
student) at the Department of Art,
University of Arizona, Tucson, USA.
1976 Completed PhD in Art History at the
Ludwig Maximilian University,
Munich.
1981–82 Visiting Professor of Art, University of
Arizona, Tucson, Arizona, USA.
1983–85 Guest Professor of Art, Staatliche
Akademie für Bildende Künste,
Düsseldorf.
1985 Distinguished Visiting Professor of
Art, University of California, Davis,
California, USA.
1987–90 Professor of Art, Rijksakademie van
Beeldene Kunsten, Amsterdam,

Netherlands.

Selected exhibitions
1979 Galerie Marzona, Düsseldorf, FRG;
The Richard Demarco Gallery,
Edinburgh, UK.
1981 Kunsthalle, Düsseldorf, FRG; Stichting
De Appel, Amsterdam, Netherlands;
SCC Gallery, Belgrade, Yugoslavia.
1982 Artists Space, New York, USA;
Franklin Furnace Gallery, New York,
USA; Articurial, Montréal, Canada;
Museum of Art, The University of
Arizona, Tucson, USA.
1983 Kunstraum, Munich, FRG.
1984 Kunstverein, Freiburg, FRG;
Kunstverein, Münster, FRG.
1985 Galerie Löhrl, Mönchengladbach,
FRG; Lorence Monk Gallery, New
York, FRG; Galerie Van Krimpen,
Amsterdam, Netherlands.
1986 Galerie Heike Curtze, Düsseldorf,
FRG; Galerie Reckermann, Cologne,
FRG; Gallery Shimada, Yamaguchi,
Japan; Galerie E.O. Friedrich, Berne,
Switzerland; Galerie Wilma Lock, St.
Gallen, Switzerland; Middendorf
Gallery, Washington, USA (with R.
Serra).
1987 Galerie Onrust, Amsterdam,
Netherlands; Lorence Monk Gallery,
New York, USA.
1988 Kunsthalle, Bremerhaven, FRG;
Galerie Hans Strelow, Düsseldorf,
FRG; Galerie Löhrl,
Mönchengladbach, FRG; Galerie
Erhard Klein, Bonn, FRG;
Nationalgalerie, Berlin, FRG; Galerie
Haas, Berlin, FRG; Galerie Wilma
Lock, St. Gallen, Switzerland.
1989 Kunstmuseum, St. Gallen,
Switzerland; Galerie Reckermann,
Cologne, FRG; Kunstmuseum,
Düsseldorf, FRG; Museum Schloß
Morsbroich, Leverkusen, FRG; Galerie
Onrust, Amsterdam, Netherlands.
1990 Kunsthalle, Hamburg, FRG; Galerie
Onrust, Amsterdam, Netherlands;
Kabinett für aktuelle Kunst,

Bremerhaven, FRG; Galerie Heike
Curtze, Vienna, Austria; Galerie
Wilma Lock, St. Gallen, Switzerland;
III. Biennale Balticum Rauma, Helsinki,
Finland (with Gerhard Richter);
Goethe-Institut, London, UK (with N.
Prangenberg and F. Klemm).
1991 Galerie Tilly Haderek, Stuttgart, GER;
Galerie Onrust, Amsterdam,
Netherlands; Elba Benitez Galeria,
Madrid, Spain; Dorothy Goldeen
Gallery, Los Angeles, USA; Galerie
Hans Strelow, Düsseldorf, GER
1992 Galerie Wilma Lock, St. Gallen,
Switzerland; Galerie Onrust,
Amsterdam, Netherlands; Galerie
Barbara Gross, Munich, GER; Galerie
Raymond Bollag, Zurich, Switzerland;
Elba Benitez Galeria, Madrid, Spain;
Galerie Erhard Klein, Bonn, GER.
(as well as many group exhibtions)

Collections
Paintings and graphical works in all major
national and international, private and public
collections.

Selected bibliography
1985 Annelie Pohlen, 'Jürgen
Partenheimer', in: *Artforum XXIV*,
April, New York.
1986 Exh. cat. *Behind the Eyes*, San
Francisco Museum of Modern Art;
Will Torphy, 'Questions and issues in
Germany', in: *Artweek*, April, San
Francisco; William Wilson, 'What you
see is not what you read', in: *Los
Angeles Times*, Los Angeles, 6. April.
1988 Exh. cat. *Jürgen Partenheimer. Das
Wesen der Dinge versteckt sich gern*,
Kunsthalle, Kunstverein,
Bremerhaven; Britta Schmitz et al.
(eds), *Jürgen Partenheimer.
Verwandlung-Heimkehr*, Art Book,
Amsterdam; Natioanlgalerie, Berlin.
1989 Exh. cat. *Jürgen Partenheimer*,
Kunstmuseum St. Gallen; Exh. cat.
Jürgen Partenheimer, Tönende
Schatten, Museum Schloß
Morsbroich, Leverkusen; Exh. cat. *Das*

1990 *Land der tieferen Einsichten*, Galerie Barbara Gross, Munich.

1990 Exh. cat. *Partenheimer. Bereiche des Ordnens*, Kunsthalle Hamburg; Max Wechsler, 'Jürgen Partenheimer. Kunstmuseum St. Gallen', in: *Artforum*, New York (February); Mathilde Roskam, 'Jürgen Partenheimer', in: *Artscribe*, London (June); Exh. cat. *Follow the Rabbit*, Galerie Heike Curtze, Vienna; Exh. cat. *Fritz Klemm, Jürgen Partenheimer, Norbert Prangenberg*, Goethe-Institut, London.

1991 Peter Frank, 'Weekly Pick, Jürgen Partenheimer', in: *LA Weekly*, Los Angeles, 21. June; *Giant Wall. Jürgen Partenheimer*, Limestone Press, San Francisco.

A.R. PENCK (RALF WINKLER)

Born Ralf Winkler in Dresden in 1939. Has lived and worked in Cologne and Düsseldorf as well as in London and Dublin since 1983.

1976 Received Will-Grohmann-Prize.
1989 Professorship at the Staatliche Kunstakademie, Düsseldorf.

Selected exhibitions

1969 Galerie Michael Werner, Cologne.
1972 Wide White Space Gallery, Antwerp, Netherlands; Kunstmuseum, Basel, Switzerland.
1973 Daner Galleriet, Copenhagen, Denmark; Städtische Galerie im Lenbachhaus, Munich, FRG.
1975 Galerie Neuendorf, Hamburg, FRG; Kunsthalle, Berne, Switzerland; Stedelijk Van-Abbe Museum, Eindhoven, Netherlands; Galerie Michael Werner, Cologne, FRG.
1978 Kunstmuseum, Basel, Switzerland; Kunstverein, Mannheim, FRG; Museum Ludwig, Cologne, FRG.
1979 Museum Boymans-van Beuningen, Rotterdam, Netherlands.
1980 Galerie Fred Jahn, Munich, FRG; Städtisches Museum Schloß

Morsbroich, Leverkusen, FRG.
1981 Kunstmuseum, Basel, Switzerland; Galerie Helen van der Meij, Amsterdam, Netherlands; Kunsthalle, Cologne, FRG; Kunsthalle, Berne, Switzerland.
1982 Galerie Michael Werner, Cologne, FRG; Ileana Sonnabend Gallery, New York, USA; Galerie Lucio Amelio, Naples, Italy; Galerie Gillespie-Laage-Salomon, Paris, France; Waddington Galleries, London, UK; Kunstmuseum, Bonn, FRG.
1983 Galerie Yarlow/Salzmann, Toronto, Canada; Galerie Springer, Berlin, FRG; Galerie Michael Werner, Cologne, FRG.
1984 Mary Boone/Michael Werner Gallery, New York, USA; Galerie Watari, Tokyo, Japan; Studio d'Arte Cannaviello, Milano, Italy; Galerie Maeght Lelong, Zurich, Switzerland; The Tate Gallery, London, UK.
1985 Brody's Gallery, Washington, USA; Museum Abteiberg, Mönchengladbach, FRG.
1986 Kunstverein, Freiburg, FRG; Maximilian Verlag Sabine Knust, Munich, FRG; Barbara Toll Fine Arts, New York, USA.
1987 Douglas Hyde Gallery, Dublin, Ireland; Edinburgh College of Art, Edinburgh, Scotland; Ulmer Museum, Ulm, FRG; Musée de Straßbourg, Straßburg, France.
1988 Galerie Chabot, Vienna, Austria; Nationalgalerie, Berlin, FRG; Kestner-Gesellschaft, Hannover, FRG; Kunstverein, Hamburg, FRG.
1989 Mary Boone Gallery, New York, USA; Galerie Michael Werner, Cologne, FRG; Stockholm Konsthall, Stockholm, Sweden.
1990 Galerie Philippe Guimiot, Brussels, Belgium; Eleni Koroneou Gallery, Athens, Greece; Cleto Polcina, Rome, Italy; Museum Waldhof, Bielefeld, FRG; Eugene Binder Gallery, Dallas,

Texas, USA.
(as well as many group exhibitions)

Collections

Paintings, graphical works and sculptures in all major national and international, private and public collections.

Selected bibliography

1971 Exh. cat. *A.R. Penck. Zeichen als Verständigung. Bücher und Bilder*, Museum Haus Lange, Krefeld.
1981 Exh. cat. *A.R. Penck, a y (a.r. penck)*, Kunsthalle Berne; Mickey Piller, 'A. R. Penck', in: *Artforum* (March).
1984 Jane Bell, 'What is German about the New German Art', in: *Art News* (March), pp. 96–101; Bazon Brock, 'Schlagzeug und Farborgel', in: *Kunstforum International* (June/August), pp. 43–61.
1985 Exh. cat. *A.R. Penck, Mike Hammer. Konsequenzen*, Museum Abteiberg, Mönchengladbach.
1986 Jamey Gambrell, 'A.R. Penck', in: *Art in America* (January), pp. 138–9; Paul Taylor, 'West German Art Today — Neoexpressionism and After', in: *Art News* (April), pp. 67–76.
1988 Exh. cat. Lucius Grisebach (ed.), *A.R. Penck*, Nationalgalerie Berlin; Exh. cat. Carl Haenlein (ed.), *A.R. Penck. Skulpturen und Zeichnungen 1971–1987*, Kestner-Gesellschaft Hannover; Wolfgang Max Faust, 'Review: A.R. Penck, Neue Nationalgalerie, Berlin', in: *Artforum International* (October), p. 163.
1989 Exh. cat. *A.R. Penck*, Galerie Beyerle, Basel.
1990 *A.R. Penck im Gespräch mit Wilfried Dickhoff*, Verlag Kiepenheuer & Witsch, Cologne; Exh. cat. *A.R. Penck. Standart Weapons, Standart Models*, Michael Werner Gallery, New York.

INGE PROKOT

Born in Cologne in 1933.
Lives and works in Cologne.
1949–55 Studies at the Kölner
Werkkunstschulen, Cologne.

Selected exhibitions

1973 Galerie Schalthöfer, Krefeld, FRG.
1974 Galerie Steinmetz, Bonn, FRG;
Rathaus, Rodenkirchen, FRG;
Artothek der Stadt Köln, Cologne,
FRG; 'Der röhrende Hirsch. Künstler
und ein Symbol der Trivialkunst',
Forum der VHS Köln, Cologne, FRG.
1975 Kunsthalle, Kiel, FRG; 'Farbe —
Material', Forum der VHS Köln,
Cologne, FRG.
1976 Galerie Inge Baecker, Essen, FRG;
Rheinisches Landesmuseum, Bonn,
FRG; 'Schuhwerke, Aspekte zum
Menschenbild', Kunsthalle, Nürnberg,
FRG.
1977 Marstallgebäude, Kassel, FRG.
1978 Museum Bochum, Bochum, FRG;
'Mona Lisa im 20. Jahrhundert',
Wilhelm-Lehmbruck-Museum,
Duisburg, FRG.
1979 'Mona Lisa au 20. Siecle' (travelling
exhibition), Tokyo/Osaka/Sapporo/
Ohita/Chiba, Japan; 'Soft-Art, weich
und plastisch', Kunsthaus, Zurich,
Switzerland.
1980 'Kölner Künstler — persönlich
vorgestellt von Mitgliedern des
Kölnischen Kunstvereins',
Kunstverein, Cologne, FRG;
'Kunstbücher', Produzentengalerie,
Munich, FRG.
1981 'Buchobjekte', Universitätsbibliothek,
Heidelberg, FRG.
1982 'Objektbücher und Buchobjekte',
Hessisches Landesmuseum,
Darmstadt, FRG; 'Arteder '82',
Muestra International de Obra
Gráfica, Bilbao, Spain.
1983 Wilhelm-Hack-Museum,
Ludwigshafen, FRG.
1986 'Le Livre Dans Tous Ses Etat', Musée
municipal, Paris, France; Galerie
Caroline Corre, Paris, France.
1987 Galerie Inge Baecker, Cologne, FRG;
Galerie Schüppenhauer (Kunstmarkt
Köln '87), Cologne, FRG; Galerie
Karlheinz Klang, Bonn-Köln, FRG.
1988 Museum Schloß Morsbroich,
Leverkusen, FRG; Galerie Fausto
Panetta, Mannheim, FRG; Galerie
Schüppenhauer, Cologne, FRG.
1990 Galerie Bea Voigt, Munich, FRG; 'ART
Nürnberg 5', Nürnberg, FRG.
1991 Galerie Fausto Panetta, Mannheim,
GER; Galerie Bea Voigt, Munich, GER.
1992 Wilhelm-Lehmbruck-Museum,
Duisburg, GER; Städtische Galerie,
Regensburg, GER; Literaturarchiv,
Sulzbach- Rosenberg, GER.

Collections

Paintings, sculptures and graphical works in
national private and public collections.

Selected bibliography

1976 Exh. cat. *Inge Prokot — Analogien.
Stele-Säule, Softskulpturen,
Ikonographien*, Rheinisches
Landesmuseum, Bonn; Rheinland-
Verlag GmbH Köln in Kommission bei
Rudolf Habelt Verlag, Bonn.
1978 Exh. cat. *Inge Prokot. Stelen, Objekte,
Photos — eine retrospektive
Übersicht*, Museum Bochum, Bochum.
1983 Exh. cat. *Inge Prokot — Neue
Arbeiten. Schamanenmäntel, Fetische,
Stelen, Rollbilder*, Wilhelm-Hack-
Museum, Ludwigshafen.
1988 Exh. cat. *Inge Prokot. Enzyklopädische
Malerei*, Museum Schloß Morsbroich,
Leverkusen.

Undated compendium of collected writings
Über die Arbeiten von Inge Prokot with texts by:
Annemarie In der Au, 'Mythologisches aus
Abfall', in: *Westdeutsche Zeitung*, Krefeld; Hans
Jürg Kupper, 'Sie zogen mich an ...', in: *Baseler
Nachrichten*, Basel; Maria Martine, 'Urgeschöpf
aus Abfallprodukten', in: *NOVUM*, Munich; Dr.
Juliane Roh (Munich) 'Die Pfahlfiguren (Objekt-
Stelen) der Inge Prokot ...'; Karin Thomas
(Cologne), 'Über Inge Prokot'; John Anthony
Twaites (Grevenbroich), 'Die Dame und die
Elefanten. Zu den neuen Arbeiten von Inge
Prokot.'

BARBARA QUANDT

Photograph: Ursula Fleischmann, Karlsruhe.

Born in Berlin in 1947.
Lives and works in Berlin.
1970–76 Studied under Hans Kuhn and K.H.
Hödicke at the Hochschule für
Bildende Künste, Berlin.
1978–79 DAAD Scholarship to live in London.
1982 PS1 Scholarship to live in New York.
1987 Scholarship by Berlin Senate to live in
Chicago.
1988 Scholarship by Walter Bischoff
Gallery, Chicago, to live in San Jose,
California.

Selected exhibitions

1974 '50 engagierte Künstler im
Nassauischen Kunstverein',
Kunstverein, Nassau, FRG.
1976 Galerie am Savignyplatz, Berlin, FRG
(with R. Pods).
1979 St. Martins School of Art, London,
UK.
1980 Forum Aktuelle Kunst, Berlin, FRG;
'Women from Berlin — The Exchange

Show', Mexico City, Mexico; San Francisco, USA; 'Frauenausstellung', Elefantenpress Galerie, Berlin, FRG.

1981 Galerie Fundus, Berlin, FRG; Galerie Andere Zeichen, Berlin, FRG; 'Berliner Szene', Rotterdam, Netherlands.

1982 Galerie Multiple, Berlin, FRG; 'Senatsankäufe', Staatliche Kunsthalle, Berlin, FRG.

1983 Galerie Fundus, Berlin, FRG; 'Alte Wilde — Neue Wilde', Siegburg, FRG.

1984 Galerie Sonne, Berlin, FRG; Künstlerhaus Bethanien, Berlin, FRG; 'Positionen', Frauen-Museum, Bonn, FRG; 'Kunst aus Berlin', Galerie Nothelfer, Berlin, FRG; Gesellschaft für aktuelle Kunst, Bremen, FRG.

1985 Kunstverein, Göttingen, FRG; Galerie Leger, Munich, FRG; Galerie Györfi, Herrenberg, FRG; Galerie im Körnerpark, Berlin, FRG.

1986 Goethe-Institut, Dar es Salaam, Tanzania; 'Images of Shakespeare', Kunstforum der Grundkreditbank, Berlin, FRG; Nationalgalerie, Berlin, FRG.

1987 Mora, Berlin, FRG; 'Berlin hat sich verändert', Studiogalerie, Sparkasse, Berlin, FRG; 'Berliner Stadtland-schaften' (travelling exhibition), Berlin/Wien/Amsterdam/London/Paris/Los Angeles; '3 Berlin Artists — 3 Berlin Contrasts', Walter Bischoff Gallery + Goethe-Institute, Chicago, USA.

1988 Walter Bischoff Gallery, Chicago, USA.

1989 Neuer Berliner Kunstverein, Berlin, FRG; Goethe-Institut, San Francisco, USA; Galerie Lacoste, San Jose (California), USA; Galerie Walter Bischoff, Stuttgart, FRG; 'Das kleine Format', Graphisches Kabinett, Galerie Pels-Leusden, Berlin, FRG.

1990 Art Galerie Leuchter und Peltzer, Düsseldorf, FRG; Galerie Huber-Nising, Frankfurt/M., FRG; Gutsch, Galerie + Edition, Berlin, FRG.

Collections
Paintings and graphical works in national and international, private and public collections.

Selected bibliography
1974 Exh. cat. *50 engagierte Künstler im Nassauischen Kunstverein*, Kunstverein Nassau.

1980 Exh. cat. *Frauenausstellung*, Elefantenpress Galerei, Berlin; Exh. cat. *Women from Berlin — The Exchange Show*, Mexico City/San Francisco.

1982 Anna Tüne, *Körper, Liebe, Sprache*, Elefantenpress, Berlin.

1984 Exh. cat. *Kunst aus Berlin*, Galerie Nothelfer, Berlin/Gesellschaft für aktuelle Kunst, Bremen; Exh. cat. *Positionen*, Frauen-Museum Bonn.

1985 Exh. cat. *Zwischen den Monden*, Galerie im Körnerpark, Berlin; Exh. cat. *Ikarus*, Neue Gesellschaft für Bildende Kunst, Berlin.

1986 Exh. cat. *Images of Shakespeare*, Kunstforum der Grundkreditbank, Berlin/Nationalgalerie Berlin.

1987 Exh. cat. *Essentiell*, Galerie im Körnerpark, Berlin; Exh. cat. *3 Berlin Artists — 3 Berlin Contrasts*, Walter Bischoff Gallery + Goethe-Institut, Chicago.

1988 Exh. cat. *Barbara Quandt. In Between*, Walter Bischoff Gallery, Chicago.

1989 Exh. cat. *Barbara Quandt. TAM TAM*, Neuer Berliner Kunstverein, Berlin; Exh. cat. *Das kleine Format*, Graphisches Kabinett, Galerie Pels-Leusden, Berlin;

1990 Exh. cat. *Barbara Quandt. Her-zeigen — Herz-zeigen, Passagen 2*, Galerei Huber-Nising.

GERHARD RICHTER

Born in Dresden in 1932.
Has lived and worked in Cologne since 1983.
1951–56 Studied at the Kunstakademie, Dresden.
1961–63 Studied at the Staatliche Kunstakademie, Düsseldorf.

1967 Junger Western Art Prize, Recklinghausen.
1967 Guest Professor at the Hochschule für Bildende Künste, Hamburg.
1971– Professor at the Staatliche Kunstakademie, Düsseldorf.
1978 Guest Professor at the College of Art, Halifax, Canada.
1981 Arnold Bode Prize, Kassel.
1985 Oskar Kokoschka Prize, Vienna.

Selected exhibitions
1964 Galerie Schmela, Düsseldorf, FRG; Galerie Block, Berlin, FRG.
1966 Galerie Friedrich & Dahlem, Munich, FRG.
1967 Galerie Heiner Friedrich, Munich, FRG.
1968 Galerie Zwirner, Cologne, FRG.
1970 Museum Folkwang, Essen, FRG.
1971 Kunstverein für die Rheinlande und Westfalen, Düsseldorf, FRG.
1973 Städtische Galerie im Lenbachhaus, Munich, FRG; Onnasch Gallery, New York, USA.
1975 Kunsthalle, Bremen, FRG.
1977 Centre Georges Pompidou, Paris, France.
1978 Midland Group, Nottingham, UK; Van Abbemuseum, Eindhoven, Netherlands; Whitechapel Art Gallery, London, UK.
1979 Whitechapel Art Gallery, London, UK.
1980 Museum Folkwang, Essen, FRG.
1981 Padiglione d'Arte Contemporanea di Milano, Milano, Italy.
1982 Kunsthalle, Bielefeld, FRG; Kunstverein, Mannheim, FRG.
1985 Staatsgalerie, Stuttgart, FRG; Marian Goodman Gallery/Sperone Westwater Gallery, New York, USA.
1986 Barbara Gladstone Gallery, New York, USA; Rudolf Zwirner Gallery, New York, USA; Städtische Kunsthalle, Düsseldorf, FRG; Kunstverein für die Rheinlande und Westfalen, Düsseldorf, FRG; Kunsthalle, Berne, Switzerland; Museum Moderner Kunst/Museum des 20. Jahrhunderts, Vienna, Austria.

1987 Museum Overholland, Amsterdam, Netherlands; Marian Goodman Gallery/Sperone Westwater Gallery, New York, USA; Galerie Rudolf Zwirner, Cologne, FRG.

1988 Galerie Fred Jahn, Munich, FRG; Anthony d'Offay Gallery, London, UK; Art Gallery of Ontario, Toronto, Canada; Museum of Contemporary Art, Chicago, USA; Hirshhorn Museum and Sculpture Garden, Washington, USA; San Francisco Museum of Modern Art, San Francisco, USA.

1989 Museum Haus Esters, Krefeld, FRG (travelling to Frankfurt/M., London, Saint Louis, New York, Los Angeles, Boston); Städtische Galerie im Lenbachhaus, Munich, FRG (travelling to Cologne); Nelson-Atkins Museum of Art, Kansas City, USA; Museum Boymans-van Beuningen, Rotterdam, Netherlands.

1991 Whitworth Art Gallery, Manchester, UK; Anthony d'Offay Gallery, London, UK; Galerie Liliane & Michel Durand-Dessert, Paris, France; Tate Gallery, London, UK.

(as well as many group exhibitions)

Collections

Paintings and graphical works in all major national and international, private and public collections.

Selected bibliography

1982 Exh. cat. *Gerhard Richter: Abstrakte Bilder 1976–1981*, Kunsthalle Bielefeld; Kunstverein Mannheim.

1986 Exh. cat. *Gerhard Richter: Paintings 1964–1974*, Barbara Gladstone Gallery, New York; Exh. cat. *Gerhard Richter: Bilder/Paintings 1962–1985*, Städtische Kunsthalle, Düsseldorf; DuMont Verlag, Cologne.

1987 Exh. cat. *Gerhard Richter: Werken op Papier 1983–1986*, Museum Overholland, Amsterdam; Exh. cat. *Gerhard Richter: Paintings*, Marian Goodman Gallery/Sperone Westwater Gallery, New York.

1988 Exh. cat. *Gerhard Richter: Neun Bilder 1982–1987*, Galerie Fred Jahn, Munich; Exh. cat. *Gerhard Richter: The London Paintings*, Anthony d'Offay Gallery, London; Exh. cat. *Gerhard Richter: Paintings*, Art Gallery of Ontario, Toronto, et al; Michael Kimmelmann, 'Style as Contradiction of Style', in: *New York Times*, 17 (December); Peter Day, 'On the Richter Scale', in: *Canadian Art*, vol. 5 (March), pp. 80–5.

1989 Exh. cat. *Gerhard Richter: Atlas*, Städtische Galerie im Lenbachhaus, Munich; Verlag Fred Jahn, Munich; William Wilson, 'Gerhard Richter's Hat Trick', in: *Los Angeles Times*, 26.3.89, pp. 88–90.

1991 Exh. cat. *Gerhard Richter*, Tate Gallery, London; Tate Gallery Publications, Millbank, London.

HEIKE RUSCHMEYER

Born in Uchte/Lower Saxony in 1956.
Lives and works in Berlin.

1976–79 Studied under Emil Cimiotti and Alfred Winter-Rust at the Hochschule für Bildende Künste, Braunschweig.

1979–82 Studied under W. Petrick at the Hochschule der Künste, Berlin. Master-class student.

1983 Bernhard-Sprengel-Prize for Fine Arts.

1985 Scholarship for Young Artists, Hochschule der Künste, Berlin.

Selected exhibitions

1978 'Hommage à Goya', Kunsthaus, Hamburg, FRG; 'Herbstausstellung', Kunstverein, Hannover, FRG; 'Die

Bildende Kunst und das Tier', Orangerie, Hannover, FRG.

1981 Selbsthilfe-Galerie Kulmerstraße, Berlin, FRG.

1982 Anderes Ufer, Berlin, FRG; 'Gefühl und Härte', Kulturhaus, Stockholm, Sweden; Kunstverein, Munich, FRG; 'Zwischen himmlischer und irdischer Liebe', Galerie Brusberg, Berlin, FRG.

1983 Sprengel Museum, Hannover, FRG; Galerie Brusberg, Berlin, FRG; 'Künstler in Niedersachsen — Ankäufe des Landes seit 1976', Kunstverein, Hannover, FRG; Deutscher Künstlerbund, Gropiusbau, Berlin, FRG.

1984 Galerie Boibrino, Stockholm, Sweden; 'Umgang mit der Aura', Städtische Galerie, Regensburg, FRG; Galerie Brusberg, Hannover, FRG (with Petrick and Stöhrer); 'Realisten in Berlin' (Sammlung Stahl), Berlinische Galerie, Berlin, FRG; Atelier Rue Sainte-Anne, Brussels, Luxemburg (with B. Niedt).

1985 '5 x junge Malerei', Galerie Brusberg, Berlin, FRG; '3. Internationale Triennale der Zeichnung', Kunsthalle, Nürnberg, FRG; '5 Jahre Ankäufe des Senats', Staatliche Kunsthalle, Berlin, FRG.

1986 'Gegenlicht', Staatliche Kunsthalle, Berlin, FRG; 'Eva und die Zukunft', Kunsthalle, Hamburg, FRG; 'ART COLOGNE' (Galerie Brusberg), Cologne, FRG.

1987 Galerie Brusberg, Berlin, FRG; 'Momentaufnahme', Staatliche Kunsthalle, Berlin, FRG; Künstlerhaus, Vienna, Austria.

1989 Galerie Brusberg, Berlin, FRG (with Rainer Schwarz); '40 Jahre Kunst in der Bundesrepublik Deutschland', Städtische Galerie Schloß Oberhausen, Oberhausen, FRG; Staatliche Kunsthalle, Berlin, FRG; 'Art in Berlin 1815–1989', High Museum of Art, Atlanta, USA.

1990 Galerie Gering-Kulenkampff, Frankfurt/M., FRG; 'Bilder vom

Menschen', Galerie Brusberg in der
Galerie Berlin, Berlin, GDR; 'Ecce
homo! oder: Christus verweigert den
Gehorsam', Galerie Brusberg, Berlin,
FRG.

1991 Samuelis Baumgarte Galerie,
Bielefeld, GER.

Collections
Paintings in mainly national, private and public
collections.

Selected bibliography
1978 Exh. cat. *Die Bildende Kunst und das
Tier*, Orangerie Hannover.

1982 Exh. cat. *Gefühl und Härte*,
Kulturhaus, Stockholm/Kunstverein
Munich, Fröhlich und Kaufmann.

1983 Exh. cat. *Künstler in Niedersachsen —
Ankäufe des Landes seit 1976*,
Kunstverein Hannover. Heinz Ohff,
'Das Trauma als Faszinosum', in: *Der
Tagesspiegel*, Berlin, 11.8.83.

1985 Exh. cat. *5 Jahre Ankäufe des Senats*,
Staatliche Kunsthalle, Berlin. Heinz
Ohff, 'Zwei Impulse vereint — 5mal
Junge Malerei in der Galerie
Brusberg', in: *Der Tagesspiegel*,
Berlin, 4.8.85.

1986 Exh. cat. *Gegenlicht*, Staatliche
Kunsthalle, Berlin; Exh. cat. *Eva und
die Zukunft*, Kunsthalle Hamburg.

1987 *Der Doppelgänger, Heike
Ruschmeyer*, Brusberg Dokumente 16,
Berlin; Exh. cat. *Momentaufnahme*,
Staatliche Kunsthalle, Berlin; Bernhard
Schulz, 'An der Grenze des
Möglichen', in: *Der Tagesspiegel*,
Berlin, 27.06.87; Angelika Ziesche,
'Die Künstlichkeit muß die größte
sein', in: *Kunst und Unterricht*,
115/87.

1989 Exh. cat. *40 Jahre Kunst in der
Bundesrepublik Deutschland*,
Staatliche Kunsthalle, Berlin; Exh. cat.
Querschnitt '89, Galerie Brusberg,
Berlin; Exh. cat. *Art in Berlin
1815–1989*, High Museum of Art,
Atlanta.

EVA-MARIA SCHÖN

Photograph: Renate Anger.

Born in Dresden in 1948.
Lives and works in Berlin.

1966–69 Served an apprenticeship for
photography in Düsseldorf under Lore
Bermbach.

1974–78 Studied under Klaus Rinke at the
Staatliche Kunstakademie, Düsseldorf.

1982 Receives Villa-Romana-Scholarship to
live in Florence.

1983–84 Received Karl-Schmidt-Rottluff-
Scholarship.

1989 Guest professorship at the
Hochschule der Künste, Berlin.

Selected exhibitions
1978 Museum Reuchlinhaus, Pforzheim,
FRG.

1979 Galerie Max Hetzler, Stuttgart, FRG;
'Schlaglichter', Landesmuseum, Bonn,
FRG; 'Europa 79', Stuttgart, FRG.

1981 Galerie Dany Keller, Munich, FRG;
'Art Allemande Aujourd'hui',
ARC/Musée d'Art Moderne de la Ville
de Paris, Paris, France; 'Bildwechsel —
Neue Malerei aus Deutschland',
Akademie der Künste, Berlin, FRG.

1982 Galerie Anselm Dreher, Berlin, FRG.

1982 Kunst und Museumsverein,
Wuppertal, FRG and Museum Düren,
FRG.

1983 Raum für Malerei, Cologne, FRG;
'Künstlerräume', Kunstverein,
Hamburg, FRG.

1985 Goethe-Institut, Paris, France; ON-
Galerie, Poznan, Poland; 'Kunst mit
Eigen-Sinn', Museum des 20.
Jahrhunderts, Vienna, Austria.

1986 Apollohuis, Eindhoven, Netherlands.

1987 'Berlin Art', Museum of Modern Art,
New York, USA.

1988 Galerie Witzel, Offenbach, FRG;
Kamakura Galerie, Tokyo, Japan; Art
Center Spiral, Tokyo, Japan; 'Das
Verborgene Museum', Akademie der
Künste, Berlin, FRG.

1989 Galerie Barbara Gross, Munich, FRG;
'Fragments', John David Mooney
Foundation, Chicago, USA.

1990 Artothek im Bonner Kunstverein,
Bonn, FRG.

1991 Städtische Galerie, Schwäbisch Hall,
GER; 'Die Ordnung der Dinge',
Palazzo Di Esposizioni, Rome, Italy;
'Dialoge', Zoologisches Museum, Kiel,
GER; 'Positionen', Art Cologne,
Cologne, GER; 'Interferenzen', Riga
and Petersburg, Russia.

1992 Apollohuis, Eindhoven, Netherlands
(with Rolf Julius).

Collections
Paintings and drawings in mainly national
private and public collections.

Selected bibliography
1981 Exh. cat. *Bildwechsel — Neue Malerei
in Deutschland*, Interessengemein-
schaft Berliner Kunsthändler, Berlin.

1985 Exh. cat. Silvia Eiblmayer, Valie
Export, Monika Prischl-Maier (eds)
Kunst mit Eigen-Sinn, Löcker Verlag,
Vienna/Munich.

1987 Exh. cat. *Das Verborgene Museum*,
Neue Gesellschaft für Bildende Kunst,
Berlin; Edition Hentrich, Berlin.

1989 Karin Graf/Patricia Ferer (eds), *Kunst
in Berlin*, Verlag Kiepenheuer &
Witsch, Cologne.

1991 Exh. cat. *Interferenzen — Kunst aus
Westberlin 1960–1990*, Verlag Dirk
Nishen, Berlin; Theresa Georgen/Ines
Lindner/Silke Radenhausen (eds), *Ich
bin nicht ich wenn ich sehe*, Dietrich
Reimer Verlag, Berlin.

1992 Exh. cat. *Eva-Maria Schön. Tastsinn
Sehsinn*, Städtische Galerie am Markt,
Schwäbisch Hall.

STEFAN SZCZESNY

Photograph: Benjamin Katz, Cologne.

Born in Munich in 1951.
Lives and works in Cologne and Croix-Valmer near St. Tropez.
1967–69 Studied at a Fachschule für Freie und Angewandte Kunst in Munich.
1969–75 Studied at the Akademie der Bildenden Künste, Munich.
1981 DAAD Scholarship to live in Paris.
1982–83 Rome-Prize to live at the Villa Massimo, Rome.

Selected exhibitions
1974 Galerie Wicke, Munich, FRG; Contemporary Art Galerie, Munich, FRG.
1976 Goethe-Institut, Paris, France.
1979 Städtische Galerie im Lenbachhaus, Munich, FRG.
1981 Galerie Friedrich und Knust, Munich, FRG; Galerie Gugu Ernesto, Cologne, FRG.
1982 Galerie A, Amsterdam, Netherlands; Galerie Brusberg, Hannover, FRG; Galerie Jamileh Weber, Zurich, Switzerland; Galerie Gmyrek, Düsseldorf, FRG.
1983 Villa Massimo, Rome, Italy; Galerie Pfefferle, Munich, FRG; Galerie Ch. Wegner, Basel, Switzerland.
1984 Glyptothek und Staatliche Antikensammlung, Munich, FRG; Galerie Jamileh Weber, Zurich, Switzerland; 'Zwischenbilanz — Neue Deutsche Malerei', Neue Galerie am Landesmuseum, Graz, Austria; Museum Villa Stuck, Munich, FRG; Forum für aktuelle Kunst/Galerie

Krinzinger, Innsbruck, Austria; Rheinisches Landesmuseum, Bonn, FRG.
1985 Galerie Heinz Holtmann, Cologne, FRG; Kunstverein, Pforzheim, FRG; Farbbad Galerie, Hamburg, FRG; Galerie Hans Barlach, Hamburg, FRG; Galerie Pfefferle, Munich, FRG; Galerie Wanda Reiff, Maastricht, Netherlands.
1986 Galerie Birgit Terbrüggen, Sinsheim/Heidelberg, FRG; Galerie Jamileh Weber, Zurich, Switzerland; Galerie Silvia Menzel, Berlin, FRG.
1988 Galerie Holtmann, Cologne, FRG; Rheinisches Landesmuseum, Bonn, FRG; Galerie Fahlbusch, Mannheim, FRG.
1989 Galerie Pfefferle, Munich, FRG (with Elvira Bach and Clemens Kaletsch); Galerie Holtmann, Cologne, FRG; Galerie Hans Barlach, Hamburg, FRG.
1990 Kunstverein, Mannheim, FRG; Galerie Pfefferle, Munich, FRG; Galerie Hilger, Vienna, Austria; Kunstverein, Augsburg, FRG; Kunstverein, Uelzen, FRG; Galerie Holtmann, Cologne, FRG; 'Blau — Farbe der Ferne', Kunstverein, Heidelberg, FRG.
1991 Galerie Pfefferle, Munich, GER (with Harald Vogl); Galerie Fahlbusch, Mannheim, GER; Kunstverein, Heidelberg, GER; Galerie AGR, Goslar, GER.
1992 DuMont Kunsthalle, Cologne, GER; Galerie Hilger, Vienna, Austria; Galerie Holtmann, Cologne, GER; Galerie Pfefferle, Munich, GER.

Collections
Paintings and graphical works in national and international, private and public collections.

Selected bibliography
1979 Exh. cat. *Stefan Szczesny*, Städtische Galerie im Lenbachhaus, Kunstforum Munich.
1982 Exh. cat. *Stefan Szczesny. Zeichnungen 1980–82*, Galerie Pfefferle, Munich; Wolfgang Max Faust/Gerd de Vries, *Hunger nach*

Bildern — Deutsche Malerei der Gegenwart, DuMont Buchverlag, Cologne;
1984 Exh. cat. *Stefan Szczesny. Metamorphosen*, Staatliche Antikensammlung und Glyptothek, Munich.
1985 Exh. cat. *Stefan Szczesny. Badende*, Galerie Barlach, Hamburg; Exh. cat. *Stefan Szczesny. Arbeiten auf Papier 1978–1985*, Galerie Terbrüggen, Sinsheim.
1986 Exh. cat. *Stefan Szczesny. Tarzan in New York*, Galerie Silvia Menzel, Berlin; Exh. cat. Stefan *Szczesny. Stilleben — Still-Life — Nature Morte*, Galerie Hans Barlach, Hamburg; Galerie Holtmann, Cologne; Edition Pfefferle, Munich.
1988 Exh. cat. *Stefan Szczesny. Portraits*, Verlag Holtmann, Cologne.
1989 Stefan Szczesny (ed.), *Maler über Malerei. Künstlerschriften zur Malerei der Gegenwart*, DuMont Buchverlag, Cologne.
1991 Wilfried Dickhoff (ed.), Exh. cat. *Stefan Szczesny. Portraits 1989–1991*. Idole-Mythen-Leitbilder, Harenberg Edition, Dortmund.

VOLKER TANNERT

Born in Recklinghausen in 1955.
Lives and works in Cologne.
1975–79 Studied under Klaus Rinke and Gerhard Richter at the Kunstakademie, Düsseldorf.
1979 Max-Ernst scholarship to live in New York, awarded by the city of Brühl.

1985 Support award Glockengasse.

Selected exhibitions

1981 Galerie Ricke, Cologne, FRG; Galerie Friedrich, Bern, Switzerland;

1982 Galerie Ricke, Cologne, FRG; Galerie Pakesch, Vienna, Austria; Realismusstudio 22, NGBK, Berlin, FRG.

1983 Goethe-Institut, Paris, France; Goethe-Institut, Brussels, Belgium; Galerie Friedrich, Bern, Switzerland; Galerie Pfefferle, Munich, FRG; Galerie Baronian-Lambert, Geneva, Switzerland.

1984 Galerie Emilio Mazzoli, Modena, Italy; 'La Scuola di Atene — il sistema dell'arte', Acireale, Palazzo di Citta, Rome, Italy; Palazzo Borghese, Ferrara, Italy; Palazzo dei Diamanti, Malo, Italy; 'Zwischenbilanz', Joanneum, Graz, Austria; Villa Stuck, Munich, FRG.

1985 Galerie Schellmann & Klüser, Munich, FRG; Sonnabend- Gallery, New York, USA; Badischer Kunstverein, Karlsruhe, FRG; Kunsthalle, Bremen, FRG; Kunstverein, Bonn, FRG; Mathildenhöhe, Darmstadt, FRG.

1986 Galerie Klüser, Munich, FRG; Galerie Wilkens & Jacobs, Cologne, FRG; Sonnabend-Gallery, New York, USA; Galerie Templon, Paris, France; 'Wechselströme', Kunstverein, Bonn, FRG; 'Hommage an Beuys', Galerie im Lenbachhaus, Munich, FRG.

1988 Galerie Klüser, Munich, FRG; Galerie Friedrich, Bern, Switzerland; 'Refigured Painting: The German Image 1960–1988', Toledo Museum of Art, Toledo, Ohio, USA; 'Der Hang zur Architektur in der heutigen Malerei', Architekturmuseum, Frankfurt/M., FRG; 'Landschaftsbilder', Kunstverein, Hamburg, FRG.

1989 'Refigured Painting: The German Image 1960–1988', Guggenheim Museum, New York, USA; William

College Museum of Art, Williamstown, Massachusetts, USA; 'Neue Figuration. Deutsche Malerei 1960–1988', Kunstmuseum, Düsseldorf, FRG, Schirn Kunsthalle, Frankfurt, FRG.

1990 Galerie L'Oeil écoute, Lyon, France; Galerie Dorit Jacobs, Cologne, FRG; Städtische Galerie, Meerbusch, FRG; 'Vom Schönen Schein', Villa Clementine, Wiesbaden, FRG; 'Blickpunkte', Goethe-Institut, Motreal, Canada.

1991 Galerie Kevenich, Cologne, GER; Galerie Zellermayer, Berlin, GER; 'Blau — Farbe der Ferne', Kunstverein, Heidelberg, GER.

1992 Galerie Van Esch, Eindhoven, Netherlands.

Collections

Paintings in national and international, public and private collections.

Selected bibliography

1981 Peter Iden, 'Die hochgemuten Nichtskönner', in: *Frankfurter Rundschau*, 18 July; Gerhard Storck, 'Selbsthilfe und feuchte Adressen. Zwei Bilder von Volker Tannert', in: *Faltblatt Krefelder Kunstmuseum*, September.

1982 Exh. cat. *12 Künstler aus Deutschland*, Basel; Barbara Straka, 'Chiffren der Existenz. Bilder und Zeichnungen von Volker Tannert', in: exh. cat. *Volker Tannert. Evolutionen*, Berlin (also includes texts by Ulla Frohne, Michael Elsen and R. Danziger).

1983 Wulf Herzogenrath, 'Die Kölner Kunstszene', in: exh.cat. *8 in Köln*, Cologne; Sabine Schütz, 'Volker Tannert', in: *Kunstforum International* (Zwischenbilanz II. Neue Deutsche Malerei), no. 68, pp. 198–9.

1984 Walter Grasskamp, 'Gespräche mit den Künstlern', in: exh.cat. *Ursprung und Vision. Neue Deutsche Malerei*, Madrid/Barcelona, Berlin, pp. 155–7;

Exh. cat. *Volker Tannert*, Galerie Emilio Mazzoli, Modena, Italy; Helena Kontova, 'Volker Tannert' (Interview), in: *Flash Art* 118, pp. 27–30.

1985 Exh. cat. *Volker Tannert. Bilder und Zeichnungen 1981 bis 1985*, Badischer Kunstverein, Karlsruhe; Kunsthalle Bremen.

1990 Exh. cat. *Volker Tannert*, Galerie L'Oeil écoute, Lyon; Exh. cat. Hans Gercke (ed.), *Blau — Farbe der Ferne*, Verlag Das Wunderhorn, Heidelberg.

THOMAS WACHWEGER

Born in Breslau in 1943.
Has lived and worked in Berlin since 1978.
1963–70 Studied at the Hochschule für Bildende Künste, Hamburg.

Selected exhibitions

1974 Galerie Silvio R. Baviera, Zurich, Switzerland.

1980 Galerie Paul Maenz, Cologne, FRG.

1981 Galerie Petersen, Berlin, FRG; 'Gegen-Bilder', Kunstverein, Karlsruhe, FRG.

1982 'La Giovane Trasavanguardia Tedesca', Galleria Nazionale D'Arte Moderna, San Marino, Italy.

1983 Galerie Schneider, Konstanz, FRG; 'Zuoberst-zuunterst', NGBK, Berlin, FRG; Galerie Fossati, Kilchberg, FRG; Galerie Six Friedrich, Munich, FRG; 'Fotocollagen', NGBK, Berlin, FRG; 'Ansatzpunkte kritischer Kunst', Bonn, FRG.

1984 Galerie Springer, Berlin; Galerie Springer, Berlin, Art Cologne, Cologne, FRG; 'Wer überlebt, winkt', NGBK, Berlin, FRG; 'Zwischenbilanz',

Joanneum, Graz, Austria; Villa Stuck, Munich, FRG; Rheinisches Landesmuseum, Bonn, FRG; 'Tiefe Blicke', Hessisches Landesmuseum, Darmstadt, FRG; 'Die Wieder-gefundene Metropole', Palais des Beaux-Arts, Brussels, Belgium.

1985 Galerie Monika Sprüth, Cologne, FRG; Produzentengalerie, Hamburg, FRG; RAI 85, Amsterdam, Netherlands; Galerie Springer, Berlin, FRG; 'Die Kunst der Triebe', Museum am Ostwall, Dortmund, FRG (with Ina Barfuss); 'Kunst in der Bundesrepublik Deutschland 1945–1985', Nationalgalerie, Berlin, FRG.

1986 Galerie Silvio R. Baviera, Zurich, Switzerland; 'Ina Barfuss/Thomas Wachweger — Ausstellung in 2 Folgen', Haus am Waldsee, Berlin, FRG; 'Global Dialog — Primitive and Modern Art', Louisiana Museum, Humlebaek, Louisiana, USA; 'Perspectives 5: New German Art', Portland Art Museum, Portland, Oregon, USA; 'Berlin Aujourd'hui', Musée de Toulon, Toulon, France.

1987 Institute of Contemporary Arts, London, UK; 'Momentaufnahme', Staatliche Kunsthalle, Berlin, FRG; 'Berlinart', Museum of Modern Art, New York, USA; 'Wechselströme', Kunstverein, Bonn, FRG.

1988 'Arbeit in Geschichte. Geschichte in Arbeit', Kunstverein, Hamburg, FRG; 'NATURE MORTE', Galerie Philomone Magers, Bonn, FRG.

1989 Galerie Springer, Berlin, FRG; 'Neue Tendenzen der Späten 80er Jahre', Padiglione d'Arte Contemporanea, Milano, Italy; '40 Jahre Bundesrepublik Deutschland — 40 Künstler — 40 Arbeiten', Kunstverein, Mannheim, FRG.

1991 Das Kleine Museum Baviera, Zurich, Switzerland; 'Interferenzen — Kunst aus Westberlin 1960–1990', Museum für ausländische Kunst, Riga, Latvia.

Collections
Paintings in major national and international, private and public collections.

Selected bibliogaphy
1981 Exh. cat. *Gegen-Bilder*, Kunstverein Karlsruhe.
1983 Exh. cat. *Thomas Wachweger. Zuoberst-zuunterst*, NGBK Berlin.
1984 Exh. cat. *Zwischenbilanz*, Joanneum, Graz, Villa Stuck, Munich, Rheinisches Landesmuseum, Bonn; Exh. cat. *Tiefe Blicke*, Hessisches Landesmuseum, Darmstadt.
1985 Exh. cat. Wolfgang Max Faust (ed.), *Die Kunst der Triebe. Ina Barfuss/ Thomas Wachweger*, Berlin; Museum am Ostwall, Dortmund, Ulmer Museum.
1986 Exh. cat. Thomas Kempas (ed.), *Ina Barfuss — Thomas Wachweger. Gemälde, Zeichnungen, Gemeinschaftsarbeiten 1978 bis 1986*, Berlin (Haus am Waldsee); Stephan Schmidt-Wulffen, 'Hübsch-häßlich', in: *Kunstforum International*, vol. 83, pp. 262–4.
1987 Exh. cat. *Ina Barfuss. Bilder 1987 sowie Gemeinschaftsarbeiten mit Thomas Wachweger*, Galerie Springer, Berlin; Stephan Schmidt-Wulffen, *Spielregeln: Tendenzen der Gegenwartskunst*, DuMont Buchverlag, Cologne; Exh. cat. *Berlinart*, Museum of Modern Art, New York; Exh. cat. *Wechselströme*, Kunstverein Bonn.
1989 Christos M. Joachimides (ed.), *Aufbruch in die neunziger Jahre. Neun Künstler in Berlin*, Milano.
1991 Exh. cat. *Interferenzen — Kunst aus Westberlin 1960–1990*, Verlag Dirk Nishen, Berlin.

BERND ZIMMER

Photograph: Thilo Märtlein, Munich.

Born in Planegg, near Munich, in 1948.
Lives and works in Polling.
1973–79 Studied philosophy and theology at the Freie Universität, Berlin.
1979–81 Received Karl Schmidt-Rottluff-Scholarship.
1982–83 Received Villa Massimo Scholarship to live in Rome.

Selected exhibitions
1977 Galerie am Moritzplatz, Berlin, FRG.
1980 Galerie Gmyrek, Düsseldorf, FRG.
1981 Galerie Art in Progress, Düsseldorf, FRG; Kunstverein, Freiburg, FRG; Barbara Gladstone Gallery, New York, USA; Yvon Lambert, Paris, France; Galerie Georg Nothelfer, Berlin, FRG.
1982 Groninger Museum, Groningen, Netherlands; Galerie Hermeyer, Munich, FRG; Städtische Sammlungen, Duisburg-Rheinhausen, Duisburg, FRG; Galerie Buchmann, St. Gallen, Switzerland.
1983 Lapis/arte, Salerno, Italy; Yvon Lambert, Paris, France; Villa Massimo, Rome, Italy; Museum Villa Stuck, Munich, FRG; Galleria Chisel, Genova, Italy; Galerie H.S. Steinek, Vienna, Austria; Steven Leiber, San Francisco, USA; Galerie Gmyrek, Düsseldorf, FRG.
1984 Albert Baronian, Knokke, Belgium; Studio d'Arte Cannaviello, Milano, Italy; Ugo Ferranti, Rome, Italy; Sainte Pierre Art Contemporain, Lyon, France; 'An International Survey of Recent Painting and Sculpture', The Museum of Modern Art, New York, USA.

1985 Galerie Hermeyer, Munich, FRG; Salle Saint-Georges, Liège, Belgium; Galerie Le Point, Monte Carlo, Monaco; Galerie d'Art Contemporain, Bordeaux, France; Galleria Lilo, Mestre, Italy (with C. Kaletsch).

1986 Kunstverein, Braunschweig, FRG; Galerie Pierre Huber, Geneva, Switzerland; Galerie Hartmann, St. Gallen, Switzerland.

1987 Ulmer Museum, Ulm, FRG; Galerie Ballegeer, Liège, Belgium; 'Berlinart 1961–1987', The Museum of Modern Art, New York, USA; San Francisco Museum of Modern Art, San Francisco, USA.

1988 Raab Gallery, London, UK; Kunstverein, Pforzheim, FRG; Fuji Television Gallery, Tokyo, Japan.

1989 Studio d'Arte Cannaviello, Milano, Italy; Harcourts Contemporary, San Francisco, USA; Städtische Galerie im Lenbachhaus/Kunstforum, Munich, FRG.

1990 Galerie im Taxis-Palais, Innsbruck, Austria (with C. Kaletsch); Von der Heydt-Museum, Wuppertal, FRG; Kunstverein, Heidelberg, FRG; Mathildenhöhe, Darmstadt, FRG; 'Blau — Farbe der Ferne', Kunstverein, Heidelberg, FRG.

1991 Galerie Holm, Ulm, GER; Galerie Wild, Frankfurt/M., GER; Galerie Holtmann, Cologne, GER.

Collections

Paintings in major national and international private
and public collections.

Selected bibliography

1981 Exh. cat. *Bernd Zimmer: Bilder*, Ausstellungshallen Mathildenhöhe, Darmstadt; Karl Schmidt-Rottluff-Förderungsstiftung, Berlin; Exh. cat. *Bernd Zimmer: 28 Tage in Freiburg*, Kunstverein Freiburg; Exh. cat. *Bernd Zimmer: Lombok, Zwieselstein, Berlin*, Galerie Nothelfer, Berlin; Rainer Verlag, Berlin.

1983 Exh. cat. *Bernd Zimmer: Abgründe. Ihr Berge, tanzt!*, Galerie Gmyrek, Düsseldorf.

1984 Exh. cat. *Bernd Zimmer*, Saint Pierre Art Contemporain, Lyon; Exh. cat. *Bernd Zimmer*, Galerie Hans Barlach, Hamburg.

1985 Exh. cat. *Bernd Zimmer*, Galerie Hermeyer, Munich; Exh. cat. *Bernd Zimmer: Bilder 1976 bis 1985*, Galerie Silvia Menzel, Berlin; Exh. cat. *Bernd Zimmer*, Salle Saint-Georges, Liège; Exh. cat. *Bernd Zimmer: Peinture-gouaches Récentes*, Galerie Le Point, Monte Carlo.

1986 Exh. cat. *Bernd Zimmer: Bilder — Landschaften 1983–1985*, Kunstverein Braunschweig; Ulmer Museum, Ulm.

1988 Exh. cat. *Bernd Zimmer. Meer*, Studio d'Arte Cannaviello, Milano; Galerie Fahlbusch, Mannheim; Raab Galerie, Berlin/London.

1989 Exh. cat. *Bernd Zimmer: Der Spiegel der Diana*, Städtische Galerie im Lenbachhaus, Munich.

1990 Exh. cat. *Bernd Zimmer: ÜBER-SICHT. Bilder 1986/89*, Von der Heydt-Museum, Wuppertal.

1991 Exh. cat. *Bernd Zimmer. Äther. Bilder und Gouachen 1990/91*, Galerie Heinz Holtmann, Cologne.